Almost nothing

Manchester University Press

rethinking
art's histories

SERIES EDITORS
Amelia G. Jones, Marsha Meskimmon

Rethinking Art's Histories aims to open out art history from its most basic structures by fore-grounding work that challenges the conventional periodisation and geographical subfields of traditional art history, and addressing a wide range of visual cultural forms from the early modern period to the present.

These books will acknowledge the impact of recent scholarship on our understanding of the complex temporalities and cartographies that have emerged through centuries of world-wide trade, political colonisation and the diasporic movement of people and ideas across national and continental borders.

Almost nothing

Observations on precarious practices in
contemporary art

Anna Dezeuze

Manchester University Press

The right of Anna Dezeuze to be identified as the author of this work has been asserted by her in accordance with the Copyright, Designs and Patents Act 1988.

Published by Manchester University Press
Altrincham Street, Manchester M1 7JA

www.manchesteruniversitypress.co.uk

British Library Cataloguing-in-Publication Data
A catalogue record for this book is available from the British Library

Library of Congress Cataloging-in-Publication Data applied for

ISBN 978 0 7190 88575 hardback
ISBN 978 1 5261 12903 paperback

First published 2017

The publisher has no responsibility for the persistence or accuracy of URLs for external or any third-party internet websites referred to in this book, and does not guarantee that any content on such websites is, or will remain, accurate or appropriate.

Typeset by
Servis Filmsetting Ltd, Stockport, Cheshire
Printed in Great Britain by
Bell and Bain Ltd, Glasgow

Contents

Figures

Acknowledgements

Short of writing the story of my life in the last twelve years, I will probably be unable to thank all those who helped me develop and complete this book.

Research for this book was made possible by the generous postdoctoral fellowships that I was awarded from the Henry Moore Foundation and the Leverhulme Trust at the University of Manchester, and from the Terra Foundation for American Art at the Smithsonian American Art Museum. It also benefited from a Getty Library Research Grant.

This project was initially conceived during my tenure at the University of Manchester, where I had the pleasure of working with, among others, David Lomas, Julia Kelly, Mark Crinson, Samantha Lackey and the late Andrew Causey. It was in Manchester that I also had an opportunity to exchange ideas with Simon Faulkner, Steven Gartside and Pavel Büchler at Manchester Metropolitan University, as well as Mary Griffiths, David Morris and Briony Bond at the Whitworth Art Gallery. I am also grateful for stimulating encounters with the work of other UK-based academics at the time including Dawn Ades, Jo Applin, James Boaden, Alison Green, David Hopkins, Margaret Iversen and Anna Lovatt.

At the Getty Research Institute, Virginia Mokslaveskas provided invaluable help, and I thank Marcia Reed for her invitation to think about the library's Fluxus material. In Washington, I was fortunate enough to cross paths with David Getsy, Hannah Higgins, and fellow fellows at the Smithsonian American Art Museum including Kathleen Campagnolo, Amanda Douberley, Nika Elder, Jason Hill, James Meyer, Amy Mooney and Julia Sienkewicz. I am also grateful for the help of Smithsonian staff members Amelia Goerlitz, Joann Moser and the late Cynthia Mills. Jon Hendricks's ongoing support over the years has been wonderful, and I am also grateful to Gilbert and Lila Silverman.

At the Université de Genève, my colleagues were very welcoming and supportive, especially Sarah Burkhalter, Dario Gamboni, Stefan Kristensen, Nolwenn Mégard, Ileana Parvu, Brigitte Roux, Marie Theres Stauffer, and Merel van Tilburg.

Over the years, I have been kindly invited to present my work through conference papers and research seminars. I am very grateful to the hosts and audiences of these events for their questions, which substantially helped me shape this project: Paul Rooney and the Castlefield Gallery, Manchester; Jonathan Harris and Tate Liverpool; Mark Godfrey and Gabriela Salgado at Tate Modern; Arnauld Pierre and the Institut National d'Histoire de l'Art, Paris; Kaye Winwood at Companis, Birmingham; Claire Bishop at the Graduate Center, City University New York; Hanneke Grootenboer at the University of Oxford; Devika Singh and the University of Cambridge; Dimitris Michalaros at Action Field Kodra, Thessaloniki; Tamara Trodd at the University of Edinburgh; Helena Reckitt and Suhail Malik at Goldsmiths, University of London; Susannah Gilbert, the University of Essex and Firstsite, Colchester; Xenia Kalpaktsoglou and the Athens Biennial; France Nerlich and Frédéric Herbin, Université François-Rabelais, Tours; Rossella Froissart, Aix-Marseille Université; Jon Wood at the Henry Moore Institute, Leeds; Stephen Maas, Ecole Supérieure d'Art et de Design de Valenciennes; Dirk Hildebrandt and the researchers at Eikones, University of Basel; Samuel Bianchini and Emanuele Quinz, ENSADlab, Ecole nationale supérieure des Arts Décoratifs. I would also like to thank the editorial teams at *Art Monthly* and *Mute*, as well as my students at the University of Manchester, the Université de Genève, the Ecole Normale Supérieure de Lyon and the Ecole Supérieure d'Art et de Design Marseille-Méditerranée.

I am greatly indebted to Francis Alÿs, Thomas Hirschhorn, Alison Knowles, Tom Marioni, Gabriel Orozco and William T. Wiley for taking time to talk with me. I also thank them, as well as the other artists, artists' estates and institutions that agreed to generously waive copyright fees, and the gallery and museum staff who assisted me with images.

I would like to extend my thanks to the team at Manchester University Press, and would like to express my deep-felt gratitude for Amelia Jones's unique brand of encouragement, enthusiasm and brilliance.

Without the unwavering support of my family and friends, this book would never have seen the light. I thank them all with all my heart, and dedicate this book to my parents, Daniel and Karen, and my sister Laure.

Introduction: almost nothing

Precarious/ephemeral

In 1999, the Mexico City based Belgian artist Francis Alÿs asked a street cleaner on the capital's main square (the Zócalo) to sweep debris into a line, which consisted mainly of dust and cigarette butts (figure 1). As the work's title, *To R.L.*, indicates, Alÿs dedicated this work to the British pioneer of Land Art, Richard Long. From 1967, Long had traced lines in the landscape, for example by walking in the grass in a straight line (figure 2). Like Long's work, Alÿs's *To R.L.* was ephemeral: photographs document the works' brief, momentary existence. In both cases, the line acts as a trace of human presence. Alÿs's homage to Long was, nevertheless, at least partly ironic. In *To R.L.* the romantic wanderer's fleeting passage is turned into a derisory pile of rubbish. The street sweeper's efforts, at Alÿs's request, to tidy up the busy square contrast with Long's solitary, leisurely walk. Accordingly, Long's photograph shows a ghostly trail in the grass, whereas Alÿs shot six successive photographs of the sweeper at work on her fragile construction, and one portrait of her smiling afterwards. Furthermore, the paved Zócalo square, a public and political place, is a far cry from the apparently virginal spaces that serve as blank pages for Long's pedestrian markings.

I would like to argue that the differences between Long's work and Alÿs's homage point to a broader distinction – between the ephemeral and the precarious. I am following here the distinction proposed in 2000 by artist Thomas Hirschhorn. 'The term "ephemeral" comes from nature', Hirschhorn explained, whereas the 'precarious' concerns human actions and decisions.[1] According to the *OED*, the word 'precarious' designates that which is 'vulnerable to the will or decision of others'. Nature, as Hirschhorn noted, 'doesn't make decisions'. Examples of ephemeral art can be found in the work of Robert Smithson, as he let his 1970 *Spiral Jetty* be transformed by the tides and currents of a salt lake, or relied on the forces of gravity to slowly destroy his *Partially Buried Woodshed* that same year. Similarly, Giuseppe Penone let nature give shape to his 1968 *Alpi Marittime*, by affixing a steel cast

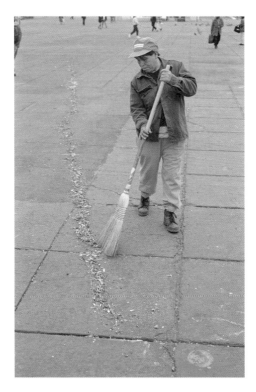

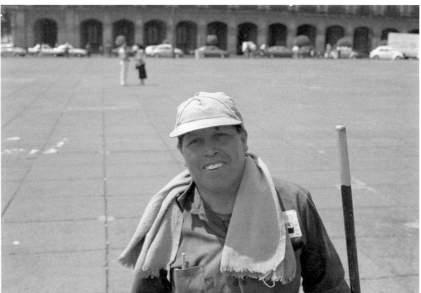

1 a and b: Francis Alÿs, *To R.L.*, Zócalo, Mexico City, 1999

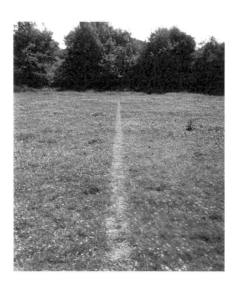

Richard Long, *A Line Made by Walking*, 1967 **2**

of his hand in the place where he had grasped a tree trunk, which went on to grow around the sculpture (figure 3).

In contrast, Hirschhorn's street *Altars*, dedicated to his favourite artists or writers, were modelled on those spontaneous shrines improvised in the street after fatal accidents: such arrangements suddenly appear, change and disappear according to unpredictable removals and contributions by anonymous passersby (figure 4). In Hirschhorn's *Altars*, which he started to install in the street in 1997, handwritten banners and signs, soft toys and balloons are often rearranged or taken away by visitors and passersby, who may also choose to light candles, or add a bouquet of artificial flowers. Both the ephemeral and the precarious suggest a fragile, uncertain process of transformation and disappearance. The word 'precarious', however, designates a temporary state whose existence and duration are subject to repeal; it is at the mercy of another. Indeed, the word derives from the Latin *precarius*: that which is obtained through prayer.

Rather than the cyclical regularity of natural phenomena, or the ineluctable logic of geological shifts and the laws of physics, precarious temporalities tend to coincide, in works such as Hirschhorn's or Alÿs's, with the ebb and flows of anonymous pedestrian traffic, cycles of waste and consumption, rhythms of work and exhaustion. Rather than staging a discrete or monumental

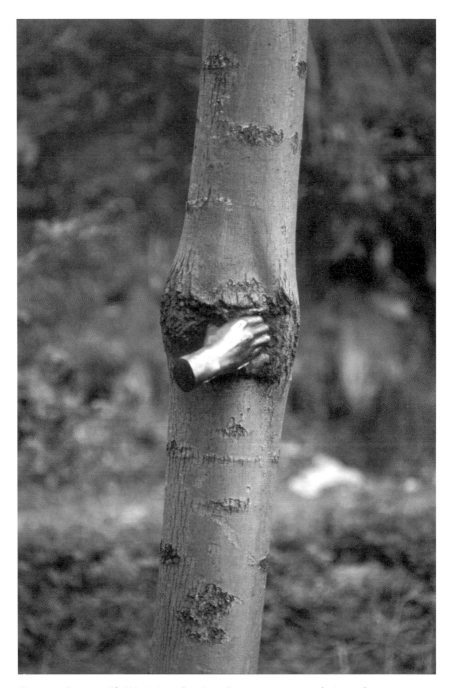

3 Giuseppe Penone, *Alpi Marittime. Continuerà a crescere tranne che in quel punto*, 1968

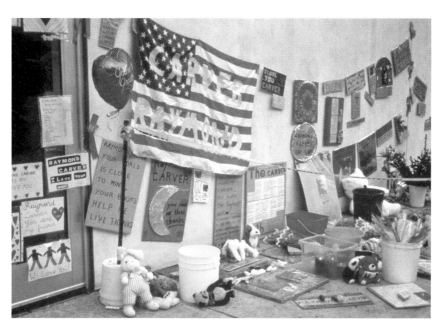

Thomas Hirschhorn, *Raymond Carver Altar*, The Galleries at Moore, Philadelphia, 2000 **4**

encounter, like Land Art or Arte Povera, between the natural and the man-made, precarious works usually consist of daily activities, banal objects and situations, or rubbish – to the point of sometimes disappearing completely into the very fabric of the viewer's everyday. Precarious works thus question the emergence, maintenance and disappearance of human constructions and endeavours, and hence their potential success or failure. They articulate a fragile balance between presence and absence, material and immaterial, some-thing and nothing. This in-between state sets precarious practices apart from artistic investigations of entropic forms and processes (such as Smithson's), as well as works involving their own planned destruction, whether spectacu-lar or systematic. As we shall see, the inherent uncertainty of precariousness equally inflects the artist's use of impermanent materials, whether natural or man-made, and the fleeting performative gesture – both recurrent features of twentieth- and twenty-first century art. Though many precarious works are transient, not all transient works are precarious.

An example of 'transient art', classified as such in Tate's excellent 2012 online exhibition *The Gallery of Lost Art*, was an ice construction which was left by British artist Anya Gallaccio to melt over three months in a London warehouse in 1996 (figure 5).[2] At first sight, Gallaccio's *intensities and sur-faces* brings to mind Allan Kaprow's 1967 *Fluids*, which consisted of seven structures similarly built with ice blocks (figure 6). The structures were built

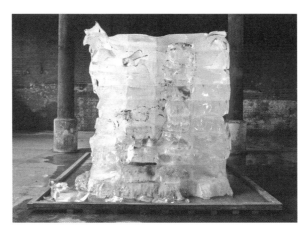

5 Anya Gallaccio, *intensities and surfaces*, 1996. Installation view, Boiler Room, Wapping Pumping Station, London, 1996

by seven different teams simultaneously across various locations in Los Angeles, following the artist's instructions. While the texture and light effects falling on the ice appealed to Kaprow as much as to Gallaccio, what mattered to the former was the teamwork involved in the construction of each of these short-term architectures, and the responses from passersby who may have come across them by chance in the cityscape. Thus, the human effort and individual experiences sought by Kaprow characterise *Fluids* as a precarious, rather than an ephemeral work, even though the artist drew on the same natural properties as Gallaccio's melting installation. And it is the urban location, as well as the time and effort of labour involved in constructing the work, that link Kaprow's *Fluids* to Alÿs's *To R.L.* An even more striking analogy between these two artists' works can be found in Alÿs's earlier *Paradox of Praxis I* of 1997, in which he pushed a block of ice through the streets of Mexico City for many hours until it melted (see cover image and figure 47). Indeed, I will argue in this book that 1990s works such as Alÿs's *To R.L.* or *Paradox of Praxis I*, like Hirschhorn's *Raymond Carver Altar*, occupy a specific field within contemporary art that can be traced back to 1960s art practices.

Moving away from the ephemeral associated with natural materials, whether in nature or in the gallery, I would like to broaden this comparison between the transient and the precarious by drawing two examples from the field of non-sculptural performance. In the first instance, visitors were invited to participate in Marina Abramović's performance, entitled *The Artist is Present*, staged over the course of the artist's 2010 retrospective at the Museum of Modern Art in New York. In the museum atrium, Abramović sat at a white table. After waiting in line, each participant was allowed to sit silently across from her, looking at her for however long they wished. As the

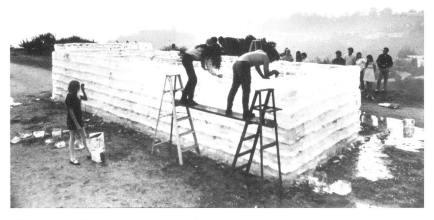

Allan Kaprow, *Fluids*, Trousdale Estate, Los Angeles, 1967 **6**

artist looked back at them, some viewers smiled, some were uncomfortable, others spoke of a 'transforming experience'.[3] A crowd usually gathered in the atrium to watch the ongoing performance. One year later, visitors to the same institution were given the opportunity to participate in another form of performance. On seven different days in the winter of 2011, anyone could sign up to have lunch with artist Alison Knowles in the museum's first-floor café. On their arrival, around eleven visitors were shown to a long table, identical to the others, except for paper placemats listing the unique menu that they would subsequently be served: a tunafish sandwich on brown bread, and a choice of soup or buttermilk. After having enjoyed their meal, and perhaps chatted with the artist, the participants left. Few eaters in the busy café noticed that this had been a performance of Alison Knowles's *Identical Lunch*.[4] While Abramović has sought, from the late 1960s onwards, to confront and provoke her audience through her bodily presence, Knowles and her fellow Fluxus artists have preferred to create 'event scores' that can be performed by anyone who reads them, sometimes in the course of their everyday lives. While Abramović cast her encounter with the viewer as an event, Knowles turned a daily occurrence, such as eating a sandwich, into a performance. Indeed, *Identical Lunch* was born when Knowles noticed, some time around 1967, that she often ate the same meal in a diner near her workplace. This prompted her to start keeping a diary of her 'identical lunches', and to invite her friends and acquaintances to eat the same meal, with or without her, and to record their experiences in turn. The results would be gathered in the 1971 *Journal of the Identical Lunch* (figure 7).[5]

The short-lived, transient and intangible quality of much performance art, which characterises both Abramović's and Knowles's works, remains

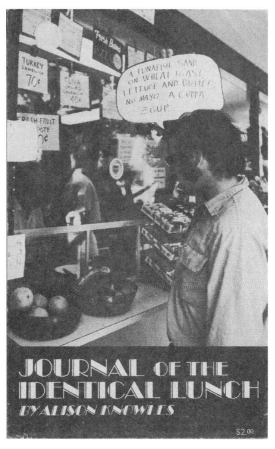

7 Alison Knowles, *Journal of the Identical Lunch*, San Francisco: Nova Broadcast Press, 1971

markedly different in each. Although both occupy the realm of human activities and decisions outlined by Hirschhorn, the banality of the *Identical Lunch* contrasts with the spectacular nature of Abramović's use of the museum as a stage. Unlike *The Artist is Present*, the *Identical Lunch* is precarious, I would argue, inasmuch as it occupies the space of mundane routines, to the point that it may pass completely unnoticed.

Knowles's aesthetic of the everyday was strongly influenced by the event scores of another Fluxus artist, George Brecht. These verbal instructions, consisting sometimes of a few single words, were written on individual cards, which the artist started to mail to friends and acquaintances around 1961, before publishing them as a Fluxus boxed collection in 1963 (figures 21, 23). The 1961 *Three Lamp Events*, for example, reads:

- on.
- off.
- lamp
- off. on.

Such words can be used as instructions for a performance, involving switching a light on and off, in front of an audience, or as a signal to consider this banal activity, which we perform many times a day, as an 'event' in itself. That same year, Brecht described his practice in terms of what he called 'borderline' art. As he described 'an art verging on the non-existent', 'an art at the point of imperceptibility', he provided an insight into what, in my eyes, is the fundamental uncertainty that characterises the nature of precarious art.6 An artwork '*at the point of* imperceptibility', *on the verge of* disappearance, an action that *risks* passing unnoticed, an object that *teeters* on the point of destruction: such is the vocabulary that describes the field of precarious practices since the 1960s. Indeed, this converges with another other set of meanings associated with the word 'precarious' according to the *OED*: 'liable to fail, exposed to risk, hazardous'.

Often, as we shall see, the borderline outlined by Brecht is mapped on to others, such as the line between success and failure, as per the definition of 'precarious', but also that between value and waste, as the work is 'exposed' to destruction and disposal by others. Since the 'borderline' work risks being thrown out or disappearing into the banality of the everyday, this uncertain state between appearance and disappearance also coincides with a more general borderline: between something and nothing. This status as '*almost* nothing' is what allows precarious works to raise a fundamental question: at what point does nothing becomes something, and vice versa?

Nothings

It is the uncertain oscillation of 'borderline' art between the perceptible and the imperceptible, between something and nothing, which warrants my use of the adverb 'almost' in the title of this book. In order to underscore the significance of this adverb, I would like to situate the precarious practices discussed in this book in a context outlined by a number of studies and exhibitions which have focused, in the first fifteen years of the twenty-first century, on 'nothing' as a theme of art since the early twentieth century. Indeed, precarious works of artists such as George Brecht or Francis Alÿs were referred to or included in some of these projects, along with those by other artists that I will be discussing in this book. Two of Alÿs's works were illustrated in a publication edited by Ele Carpenter and Graham Gussin that accompanied the 2001 travelling exhibition *Nothing*, which set out to investigate a field of interests including 'absence, formlessness, invisibility and the immaterial'.[7] For their part, Brecht's event

scores were included in *Fast Nichts* (*Almost Nothing*), an exhibition that took place in Hamburg between September 2005 and April 2006. The exhibition proposed a focus on a 'minimalistic tendency' in art since the 1960s, characterised by a 'new silence' and a general withdrawal from visibility.[8]

A year earlier, in their 2004 exhibition titled *Densité ± 0*, curators Caroline Ferreira d'Oliveira and Marianne Lanavère had highlighted the importance of Brecht's scores in their catalogue, as well as including a work by Francis Alÿs in the show. In their catalogue essay, they described this type of work as 'micro-events' or 'micro-actions' tending, along with a number of other practices, towards the 'invisible, the void, the impalpable and the fugitive'.[9] Like Carpenter and Gussin, Lanavère and Ferreira d'Oliveira listed 'the immaterial' as a theme of their exhibition, alongside emptiness and the imperceptible.

Speaking of 'nothing', Carpenter pointed out the 'difficulty of pinning down a concept which – paradoxically – is impossible to quantify'.[10] Indeed, this difficulty comes through in the variety and inconsistency of many exhibitions on the theme of 'nothing'. *The Big Nothing*, a 2004 exhibition at the Institute of Contemporary Art in Philadelphia, embraced an extremely broad definition including not only the 'void', the 'invisible' 'absence' and 'zero', like the aforementioned exhibitions, but also notions as widely different as 'anarchy, the absurd, nonsense, zip … infinity, atmosphere, ellipsis, negation, annihilation, whiteness, blackness' and 'abjection' (in addition to the 'formlessness' also of interest to Carpenter and Gussin).[11]

Within this potentially sprawling field of nothingness can be singled out some more specific strands. As a starting point, let us compare for example the above-mentioned references to George Brecht's scores in *Densité ± 0* and *Fast Nichts*. In *Fast Nichts* Brecht's scores were inscribed within a trajectory of 'reductive, minimalist tendencies in art since circa 1960' characterised by an 'art of simplicity'.[12] The exhibition also included Minimalist sculptures by Dan Flavin, Carl Andre and Richard Serra, conceptual pieces by Joseph Kosuth, On Kawara and Lawrence Weiner, as well as abstract works by Josef Albers and Blinky Palermo, and photographs spanning the twentieth century, from the work of Albert Renger-Patsch and Alfred Stieglitz to that of Thomas Ruff.

In contrast, *Densité ± 0* focused less on this 'reductive' tendency than on what the curators perceived as the 'field of possibilities' opened by Brecht's event scores, which can be interpreted in a potentially infinite range of ways, whether through action or imagination. For the curators, Brecht's scores thus belong to a field of 'immanence', influenced by a Zen-inspired philosophy.[13] Brecht's interest in Zen, they reminded us, was mediated by the crucial figure of composer John Cage, whose engagement with Zen master D.T. Suzuki was pivotal for his exploration of silence, chance and everyday noise. That Cage was also included in *Fast Nichts* suggests, in my eyes, that this exhibition collapsed two radically different tendencies in the exploration of nothingness:

one bent on the minimalist and the reductive, and the other open to chance and the everyday. Since my study of precarious 'borderline' art will resolutely follow the latter trajectory, I would like to take this opportunity to touch further on this fundamental divergence.

In particular, I would like to link the reductive, subtractive trajectory to a broader tendency put forward in a number of exhibitions that sought to position the artists' turn to 'nothing' as a strategy of negation and refusal. In the above-mentioned catalogue for the *Big Nothing*, for example, curator Ingrid Schafner pointed to two genealogies of such a strategy. On the one hand, her vocabulary appears indebted to the anti-art stance inaugurated by Dada's refusal of meaning and value, often accompanied by a celebration of destruction – hence her references to 'anarchy, the absurd, nonsense' and to Marcel Duchamp's affirmation, cited in the catalogue, that 'Dada is nothing'.[14] On the other hand, Schafner's references to 'whiteness' and 'blackness' evoke the history of the monochrome – which she calls 'modernism's tendency to zero', citing works by Kasimir Malevich, Robert Ryman and Ad Reinhardt.[15] When we look at these two genealogies more closely, however, it becomes evident that both tendencies exceeded the logic of 'reductivist impulses, refutations and refusals' emphasised by Schafner.[16] Indeed, Martina Weinhart's very good essay, in the catalogue for another exhibition on 'nothing' (*Nichts*, at the Schirn Kunsthalle in Frankfurt in 2006), also singled out Duchamp and Malevich as the two central historical references in this history, but provided a more nuanced analysis than Schafner's inventory.[17] Let us briefly look at each of these two genealogies in turn.

Rather than navigate the immense literature on Dada and Duchamp in order to single out these artists' relation to nothingness, I would like to sketch some general divergences that might emerge from different interpretations of Duchamp's readymades. When Duchamp submitted a urinal, dated and inscribed with the signature 'R. Mutt', to the Salon des Indépendants in New York in 1917, this *Fountain* appeared as a radical challenge to accepted definitions of taste, value and meaning in the institutional and discursive field of art. The readymade could thus be read as a destructive Dada 'nothing' in multiple ways: it was an insignificant object, it was an artwork that involved no work beyond its selection, and it challenged existing categories of aesthetic judgement. On the other hand, however, numerous interpretations of Duchamp's *oeuvre* have revealed the wealth of other issues, ideas and practices that ran through his work, including the readymades. For our purposes, I would like to point to one study in particular, by Thierry Davila, that has proposed an in-depth reading of Duchamp's *inframince*, a term which also came to the fore in the essays for *Densité ± o*.[18] In his notes on the *inframince* or 'infra-thin', Duchamp ventured into the realm of the barely perceptible, citing examples such as 'the heat of a (recently occupied) seat' or the sound produced by the

friction of two legs clad in velvet trousers as one walks.[19] Just as the *Densité* ± *o* curators highlighted the exhibition artists' quest to capture 'the slightest nuance' in the world, Davila proposed that Duchamp's *inframince* was a means 'to open the field of perception' by introducing infinitesimal differences.[20] Like Davila, the *Densité* ± *o* curators found examples of this *inframince* in works by Duchamp such as his 1919 *Air de Paris*, a glass apothecary phial containing, as a label informs us, 50 cubic centimetres of Paris air (figure 8).

Here an infra-thin transparent surface – both present and vanishing (if perfectly clean) – serves to mark an imperceptible difference between two apparently identical, if intangible, materials: the Paris air captured by the artist in 1919 and whatever other air surrounds the work as we view it. Significantly, Davila extended his analysis of the *inframince* to the readymades themselves, which, as he suggested, similarly perform an *inframince* 'écart' – a gap or displacement – and a 'distinction without thickness' between the mass-produced urinal and its *Fountain* double, appropriated by the artist through an inscription, a title and a change of position.[21] It is in this sense that Duchamp's readymades, in Davila's terms, 'describe nothing but a threshold of visibility, of perceptibility, of intelligibility'.[22] Rather than a negation, the readymade thus opens up a field of enquiry into the very nature of perception as a performative process.[23]

The monochrome may also appear at first sight, like the Duchampian readymade, to be driven by a list of refusals. Following the rupture inaugurated by abstract art, the monochrome excluded the illusionist, perspectival space of representation. Furthermore, unlike much abstract art, the monochrome

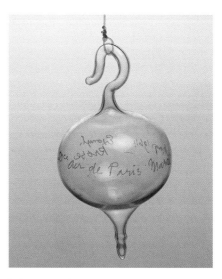

8 Marcel Duchamp, *Air de Paris*, 1919/1964

evacuated any suggestion of figure/ground relationships and reduced com-
position to its barest minimum – whether to suggest an immaterial space (as
did Malevich), to explore the picture's materiality (like Robert Ryman), or to
search for an 'essence' of painting devoid, in Reinhardt's words, of 'symbols',
'signs', 'ideas', 'attributes' or 'qualities'.[24] As a contrast with such refutations,
however, I would like to turn to Cage's texts on Robert Rauschenberg's mono-
chromatic *White Paintings* of 1951 (figure 9).

While a 1953 essay lists, very much like Reinhardt, a series of refusals – of
'subject' and 'message', 'image' and 'idea', as well as 'technique' and 'talent',
'intention' and 'beauty' among others[25] – a well-known text of 1961 focused
on what actually happens once these elements are removed. Rauschenberg's
monochromes, Cage argued, became 'airports for the lights, shadows and par-
ticles' and 'caught whatever fell on them'.[26] Indeed, with this interpretation,
the *White Paintings* appear as the visual counterpart of Cage's famous 1952
4′33″, a musical composition that invites the performer to remain silent for
this specific duration of time, during which the audience inevitably ends up
focusing on the sounds, noises and micro-events that occur in the concert hall.

Just as Duchamp's readymade can be read as both a strategy of refusal and
an *inframince* intervention in the everyday, then, the two trajectories of the
monochrome similarly diverge when it comes to their relation to nothing-
ness. In one narrative, Minimalism is read as pursuing the monochrome's
rejection of representation and illusion by further turning the viewer's atten-
tion away from the art object's visual properties, and towards the specific
conditions of its production and exhibition. In the other account, the mono-
chrome contributed to dissolve the art object into the mundane space of the
everyday, thus inviting the kind of heightened attention to dust particles and
infinitesimal nuances at play in Duchamp's performative *inframince*.

Dematerialisations

These two tendencies were brought together by John Chandler and Lucy
Lippard in a 1968 essay on what they famously diagnosed as a contemporary
'dematerialization of art'.[27] This dematerialisation, they argued, involved
challenging the status of 'art as an object' through a 'deemphasis', as Lippard
would subsequently call it, of the 'material aspects' traditionally ascribed to the
autonomous artwork: 'uniqueness, permanence, decorative attractiveness'.[28]
Contrasting the work of Rauschenberg with that of Minimalist artists such as
Donald Judd or Sol LeWitt, Chandler and Lippard highlighted two 'sources' or
drives for this trend towards dematerialisation: Rauschenberg's work pointed
to 'art as action', whereas Minimalism opened the way for 'art as idea'.[29] With
Minimalism, observed Chandler and Lippard, 'more and more work' was
'designed in the studio but executed elsewhere by professional craftsmen'. Like

9 Robert Rauschenberg, *White Paintings* [two panel], 1951

LeWitt himself, Chandler and Lippard interpreted this new division of labour as signalling a possible conception of the art object as 'merely the end product', whereas the 'idea' had become primordial. It is in this sense that Chandler and Lippard concluded that in such cases, 'matter is denied, as sensation has been transformed into concept'. This gesture of denial, it seems, extended the refusals embodied in Reinhardt's monochromes to Judd's 'specific objects' and beyond, as it found its logical conclusion not only in LeWitt's structures, but also in text-based works by conceptual artists such as John Baldessari, Joseph Kosuth and Art & Language. In some of these artists' works, as Martina Weinhart has pointed out, the black or white monochrome became, in effect, the material support for the exploration of art-related ideas.[30]

In the other trajectory, inaugurated with Rauschenberg's works according to Chandler and Lippard, 'matter has been transformed into energy and time-motion'.[31] Here the monochrome – in its Cagean interpretation – is the first step in the direction of opening the artwork to fields beyond art in a variety of ways: through the use of intangible materials, or the focus on process, performance and experience. Thus a line can be drawn from Duchamp's *inframince*, via Cage's *4′33″* and Rauschenberg's *White Paintings* in the 1950s, to George Brecht's event scores or Allan Kaprow's performances in the early 1960s, and beyond, to conceptual practices later in the decade by artists such as Bruce

Nauman or Tom Marioni, whose work I will also discuss in this study. While this lineage is well established in the history of contemporary art, I wish to map out the specificities of its defining features and of the issues at stake.

In order to further distinguish between various forms of dematerialisation in the late 1960s, I would like to introduce into this discussion a lesser-known essay, written by art critic Lawrence Alloway shortly after Chandler and Lippard's. Like them, Alloway addressed the changing status of the art object in contemporary practices. As Alloway explained, an artwork traditionally required 'a degree of compactness (so that the object is united, composed, stable)'.[32] 'In the 'sixties', however 'a number of non-compact art forms' had started to proliferate that appeared either 'diffuse or nearly imperceptible'. Unlike Chandler and Lippard, however, Alloway chose to describe this shift not as a dematerialisation, a 'deemphasis' suggesting operations of subtraction or reduction. Instead, he spoke of an 'expanding and disappearing work of art', the contours of which were being shaped and blurred according to new 'interfaces' between art and fields of enquiry lying outside the world of art. As we shall see in Chapter 3, Alloway's discussion may have been informed by his reading of the 'borderline' precarious practices developed by George Brecht and Allan Kaprow during that decade. In the context of this introduction, I will only point out that Alloway's definition of an 'expanding and disappearing work of art' comes closer to the Cagean and the *inframince* genealogies than to the logic of 'strategies of refusal' and negation. Chandler and Lippard had themselves remarked, like Alloway, that 'art as action' had 'expanded' to the extent that it had become 'inseparable from its non-art surroundings'. Nevertheless, they appeared to give priority to 'art as idea', in the form of an 'ultraconceptual' form of dematerialisation 'in which the object is simply an epilogue to the fully evolved concept'.[33]

After the publication of her article with John Chandler, Lippard herself acknowledged that this 'rejective' stance, as they had called it in 1968, did not characterise all forms of conceptual art.[34] As she declared in a 1969 interview, some conceptual artists adopted 'an acceptive instead of a rejective approach', inasmuch as they sought to 'include … far more than … they exclude'. A 'rejective approach' was attributed to those artists concerning themselves exclusively 'with Art' and 'with retaining a consistency, or coherency'. Whereas such artists were influenced by the 'rejectively self-contained' structures of Minimalism (as Lippard would describe them in a later text),[35] other conceptual artists embraced a Dada and Surrealist lineage of acceptance instead. As examples of such 'acceptive' conceptual practices, Lippard cited Bruce Nauman, alongside the chance experiments of Cage and the 'borderline' practices of Brecht, Fluxus and Allan Kaprow, all discussed in the first part of this book.

Artists such as Robert Barry, noted Lippard, hovered on the boundary of

these two categories: his work is 'acceptive' in that it tends to 'use non-art, immaterial situations' but it is 'rejective' to the extent that it may impose 'a closed instead of an open system' that will work to assert 'a formal or structural point of view'.[36] In this way, Lippard extended Alloway's opposition between the 'solid', 'united, composed, stable' object on the one hand, and 'diffuse' or 'expanded' art forms on the other. Even 'non-compact' forms, she suggested, can carry over certain artistic concerns with 'compact', coherent and consistent structures. Although Lippard's inventory in *Six Years*, like Alloway's list of 'non-compact' art forms, made no distinction among these two radically different approaches, I would argue that this divergence played a crucial role in the development of various kinds of dematerialisations in the late 1960s, including the emergence of precarious artworks. In this study, I will trace the trajectory of a specific form of 'diffuse or nearly imperceptible' work back to the early 1960s, and pinpoint some of the ways in which it evolved throughout the decade, before being taken up again by artists in the 1990s. In the lineage of Duchamp's *inframince* as well as Cage's experiments with chance, this kind of precarious practice will prove to be 'acceptive' and inclusive, as well as 'expanded' to the point of sometimes 'disappearing'.

Material, immaterial, invisible

In the late 1960s, dematerialised and expanding practices promised to challenge the fetishism of the modern art object, whose value had traditionally been defined by its status as a unique commodity exchanged in an art market with its own discursive hierarchies and economic rules. Indeed, in their 1968 article, Chandler and Lippard assumed that art dealers would not be able to 'sell art-as-idea': hence, they argued, dematerialised art posed a simultaneous challenge to 'physical materialism' as well as 'economic materialism'.[37] By the time Lippard published her compendium of dematerialised practices in 1973, however, she had to admit that: 'Hopes that "conceptual art" would be able to avoid … general commercialization … were for the most part unfounded.'[38] This inevitable commodification of art – however dematerialised – will serve as a backdrop for my observations on the evolution of precarious practices from the early 1960s to the first decade of the twenty-first century.

Rather than throwing out the baby with the bathwater, retrospective readings of conceptual art's ultimately failed attempt to escape the nets of capital have nevertheless yielded significant conclusions. Some of the more relevant questions today have been raised by a number of studies in the past ten years that have revisited a central innovation of conceptual art: the creation of exhibitions in which there appeared to be, quite simply, nothing to see. Inaugurated in 1958 with Yves Klein's *Le Vide* at the Galerie Iris Clert in Paris, such forms of empty exhibitions multiplied in the late 1960s,

and included Lippard's own curatorial experiments. In addition to being discussed in the above-mentioned studies and exhibitions focused on an art of 'nothing', these empty displays or exhibitions of so-called invisible works have also been the subject of exhibition surveys, including curator Ralph Rugoff's 2005 *A Brief History of Invisible Art* and its updated version in 2012 under the title *Invisible: Art about the Unseen, 1957–2012*, and the travelling 2009 exhibition entitled *Voids: A Retrospective*, curated by John Armleder, Mathieu Copeland, Laurent Le Bon, Gustav Metzger, Mai-Thu Perret and Clive Phillpot. As with discussions of nothing, a dividing line separates those curators who considered the empty gallery as a refusal, and those who sought to tease out the specificities of these voids. For example, the exhibition *Voids* literally presented visitors with a series of empty rooms that contained no object or document whatsoever. An explicative wall text displayed at each room's entrance replaced the actual recreation of each historical exhibition with information about the event and the component elements present at the time. (Yves Klein's exhibition, for example, had involved two Republican guards standing on each side of a curtained entrance, as well as painting the gallery's furniture white and serving blue cocktails at the opening.) In their choice to leave the exhibition rooms empty, the curators of *Voids* put forward a logic of refusal similar to that showcased in the previously mentioned exhibition *The Big Nothing*, which had included a documentary section mapping out the history of closed exhibitions which visitors were unable to enter – the mirror image of the empty gallery. In contrast to *Voids*, Rugoff's exhibitions foregrounded the rich variety of meanings historically attributed to the empty gallery and apparently invisible art. Like *Densité ± o*, Rugoff's exhibitions included works so tenuous or commonplace as to be *nearly* imperceptible, as well as practices that mobilised other senses than the visual. The empty gallery was shown to be used to different ends, ranging, according to Rugoff, from 'institutional critique', 'avant-garde antagonism' or 'cultural commentary', to 'personal humility', 'social idealism' and even 'transcendental mysticism'.[39]

The first conclusion that can be drawn from Rugoff's exhibitions – in marked contrast with *Voids* – is that there has never been, in fact, such a thing as either nothing or a completely empty gallery. In this sense, such exhibitions chimed with Cage's demonstration, with *4′33″*, that there was no such a thing as silence. As Chandler and Lippard noted in 1968, the detractors' frequent cry that in conceptual art 'there is "not enough"' – or even, one might add, 'nothing' – '"to look at"', needed be rephrased: was it not rather a matter of there being 'not enough of what they are accustomed to looking *for*'?[40] So-called empty exhibitions or invisible works, it turned out, contained in fact a range of non-visual material – whether sounds, texts or information, nearly imperceptible objects or interventions in the architectural space of the gallery. They played with the viewers' expectations, actions or imaginary

projections, as they stood looking for something to see in the white cube of the gallery.

In the same way as simplistic definitions of emptiness or nothing have been challenged, the very term 'dematerialization' has repeatedly been rephrased since Chandler and Lippard's usage. Just as Robert Barry's 'dematerialization' was described by the curators of *Densité ± o* as a 'materialization of the invisible',[41] some studies of conceptual practices have defined them more precisely as experiments with language, publicity or systems, as well as new forms of work and exchange.[42] Other authors have proposed replacing the term 'dematerialization' with more accurate descriptions such as 'displacements and rethinkings of materiality itself' (according to Michael Newman) or 'differently material' practices (Shannon Jackson).[43] My study of precarious practices similarly aims at developing a more specific vocabulary to describe and analyse some of the new forms of materiality as they emerged in the 1960s and evolved at the end of the twentieth century. In this way, I will inscribe these artistic forms within broader shifts in the development of capitalism during this period, from the accelerated production and consumption of material goods of the late 1950s, to the increased development of a service economy in the late 1960s, and the 1990s explosion of the information economy's 'immaterial' products.

Significantly, such shifts in perspective in the definition of dematerialised art practice allow us to leave behind a vocabulary relating to absolute values often associated with terms such as 'nothing' or 'emptiness' – be it the provocative rejection of all forms of order, reason and meaning, an abdication to the overpowering depths of the void, or a metaphysical search for the invisible and the infinite. It is this move away from the absolute, of course, that the *almost* in 'almost nothing' signifies. By existing on the brink of disappearance, on the borderline between art and the everyday, the precarious practices discussed in this book occupy a space of immanence far removed from any mystical, nihilistic or scientific aspirations. Rather, the material existence of the 'almost nothing', as we will see, has often been shaped by the artists' desire to be as matter-of-fact, to add as little to the world, as possible; reality is disturbed only in discreet, casual, minute and often reversible ways, at the risk of passing unnoticed. This is why precarious practices shun the illusionistic ambiguities between reality and artifice, as in the case of other practices verging on nothing by artists such as Ceal Floyer, whose work has been frequently included in exhibitions on this topic. Above all, precarious works are attached to concrete actions and constructions in the here-and-now, in order to capture the fleetingness of the everyday. Here, my perspective dovetails with British philosopher Simon Critchley's use of the term 'almost nothing' as the title of one of his books.[44] In his attempt to avoid both nihilism and the desire to overcome it, Critchley proposed 'almost nothing' as a refusal

of absolutes, in favour of an Emersonian focus on the 'particulars' of the everyday.

Paradoxically, the 'almost nothing', according to my definition, turns out to be invisible precisely *because* it is visible everywhere and anywhere. This 'hypervisibility', as Mieke Bal called it in her essay for the exhibition *Nichts*, is able 'to join forces' with 'invisibility' in the exploration of forms that challenge 'imagery', 'figuration' and the fetishised materiality of the commodified art object, while nevertheless staying clear of either 'abstraction' or the 'sublime'.[45] As Bal suggested, artworks that plumb the fields of both invisibility and hypervisibility can make 'visible what is there for everyone to see but which remains unseen, because it does not have a form that stands out'. Unsurprisingly in my eyes, Bal related that which 'is there for everyone to see but which remains unseen' to the everyday itself, which has been defined in these terms.[46] As Maurice Blanchot explained in a 1962 text to which I will return later in this book, the everyday may be everywhere, but we cannot, in fact, grasp it.[47]

In addition, Bal's repeated references to the 'formless' echo the recurrence of this term in discussions of nothingness in art – as we saw earlier – as well as Blanchot's definition of the everyday as evading form. In this book, I will seek to demonstrate how the material specificities of precarious practices were shaped through diverse interrogations of the very processes involved in defining a 'form that stands out', as Bal put it,[48] or, in other words, an order and logic that gives the artwork its 'compact' and 'coherent' character, as Alloway would phrase it. Based in the elusive field of lived experience, the everyday according to Blanchot evades both administrative structures and forms of knowledge. It is distorted through either representation or classification. Furthermore, unlike the sensationalist news story, the everyday is fundamentally devoid of spectacular events.

Indeed, the second characteristic that the invisible or nearly invisible works discussed by Rugoff had in common – and what his exhibitions did share with *Voids* as well as with most of the previously mentioned shows revolving around the question of 'nothing' – involves a general resistance to definitions of the art exhibition as entertainment and spectacle. As early as 2002, Rugoff had pitted 'invisible art' against recent 'architectural showpieces such as the Guggenheim Bilbao or the new Tate Modern' which encourage 'ever more spectacular exhibitions'.[49] Over ten years later, he could only confirm this tendency, which constituted, alongside the multiplication of international art exhibitions and the increasingly high prices reached in auction sales, so many 'flamboyant displays' of capital.[50] In his 2004 foreword to *Densité ± o*, Henry-Claude Cousseau similarly located the exhibition in a context dominated by 'immediate spectacularity'.[51] Just as *Voids* co-curator Laurent Le Bon described the exhibition as a 'pause' in the 'frenetic race' of the cultural industry, the curator

of the above-mentioned *Nichts* described 'stillness, emptiness and silence' as a response to the excessive quantity of images in contemporary society.[52] In the same way, the 'insignificant' and uneventful everyday defined by Blanchot resists its spectacularisation through mass media.

In this sense, the art of the 'almost nothing' discussed in this book dovetails as much with the aforementioned field of practices concerned with 'nothing' or the 'invisible', as with a range of other contemporary practices that set themselves against the spectacular by exploring the insignificant, the trifling, or the anti-monumental. Thus we shall see how precarious works intersected with practices of junk art, assemblage, the 'makeshift', the 'derisory' and the 'unmonumental' (both in the 1960s and more recently), as well as with various forms of performance, participatory and conceptual art, and even certain kinds of optical and kinetic experiments. Comparing precarious works from the 1960s to more recent contemporary practices will allow us to draw out their specificities and carve out a new field of enquiry beyond any single medium or format. Most importantly, I will argue in this book that it is the precarious materiality of such artworks that allows them to explore political and economic issues.

The opposition I have just sketched out between almost imperceptible works and spectacular tendencies in contemporary art logically steers us towards a discussion of the politics of the 'society of the spectacle', as Guy Debord famously termed it in 1967, and of the Situationists' refusal to produce art objects in favour of the practice of *détournement* and 'psychogeographic' experiments such as the *dérive*. Certainly, the Situationists' celebration of lived experience against the alienation of capitalism was directly echoed in Blanchot's definition of the everyday as '*ce qui se vit*' ('what is lived') rather than '*ce qui se regarde ou se montre*' '*sans nulle relation active*' ('what is watched or is shown', 'with no active relation'), in mass media in particular.[53] Like the Situationists, artists producing precarious works explored the everyday as an alternative to capitalism's ever more ubiquitous spectacle. As Brian Kuan Wood suggests in a 2015 essay, the *société du spectacle* described by Debord had mutated, by the first decade of the twenty-first century, into a global capitalism based on visibility and speculation.[54] Moreover, Kuan Wood argues that the 'dematerialization' of 1960s conceptual art, which highlighted the relations between material support and immaterial ideas, processes and affects, opened a path for reflections on the 'economy of visibility' that appears to drive capitalism at the beginning of the twenty-first century.[55] In this book, I will analyse the alternative 'economy of visibility' at work in 'borderline', 'hypervisible' or nearly imperceptible artworks. By relating their status as objects to the capitalist practices of consumption and production of commodities, and to forms of artistic and non-artistic work, I hope to shed some light on what Kuan Wood aptly described as a 'tangle' of 'symbolic, informational, and economic

values'[56] which dematerialised, or 'expanding and disappearing' practices (as I prefer to call them), sought to embed in new material forms.

Precariousness, precarity and the 'human condition'

In order to start unpacking this complex nexus of ontological issues connecting the status of the object to political questions raised by socio-economic developments, I have turned to Hannah Arendt's 1958 study *The Human Condition* for several reasons. Firstly, Arendt's interest in 'human existence as it has been given' shares the same basis as the 'acceptive' approach of precarious practices: it is a matter of addressing the situation of the individual, here and now, in the concrete world, on a human scale.[57] Arendt's starting point, like Critchley's in *Very Little, Almost Nothing*, is a condemnation of the way '[o]ur culture is endlessly beset with Promethean myths of the overcoming of the human condition'.[58] Secondly, Arendt's analysis of this condition focused on its 'most elementary articulations', which are none other than human activities themselves.[59] There are three main activities for Arendt: work, labour and action. Whereas work aims at the human production of artificial goods, the term 'labour' designates, according to Arendt, the non-productive activities required by 'vital necessities', such as cooking, cleaning and taking care of children.[60] The third form of activity that Arendt highlights is action, also closely connected to thought and speech. The relations between precarious artworks and these three activities will be one of the guiding threads running through this study. Such human activities were defined by Arendt in terms of their relations to biological and natural cycles, and the kind of relationships they set up between individuals. Clearly dependent on the limits of the human body as much as on the contingent networks of collective decisions, these human activities are shown to be precarious – a third reason why I believe Arendt's perspective to be a key reference for this study. Indeed – and this is a fourth and final point – Arendt tried to situate the evolution of these activities historically, thus relating developments in the human condition to socio-political changes. And it is within this initial historical context that this study similarly seeks to inscribe the origins and evolution of precarious works.

In fact, *The Human Condition*, written by Arendt in late 1950s America, provides us with indispensable insights into the evolution of the three fields of human activity – work, labour and action – and its impact on the 'human condition' in the expanding consumer society of that time. In this way, as I will demonstrate in Chapter 1, Arendt's study sheds light on the very context in which the precarious practices of assemblage and happenings emerged. By relating Arendt's study to contemporary sociological reflections on 1950s America, I will outline a network of concerns with the precarious condition of goods and workers in a society organised around the single-minded logic

of planned obsolescence and profit-driven organisation. In the eyes of some commentators, as for Arendt, such developments led to an alienation of the individual characterised by an atrophy of both lived experience and the political will to action. These were the conditions to which artists also responded through their precarious works.

Since that moment, I will argue in this book, precarious practices have been intrinsically connected to the 'human condition' of individuals living in the capitalist consumer society that took shape in the 1950s and continued to evolve over the next six decades. As capitalism during this period found new ways of pursuing and refining the logic of efficient production and consumption pioneered in 1950s America, the fundamental shifts in the human condition pinpointed by Arendt continued to serve as a reference for political philosophers. Writing, thirty years after Arendt, about the *Metamorphoses of Work* in capitalist society, French philosopher André Gorz explicitly aligned himself with her thinking, as he cited in full, as an epigraph to his book, the statement of intent that Arendt included in the prologue to *The Human Condition*:

> What I propose in the following is a reconsideration of the human condition from the vantage point of our newest experiences and our most recent fears. This, obviously, is a matter of thought, and thoughtlessness – the heedless recklessness or hopeless confusion or complacent repetition of 'truths' that have become trivial and empty – seems to me among the outstanding characteristics of our time. What I propose, therefore, is very simple: it is nothing more than to think what we are doing.[61]

By the late 1980s, the 'heedless recklessness' of what Gorz called 'economic reason', and its direct impact on the human condition first observed by Arendt, were increasingly observable, as the principles of a neoliberal economy had been aggressively applied across Europe and North America throughout the decade. Two developments, in particular, preoccupied Gorz. On the one hand, Gorz deplored the deep disparity in the distribution of work between an elite of 'privileged' workers and 'an increasing mass' of 'precarious' and unemployed workers.[62] On the other, he followed Arendt in mourning the loss of an *art de vivre* – an art of living – in an ever more efficient and consumer-oriented society.[63]

At the beginning of the twenty-first century, sociologist Zygmunt Bauman also witnessed the 'profound changes to the human condition' inflected by the advent of an expanding global neoliberalism.[64] Although Bauman did not refer to Arendt, he seemed to be following in her footsteps as he focused on these changes from the perspective of the individuals living under this economic regime. For example, Bauman highlighted an increasingly widespread 'combined experience of insecurity (of position, entitlements and livelihood), of *uncertainty* (as to their

continuation and future stability) and of *unsafety* (of one's body, one's self and their extensions: possessions, neighbourhood, community)'.[65]

By 2000, as Bauman noted, this experience had already been analysed from different perspectives by a number of European thinkers. A growing sense of uncertainty could be partly attributed to neoliberal onslaughts – unprecedented since the 1950s – on stable employment, workers' rights and benefits. French sociologist Pierre Bourdieu, for example, had condemned in 1997 an increasing 'precarity' whereby the far-reaching effects of job insecurity were knowingly mobilised by neoliberalism in order to create 'a generalised subjective insecurity'. This led, according to Bourdieu, to a 'destructuration of existence, and a subsequent degradation' of any possible 'relation to the world, time, space', as well as relations among individuals willing to rebel collectively against this situation.[66] Precarity, as Italian activist Alex Foti would put it in a 2004 interview, can describe a 'precarious' life in times of global war, or in a general state of 'total domination', as well as 'the condition of being unable to predict one's fate', let alone rely on 'degrees of predictability on which to build social relations and feelings of affection'.[67] By the late 1990s, a number of groups in Europe had started to organise discussions, actions and demonstrations against 'precarity'. Bourdieu lent his support to demonstrations by the French unemployed in 1998, and Foti headed the ChainWorkers organisation in Milan which put in place the first European May Day demonstrations against precarity in 2001.[68] The English term 'precarity' (a latinised form of 'precariousness') as well as the expressions 'precarisation' and 'precariat' (an updated version, for many activists at that moment, of the proletariat) were derived from such Italian, French and Spanish debates at the turn of the twenty-first century. In this book, I will be using such terms to describe the socio-economic phenomena that started to be contested at this time.

In contradistinction, I will use the adjective 'precarious', and the noun 'precariousness', to describe the broader, existential state that accompanies the socio-economic phenomenon of precarity. In the footsteps of Arendt, and of the above-mentioned analyses by Gorz, Bauman or Bourdieu, I consider this experience as affecting the very core of our emotional and political beings. This slippage from precarity to precariousness lies at the heart of the precarious art practices discussed in this book. My distinction is aligned with those made by theorists such as Judith Butler and Lauren Berlant who have emphasised that 'precarity' as a socio-economic condition affects different individuals in radically unequal ways, while 'precariousness' can be a shared condition of uncertain experience.[69] Another theorist, Isabell Lorey, makes the distinction in German between *Prekarität*, precarity, and *Prekärsein*, a term that aptly describes precariousness as a state of being.[70]

In her 2011 book *Cruel Optimism*, Berlant develops case studies in which she analyses the very forms that precariousness takes as an experience, which

she usefully describes as an affective state of being. Precariousness, Berlant argues, emerges as a ceaseless attempt to 'maintain footing, bearings, a way of being, and new modes of composure amid unraveling institutions and social relations of reciprocity'.[71] This precarious experience is thus embodied in the individual's affective, physical and social existence. The intrinsic relation, in Berlant's and Butler's writings, between precarious existence and the vulnerable body recalls in my eyes Arendt's analysis of the relations between human activities and biological life. The legacy of this specific aspect of Arendt's thinking was explicitly retrieved by Italian philosopher Giorgio Agamben in his 1990s writings on what he called 'bare life', a form of precarious life that exists at the crossroads of political precarity and biological vulnerability, as we shall see in Chapter 5.[72] For the purposes of this introduction, I will point to the conception of precariousness as an embodied 'way of being', as Berlant called it – an idea that also seems to run through the writings of Agamben as well as Butler. For this book's argument hinges on a central analogy between a precarious 'way of being' in a state of uncertainty, insecurity and 'unsafety' (to use Bauman's terms), on the one hand, and, on the other hand, the ways of being of what I call precarious artworks, which exist, as we saw, on the threshold of imperceptibility, on the 'borderline' between appearance and disappearance, on the cusp of failure.

Ways of being, ways of doing

In his catalogue essay for the aforementioned *Fast Nichts* exhibition, Hannes Böhringer traced an interest in the 'almost nothing' back to the Baroque period. It was at that moment, he observed, that the 'How' – instead of the 'What' – became 'crucial'.[73] Böhringer cited two French terms which reflected such a shift during this period: the *presque rien* (almost nothing), and the untranslatable *je-ne-sais-quoi*. These two terms were analysed in depth by French philosopher Vladimir Jankélévitch in a 1957 study, which similarly located their appearance within a specific body of sixteenth-century philosophical, theological, political and literary writings.[74] As Christine Buci-Glucksmann has pointed out more recently, Baroque poetry and painting betrayed a new aesthetic of the ephemeral, as artists sought to explore the fragile, the fugitive, the unstable and the perishable.[75] According to Jankélévitch, terms such as *je-ne-sais-quoi* and *presque rien* articulated corollary concerns in Baroque philosophy with the elusive and the intangible 'How', in particular in the *manières* – the manners, or ways – of being and appearing. Above all, argued Jankélévitch, such concerns brought to the fore a new conception of being as *becoming*, in which temporality played a crucial role. While I will not discuss, in this book, works from the Baroque period, nor try to trace a Baroque genealogy for contemporary art, I believe that Jankélévitch's study provides

a number of useful terms to map out and analyse the field of the almost nothing.

In the first place, Jankélévitch's focus on *ways* or manners of becoming and appearing chimes with my definition of precariousness, discussed above, as a *way* of being and becoming. Such ways are characterised by an elusive *je-ne-sais-quoi* that resists all forms of absolute, stable, ontological definition. Of interest to Jankélévitch was precisely that which exceeds definition, categorisation or comprehension. I would like to draw a parallel here between Jankélévitch's focus on the *manière* and the *manières de faire* that lie at the heart of Michel de Certeau's groundbreaking 1980 study of everyday life, *L'Invention du quotidien* (*The Practice of Everyday Life*). Like Blanchot, whom I mentioned earlier, Certeau believed that the everyday is inherently elusive.[76] Nevertheless, his study of everyday life sought to develop a vocabulary of terms with which to articulate recurrent patterns and issues that link together such varied 'ways of doing' as walking or cooking. In both Jankélévitch's and Certeau's studies, the authors set themselves an 'acrobatic' challenge (to use one of the former's expressions): that of examining a dynamic, fugitive movement of doing and becoming.

Just as the everyday, as Blanchot put it, is difficult to grasp (*ne se laisse pas saisir*),[77] the *presque rien* is characterised, according to Jankélévitch, by its *apparition disparaissante*, a momentary appearance which threatens to disappear as immediately as it emerged.[78] Like precarious works, then, such studies focus our attention on the very moment of appearance and the fragile maintenance of such a moment. This resonates with the Duchampian *inframince*, which, as we saw earlier, similarly questioned 'the threshold of appearance' of an artwork, as Davila put it. Furthermore, the term 'appearance' is crucial for Arendt in *The Human Condition* to the extent that it relates to the birth of the individual into a world governed by enduring as well as ephemeral structures, as much as to the public space in which individuals 'appear' to each other through action and speech. Not only are the appearance and disappearance of things and human beings intrinsically connected for Arendt, but, crucially, this 'space of appearance' constitutes, according to her, the very space of politics. Significantly, the relationships between man and the man-made, just as the relations among individuals, are subject to change and transformation. Since the 'space of appearance comes into being wherever men are together in the manner of speech and action', it is in fact as precarious as the human activities through which it comes to exist.[79]

The challenge, then, for students of the 'almost nothing' – be they Jankélévitch, Certeau, Arendt, or creators of precarious artworks – is to find the right tools with which to apprehend this precarious 'disappearing appearance'. For Jankélévitch, the nature or 'charm' of the *je-ne-sais-quoi* may perhaps be grasped in the instantaneous, 'infinitesimal space' of the 'opportunity'

(*occasion*). The Greek term used by Jankélévitch for this opportunity, the '*kairos*', is also extensively discussed by Michel de Certeau as a central focus of practices of everyday life. Such practices, according to Certeau, operate through a 'way' or 'manner' of taking advantage of opportunities as they arise – the *kairos*, this opportunity, is 'seized' rather than 'created'.[80] Before developing the political implications of the *kairos* in Part II of this study, I would like to follow Certeau's definition of everyday practices as operating in the space of the given, a set of circumstances of which one has to make the most. Since, as Jankélévitch emphasised, the *kairos* is by nature unpredictable and fugitive, seizing it requires a heightened form of attention, a 'vigilance' to the world, as well as an ability to improvise in response to a specific conjunction of events.

Crucially, such conjunctions are never the same, so that the ruses of the *kairos* can only be conceived, according to Jankélévitch, as an 'art of turning' a singular situation 'into an opportunity' (*art de tourner le cas en occasion*).[81] Similarly, this study will try, like Davila in his book *De l'inframince*, to 'find' the appropriate 'means' with which to pay attention to the 'particularity' and singularity of each case study.[82] This will involve analysing, in every instance, the *ways* or *manners* in which each precarious work stages its modes of appearance and disappearance, by inscribing it within a specific context and mapping out a circumscribed set of issues and concerns. Like the Duchampian *inframince*, which cannot be defined otherwise than through examples, like the everyday which loses its singular relation to lived experience in the moment it is theorised on a general level, precarious practices lend themselves to fragmentary, provisional observations rather than a systematic survey. This is why I have selected case studies from different artistic and geographical contexts in order to draw a mobile constellation of practices that shed light on a range of art historical and socio-political issues revolving around precarious art.

Overall, these examples will be drawn from two different periods: 1958–71, and 1991–2009. Arendt's 1958 study *The Human Condition*, as we have seen, will serve as a guiding thread throughout this book. In the first part, Arendt's response to the rise of consumer society in the United States in the 1950s will provide the backdrop for a study of the emergence of precarious practices from the late 1950s to the late 1960s. In the second part, I will outline a correlation between the development of new precarious practices in the 1990s such as those of Thomas Hirschhorn and Francis Alÿs (discussed at the beginning of this introduction) and the aforementioned re-readings of Arendt's earlier study provided by authors such as André Gorz, Pierre Bourdieu, Zygmunt Bauman and Giorgio Agamben in the period between the late 1980s and the first decade of the twenty-first century. More specifically, this study seeks to articulate a central relationship between three crucial terms: firstly, a critique

of consumption and organised labour; secondly, an alternative worldview to the systematic enterprise of channelling natural and human resources towards an ever more efficient, profit-driven organisation; and, thirdly, new artistic and cultural forms which privilege instability and precariousness.

In terms of periodisation, then, the publication date of Arendt's book serves as the starting point for this study. In addition to providing a fruitful analysis of the socio-economic context of the 1950s, the questions raised by Arendt's study will be shown to resonate with central tenets of Zen Buddhism, as it was popularised in the 1960s by writers such as D.T. Suzuki and Alan Watts. The articulation between critique and liberatory aspirations that runs through Arendt's writings as well as such Zen principles and precarious practices during this period will be situated within a field divided between a dominant culture on the one hand, and a rebellious counterculture on the other. This countercultural movement, which came to the fore with 1950s Beat culture, exploded with student protests around the world in the 1960s. By the mid-1970s, I suggest, such a movement had petered out, and was being chan-nelled in different ways.

The title of Part I, 'Dharma bums', refers to Jack Kerouac's 1958 Beat novel of that title, which resonated with critiques of consumer society such as Arendt's as well as the newly proposed Zen alternatives. While Chapter 1 outlines some of the links between Kerouac's Beat aesthetic and the assem-blage and happenings of the early 1960s, in the reception of assemblage art in particular, Chapter 2 points to some overlaps between Zen philosophy and a new scientific worldview, at play in other precarious practices in the 1960s. The dropout celebrated in Kerouac's *Dharma Bums* continued to serve throughout that decade as a countercultural model for artists concerned with precarious-ness. This type of 'dharma bum' figures among the 'good-for-nothings', who – as we will see in Chapter 3 – celebrated leisure, laziness and what Kaprow called 'useless work', as so many challenges to the capitalist work ethic.

Chronologically, Part II is roughly framed by two events in recent finan-cial history: the market crash of 1987 and the so-called global financial crisis running from 2007 to 2009. I would suggest that 1987 marked, symbolically, the end of a period of increased prosperity – accompanied, as Gorz pointed out, by greater inequalities. With the realisation that this prosperity was as fragile as it had been short-lived emerged a growing interest in the precarious 'human condition' of workers and consumers in Europe and North America. Debates concerning a growing precariat and possible alternatives to a glo-balised capitalism would continue into the first decade of the new millen-nium. My purpose in Part II is to locate the precarious practices developed in the early 1990s in this context. Its title, 'The light years', is inspired by contemporary studies such as Bauman's analysis of a new 'liquid modernity' which suggested that global capitalism was increasingly characterised by its

'weightlessness', 'motility' and even 'buoyancy'. Part II starts in 1991, four years after the economic crash. The chosen date coincides with the publication of Douglas Coupland's novel *Generation X*, which I will propose as the 1990s equivalent of what Kerouac's *Dharma Bums* had been for the Beat generation (as I will explain in Chapter 5). Indeed, at the heart of my study lies a reflection on the similarities and differences between the 1990s and the 1960s, and the precarious practices that emerged in both these moments.

Chapter 4 will frame 1990s precarious practices as both responses to forms of aggressive capitalism that had become widespread since the 1980s, and reactions to some of the more visible art practices that had emerged during that decade. Certainly 1987, the year of the major market crash, also saw the release of Swiss duo Peter Fischli and David Weiss's film *The Way Things Go*, which exploits to great effect the highly precarious nature of a chain reaction that sets a whole range of banal objects in movement. This duo's unique combination of humour, low-tech *bricolage* and interest in wasted time and failure set them apart from many of their contemporaries, and placed them as important precursors for the precarious art developed by a generation of younger artists in the 1990s. In spite of this and other significant exceptions, however, this book's periodisation reflects my general hypothesis that precariousness did not figure prominently among the concerns of 1970s and 1980s art practices and their critical reception at the time. These two decades will thus be considered as a hiatus in the history of precarious practices from the late 1950s to the first decade of the twenty-first century.[83]

Chapter 5 will pursue the study of those selected precarious practices that emerged in the 1990s as they developed over the next decades, in parallel with a generalised renunciation of both the utopian aspirations of the 1960s and the political activism of the 1970s. The emergence of new forms of protest at the beginning of the twenty-first century will also serve as a point of reference. I have chosen the end of the 2007–09 economic crisis as the cut-off point for this study because it may also mark a critical turning point. As we will see in Chapter 4, two different art historical texts from 2009, by Nicolas Bourriaud and Hal Foster, acknowledged 'precariousness' as a characteristic feature of art at the beginning the twenty-first century, thus suggesting the culmination of a trajectory begun in the 1990s.[84] In this sense, this trajectory paralleled the evolution of capitalism during this period, which led to a major economic crisis in the first decade of the new millennium. I imagine that a new generation of artists will respond to this crisis in their own ways, while working through the precarious practices developed before them.

Geographically, Part I of this study generally focuses on practices developed in the United States. In Chapter 1, practices of New York-based artists such as Robert Rauschenberg and Claes Oldenburg will be compared to those of Californian 'junk' artists such as Bruce Conner, while the relations

between assemblage and new forms such as environments and happenings will be explored, in the work of Allan Kaprow in particular. The evolution of Kaprow's work will constitute a running thread in Part I, as I go on to compare his early to mid-1960s activities to George Brecht's 'borderline' art in Chapter 2, and, in the subsequent chapter, his works later in the decade to works such as Alison Knowles's above-mentioned *Identical Lunch*, as well as a collaborative project developed by George Brecht and Robert Filliou on the Côte d'Azur between 1966 and 1968 entitled *La Cédille qui sourit*, and contemporary practices by American artists such as Tom Marioni and Bruce Nauman, both based on the US West Coast at the time. Indeed, I will return in Chapter 3 to the work of Bruce Conner, another artist discussed in Chapter 1, to point to the inter-generational links established on the West Coast between 'junk' and 'funk' sculpture. Thus I will demonstrate how the varied practices that emerged throughout the 1960s – ranging from event scores to publications, from assemblage and sculpture to performance and early video – contributed to what I called, earlier in this introduction, the 'expansion and disappearance' of the artwork into the artists' daily activities.

Furthermore, in Chapters 2 and 3, these 1960s practices developed by North American artists (and the Frenchman Robert Filliou working with Brecht), will be compared to the works of Brazilian artists Lygia Clark and Hélio Oiticica. Although these practices evolved independently on each of the two continents, and the artists did not know each other, an analysis of their work will serve three specific purposes. Firstly, Clark's and Oiticica's works provide an alternative genealogy for precarious practices. Significantly, their work was received in Europe in the context of constructivist and kinetic art as it was presented at the Signals Gallery in London between 1964 and 1966. The particular concerns with the invisible displayed by artists at the Signals Gallery will be compared in Chapter 2 to Brecht's and Kaprow's explorations of 'borderline' art. Secondly, Clark's and Oiticica's works in the mid- to late 1960s will point to the radical political models provided by art in Latin America at the time. As in Brazil, dictatorial regimes forced artists to address urgent debates concerning both precarity and precariousness, yielding a great variety of precarious art forms. Finally, as debates concerning precarity came to the fore in Europe and North America at the turn of the twenty-first century, the model provided by Hélio Oiticica's works and writings in particular was taken up by a number of critics and curators as they brought Latin American practices into the global art scene. Thus I will argue that the works developed in 1990s Mexico City by Gabriel Orozco and Francis Alÿs, discussed in the second part of this book, can be related to those earlier Brazilian practices as much as to the North American precarious practices also discussed in Chapter 3.

If the transnational exchanges among artists involved in Fluxus and the Signals Gallery point to the growing internationalisation of the art world

in the 1960s, Part II of this study will navigate the global art scene at the beginning of the twenty-first century as it expanded and spread through biennials and other international exhibitions in which a growing number of Latin American, Asian and African artists started to be included. In the face of this global art's variety and plethora, I have chosen to focus on four artists only, in order to address a number of specific issues in contemporary art and politics at the turn of the millennium. These four artists are of different nationalities. While Thomas Hirschhorn is a Swiss-German artist based in Paris and Francis Alÿs a Belgian artist living in Mexico, I will also study the work of Mexican artist Gabriel Orozco, who has lived between Mexico, New York and Paris. The fourth contemporary artist in this study is the Briton Martin Creed. Although Alÿs and Orozco know each other, and the works of these four artists have sometimes been shown or discussed together in various constellations in the course of international collections and exhibitions – not least in those exhibitions on the theme of 'nothing' that I discussed earlier – I am less interested in such encounters than in the common features that I perceive in their works. Part II will be largely dedicated to bringing out the links among these four artists' practices that define them as 'precarious' in my eyes, and to relating them to the 1960s practices discussed in Part I. Furthermore, I will compare them to other contemporary practices and situate them within socio-economic developments at the time, including the new 'liquid modernity' described by Bauman, global flows of migration, as well as the 'alterglobalisation' movements that sought to find alternatives to global neoliberalism.

Although anchored in the global development of capitalism over the four decades between 1958 and 2009, this study will thus focus on a small selection of case studies limited both geographically and historically. In order to carve out a new field of enquiry in the history of art from the late 1950s to the present, I will map out a network of forms and questions uniting the singular 'ways of being' staged by the art practices within this small selection. Analysing the similarities and differences among such works as these will not only help us trace the evolution of precarious practices from the 1960s to the 1990s: it will also provide a new vocabulary to define and describe a specific tendency in contemporary art, and to understand its political ramifications. To this effect, I will inscribe the selected artists' practices and writings, and the contemporary reception of their work, within their socio-cultural contexts by occasionally drawing on contemporary literature, film and socio-political texts. Like Arendt's writings, other philosophical references will be used as historical documents as well as methodological tools.

By focusing on a particular nexus of artistic, intellectual, socio-economic and political issues, I hope to draw out the specificities of each practice and context, and acknowledge the differences, as well as the similarities, among them. To return to an example cited at the beginning of this introduction,

I will underline how the construction of Kaprow's ice architectures in the 1967 *Fluids* carries socio-political connotations that are different from Alÿs's melting block of ice in the *Paradox of Praxis* thirty years later. Geographical differences are also important. For example, in his relation to Mexico City, Alÿs's attitude as a Belgian artist diverged as much from Kaprow's engagement with the landscape of Los Angeles in *Fluids* as it did from the position of Mexican-born Gabriel Orozco. Similarly, American 'junk' practices on the West Coast differed from those on the East Coast, while artists working under the Brazilian dictatorial regime were evidently confronted with another set of constraints than their European or North American counterparts.

In different ways, the Brazilians Lygia Clark and Hélio Oiticica, the Mexican Orozco, as well as the American artist Alison Knowles, whom I mentioned earlier in this introduction, constitute some of the exceptions in the body of artists selected in this study, who are largely white, middle-class and male. Thus, for example, I have chosen (in Chapter 5) to mention in passing, rather than analyse in depth, the works of American-Indian Jimmie Durham and the African-American David Hammons, which were conceived in the 1980s in response to forms of precarity experienced by marginalised, non-white individuals in American culture. If precarity, as I suggested earlier, is unevenly distributed among different constituencies, then the forms of precariousness explored by female or African-American artists, for example, certainly diverge from those that will be discussed in this book within a more circumscribed body of works.

As we will see, the kind of precariousness at the heart of this study emerges with the anxieties of the white middle-class man faced in the 1950s with a choice between two masculine roles: middle-class white-collar worker, or Beat dropout. While attracted to African-American music and seduced by the model of the unemployed 'bum', Beat culture nevertheless remained largely white and middle-class. Some forty years later, the type of precariousness at stake in the artistic practices that I have selected comes close to the experience of 'self-precarization' analysed by Isabell Lorey: a status sometimes voluntarily adopted by freelance workers, for example, who work at home and sometimes choose part-time or intermittent contracts.[85] In terms of class and income, such 'self-precarizing' individuals may appear, at first sight, to be exposed to a very different kind of economic precarity from a labourer or a domestic worker on short-term contracts. At the turn of the twenty-first century, however, the term 'precariat', which I mentioned earlier, signified a political desire to unite these various constituencies and highlight their common experience of precariousness. In this book, I will explore the complex forms of alliance, empathy and solidarity that are suggested by precarious works, while pointing to some of the issues that they raise concerning the (in)commensurability of such different experiences.

One may wonder, for example, what happens when, in Alÿs's *To R.L.*, a white European artist works with a female Mexican street sweeper, whose social and economic status is obviously more precarious than his. In this way, this study will address some of the uncertainties specific to the evolving place of a largely white, middle-class, heterosexual European and North American male population, as it has been subjected to the developments of capitalism over six decades.

Focusing on a selection of works, the positions of which have by now generally been established within mainstream art history, allows us to further delve into their particularities and address the specific questions raised by such precarious practices. How does an artwork exist? And how does it relate to other kinds of actions and materialities in a shared economic, social and political context? Ultimately, I would like to argue that such questions can be answered from two intrinsically connected perspectives. On the one hand, this study aims to shed new light on a specific trajectory of art since the 1960s that addresses its status as a material object, and the material conditions of its existence, in its appeal to the spectator's heightened perception and ever-renewed validation. On the other hand, the radical *material* instability of precarious works will be related to the *political* instability of the human condition in the age of capitalism. Just as individuals, as Berlant put it, struggle to find the means to 'maintain' 'a way of being', in the face of conditions beyond their control, I will demonstrate that precarious practices have explored ways of existing on the brink of disappearance, and manners of making the most of the 'almost', in order to fend off the 'nothing'. Related questions then emerge: how do we exist? And how do *we* relate to the economic, social and political conditions in which we live?

Notes

1 'Alison Gingeras in Conversation with Thomas Hirschhorn', in Benjamin H.D. Buchloh, A. Gingeras, Carlos Basualdo et al., *Thomas Hirschhorn* (London: Phaidon, 2004), p. 24.

2 See Jennifer Mundy (ed.), *Lost Art: Missing Artworks of the Twentieth Century* (London: Tate, 2013), pp. 234–8.

3 Marco Annelli, who participated in the performance over 14 times, quoted on the MoMA blog on http://www.moma.org/explore/inside_out/2010/05/10/visitor-viewpoint-momas-mystery-man (accessed 3 July 2011).

4 My thanks to Alison Knowles for letting me watch unpublished video documentation of some of the lunches. For more information about the event, see Randy Kennedy, 'Art at MoMA: Tuna on Wheat (Hold the Mayo)', *New York Times*, 2 February 2011, http://www.nytimes.com/2011/02/03/arts/design/03lunch.html (accessed 3 July 2011).

5 *Journal of the Identical Lunch* (San Francisco: Nova Broadcast Press, 1971).

6 George Brecht, 'Events: Scores and Other Occurrences', 12/28/61, *cc V TRE No.1 FLUXUS* (January 1964), 2.

7 Ele Carpenter, 'Something about Nothing', in Ele Carpenter and Graham Gussin (eds), *Nothing* (Sunderland: Northern Gallery for Contemporary Art, 2001), p. 7.

8 Peter-Klaus Schuster, 'Foreword' and Catherine Nichols, 'Silence and "nothingto-seeness" in contemporary art', in Eugen Blume, Gabriele Knapstein and Catherine Nichols (eds), *Fast Nichts: Minimalistische Werke aus der Friedrich Christian Flick Collection im Hamburger Bahnhof*, exh. cat. Hamburg, Hamburger Bahnhof, 2005 (Berlin and Cologne: SMB-Dumont, 2005), pp. 263 and 272.

9 Caroline Ferreira d'Oliveira and Marianne Lanavère, 'Densité ± 0', in Caroline Ferreira d'Oliveira and Marianne Lanavère (eds), *Densité ± 0* (Paris: Ecole nationale supérieure des Beaux-Arts, 2004), pp. 24, 27, 23.

10 Carpenter, 'Something about Nothing', p. 7.

11 Ingrid Schafner, 'Doing Nothing', in *The Big Nothing* (Philadelphia: Institute of Contemporary Arts, 2004), p. 29.

12 Schuster, 'Foreword', p. 263.

13 Ferreira d'Oliveira and Lanavère, 'Densité ± 0', p. 27.

14 Schafner, 'Doing Nothing', p. 18.

15 *Ibid.*, p. 21.

16 *Ibid.*, p. 18.

17 Martina Weinhart, 'Seeing Nothing: Experiences of Radical Reduction in Image and Space since the 1960s', in M. Weinhart and Max Hollein (eds), *Nichts/Nothing*, exh. cat. Frankfurt, Schirn Kunsthalle Frankfurt, 2006 (Ostfildern: Hatje Cantz, 2006), pp. 9–51.

18 See Didier Semin, 'A Note on the Duchampian "infra-thin"', in Ferreira d'Oliveira and Lanavère (eds), *Densité ± 0*, pp. 49–53; Thierry Davila, *De l'inframince: brève histoire de l'imperceptible de Marcel Duchamp à nos jours* (Paris: Editions du regard, 2010).

19 *La chaleur d'un siège (qui vient d'être quitté).* Marcel Duchamp, *À l'infinitif* (New York: Cordier & Ekstrom, 1966), n.p. The notes were written between 1912 and 1920. Unless otherwise specified, all translations from the French are the author's.

20 Ferreira d'Oliveira and Lanavère, 'Densité ± 0', p. 23; Davila, *De l'inframince*, p. 16.

21 *Une distinction sans épaisseur.* Davila, *De l'inframince*, p. 54.

22 *seuil de visibilité, seuil de perceptibilité, seuil d'intelligibilité. Ibid.*, p. 20.

23 For another reading of the *inframince* and its legacies, see Amelia Jones, *Postmodernism and the En-gendering of Marcel Duchamp* (Cambridge: Cambridge University Press, 1995), pp. 142–5; and 'Space, Body and the Self in the Work of Bruce Nauman', in Anna Dezeuze (ed.), *The 'Do-It-Yourself' Artwork: Participation from Fluxus to New Media* (Manchester: Manchester University Press, 2010), ch. 8.

24 Schafner, 'Doing Nothing', p. 21

25 John Cage, untitled statement, 1953, reprinted in Richard Kostelanetz (ed.), *John Cage* (London: Allen Lane, The Penguin Press, 1971) pp. 111–12.

26 John Cage, 'On Robert Rauschenberg, Artist, and his Work' (1961), in *Silence: Lectures and Writings by John Cage* (Middletown, CT: Wesleyan University Press, 1961), p. 98.

27 Lucy Lippard and John Chandler, 'The Dematerialization of Art', *Art International*, 12:2 (1968), reprinted in Lippard, *Changing: Essays in Art Criticism* (New York: Dutton, 1971), pp. 255–76.

28 Lucy Lippard, 'Preface', in *Six Years: The Dematerialization of the Art Object from 1966 to 1972* (1973) (Berkeley: University of California Press, new edn, 1997), p. 5.

29 Lippard and Chandler, 'The Dematerialization of Art', p. 255. Other quotes in this paragraph are from the same page.

30 See Weinhart, 'Seeing Nothing', pp. 16–25.

31 Lippard and Chandler, 'The Dematerialization of Art', p. 255.

32 Lawrence Alloway, 'The Expanding and Disappearing Work of Art', *Auction*, III/2, October 1969, reprinted in *Topics in American Art since 1945* (New York: Norton, 1975), p. 207.

33 Lippard and Chandler, 'The Dematerialization of Art', p. 256.

34 Lippard, 'Preface', p. 7. This passage is drawn from a 1969 interview with Ursula Meyer.

35 Lippard, 'Escape Attempts' (1995), in *Six Years*, p. xiii.

36 Lippard, 'Preface', p. 7.

37 Lippard and Chandler, 'The Dematerialization of Art', p. 270.

38 Lippard, 'Postface', in *Six Years*, p. 263.

39 Ralph Rugoff, 'A Brief History of Invisible Art', in Ralph Rugoff (ed.), *A Brief History of Invisible Art* (San Francisco: California College of the Arts Wattis Institute for Contemporary Arts, 2005), p. 17.

40 Lippard and Chandler, 'The Dematerialization of Art', p. 257.

41 Ferreira d'Oliveira and Lanavère, 'Densité ± 0', p. 25.

42 See, for example, Liz Kotz, *Words to be Looked At: Language in 1960s Art* (Cambridge, MA: MIT Press, 2007); Alexander Alberro, *Conceptual Art and the Politics of Publicity* (Cambridge, MA: MIT Press, 2003); Donna de Salvo (ed.), *Open Systems: Rethinking Art c.1970* (London: Tate, 2005); Helen Molesworth (ed.), *Work Ethic* (Baltimore and University Park, PA: Baltimore Museum of Art and Penn State Unversity Press, 2003); and Miwon Kwon, 'Exchange Rate: On Obligation and Reciprocity in Some Art of the 1960s and After' (2003), in Dezeuze (ed.), *The 'Do-It-Yourself' Artwork*, ch.12.

43 Michael Newman, 'The Material Turn in the Art of Western Europe and North America in the 1960s', in Milena Kalinovska (ed.), *Beyond Preconceptions: The Sixties Experiment* (New York: Independent Curators International, 2000), p. 73; Shannon Jackson, 'Just-in-time: Performance and the Aesthetics of Precarity', *The Drama Review*, 56:4 (2012), 19.

44 Simon Critchley, *Very Little, Almost Nothing: Death, Philosophy, Literature* (1997) (London and New York: Routledge, 2nd edn, 2004).

45 Mieke Bal, 'Invisible Art, Hypervisibility, and the Aesthetics of Everyday Life', in Weinhart and Hollein (eds), *Nichts/Nothing*, p. 83.

46 *Ibid.*, p. 92.

47 Maurice Blanchot, 'L'Homme de la rue', *Nouvelle Revue Française*, 114 (June 1962), pp. 1070–81, reprinted as 'La Parole quotidienne', in M. Blanchot, *L'Entretien infini* (Paris: Gallimard, 1969), pp. 355–66.

48 Bal, 'Invisible Art', p. 92.

49 Ralph Rugoff, 'Touched by your Presence: Invisibility in Art', *Frieze*, 50 (January–February 2000), http://www.frieze.com/issue/print_article/touched_by_your_presence/ (accessed 6 May 2015).

50 Ralph Rugoff, 'How to Look at Invisible Art', in R. Rugoff, *Invisible: Art about the Unseen, 1957–2012* (London: South Bank Centre, 2012), p. 27.

51 Henri-Claude Cousseau, 'Preface', in Ferreira d'Oliveira and Lanavère (eds), *Densité ± 0*, p. 9.

52 Laurent Le Bon, 'Qui ne risque rien n'a rien', in Mathieu Copeland (ed.), *Vides: une retrospective* (Paris and Zurich: Centre Pompidou and JRP Ringier, 2009), p. 163; Weinhart, 'Seeing Nothing', p. 10.

53 Blanchot, 'La Parole quotidienne', p. 360.

54 Brian Kuan Wood, 'Is it Heavy or Is it Light?', *e-flux journal,* 61 (January 2015), http://www.e-flux.com/journal/is-it-heavy-or-is-it-light/ (accessed 9 January 2015)

55 *Ibid.*, 4.

56 *Ibid.*, 4.

57 Hannah Arendt, *The Human Condition* (1958) (Chicago: University of Chicago Press, 2nd edn, 1998), p. 2.

58 Critchley, *Very Little*, p. xvii.

59 Arendt, *The Human Condition*, p. 5.

60 *Ibid.*, p. 7.

61 *Ibid.*, p. 7. Quoted in its French translation in André Gorz, *Métamorphoses du travail. Quête du Sens. Critique de la raison économique* (Paris, Galilée, 1988), n.p.

62 Gorz, *Métamorphoses du travail*, p. 87.

63 *Ibid.*, p. 159.

64 Zygmunt Bauman, *Liquid Modernity* (Cambridge and Malden, MA: Polity Press and Blackwell, 2000), p. 8.

65 *Ibid.*, p. 161.

66 Pierre Bourdieu, 'La précarité est aujourd'hui partout' (1997), in *Contrefeux: propos pour servir à la résistance contre l'invasion néo-libérale* (Paris: Editions Liber, 1998), p. 96.

67 'Precarity and North American/European Identity: an Interview with Alex Foti (ChainWorkers) by Merijin Oudenampsen and Gavin Sullivan' (2004), in John Barker et al., *Mute Precarious Reader: Texts on the Politics of Precarious Labour* (London: Mute, 2005), p. 45.

68 For one account of this history, see Guy Standing, *The Precariat: The New Dangerous Class* (London and New York: Bloomsbury, 2011).

69 See, for example, Jasbir Puar, Lauren Berlant, Judith Butler, Bojana Cvejic, Isabell Lorey and Ana Vujanovic, 'Precarity Talk: A Virtual Roundtable', *The Drama Review*, 56:4 (2012), 163–77.

70 Isabell Lorey, 'Post One', in *ibid.*, 165.

71 Lauren Berlant, *Cruel Optimism* (Durham, NC: Duke University Press, 2011), p. 197.

72 See Giorgio Agamben, *Homo Sacer: Sovereign Power and Bare Life* (1995), trans. D. Heller-Roazen (Stanford, CA: Stanford University Press, 1998).

73 Hannes Böhringer, 'Almost Nothing', in Blume, Knapstein and Nichols (eds), *Fast Nichts*, p. 265.

74 Vladimir Jankélévitch, *Le Je-ne-sais-quoi et le presque rien* (1957) (Paris: Seuil, new edn, 1980).

75 Christine Buci-Glucksmann, *Esthétique de l'éphémère* (Paris: Galilée, 2003), pp. 23–5.

76 Michel de Certeau, *L'Invention du quotidien, vol. I: Arts de faire* (1980), ed. Luce Giard (Paris: Gallimard, 1990)

77 Blanchot, 'La Parole quotidienne', p. 357.

78 Jankélévitch, *Le Je-ne-sais-quoi*, p. 57.

79 Arendt, *The Human Condition*, p. 199.

80 Certeau, *L'Invention du quotidien*, p. 130.

81 Jankélévitch, *Le Je-ne-sais-quoi*, p. 120.

82 *A nous de trouver les moyens d'accueillir la particularité du cas.* Davila, *De l'inframince*, p. 25.

83 Other exceptions include Swiss artist Roman Signer, who influenced Fischli/Weiss, and British sculptor Richard Wentworth's ongoing photographic series titled *Making Do, Getting By*, started in 1977. See my 'Photography, Ways of Living, and Richard Wentworth's Making Do, Getting By', *Oxford Art Journal*, 36:2 (2013), 281–300.

84 'Precarious: Hal Foster on the Art of the Decade', *Artforum*, 48:4 (2009), 207–9, 260; Nicolas Bourriaud, *Radicant. Pour une esthétique de la globalisation* (Paris: Denoël, 2009).

85 See, for example, Isabell Lorey, 'Governmentality and Self-Precarization: On the Normalization of Cultural Producers', *transversal*, 11 (2006), special issue on 'Machines and subjectivity', http://eipcp.net/transversal/1106/lorey/en (accessed 15 May 2015).

<div style="text-align: right;">

Part I

'Dharma bums', 1958–71

</div>

In America, one is either 'Hip' or 'Square', declared Norman Mailer in 1957. Such are the alternatives: 'one is a rebel or one conforms, one is a frontiersman in the Wild West of American night life, or else a Square cell, trapped in the totalitarian tissues of American society, doomed willy-nilly to conform if one is to succeed'.[1] By 1959, this opposition had been popularised to the point that *Life* published an illustrated article relishing the contrasts between Squaresville (Hutchinson, Kansas) and Beatsville (Venice, California).[2] That same year, Edward Kienholz presented viewers with his image of Mailer's 'Square cell' (figure 10). On a child's perambulator, on which a mannequin figure of *John Doe* is mounted, a riddle is displayed: 'Why is John Doe like a piano?', followed by the answer: 'because he is square, upright and grand'. The square John Doe is so 'upright', so solid, in Kienholz's assemblage, that he can be split into two: his torso and head facing forward, and the lower half of his body behind them on the perambulator, legs rigidly stretching upwards. Armless and splattered with paint, waiting to be pushed (or taken advantage of, like a grand piano being 'played'), the grinning John Doe is anything but 'grand'. A hanging cross ineffectually tries to fill the void left in his heart, where a pipe connects his torso to his lower body (just above the genital area), visualising the gaping hollowness of his conformism. A possibly menacing grin, mutilations and drips of paint evoking blood and dirt all convey an image of John Doe as both a monster about to run someone over and a victim of the latent violence of a 'totalitarian society', as Mailer called it.[3]

For Mailer, the hipster and beatnik resist such a square society by exploring alternative marginal lifestyles and modes of existence. Does Bruce Conner's 1960–61 portrait of Beat poet Allen Ginsberg (figure 11) offer a pendant to Kienholz's square John Doe? An assemblage of wood and stretched nylon sprayed with paint, including assorted detritus and a limply hanging, formless sack, Conner's PORTRAIT OF ALLEN GINSBERG certainly makes no claims to grandness: it celebrates a voluntary poverty and the original meaning of the slang word 'beat' – penniless, exhausted, worn out. Indeed, the work cannot even claim to be a portrait, as it appears to convey nothing

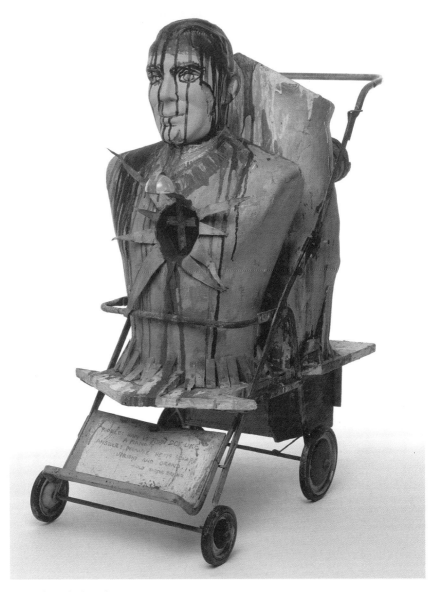

10 Edward Kienholz, *John Doe*, 1959

of Ginsberg's subjectivity or identity. The assemblage was partly inspired by Conner's experience of taking peyote, during which he perceived himself as 'a very tenuously held together construction – the tendons and muscles and organs loosely hanging around inside'.[4] In their explorations of the 'frontiers'

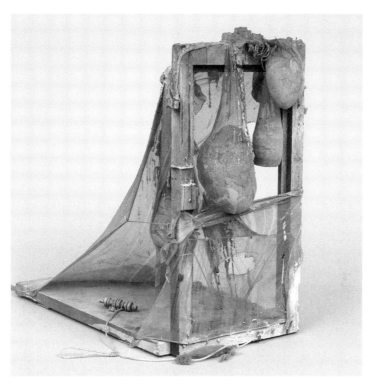

Bruce Conner, *PORTRAIT OF ALLEN GINSBERG*, 1960–61 **11**

of American life, the Beats sought such heightened and disorienting percep-
tions of the self, through mystic experiences as well as drugs.

Though affiliated with the Beat culture that thrived in California during
the late 1950s, neither Kienholz nor Conner considered themselves to be 'Beat'
artists; indeed Conner explicitly sought to distance himself from the label,
especially after it had been widely appropriated and distorted by the media.
The Beat aesthetic was largely literary, and its intersections with trends in
music, cinema and the visual arts took on diverse forms. The visual tendency
with which Kienholz's and Conner's works were associated at the time was
described variously as 'neo-dada', 'assemblage', or 'junk' – junk 'sculpture',
'culture' or 'aesthetic'. *PORTRAIT OF ALLEN GINSBERG*, for example, was
included in the second instalment of the exhibition *New Forms, New Media* at
the Martha Jackson Gallery in September–October 1960. The *New Forms, New
Media* exhibitions, and the catalogue in which Lawrence Alloway coined the
term 'junk culture', paved the way for the landmark *Art of Assemblage* survey
curated by William Seitz at the Museum of Modern Art in New York, in which
Kienholz's *John Doe* would be displayed in October–November 1961. Rooted

in the West Coast art scene, the assemblages of Kienholz and Conner were often exhibited at the time alongside the works of New York based artists such as Robert Rauschenberg, John Chamberlain, Richard Stankiewicz and Jean Follett, as well as artists exploring environments and happenings such as Allan Kaprow, Jim Dine, Claes Oldenburg, Robert Whitman and Red Grooms.

Though not central to the reception of such artistic developments, hints of Mailer's 'hip'/'square' polarity, characteristic of the social landscape of the time, are perceptible in the press reviews of junk art. This perspective was developed more extensively, if awkwardly, in William Seitz's catalogue essay for *The Art Assemblage*, as well as in a more focused reflection, published in *Artforum* in October 1962, entitled 'Junk Sculpture: What Does it Mean?' by philosopher Donald Clark Hodges, who referred directly to contemporary reflections on American society, including Mailer's. Discussing these essays, and wider debates that characterise the critical reception of the 1950s junk aesthetic, will allow me to articulate more specifically some of the relations between junk practices and the society in which they were developed.

In particular, junk in these practices will be shown to be used in varied, and often widely diverging, ways. A simple comparison of Kienholz's *John Doe* and Conner's *PORTRAIT OF ALLEN GINSBERG* suggests such distinct uses. Firstly, the discarded objects used by Kienholz remain sturdy and recognizable, despite the artist's interventions (cutting, assembling, painting). In contrast, Conner's materials are deformed beyond recognition, approximating the condition of dust and decomposition rather than that of the scattered junkyards or thrift stores visited by Kienholz. Secondly, Kienholz mobilises discarded objects in order to mount an angry attack on a hypocritical 'square' society, setting up an opposition between the two polarities, whereas Conner appears more concerned with blurring the differences between art and rubbish. By celebrating garbage, Conner inverts the negative value of junk, in much the same way as Beat author Jack Kerouac could exclaim: 'I love it because it's ugly.'[5] The precariousness of the junk aesthetic, I will argue, lies in such varyingly and variously dynamic relations between art and trash, as they operate through the artists' choices of materials and their modes of assemblage. The politics of such precarious practices emerge in their interactions with the social critiques concerning the place of the subject in late 1950s and early 1960s capitalism. In particular, I will suggest that the individual's life and identity at the time were affected by an ever more 'squarely' organised society, in which operations of work, consumption and administration were increasingly controlled. It is within this shifting landscape that I will map out various assemblage practices and the debates surrounding them, referring to works by Claes Oldenburg and Robert Rauschenberg, before focusing more extensively on the exemplary junk practices of Bruce Conner and Allan Kaprow.

Junk

The term 'assemblage', explained William Seitz in his introduction to *The Art of Assemblage*, 'has been singled out … to denote not only a specific technical procedure and form used in the literary and musical, as well as the plastic, arts, but also a complex of attitudes and ideas'.[6] If *New York Times* critic John Canaday dismissed Seitz's catalogue as 'juvenile' and a 'bad mix-up of long hair and starry eyes'[7] – terms resonating with the 'square' criticisms of 'hip' subcultures – it was partly because of the different adjectives used by the *Art of Assemblage* curator to describe the 'attitudes and ideas' of contemporary assemblagists.[8] 'Many cultivate attitudes that could be labeled "angry," "beat," or "sick"', proposed Seitz at one point, referring to both the Beats and the affiliated 'angry young men' in the United Kingdom.[9] Scattered throughout Seitz's text, the repeated references to feelings of dissatisfaction, impatience, malaise, 'embittered' 'disenchantment' and anger, all suggest the author's sympathy with this disaffected generation.[10]

For his part, Donald Clark Hodges explicitly compared, in his *Artforum* article, the new 'junk sculpture' to 'the current epidemic of white negroes, hipsters and junkies', affirming that both 'are a reaction to growing up absurd in the affluent wasteland'.[11] Clark Hodges's formulation is historically interesting in that it evokes no fewer than four studies from which the author drew in his article – explicitly or implicitly – for his analysis of 1950s American society: Norman Mailer's 1957 essay on 'The White Negro: Superficial Reflections on the Hipster' (which I quoted above), Paul Goodman's 1960 *Growing up Absurd: Problems of Youth in the Organized Society*, John Kenneth Galbraith's 1958 *The Affluent Society*, and Vance Packard's 1960 study *The Wastemakers*. Goodman had addressed the disaffection of American youth, focusing on delinquents as well as the Beat hipsters celebrated by Mailer; Galbraith and Packard had analysed the problems raised by a new unprecedented growth of industrial production and consumption.

In a similar acknowledgement of the growing literature on socio-economic shifts in 1950s America, Reverend Howard Moody asked, in his 1959 'Reflections on the Beat Generation': 'Should we be surprised that in the age of "the lonely crowd," "the organization man," and "the hidden persuaders" we should get a generation, or at least a segment, that is sickened on the inside and rebellious on the outside at having seen human existence being squeezed into organized molds of conformity?'[12] Moody refers here to David Riesman's bestselling 'study of the changing American character' (*The Lonely Crowd*, 1950), as well as another book by Packard focusing on advertising (*The Hidden Persuaders*, 1959), and C.S. Whyte's 1956 study of the *Organization Man*, on which Goodman drew for his definition of 'the organized society' from which the youth felt disaffected. As the minister of the Judson Memorial Church, Moody

would invite Allan Kaprow in 1960 to direct a gallery, in this church, where significant junk environments and happenings would be staged.

If the threat of war and atomic conflict figured in Seitz's reflections as well as those of Mailer and other contemporaries, Moody's perception of a threat to 'human existence' in the alarming 'conformity' of American society was not untypical. A recurring trope in the literature, voiced by Mailer's study as well as Riesman's *Lonely Crowd*, went so far as to describe such an 'organized society' as 'partially totalitarian', since every sphere of human existence appeared colonised by a constraining and controlling drive – in this case, towards ever-increasing economic efficiency. Thus Clark Hodges feared a 'deshumanization' [*sic*] of contemporary work conditions, and condemned the 'mass production of junk-to-be' (that is, the planned obsolescence that is the focus of Packard's *Wastemakers*) as 'absurd by humanistic standards'.[13]

Although he did not cite it, Clark Hodges' humanist critique of American society resonated with Hannah Arendt's 1958 study *The Human Condition* in which she diagnosed a loss of the equilibrium – necessary to people, according to her – following recent technological and socio-economic advances. Based in the United States at the time, Arendt observed the rise of a new 'waste economy, in which things must be almost as quickly devoured and discarded as they have appeared in the world, if the process itself is not to come to a sudden catastrophic end'.[14] In this analysis, her work echoed Packard's sociological study of a 'throwaway age' driven by 'a hyperthyroid economy that can be sustained only by constant stimulation of the people and their leaders to be more prodigal with the nation's resources'.[15] As Packard's exposé demonstrated, different strategies were being developed to sustain this necessary 'forced consumption': pressure to buy more than one identical item, shortening the life-span of commodities, and the 'obsolescence of desirability', promoted by advertising, through which 'a product that is still sound in terms of quality or performance becomes "worn out" in our minds because a styling or other change makes it seem less desirable'.[16]

The 'human condition', according to Arendt, exists in a balance between labour (the activities necessary for survival), work (the production of durable goods) and action (the decision-making processes debated in the sphere of politics). Through planned obsolescence, however, durable goods had disappeared, as had the satisfactions of work, now entirely replaced by labour: work had been entirely commodified as a *means* through which to consume commodities. As a consequence, argued Arendt, there was no space left for the relationships between people required for action. Citing Riesman's study of the *Lonely Crowd*, Arendt insisted that the 'antihuman form' of modern 'loneliness' was a result of a 'deprivation of "objective" relationships to others

and of a reality guaranteed through them'.[17] For Arendt, then, the solid
objectivity of durable goods was tied to the objective reality required for indi-
viduals to develop relationships with each other.

Junk art, according to Clark Hodges, offered a critique of the 'affluent' soci-
ety's 'thoughtlessly wasteful habits' and the 'foolery' of planned obsolescence,
by simply focusing our attention on this waste.[18] Like the catalogue of works
in *The Art of Assemblage*, the literature on junk art contained abundant lists
of objects and materials used by the artists. For example, critic Thomas Hess
described the *New Forms, New Media* exhibition through an inventory of
materials: 'sponge, wood pegs, tacks, a smashed fender, folded paper, pingpong
balls, playing cards, spikes, a stuffed chicken, a cut-out bird, tar, garter-belts,
coffee-grounds, a railroad tie, styrofoam, polyesters, corrugate, pillows, an
electro-magnet…'[19] The 'stuffed chicken' and the 'pillow' mentioned by Hess
were included in two of Rauschenberg's works (*Odalisque* and *Canyon*), and
critics seemed to take a particular delight in listing the objects found in what
the artist called his 'combines'. A *Life* article mentioned 'old photographs,
clippings, signs, bottles, boards, stuffed birds, clothes',[20] while Alloway cited
another critic's inventory of 'table cloths, kitchen utensils, light bulbs, animals,
baseballs, reproductions of Old Masters, hats, packing crates, comic strips, love
stories, Coca Cola'.[21] To the artist's selection of available objects corresponded
an enumeration that would serve to highlight both the heterogeneity and the
sheer abundance of contemporary waste.

'The source of junk culture is obsolescence, the throwaway material of
cities', noted Alloway in his essays, suggesting that junk art spoke of the
shortened 'history' or lifespan of the commodity in the 'throwaway age'
mentioned by Packard.[22] In his correspondence about *The Art of Assemblage*,
Seitz insisted that the works in the exhibition should not only juxtapose at
least two different materials, but that these materials should be 'discarded or
purloined' 'rather than new'.[23] A temporal typology of junk art could thus be
articulated according to the degree and stages of decay of the discarded mate-
rials included in various assemblages. Often intact and functional, objects in
Arman's *Accumulations*, for example, suffer more from what Packard called
the 'psychological obsolescence' of goods that have been replaced with more
fashionable, branded items. Indeed, like most assemblage artists – and unlike
Pop artists – Arman tended to choose unbranded as well as old-fashioned
commodities. Through the repetition of identical goods, Arman further
reduced the illusion of novelty that advertising seeks to create – as Jaimey
Hamilton has convincingly argued, some of Arman's *Accumulations* could in
fact be read as summarising the object's complete lifespan, as they evoke the
assembly line as much as the shop window and the flea market.[24]

In his catalogue essay, Seitz mused that used, weathered and faded objects
in assemblage tended to awake 'a romantic response to ruins, architectural

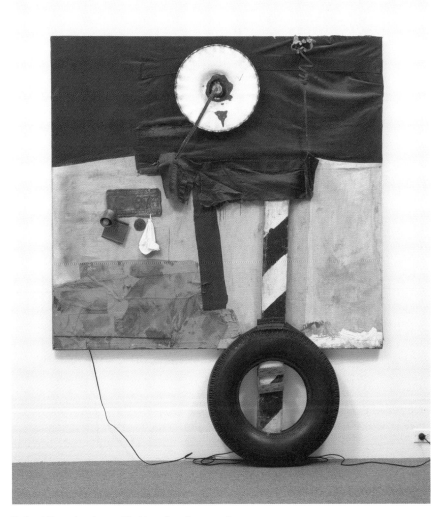

12 Robert Rauschenberg, *First Landing Jump*, 1961

and sculptural fragments, and the evocative richness of old walls or ritual vessels'.[25] The found photographs, used objects, architectural fragments and road signs in Rauschenberg's work certainly figure in this category (figure 12).

A second type of object, like the perambulator in Kienholz's *John Doe*, or the wheels, bedsprings (figure 16) and abandoned furniture used by other junk artists, belong to the universe of wrecks found in city dumps. Broken or torn, wrecks remain recognizable. While the metal scrap used by artists such

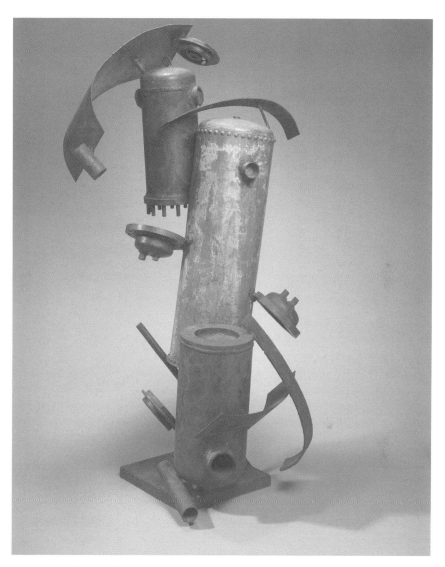

Richard Stankiewicz, *Untitled*, 1961 **13**

as Richard Stankiewicz belongs to the field of the remainder rather than the abandoned object, its size and solidity allow the pieces to function as fragments rather than rubble or dust (figure 13).

In a third category, which comes closer to dirt, decomposition and excrement, things and fragments are stripped of 'any descriptive characteristics that allows us to individuate' them, as John Scanlan has explained.[26] While soiled goods in varying states appear contaminated by what Scanlan called

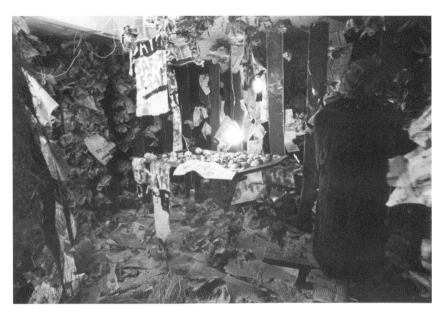

14 Allan Kaprow, *Apple Shrine: Altar with apples*, 1960

the 'taint of garbage', it is works such as Conner's, where individual objects are difficult to discern, that most closely approximate the final stages of decay (figure 11). Enumeration is no longer possible.

A fourth and final category, I would suggest, was proposed by Kaprow as he celebrated wholly impermanent materials by advocating 'the use of obviously perishable media such as newspaper, string, adhesive tape'.[27] As Alex Potts has pointed out, such materials – often combined by Kaprow with chicken wire, paint and fabric to stage temporary environments and happenings – were 'neutral' in that few personal or cultural associations could immediately be projected on to them (figure 14).[28] Such materials are 'obviously perishable' less because they have been used and discarded than because they are fragile, and highly vulnerable to weather conditions and human wear. Looking at such materials, as Kaprow put it, 'no one can mistake the fact that the work will pass into dust or garbage quickly'.[29]

In general, the use of junk in its various states appeared to resist the illusion of novelty and desirability of the perfect gleaming commodity on which the economy of waste was premised, thus contradicting the consensual calls for 'growth' that characterised the period, according to Packard.[30] Readings of the junk aesthetic often implied a 'truth' or honesty of materials, against the hypocrisy of the middle-class occultation of dirt, detritus and poverty, echoing Victor Hugo's belief in the 'sincerity of refuse' (*la sincérité de l'immondice*).[31]

Integration and disintegration

I would like to argue, however, that within the junk aesthetic important variations exist in terms of the operations of decay, decomposition and detritus, and their relations to the cycle of ever-accelerated consumption and obsolescence. Assemblage, as Seitz defined it, involved 'the fitting together of parts and pieces'.[32] In his correspondence in preparation for the exhibition, he insisted that such 'parts and pieces' must remain 'identifiable'.[33] For example, in a letter to David Smith, in which he sought to justify the inclusion of only one of the American sculptor's works in the exhibition, he explained: 'You so often obliterate the sources of the things you use, that I did not regard you as essentially an assembler but as a sculptor.'[34] Thus the relations between 'real-life object' and 'aesthetic considerations', as one reviewer called them, were central to a definition of assemblage.[35] Indeed, Seitz would conclude in 1962 that 'the most controversial … fact about the current wave of assemblage does not concern unorthodox materials but how they are fastened together'.[36]

In his above-mentioned essay of the same year, Donald Clark Hodges argued that the lack of relations between parts and whole in junk sculpture reflected 'the disintegration of personality, a sense of dislocation and disconnectedness resulting from increasing specialisation, artificial role-taking, and the split personality into incompatible parts'.[37] In an analysis derived from C. Wright Mills' 1951 *White Collar: The American Middle Classes*, Clark Hodges highlighted the 'deshumanisation' [*sic*] of work conditions, in which the 'feeling man' was forced to identify with a job from which he felt alienated. The absence of gratification at work was partly the result of automation and specialisation – the worker no longer controlled the result of his work, he had become a cog in an organised machine that he could not understand. At the same time, however, the white-collar worker came to be asked to invest his job with his personality, his disposition, his feelings, thus dissociating himself from himself.

As André Gorz demonstrated in his 1988 history of modern work (indebted to Hannah Arendt's 1958 study, as I mentioned in the introduction), the 'economic rationalisation' of capitalism, in its drive towards efficiency and unlimited growth, was able to transform the 'worker-producer' into a 'labourer-consumer'.[38] Following Marx, Gorz described this as a shift from 'concrete work' to 'abstract work'. This abstraction involved not only a never-ending increase in the calculability, reliability and productivity of the workers' behaviours and time management; it required, as Max Weber put it, that a state's justice and administration institutions followed suit, so that its operations could become 'as predictable as that of a machine'.[39] It is in the context of this new 'organized society', understood as an abstracting system, that I would like to situate the debates concerning the integration and

disintegration of junk. Although Clark Hodges aptly noted that Kienholz's work was unified through 'the logic of resentment against the "system"',[40] my analysis will hinge less on such symbolic indictments of the 'organization man' than on the structural dynamics at the heart of assemblage.

'Essential to junk culture,' according to Alloway, 'is retention of the original status of the objects, things to be worn, eaten, handled, whatever it may be.'[41] This 'first function', argued Alloway, served to introduce a form of friction in the work, by 'grittily resisting incorporation into a smooth esthetic whole'. The 'retention of the original status' singled out by Alloway required a new attitude on the part of the artist, which was the object of critical debate. In a magazine review, Hilton Kramer, for example, explicitly objected to Alloway's perspective: 'Junk *is* interesting; it *does* tell a symbolic story of our civilization. But what has this got to do with art? It is what the artist *makes* that is interesting'[42] – not the 'original status' of the objects described by Alloway. Although *Village Voice* critic Suzanne Kiplinger was more sympathetic to assemblage than Kramer, she pursued a similar dialectic by affirming that:

> the less abstract these arrangements are, the less the artist has wrought his own individuality upon them, the worse they are. The crucial issue in this art is to bend the 'found object' to the artist's spirit. Where he has absorbed it into his own creativity, it works. Where it remains resolutely itself, it fails.[43]

Max Kozloff similarly described a logic of power relations, but from the opposite perspective, as he noted with interest that '[e]xactly in proportion to the power he would gain over the inanimate matter, the assembler has to drop visible execution, forfeit personal style, and ignore any kind of pictorial or three-dimensional structuring'.[44] The deliberate act of conceding power to 'inanimate matter' would allow junk to remain 'resolutely itself' (in Kiplinger's terms), to resist 'incorporation into a smooth esthetic whole' (in Alloway's formulation).

As Seitz had suggested in the *Art of Assemblage*, John Chamberlain exploited the 'new formal qualities' of 'scrap automobile bodies and other painted metal' to create polychrome sculpture, aware that 'unless he carefully obliterates marks of the origin and history of each element these qualities inevitably transcend abstractness of form, texture, and color'.[45] This echoed Richard Stankiewicz's statement, cited in a *Life* article: 'If you forget that a wheel is a wheel … it becomes very interesting.'[46] Drawing from such perspectives, the scrap-metal works by Chamberlain, Stankiewicz (figure 13) or Jean Follett could similarly be described as 'abstract' in that these artists clearly imprinted their chosen 'inanimate matter' with forms, patterns and rhythms which allow viewers to 'forget' the 'origin and history of each element' – the 'original status' that needed to be retained, according to Alloway, to allow some grit to clog up the 'smooth esthetic whole'.

Furthermore, Seitz raised the issue of craftsmanship, as he contrasted for example the neatness, delicacy and precision of some assemblages with the deliberate appearance of 'sloppy workmanship' in constructions such as Kienholz's.[47] If Louise Nevelson's work was praised by a number of critics as an example of good assemblage because of its 'formal purity'[48] and 'compositional skill',[49] Seitz admitted that the most controversial works in the *Art of Assemblage* had turned out to be those in which craftsmanship seemed to have been put aside, and objects were presented in a little-transformed state. His examples included Nouveaux Réalistes works such as Daniel Spoerri's 'snare pictures' (figure 15) and the torn street posters displayed by Raymond Hains, Mimo Rotella and Jacques de la Villéglé.[50]

While such assemblages nevertheless remained close to the 'abstract art' of painting and sculpture, Seitz singled out further 'evaluative problems' – as he called them – raised by three other categories of junk art. Firstly, an artist such as George Herms's use of 'extra-formal references' 'dematerializes' the found objects in order to convey the artist's idiosyncratic 'symbolism'.[51] A second category of assemblage, exemplified by Bruce Conner's *CHILD*, is characterized, according to Seitz, by a 'radical realism', an 'immediate … impact' that exceeds abstract forms of sculpture.[52] The third and final category brings together participatory works by George Brecht and

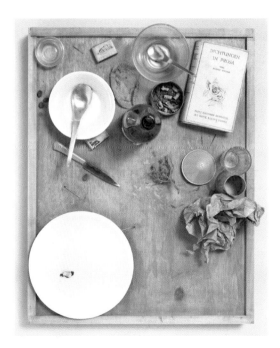

Daniel Spoerri, *Prose Poems*, 1959–60 **15**

environments by Allan Kaprow, in both of which the artist 'undermines the separation of the plastic and graphic arts from ordinary life, and also demonstrates the inadequacy of the museum'.[53] Seitz drew a parallel between Brecht's arrangements of objects (to be handled and possibly exchanged by visitors) and Kaprow's 'rambling "environments" of fragile waste materials loosely constructed'.[54]

In this book, I will argue that it is in these last two categories, and in the practices of these latter three artists in particular, that the most precarious forms of early 1960s junk aesthetic can be found. Brecht's practice will be extensively discussed in the next chapter, whereas I will focus in this chapter on Conner's and Kaprow's work, which I will contrast with some of the above-mentioned assemblage practices, in particular Robert Rauschenberg's 'combines'. Crucial to my discussion is Seitz's reading of assemblage as a technique and a set of ideas and attitudes, which confirmed that his editorial consultant for *The Art of Assemblage*, Helen Franc, was right to worry that the exhibition title placed 'emphasis on the *act* rather than on *the finished product*'.[55]

A science of the concrete

Writing about junk art, Irving Sandler mused: 'There is poignancy in this rejected matter – the expendable detritus of a concrete, steel and glass leviathan – that evokes the tragic vulnerability of the city dweller, his progressive insignificance.'[56] Seitz similarly suggested that the 'drab and monotonous' 'hygienic uniformity of garden suburbs and the glass-curtained propriety of Park Avenue or Lake Shore Drive' present the city dweller with 'the deadening imprint of arbitrary planning on the interplay of life'.[57] For Seitz, the 'actualism' [*sic*] of assemblage – its refusal of illusion and representation – may be related to the 'feelings of disenchantment with the slick international idiom that loosely articulated abstraction has become, and the social values that this situation reflects'.[58] Since Seitz spoke, elsewhere in his essay, of the 'slickness' and 'cold planning' of the modern city, might it be possible to read assemblage's refusal of 'the slick international idiom' of abstraction as a resistance to the 'deadening' uniformity of rationalised capitalism?

Although he does not cite Seitz, Joshua Shannon's excellent study of *The Disappearance of Objects: New York Art and the Rise of the Postmodern City* maps out precisely such a field of enquiry. Shannon 'repositions the scraps of urban detritus' characteristic of the early 1960s work of Claes Oldenburg, Robert Rauschenberg, Jasper Johns and Donald Judd in the historical context of the 'vitriolic fights over the transformation' of New York during the urban renewal projects that were implemented at the time.[59] Of crucial interest is Shannon's explicit reading of such urban projects as participating in a 'process

of abstraction'. Shannon speaks of a general 'abstract aesthetic of smoothness and clarity' – typical of the 'organized society' that I described earlier – which involves 'systematic administration' and the development of 'symbolic goods' (thanks to advertising and planned obsolescence), as well as strategies of urban development.[60] The replacement of 'chaotic tenements' with 'simple towers' (invoked by Sandler and Seitz), and the creation of 'speedy express-ways' instead of 'crowded streets', were inherent features of a process deemed 'necessary to bring order and clarity to the urban environment' – that very same 'cold', 'arbitrary planning' denounced by Seitz. Significantly, Shannon presents junk art's 'obsession with urban detritus' as both a fascination with, and a 'wilful resistance to, New York's transformation'.[61] In his analyses of Claes Oldenburg's and Rauschenberg's junk aesthetics in particular, Shannon relates the urban dialectic between abstraction and materiality to the artists' engagement with the obdurate objecthood of their materials, and questions of representation and signification. In this sense, Shannon seems to develop Alloway's description, cited above, of junk materials 'grittily resisting incor-poration into a smooth esthetic whole'.

For example, Oldenburg's use of trash in his environment *The Street* and in his happening *Snapshots of the City* – made out of cardboard, crumpled package paper, broken slats of wood 'dirtied' with black paint – combined the obdurate materiality of junk with a 'deliberate refusal of logic' compara-ble to the Beat celebration of irrationality and madness against mainstream rationalisation.[62] Oldenburg thus invited a reading that equates the way the 'litter of the city clogs up renewal' and 'traffic' with the way his works operate 'a blockage of meaning' and of 'representation itself'.[63] Oldenburg, according to Shannon, thus explored the impossibility of bringing 'order and legibility' to 'material chaos'.[64]

Shannon reads Rauschenberg's 1960–61 combines as grappling with similar issues of legibility and blockage. This time, Shannon focuses on the specific relation at play in Rauschenberg's works between objects and mean-ing. Although the found objects included in the combines – whether road signs and architectural fragments or abandoned commodities (figure 12) – are shown to carry 'specific … associations', argues Shannon, any 'redemptive meaning' is frustrated by their materiality.[65] 'The possibility of drawing any abstractions from the material world,' observes Shannon, 'is seen to be forever in doubt.'[66] This resonated with Rauschenberg's reading of New York City as still 'illegible, still particular, still material and impossible to summarize'.[67]

In a 1965 essay, Alloway contrasted Rauschenberg's combines with the work of artists associated with the Reuben Gallery, such as Claes Oldenburg, Jim Dine (figure 16) and Robert Whitman, as well as Kaprow and Brecht. While Rauschenberg's combines played on the 'incorporation of solid found objects', Alloway explained, the Reuben Gallery artists were more interested

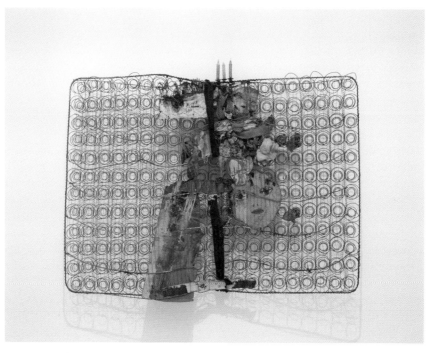

16 Jim Dine, *Bedspring*, 1961

'in stretching and violating the borders of art'.[68] Some of these artists, for example, embedded objects in shapeless compositions, thus creating 'an organic continuum, expressionistically taken possession of and shaped', a flow of 'homogeneous, undifferentiated materials'. (In 1962, Alloway had similarly suggested that Bruce Conner's *PORTRAIT OF ALLEN GINSBERG* [figure 11], like Dine's work, 'presented' 'objects' 'in terms that dramatise the spread, flow, tension, trespass'.)[69] Although Alloway acknowledged the importance of figuration for many Reuben Gallery artists, his discussion privileged their use of impermanent, throwaway materials – such as paper and cardboard, cloth and plaster – in order to construct 'untidy, and highly physical' assemblages and environments.[70] Such works, he suggested, 'echo experiences of the environment beyond the gallery or museum in which individual objects, made out of its substance, are shown'.

Seitz had also remarked that 'unorthodox' practices such as Conner's, Brecht's and Kaprow's 'violate the limitations of painting and sculpture' in 'reaction to the dominance of abstract art'.[71] While Seitz emphasised the physicality of Conner's works, he spoke of the 'looseness' of Kaprow's and Whitman's works, 'whose fluttering creations of newspaper and rags, doctrinaire in their fragility, are barely joined to each other at all'.[72] In the notes

he took on *New Forms, New Media II*, Seitz described Whitman's work as a 'heap of paper';[73] Kaprow's 1959 *Mountain* was also little more than a mound of painted crumpled paper. In a letter to critic Fairfield Porter, Allan Kaprow insisted that his use of materials was very different from Rauschenberg's: the combines were elegant, displaying 'a refinement of the "apparently" sloppy', whereas Kaprow's happenings and environments featured 'coarse' and 'immediate' materials (figure 14).[74] Moreover, Rauschenberg maintained the 'detached quality' of painting, while Kaprow favoured the 'environmental'. Crucially, then, the 'opposition to the intact surface or the compact rectangle by which art is habitually separated from nature and random events', which Alloway would highlight, is what set the practices of Conner and the Reuben Gallery artists apart from Rauschenberg's combines as well as works by Stankiewicz, Chamberlain and Follett, or even those of the Nouveaux Réalistes, which are more closely comparable to traditional painting and sculpture. Similarly, despite their sloppiness and physicality, assemblages such as Kienholz's constructions appeared to be still tied to the 'intact surface' of sculpture, and less concerned with material conditions of 'spread, flow, tension, trespass'.

In his probing analysis of Conner's 'violation' of the limitations of painting, Kevin Hatch provides an excellent comparison with Rauschenberg's combines. Indeed, Hatch's discussion specifically focuses on the intelligibility of signs discussed by Shannon. According to Hatch, 'rather than elaborating the meaning in metonymic chains of signifiers or infinitely deferring it in a play of difference' like Rauschenberg, Conner created a kind of assemblage which 'approaches a density beyond sign systems'.[75] Thus, in Conner's work, '[s]ignificatory meaning of any kind is dispensed with in favor of the brute power … of tangible reality'. For Hatch, intelligibility in Conner's works lies crushed 'under the weight of their own sheer physicality'.

When Lil Picard described in 1960 the junk aesthetic as 'superrealistic concrete', she brought together two different semantic fields characteristic of its contemporary reception:[76] the 'actualist' (as Seitz called it),[77] realist, hyperrealist on the one hand, and the physical, tangible, material, crude, raw, direct on the other. In his 1958 landmark essay on 'The Legacy of Jackson Pollock' Kaprow had hailed the arrival of a 'new concrete art' which would embrace everyday materials.[78] This 'new concrete art', I would suggest, bears affinities with Claude Lévi-Strauss's discussion of a 'science of the concrete' in his 1962 book *Savage Thought*. Moreover, it is in the book's chapter bearing this title that Lévi-Strauss described the operations of *bricolage*, which are very similar to those of assemblage. My comparison between assemblage and *bricolage* – the handyman and hobbyist's activities involving repairing and constructing objects with found odds and ends – hinges on three central elements. Firstly, the *bricoleur*, like the assemblagist,

draws on a stash of existing, found objects that he or she has collected over time. Secondly, *bricolage* requires a specific attitude to the world, a dialogue with things themselves, which involves paying attention to the particularities of each object and material. For Lévi-Strauss, the *bricoleur* 'speaks, not only with things … but also through things'.[79] As a result, the structures of *bricolage* and assemblage both betray their constructors' subjectivities, their individual histories and the history of the society in which they work. Significantly, Lévi-Strauss set up a contrast between the *bricoleur* and the scientist, which illuminates the distinction between a 'concrete' and an abstract attitude to the world. Whereas the scientist develops concepts with which to 'tear' meaning from the world that he or she is interrogating, the *bricoleur* tries to find 'possible answers' in what is already there, by 'asking' the objects what they can offer.[80]

Concerned with the increasing isolation of human beings from the world, Hannah Arendt traced this tendency back to the original Cartesian turn to science, in particular geometry. It was at this moment, argued Arendt, that humans decided to 'handle the multitude and variety of the concrete in accordance with' their minds' 'own patterns and symbols'.[81] 'Under this condition of remoteness,' explained Arendt, 'every assemblage of things is transformed into a mere multitude, and every multitude, no matter how disordered, incoherent, and confused, will fall into certain patterns and configurations possessing the same validity.' In *The Origins of Geometry* (1936), Edmund Husserl had similarly explained how geometry pries from the concrete world pure ideal forms such as surfaces, edges and angles. As art historian Jean-Pierre Mourey has pointed out, it is precisely this movement of abstraction that is reversed by assemblage artists, who 'construct their alphabets and forms on the basis of the scraps and trash' of the 'concrete world'.[82] In their work, traditional relations between form and matter are thus inverted. Lévi-Strauss would no doubt agree that this corresponds to the *bricoleur*'s, rather than the scientist's, approach to the world.

In Arendt's study of the human condition, the 'sense of dislocation and disconnectedness' of man from himself deplored by Clark Hodges was partially attributed to man's 'remoteness' from the world.[83] André Gorz similarly followed in Arendt's footsteps when he related the 'rationalisation' of capitalism in 'organized society' to the rationalising operations of science. Gorz condemned the way in which the sensitive, lived qualities of reality had disappeared in what Husserl had called 'the mathematization of nature', and how the organisation of work in capitalist society followed suit.[84] Lived experience has been silenced in the capitalist system, whose values of truth – 'what is calculable, quantifiable' – have replaced the 'lived certainties' of our bodies in the word. Just as Gorz spoke of the need to retrieve from this abstract order the 'sensory thickness' (*épaisseur sensible*) of the world, assemblage artists

sought to develop a renewed 'sensibility' to reality; the emphasis on bodily, lived experience was a central trope for both the Beat aesthetic and early 1960s art forms ranging from junk art and environments to happenings and works involving spectator participation.

In this context, Hatch's aforementioned discussion of the 'density', 'brute power' and 'sheer physicality' of Conner's assemblages certainly implied the artist's rejection of all mathematical or geometrical 'intelligibility'. Although Rauschenberg, as Shannon demonstrated, problematised the legibility of his combines, his works nevertheless relied on a system of signs that could be – at least provisionally – decoded. This point could be further developed by comparing the two artists' respective relations to the canvas. Conner's *PORTRAIT OF ALLEN GINSBERG* stands as one of the exceptions in the artist's assemblages, which remained largely planar and engaged in a dialogue with painting, as Hatch has aptly demonstrated. Rauschenberg's earlier *White Paintings*, which John Cage compared to 'airports for shadows and dust', as we saw in the introduction to this book, point to the fact that his surfaces always served, above all, as receptacles, fixed planar surfaces on which objects, traces and signs will accrue. In contrast, one of Conner's first assemblages, the 1958 *RATBASTARD* (figure 17), emerged from the artist's fight with the canvas, during which he decided to slash its surface and stuff nylon stockings in it, so

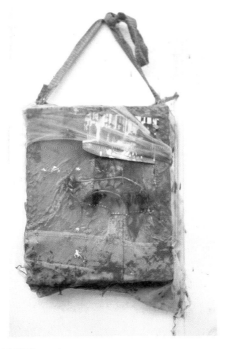

Bruce Conner, *RATBASTARD*, 1958 **17**

that, as the artist explained, 'it looked like its innards were coming out'.[85] This act of slashing and stuffing confers a bodily dimension to the work; the nylon layers typical of Conner's assemblages at the time resemble painterly skeins as well as skin, the bundled protrusions evoke organs as much as cancerous growths. Moreover, a reference to nature continues to hover in Conner's works, as the transparency of the tights recalls underwater landscapes, where feathers float like weeds and stretched nylon creates an organically repulsive impression of viscosity. As Hatch points out, Conner tends to veil his work, whether by wrapping it in nylon or covering it with wax and paint. Following one of Conner's statements, Hatch underlines how such strategies of display and secrecy created a form of intimate theatre in which the artist staged 'concrete, material dramas in which the viewer was offered competing roles – saint and sinner, voyeur and victim, murderer and prey – without clear guidance'.[86] Indeed, the 'brute power' of Conner's assemblages results in part, according to Hatch, from the artist's engagement with Antonin Artaud's reflections on a 'theatre of cruelty', 'which gives the heart and the senses that kind of *concrete bite* which all true sensation requires'.[87]

Rags and rucksacks

In 1962, Susan Sontag remarked that three features of contemporary happenings bore the influence of Antonin Artaud's 'theatre of cruelty': 'first, its supra-personal or impersonal treatment of persons; second, its emphasis on spectacle and sound, and disregard for the word; and third, its professed aim to assault the audience'.[88] If the happening's 'assault' on the audience can be detected in Conner's ambivalent assemblages, it is its first feature that I would like to emphasise here: the 'supra-personal or impersonal treatment of persons'. As Judith Rodenbeck has explained, such an Artaudian feature set happenings apart from traditional forms of acting (in particular the 'method acting' used in contemporary cinema as well as the theatre): the performers' actions could no longer be identified with those of an apparently subjective 'character'.[89] For Sontag, this detachment reflected 'modern experience … characterized by meaningless situations of disrelation' [*sic*][90] – a diagnostic akin to Clark Hodges' and Arendt's concerns with the 'disconnectedness' of the contemporary human condition.

In Oldenburg's happening *Snapshots of the City* which took place in his installation *The Street* at the Judson Gallery, the performers, wearing costumes made out of sackcloth, strips of cloth, newspaper and stuffed rags, stood still as the audience arrived, as if 'not exactly buried but part of the landscape'.[91] Here the Artaudian 'impersonal treatment of persons' identified the performers as trash; they evoked the victims of the city – the poor, marginal, disposable, 'beggars and cripples', as Oldenburg remembered

them. The performance appeared as a series of 'snapshots' because Lucas Samaras repeatedly turned the light on and off, thus reinforcing the sensation of fragmentation and alienation. As Donald Clark Hodges pointed out, junk could be 'symbolic not only of discarded (superfluous) wealth that needs criticising, but also of rejected (superfluous) men'.[92]

Bruce Conner also suggested a relation between trash and marginal urban figures in his *RATBASTARD* series of assemblages. Borrowing the term 'rat bastard' from his friend the poet Michael McClure, who had himself overheard it in a gym locker room, Conner created a 'Ratbastard Protective Association' in homage to the trash collectors' association in San Francisco, The Scavengers Protective Association. Conner commented on the process of contamination of trash: because 'they were using all the remnants, refuse, and outcasts of our society' they were themselves 'considered the lowest people employed in society'.[93] He created a stamp for his new RATBASTARD PROTECTIVE ASSOCIATION to designate his community of artist friends in San Francisco, 'who were making things with the detritus of society, who themselves were ostracized or alienated from full involvement with the society'.

Conner recalled that the San Francisco scavengers would empty trash cans 'onto big flat burlap sheets', which they would then gather up into sacks, throw over their backs and then dump in their truck or hang on its sides.[94] He remembered the 'chair legs sticking up and these big pendulous testicles hanging out on the side' of the vehicle.[95] If the burlap bags hanging like 'lumpy testicles' might have provided a formal influence for Conner's layered reliefs and pendulous protrusions,[96] he was also interested in the image of the truck driving around loaded with improvised assemblages, and with the scavengers themselves hanging on to the truck's sides: 'It was like a parade that was going on.'[97] At the time, Conner and his RATBASTARD PROTECTIVE ASSOCIATION staged impromptu parades in the North Beach neighbourhood of San Francisco where they lived. This sense of movement is physically suggested in the structure of some of the *RATBASTARD* assemblages: Conner added a handle to the first *RATBASTARD* relief (figure 17), which can be viewed from both sides, and he arrived at his exhibition at the Batman Gallery wearing his *RAT BACKPACK* on his back. In the series of photographs showing the artist carrying the work, his face is framed by large sunglasses and the fur-lined hood of his anorak, as if setting out on a trip or, as John Bowles has suggested, a military campaign.[98] In one of the pictures, published in the *San Francisco Sunday Chronicle* of 13 November 1960, Conner is seen crouching, in profile, his grinning face practically invisible in the darkness; in another, he stands displaying the *RAT BACKPACK* with his back to the viewer, the roughly cut-off sleeves of his anorak in sync with the ripped cotton rags wrapped around, and hanging from, the bulky assemblage (figure 18).

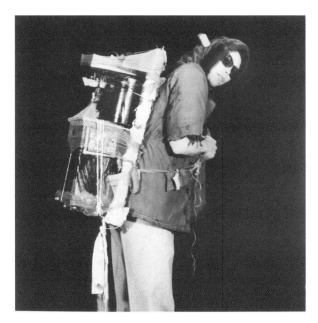

18 Bruce Conner wearing his *RAT BACKPACK*, 1959

In his interviews, Conner repeatedly referred to the ragpickers he encountered during his early career. Before coming to San Francisco, he lived in Brooklyn in 1956, where he admired the windows 'piled with multicoloured cloth' in which New York rag pickers would display the rags and clothes they wished to sell.[99] Such an image might have contributed to Conner's gestures of packing, stuffing, compressing fabrics and objects in two-dimensional reliefs. During his stay in Mexico in 1962, he observed scavengers 'going around collecting every little piece of paper'. Carrying a very heavy burlap bag, these ragpickers wore 'just rags, no shoes', 'just a loin cloth' and a 'shirt full of holes'.[100] Ironically, because trash in Mexico was more valued than in the United States, Conner could not find much material for his assemblages. For the opening of his exhibition in Mexico City, he thought of paying one of the local ragpickers to 'stand there for an hour and a half', as a provocation against the pretentiously 'fancy' international opening. In the end, he decided against it: 'I figured I couldn't stand it myself. I wouldn't be able to deal with it', even if the gallery patrons 'deserved' to be made fun of.

Conner's sympathy with scavengers brings to mind the Beat identification with the figure of the 'outcast' in American society – whether the delinquent or the junkie, marginalised African Americans or bohemian jazz players. Kerouac's description of the Beats as *Dharma Bums*, in his novel of 1958,

implied an identification with the junkie, the wino, the homeless and the vagrant. John Canaday's condemnation of at least half of the art in the *Art of Assemblage* as 'the esthetic counterparts of the social deficiencies that land people in the clink on charges of vagrancy' reminds us that vagrancy was considered to be a crime at the time.[101] Indeed, when the teenage girls from 'Squaresville' invited Beat poets for a visit to their Kansas town, as reported in the above-mentioned *Life* article, 'the police passed the word that a "beatnik doesn't like work, any man that doesn't like work is a vagrant, and a vagrant goes to jail around here."'[102] Although John Bowles suggests that the military connotations of Conner's RATBASTARD PROTECTIVE ASSOCIATION were part of the artist's 'aggressive strategy' against the 'Beat' label that he rejected, I would like to relate Conner's portable *RATBASTARD* assemblages to 'Dharma Bum' Japhy Ryder's call for a 'rucksack revolution' as an alternative to the smooth efficiency of square, organised society. Japhy Ryder, Kerouac tells us, dreamt of:

> a world full of rucksack wanderers, Dharma Bums refusing to subscribe to the general demand that they consume production and therefore have to work for the privilege of consuming, all the crap they didn't really want anyway such as refrigerators, TV sets, cars, at least new fancy cars, certain hair oils and deodorants and general junk you finally always see a week later in the garbage anyway, all of them imprisoned in a system of work, produce, consume, work, produce, consume…[103]

Conner's vision of an embattled RATBASTARD SOCIETY may have been darker than Ryder's imagined community, but the mobility implied by the *RATBASTARD* assemblages suggests lightness as well as weight, the freedom as well as the alienation of living on the margins. This is certainly where Conner's theatrical assemblages differ, in my eyes, from the 'impersonal treatment of persons' in happenings such as Oldenburg's *Snapshots of the City*.

Another of Conner's performative gestures, staged at the opening of *The Art of Assemblage* in 1961, playfully suggested a vagrant mobility. As Hatch recounts, Conner came to the opening carrying an assemblage that he had improvised shortly before, using the remainders of a work of his, *SUPERNATURAL DEVOTION*, which had been sent to New York for his one-man show at the Alan Gallery but had arrived in pieces.[104] With the help of fellow artist Ray Johnson, Conner had placed the jumble of objects – previously contained in a glass box – in a wooden box, the surface of which they both deliberately damaged with holes, additional objects and burns. Having added a rope handle, as in the *RATBASTARD* reliefs, Conner and Johnson brought the new construction to the MoMA, where, as Hatch relates, 'museum guards barred their entry, and the repulsive box ended up straddling the threshold of the building's entrance', requiring guests to walk around it

to enter the institution. (After the opening, Conner and Johnson threw the box from the Staten Island Ferry.) For Hatch, Conner's gesture revealed the 'gulf' between 'the ephemeral and playful ethos of the Bay Area art scene' and 'the solemn attitudes and protocols of the East Coast art world', while contesting the 'museification' of assemblage by Seitz's exhibition. Conner's 'gesture', according to Hatch, 'articulated' 'the limits of institutionally sanctioned assemblage' 'in literal, spatial terms': although some of Conner's work was included in *The Art of Assemblage*, his status as a marginal figure was made visible by the exclusion of a more spontaneous and performative object. Though less controversial than his unrealised plan to invite a ragpicker to his 1962 Mexican opening, Conner's failed introduction of a trashy assemblage into the MoMA tested the museum's definitions of taste and value. The 'rucksack wanderer' had been mistaken for an unwelcome vagrant.

Change

Allan Kaprow tested the limits of the Museum of Modern Art in a different way from Conner when he proposed an environment for the exhibition *The Art of Assemblage* to William Seitz in a letter dated January 1961.[105] To my knowledge, Seitz never acknowledged any correspondence or conversations with Kaprow on this topic, and justified his exclusion of environments and happenings from *The Art of Assemblage* by quoting Kaprow's published criticisms of the museum as an institution. In his letter to Seitz, Kaprow certainly admitted his reservations about museums while nevertheless displaying a keen willingness to be included in *The Art of Assemblage*. Kaprow's arguments were twofold: firstly, it would be useful for his work to reach a wider audience (and potential wealthy patrons), and secondly, the museum's newly developed 'educational functions' opened up a space for the display of artworks with no inherent monetary 'value'. Thus, argued Kaprow, the museum could perhaps 'change' 'from an institution dedicated to displaying gravestones to a place where things "happen" in a more active way'. The use of the term 'happen' referred to the happenings that Kaprow had been developing since 1959, thus rehearsing the continuity between assemblages, environments and happenings that the artist consistently highlighted in his writings. *Chapel*, the environment that Kaprow proposed to Seitz, closely resembled the earlier *Stockroom*, which would be displayed in the *Art in Motion* exhibition at the Stedelijk Museum in Amsterdam, from March to June 1961 (figure 19). Both environments were to be assembled in the museum and 'continuously altered by the visiting public'. Where *Stockroom* consisted largely of a room-size arrangement of hanging and stacked cardboard boxes (assembled by the exhibition curators) to be rearranged and painted by visitors, *Chapel* required five artists to successively paint and staple together newspapers and flattened

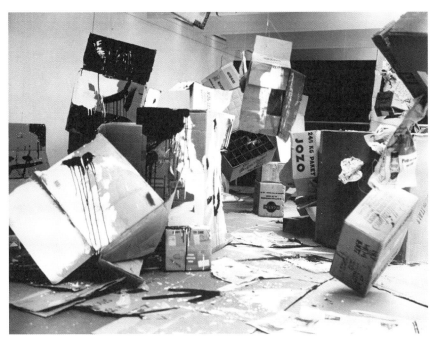

Allan Kaprow, *Stockroom*, 1961 **19**

cardboard cartons in a room, before leaving the environment open to visitors who were invited to continue working with the materials in a similar fashion. In both cases, the materials were to be replenished daily by the museum staff; both environments would thus be 'ever-changing' works.

A few months before his letter, Kaprow had remarked in his text in the catalogue for *New Forms, New Media* that artists working with assemblage, environments and happenings 'recognized the connection between the impermanence of the physical life of their work and the principle of change'.[106] For Kaprow, *Chapel* was highly appropriate to Seitz's 'collage-and-construction show' (not yet titled *The Art of Assemblage*) because, as he indicated in his letter, 'it is a growing and dying and growing etc. collage' and 'it seems in the very intrinsic nature of the medium to undergo such life processes'. As Kaprow would later explain, in such work 'the usually slow mutations wrought by nature are quickened and literally made part of the experience of it; they manifest the very processes of creation-decay-creation almost as one watches'.[107] In *Chapel*, as in *Stockroom*, the composition would 'continue to change (like the seasons, like furniture in a room, or chessmen…) from day to day'.[108]

As suggested by the repeated references, in his writings, to seasons and 'life processes', the cycles of growth and decay that interested Kaprow were

intrinsically modelled on nature and biology. In this sense, Kaprow's avowed desire to 'bypass "art" and take nature itself as a model or point of departure'[109] bore the influence of his teacher, the composer John Cage, who liked to quote Hindu philosopher Ananda Coomaraswamy in urging his students 'to imitate nature in her manner of operation'.[110] This injunction led to three crucial conclusions. Firstly, artists needed to respect the specificities and particularities of their materials. If Cage encouraged composers to 'let sounds be themselves, rather than the vehicle for artistic expression',[111] Kaprow described each activity performed in a happening such as *18 Happenings in 6 Parts* as a 'simple thing-in-itself'.[112] This may be where *18 Happenings in 6 Parts* brings together Cage's and Artaud's approaches: revealing 'the concrete bite which all true sensation requires' (in Artaud's aforementioned expression) involved letting the elements 'be themselves' (as Cage put it). Not only does this recall debates, discussed earlier, about junk 'grittily resisting incorporation into a smooth esthetic whole' in assemblage practices: it also resonated with Allen Ginsberg's retrospective remark that for the Beats, the 'return to an appreciation of idiosyncrasy' was posited specifically 'against state regimentation'.[113] Thus the particularity of the 'thing-in-itself' would suggest a 'gritty' resistance to a conformist, abstracting system.

The starting point for a happening, according to Kaprow, was 'a molecule' made 'out of the sensory stuff of ordinary life' – whether sounds, smells, images, objects or activities.[114] In his 1959 happening *Laughs and Balloons*, for example, Kaprow chose as his 'molecule' two actions – laughing and blowing air into balloons – to be alternated with two others: sitting and walking. In order to preserve the 'suchness' of these elements, new modes of composition were required that would neither transform them nor turn them into 'vehicles' of expression. Thus, as Seitz noted, materials in Kaprow's environments appeared to be 'barely joined to each other at all' – a far cry from Suzanne Kiplinger's call for assemblage artists, cited earlier, to 'bend the "found object" to the artist's spirit'. Following Cage, who had famously drawn on chance operations to determine the sequence, pitch, tone and duration of his sounds, Kaprow used chance methods to 'extend' a selected 'molecule'. For example, a 'laugh' could be 'broken down' into different kinds of laughs – including 'heh', 'how', 'ha', 'hee', 'giggle', 'chuckle' – and their sequence, duration and mode of delivery were to be selected and performed by individual performers.

Related to this deliberate erasure of artistic intervention on individual events was thus an attempted illusion of 'artlessness and stylelessness [*sic*]', as Kaprow called it.[115] The growth of a molecule in the happening, or of materials in an environment, needed to appear as 'natural' as possible. For example, Kaprow instructed each performer that an individual element in *Laughs and Balloons* should never be repeated. Similarly, repetition was to be avoided

while hanging the cardboard boxes in *Stockroom*: the curators 'should try to avoid similar sizes of elements, similar groupings, similar heights and place-ments of paper and boxes, similar spaces in between them, repeated cuts, tears, rumples, scrawls, strokes, etc.' Paradoxically, much effort went into creating an appearance of casualness, naturalness. Thus Kaprow's highly detailed instructions concluded with similar injunctions: 'A weaving of con-tinuous fluctuation, punctuated by unforeseen accents and sharp edges is the goal to be striven for' in *Laughs and Balloons*, while in *Stockroom* (figure 19) '[m]aterials and their arrangement are to "grow" from each other.'

Finally, Kaprow's deliberate 'use of obviously perishable media', which I discussed earlier, contributed to the impressions of impermanence and change, of 'growing and dying and growing etc.' Alloway's praise for the 'organic continuum' in works such as Kaprow's resonated with the artist's concerns with flowing, 'open and fluid' forms mimicking those of everyday experience. In 1958, Kaprow had praised Pollock for 'ignoring the confines of the rectangular field in favour of a continuum going in all directions simul-taneously, beyond literal dimensions of any work'.[116] By extension, Kaprow sensed a 'discrepancy between the organic, unmeasurable and extensional character of the forms of the Assemblages and Environments, and the limit-ing rectangularity of the gallery architecture'.[117]

The main reason that *Stockroom* ultimately failed in Amsterdam was, indeed, connected to the museum context: museum staff did not replenish the materials after the room had been destroyed by visitors early on in the exhibi-tion. Within the frameworks of happenings, Kaprow also came to realise that asking his performers to achieve 'the spontaneous' 'by the greatest discipline and control' (as in *Laughs and Balloons*) was too demanding. As Fairfield Porter's review of *18 Happenings in 6 Parts* suggested, the 'solemnity' of the controlled activities and spoken words may have obscured their sensory and humorous qualities,[118] as well as the 'natural' variety and confusion that the artist had deliberately sought to achieve.

Kaprow's disappointment with Porter's review may partly account for some of the important shifts in the artist's happenings in 1961 and 1962. Increasingly, the artist turned to more narrative sequences, which were more structured and atmospheric – indeed, from 1962, they were mainly staged in different sites outside galleries (figure 20). The happenings also became more symbolic. Archetypal figures such as children, a naked woman or an animal-man, recurrent activities involving cleaning and soiling, building and destroying, as well as suggestions of funerary services and fertility rites, all contributed to confer Kaprow's happenings more 'mythical' readings, often related to the cycles of creation and decay, growing and dying, that had been his concern from the beginning. Significantly, Kaprow sought to justify this tendency towards symbolic structures by arguing that 'patterns' could be

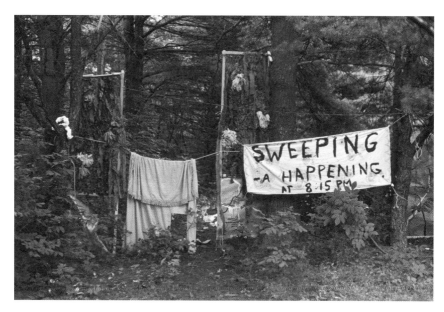

20 Allan Kaprow, *Sweeping*, Woodstock, NY, 1962

'recognized' in nature itself, 'and in them can be found larger meanings and truths which unify and structure every passing NOW'.[119]

Reviewing Kaprow's 1962 *Service for the Dead II*, *Village Voice* critic Jill Johnston was evidently not convinced by the 'naturalness' of such symbolic patterns, and deplored what she saw as the artist's simplistic imposition of 'meaning'.[120] Quoting Antonin Artaud's condemnation of any 'artistic dallying with forms', Johnston concluded that Kaprow's happening 'didn't dally enough to be interesting Art and wasn't real enough to be a moving experience'. Kaprow's defence, in his letter to Johnston, of a 'meaning' detached from traditional narrative theatre certainly set him apart from the more Artaudian practices of fellow happeners such as Claes Oldenburg, or even from Bruce Conner's dark humour.[121] In this sense, he remained more Cagean, and never fully embraced the picture of alienation that Sontag had detected in the happenings. Crucially, for Kaprow, the impermanence of environments and happenings 'implies', above all, a 'philosophically greater preoccupation with *the changeable* as a raison d'être'.[122] Indeed, Kaprow regarded contemporary '"throwaway" culture' less as a concern in itself than as a 'topical vehicle' for age-old reflections on the 'larger issue of reality understood as constant metamorphosis'.[123]

Discussing the impermanence of his work in an unpublished 1960 interview with Seymour Krim, Kaprow compared his work to 'a good meal', and his role as an artist as that of a chef. 'If you eat a meal,' remarked Kaprow, 'let's face it, it comes out … in another form': all that remains 'is the memory

that that guy cooked a terrific meal', and the desire to bring your friends to that restaurant.[124] In *The Human Condition*, published two years before this interview, Arendt had compared the cycle of labour and consumption – ever-speedier, as we saw, in a 'waste economy, in which things must be almost as quickly devoured and discarded as they have appeared in the world' – to 'the ever-recurring cycle of biological life'.[125] Never-ending and continuous, both appear driven by an urgency that will only cease with the death of the individual. This is precisely what Japhy Rider had in mind when he condemned 'a system of work, produce, consume, work, produce, consume'. On the one hand, then, Kaprow's impermanent works, constructed and discarded in the same way as perishable food is ingested and digested, may thus appear to mimic the very processes of this system's voracious impulses, which erase the identity of the worker turned consumer.

On the other hand, however, Kaprow reads the 'terrific meal' as an exceptional, memorable experience. In this sense, his concerns intersect with the Beats' quest for intense experiences. In his interview with Kaprow, writer and critic Seymour Krim (who had reviewed Kerouac's *Dharma Bums* in 1959) directed the discussion towards such Beat concerns. After Kaprow explained that his objective was to communicate to his audience a desire to 'dig the scene, whatever the scene is', Krim asked him whether getting 'high on a stick of tea' (a cannabis joint) could achieve the same effect.[126] After some hesitation Kaprow conceded that 'a stick of tea' may in fact be 'the same thing' as the score for one of his happenings. 'Looked at equally, one sets you going, the other sets you going.' Elsewhere, following on from Kaprow's 'hip' claim that he wanted to invite his viewers to live a 'live life' 'rather than just living vegetably' – even if it meant that 'they go out and perform criminal acts' – Krim asked the artist whether he applied 'the same adventurousness' to his own everyday life.[127] When Kaprow was forced to admit that he was 'a middle-class family man', Krim wondered: 'You do then make a separation between art and life?' Returning to the image of his work as a 'good meal', Kaprow replied by emphasising that you need some time to prepare it: 'just as there are moments that are very boring and conventional in happenings it seems to me these are also characteristic of life'.[128]

In this light, the difference between Conner's and Kaprow's challenges to the Museum of Modern Art's *The Art of Assemblage* are significant. Included in the exhibition, Conner performed the role of the outsider as an act of defiance, while Kaprow, already a recognised figure of the New York art scene, was ready to step out of the margins, only to find that his practice was too radical for William Seitz. Less than six months after writing to Seitz, Kaprow published an essay in *ARTnews* which included a specific reflection on the place of 'happeners' in society. For Kaprow, 'the passing, the changing, the natural, even the willingness to fail' that characterise environments and

happenings 'reveal a spirit that is at once passive in its acceptance of what may be and affirmative in its disregard of security'.[129] This acceptance of chance and change made for an 'advanced art' which 'approaches a fragile but marvellous life, one that maintains itself by a mere thread, melting the surroundings, the artist, the work, and everyone who comes to it into an elusive, changeable configuration'.[130] Such precariousness suggests an 'existential commitment', argued Kaprow, which takes the form of a truly 'American' melodrama for today's artist. American melodrama for Kaprow ranged from 'the saga of the Pioneer' to Charlie Chaplin and the 'organization man': one lonely individual's struggle to affirm himself in a hostile environment, to succeed in finding his way against the odds.[131] Kaprow concluded that 'artists who make Happenings are living out the purest melodrama' for two reasons. Firstly, because happenings cannot be sold, such an 'activity embodies the myth of nonsuccess'. Secondly, 'the creators of such events are adventurers too, because much of what they do is unforeseen'.[132] This adventurer, this 'Pioneer', recalls Normal Mailer's definition of the hipster as a 'frontiersman'; the 'myth of nonsuccess' aligns Kaprow and his fellow 'happeners' with the Beat's deliberate courting of poverty and precariousness. By comparing 'the hard and silly melodrama' of the artist's life[133] to that of the 'organization man', however, Kaprow acknowledged that artists can easily become conformists as well – to use Mailer's terms, they can be 'square' as well as 'hip'.

But what about the publicity that happenings – like the Beat subculture – had acquired by 1961? In this same essay, Kaprow argued that the fact that few people had actually seen a happening located this publicity in the field of the 'imaginary', of myths like sea monsters or flying saucers, which would divert the public's attention, thus preserving the artist's 'beautiful privacy'.[134] As Alex Potts has pointed out, language was very important for Kaprow, as he actively participated in the dissemination of his happenings and environments through publications, lectures and letters. Like the friends telling each other about the 'terrific meal' they had, Kaprow spread rumours about his precarious works, thus guaranteeing their durability. It is in this move that the works (like the meal) become less akin to labour and consumption, and more closely related to Arendt's definition of action: an intangible 'living flux' emerging from a 'web of relationships', about which stories can only be told after the event.[135] This tendency, as we will see in Chapter 3, would become even more pronounced in Kaprow's later works.

'Supreme matter-of-factness'

Arendt had opened her account of the human condition by commenting on the launch of the first satellite in 1957. Rather than joy and pride, she observed, what dominated the reception of this historic event was the impression that

human beings desperately needed to escape their earthly condition. Arendt bemoaned this 'rebellion against human existence as it has been given';[136] *The Human Condition* attempted to explain what she saw as this form of alienation typical of modern man. Looking up at the sky around the same time as Arendt, Zen teacher D.T. Suzuki was struck with a similar thought. In a lecture delivered at the conference 'In Defense of Spiritual Values in the Contemporary World' in Brussels in 1958, Suzuki noted that Westerners 'claim that they have conquered the air' instead of saying 'that they are now better acquainted with Nature'.[137] What Suzuki's Zen shared with Arendt's otherwise very different Marxist humanism was a diagnosis of modern man's loss of what Arendt called a 'genuine experience of and love for the world'.[138] For both, the desire to rekindle the relationship between human beings and the world was related to a sense of responsibility towards nature as well to other humans.

Accounting for the widespread popularity of Zen Buddhism in a 1956 essay, Zen populariser Alan Watts explained its 'appeal' to 'the Westerner in search of reintegration of man and nature' by referring to the general 'disquiet with the artificiality or "anti-naturalness" of both Christianity … and technology, with its imperialistic mechanization of a natural world from which man himself feels strangely alien'.[139] When Watts pointed out in this same passage that both Christianity and technology 'reflect a psychology in which man is identified with a conscious intelligence and will standing apart from nature to control it', we are reminded of Arendt's warning against the Cartesian propensity to impose 'patterns and configurations' on the concrete reality of nature. By the late 1950s, as we saw, this desire to 'control' nature had driven the full rationalisation of an organised society. Against the alienating abstractions of modern science, Zen affirmed a 'supreme matter-of-factness' according to William Barrett, an American philosopher who happened to appreciate both Suzuki's and Arendt's writings.[140]

Beat writers such as Kerouac and Ginsberg also became interested in Buddhism in the 1950s. Their friend and fellow Beat, the poet Gary Snyder, who served as the model for the visionary character of Japhy Rider in *The Dharma Bums*, went so far as to study Oriental Languages in Berkeley in 1952 after having discovered Suzuki's writings in 1951. Not only did he attend Alan Watts's lectures as well as Suzuki's: he eventually travelled in 1956 to Japan, where he would remain for twelve years. While Snyder recalled that his first encounter with Suzuki's writings revealed for him the importance of 'personal direct experience', Alan Watts acknowledged, in a 1959 text, that some Beat poetry encouraged a general 'digging of the universe'.[141] Watts denounced 'Beat Zen', however, as a distortion of Zen, although he was careful to note that Snyder was an exception among the Beats. At best, Watts criticised the Beat aesthetic for being 'a shade too self-conscious' to be truly Zen. At worse, Zen was used, according to Watts, 'for justifying sheer caprice in art, literature,

and life'; it confused a Zen worldview with an indifferent pose of detachment from society that was often used to justify 'the callous exploitation of others'.[142] Moreover, Watts objected to the supposed equivalence, widespread among the Beats, between drug-induced states of awareness and the Zen experience of *satori* or enlightenment. All in all, Watts argued that Beat Zen failed as much as its opposite extreme, Square Zen, which found in the austere and disciplined pursuit of *satori* a no less artificial set of conformist conventions.

The real Zen, for Watts, was inherently un-artificial. 'In Buddhism there is no place for using effort,' as T'ang master Lin-chi explained: 'Just be ordinary and nothing special. Eat your food, move your bowels, pass water, and when you're tired go and lie down.'[143] In a 1963 interview for a French newspaper, Kaprow similarly pointed out that 'oriental thought' 'recommends we develop an awareness of what appears natural'.[144] In a 1981 interview, Kaprow retrospectively remembered that the appeal of Zen for him, from the late 1950s onwards, lay in its 'simplicity, its close appreciation for everyday life', its way of allowing one 'to see the world more freshly and simply and coherently'.[145] It is in this sense, then, that I would like to argue that Zen contributed to the 'concrete' turn in the late 1950s and 1960s. The popularisation of Zen in America inspired those who tried 'digging the universe' anew as an alternative to the organised society, whether through a Beat lifestyle, or the creation of assemblages, environments and happenings, whether through an Artaudian theatricality, or a Cagean musicality. Kaprow's knowledge of Zen in the 1950s was certainly inflected by Cage's crucial reception of Suzuki's teaching (Cage attended Suzuki's classes at Columbia University). If Cage's use of nature as a model for art was indebted to Hinduism, his concern with letting 'sounds be themselves' was more closely related to Suzuki's Zen teaching. As Kaprow moved away from chance compositions and towards change and impermanence within a visual vocabulary of everyday activities and spaces, his reading of Zen seemed to have focused more closely on the concreteness of the everyday, the *wu-shih*, 'no fuss' or 'nothing special' advocated by T'ang Lin-chi.

It may be surprising that in the revised 1959 version of his 'Beat Zen, Square Zen' essay, Watts explicitly condemned one of Cage's most famous works, the 1952 landmark *4'33"*.[146] For Watts, Cage's work embodied a 'shameless' use of Zen to justify capricious or arbitrary artworks. Although it is possible to dismiss Watts's rejection of Cage's 'silent music' as little more than a misunderstanding based on caricature, his concerns about the 'frame' of the work, voiced on this occasion, nevertheless remain relevant. Watts argued that artists who refuse that their work be distinct from the rest of the world should not present them in institutional situations such as concert halls and galleries, which de facto isolate the concrete facts and processes from their 'natural context'. Moreover, Watts insisted that truly Zen works should neither be signed nor sold. Kaprow, who had attended a performance of Cage's *4'33"*, seemed

to be grappling, as we saw, with this very problem of the 'frame' in the period between 1958 and 1962. Although Bruce Conner was much less articulate than Kaprow, he also displayed a comparable ambivalence towards the framing and fixing involved in assemblage – a medium that he would abandon altogether in 1964, in a move to which we will return in Chapter 3.

Assemblage in the late 1950s opened the way towards a 'concrete' reflection on the everyday and new conceptions of the artwork as both an attitude to the world and a process – two developments that would become central to a great variety of practices from the mid-1960s to the present. Although the use of junk could in itself appear as a document of the 'throwaway age', it was the articulation *between* the materials, as well as the relations *between* the artist and the concrete world, that addressed, metaphorically, the place of the individual within an ever-expanding capitalist machine.

Reciprocal relations are often mentioned by Kaprow, whether speaking of the 'fairly natural give and take between the human being and the constructed materials' in his environments and happenings, or describing the 'give-and-take between the artist and the physical world'.[147] If the artist manages to 'shake hands' with the concrete world, as Kaprow suggests in one text, 'life and art' can perhaps 'begin flowing together in an easy give and take' (as he describes it in another essay).[148] The Zen conception, described by Watts in his 1957 *The Way of Zen*, of a 'mutuality in which the subject creates the object just as much as the object creates the subject' resonated with those who felt that a fully rationalised society implied a loss of this 'give and take' with a concrete, natural world, increasingly abstracted by an ever more efficient cycle of production and consumption.[149] If, as Zen proposes, 'I have no other self than the totality of things of which I am aware', I am at once more conscious of and more vulnerable to both the concrete world and the society around me. I am traversed by the life cycles of things turning into junk, shaped by organisation and obsolescence, disintegrated by splits and contradictions, involved in change and flux. Thus I can be at once 'square' *and* 'hip', sharing with Kaprow 'a spirit that is at once passive in its acceptance of what may be and affirmative in its disregard of security'.[150] To capture such multiple states, artists in the late 1950s started to develop new forms of art, exploring flows of abstraction and 'blockages' of meaning, identifying with 'gritty' junk as well as marginal figures, embracing 'concrete' processes and lived experiences, or going further by creating an 'advanced art' which 'maintains itself by a mere thread', as Kaprow put it.

The next two chapters will consider practices that were even further involved in this process, which Kaprow would also describe as 'balancing … as precariously as possible' on a 'tightrope' between art and the concreteness of everyday life.[151] In the next chapter, I will analyse George Brecht's work, which was included in *The Art of Assemblage*, and his concept of 'borderline

art', which relates this work to other contemporary practices concerned with the nearly imperceptible. In Chapter 3, I will situate some of Conner's and Kaprow's later work in the context of practices from the mid- to late 1960s that were less concerned with assemblage than with the everyday. Chapters 2 and 3 will return to the relationship between precarious practices and the Zen pursuit of the 'nothing special', while Arendt's discussion of the human condition will continue to guide us as we further explore the relations between work, labour and art during this later period.

Notes

1 Norman Mailer, 'The White Negro: Superficial Reflections on the Hipster', *Dissent* (Autumn 1957), reprinted in *Dissent* (20 June 2007), available at http://www.dissentmagazine.org/online_articles/the-white-negro-fall-1957 (accessed 7 May 2015)
2 'Squaresville US vs Beatsville', *Life*, 21 September 1959, pp. 31–7.
3 Mailer, 'The White Negro'.
4 Bruce Conner, quoted in Kevin Hatch, *Looking for Bruce Conner* (Cambridge, MA: MIT Press, 2012), p. 208.
5 Jack Kerouac, quoted by Lisa Phillips, 'Beat Culture: America Revisioned', in L. Phillips (ed.), *Beat Culture and the New America, 1950–1965* (New York and Paris: Whitney Museum of American Art and Flammarion, 1996), p. 33.
6 William Seitz, *The Art of Assemblage* (New York: Museum of Modern Art, 1961), p. 10.
7 John Canaday, 'Art: Spectacular Show', *New York Times*, 4 October 1961, p. 42.
8 Seitz, *Art of Assemblage*, p. 10.
9 *Ibid.*, p. 87.
10 *Ibid.*, p. 89.
11 Donald Clark Hodges, 'Junk Sculpture: What Does It Mean?', *Artforum*, 1:5 (1962), 34.
12 Howard R. Moody, 'Reflections on the Beat Generation' (1959), quoted by Phillips, 'Beat Culture', p. 29.
13 Clark Hodges, 'Junk Sculpture', p. 34.
14 Hannah Arendt, *The Human Condition* (1958) (Chicago: University of Chicago Press, 2nd edn, 1998), p. 134.
15 Vance Packard, *The Wastemakers* (Harmondsworth: Penguin Books, 1960), p. 17.
16 *Ibid.*, p. 58.
17 Arendt, *Human Condition*, p. 59.
18 Clark Hodges, 'Junk Sculpture', 34.
19 Thomas B. Hess, 'Mixed Mediums for a Soft Revolution', *Art News*, 59:4 (1960), 45.
20 Anon., 'Art Crashes through the Junkpile', *Life*, 24 November 1961, p. 6.
21 David Myers, quoted by Lawrence Alloway, 'Junk Culture as a Tradition', in Lawrence Alloway et al., *New Forms, New Media* (New York: Martha Jackson Gallery, 1960), n.p.

22 *Ibid.*

23 This was the wording of a standard letter that Seitz sent to a number of American museums during the summer of 1960, when he was looking for works to include in the exhibition. See Museum of Modern Art Archives, New York, Box 'CUR, Exh. #695'.

24 Jaimey Hamilton, 'Arman's System of Objects', *Art Journal*, 67:1 (2008), 43–57.

25 Seitz, *Art of Assemblage*, p. 85.

26 John Scanlan, *On Garbage* (London: Reaktion Books, 2005), p. 43.

27 Unpublished manuscript by Allan Kaprow for *Paintings, Environments, and Happenings* (1960), sent to the curator by the artist, quoted by Seitz, *Art of Assemblage*, p. 90.

28 Alex Potts, 'Writing the Happening: The Aesthetics of Nonart', in Eva Meyer-Hermann, Andrew Perchuk and Stephanie Rosenthal (eds), *Allan Kaprow – Art as Life* (Los Angeles and London: Getty Research Institute and Thames and Hudson, 2008), p. 23.

29 Kaprow, cited by Seitz, *Art of Assemblage*, p. 90.

30 See Packard, *Wastemakers*, ch. 3.

31 Victor Hugo, quoted by Gérard Bertolini, 'L'or et l'ordure, le déchet et l'argent', in Jean-Claude Beaune (ed.), *Le Déchet, le rebut, le rien* (Seyssel: Champ Vallon, 1999), p. 40.

32 Seitz's use of this definition is referred to in Helen Franc, letter to Peter Selz and William Seitz, 30 March 1961. New York, Museum of Modern Art Archives, René d'Harnoncourt Papers, IV, 179.

33 See, for example, William Seitz, letter to Gordon M. Smith, Director of the Albright Art Gallery, 29 July 1960. New York, Museum of Modern Art Archives, Curatorial Exhibition Files, Exh #691–695, Box 79, 'Assemblage General: A-L'.

34 William Seitz, letter to David Smith, undated. New York, Museum of Modern Art Archives, Registrar Exhibition Files, Exh. #695.

35 Henry J. Seldis, 'Art of Assemblage: The Power of Negative Thinking', *LA Times*, 18 March 1962, p. 26.

36 William Seitz, 'Assemblage: Problems and Issues', *Art International*, 6 (February 1962), 31.

37 Clark Hodges, 'Junk Sculpture', 34.

38 André Gorz, *Métamorphoses du travail. Quête du Sens. Critique de la raison économique* (Paris, Galilée, 1988), p. 36. All translations from the French are mine.

39 Max Weber, *Wirtschaft und Gesellschaft* (1964), quoted in French by Gorz, *ibid.*, p. 47.

40 Clark Hodges, 'Junk Sculpture', 34.

41 Alloway, 'Junk Culture as a Tradition', n.p.

42 Hilton Kramer, 'Month in Review', *Arts* 35 (November 1960), microfilm in New York, Museum of Modern Art archives.

43 Suzanne Kiplinger, 'Assemblage', *Village Voice*, 26 October 1961, p. 8.

44 Max Kozloff, 'Art', *The Nation*, 11 November 1961, p. 382.

45 Seitz, *Art of Assemblage*, p. 85.

46 Stankiewicz, cited in 'Art Crashes through the Junkpile', p. 4.

47 Seitz, *Art of Assemblage*, p. 85.

48 Alfred Frankenstein, 'Art Assembled from the Scrap Pile', *San Francisco Sunday Chronicle*, 18 March 1962, microfilm, New York, Museum of Modern Art archives.

49 Emily Genauer, 'Fur-Lined Cup Back, In Dada – 1st Exhibit', *New York Herald Tribune*, 4 October 1961, microfilm, New York, Museum of Modern Art archives.

50 Seitz, 'Assemblage', p. 27.

51 *Ibid.*, p. 31.

52 *Ibid.*, p. 31.

53 *Ibid.*, p. 30.

54 *Ibid.*, p. 30.

55 Franc, letter to Peter Selz and William Seitz, n.p.

56 Irving Sandler, 'Ash Can Revisited, A New York Letter', *Art International*, 25 October 1960, p. 28.

57 Seitz, *Art of Assemblage*, p. 76.

58 *Ibid.*, p. 87.

59 Joshua Shannon, *The Disappearance of Objects: New York Art and the Rise of the Postmodern City* (New Haven, CT: Yale University Press, 2009), p. 4.

60 *Ibid.*, p. 6.

61 *Ibid.*, p. 5.

62 *Ibid.*, p. 25.

63 *Ibid.*, p. 31.

64 *Ibid.*, p. 48.

65 *Ibid.*, pp. 107, 130.

66 *Ibid.*, p. 107.

67 *Ibid.*, p. 127.

68 Lawrence Alloway, 'Introduction', in *Eleven from the Reuben Gallery* (New York: Guggenheim Museum, 1965), n.p.

69 Lawrence Alloway, 'Junk Culture', *Architectural Design*, 31 (March 1961), 122.

70 Alloway, 'Introduction', n.p.

71 Seitz, 'Assemblage', p. 31.

72 Seitz, *Art of Assemblage*, p. 85.

73 Price list for *New Media – New Forms II* (New York: Martha Jackson Gallery, 1960), annotated by Seitz. William Seitz Papers, New York, Museum of Modern Art archives, Box II, File 3.

74 Allan Kaprow, draft letter to Fairfield Porter, ca. November 1959. Los Angeles, Getty Research Institute, Allan Kaprow Papers, Box 5, Folder 12.

75 Hatch, *Looking for Bruce Conner*, p. 50. The two subsequent quotes are from the same page.

76 Lil Picard, 'Warfare of words: What is behind the so-called new young dadaism in America?'. Typescript of the English version of a review published in German in *Die Welt*, 27 July 1960, included in the press release for *New Media – New Forms II*, September 1960.

77 Seitz spoke of 'actualism', *Art of Assemblage*, p. 83. For more on this take on

assemblage, see Julia Robinson (ed.), *New Realisms, 1957–1962: Object Strategies between Readymade and Spectacle* (Cambridge, MA, and Madrid: MIT Press and Museo nacional Centro de arte Reina Sofía, 2010).

78 Allan Kaprow, 'The Legacy of Jackson Pollock' (1958), in *Essays on the Blurring of Art and Life* (Berkeley: University of California Press, 1993), p. 9.

79 *non seulement avec les choses, … mais aussi au moyen des choses.* Claude Lévi-Strauss, *La Pensée sauvage* (Paris: Plon, 1962), p. 32.

80 *les réponses possibles que l'ensemble peut offrir au problème qu'il lui pose. Ibid.*, p. 28.

81 Arendt, *Human Condition*, p. 267.

82 *ont investi le monde concret et construit leurs alphabets et formes à partir de ses bribes et déchets.* Jean-Pierre Mourey, 'Pratiques du rebut et matériologies dans l'art du XXè siècle', in Beaune (ed.), *Le Déchet*, pp. 22–3.

83 Clark Hodges, 'Junk Sculpture', p. 34.

84 Gorz, *Métamorphoses du travail*, p. 111. Further quotes are from the same page.

85 Bruce Conner, quoted in Hatch, *Looking for Bruce Conner*, p. 38.

86 *Ibid.*, p. 36.

87 Antonin Artaud, *The Theatre and its Double*, quoted in *ibid.*, p. 36 (the emphasis is Hatch's). As Hatch noted, Artaud's 1938 text was translated into English in 1958.

88 Susan Sontag, 'Happenings: An Art of Radical Juxtaposition' (1962), in *Against Interpretations and Other Essays* (New York: Octagon Books, 1982), p. 273.

89 Judith F. Rodenbeck, *Radical Prototypes: Allan Kaprow and the Invention of Happenings* (Cambridge, MA: MIT Press, 2011), ch. 4.

90 Sontag, 'Happenings', p. 274.

91 Richard Kostelanetz, [Conversation with Claes Oldenburg], in *The Theater of Mixed Means: An Introduction to Happenings, Kinetic Environments, and Other Mixed-Media Performances* (1968) (New York: RK Editions, 1980), p. 140.

92 Clark Hodges, 'Junk Sculpture', 34.

93 Bruce Conner, quoted in Peter Boswell, 'Bruce Conner: Theater of Light and Shadow', in Peter Boswell, Bruce Jenkins and Joan Rothfuss, *2000 BC: The Bruce Conner Story Part II* (Minneapolis: Walker Art Center, 2000), p. 41.

94 Paul Karlstrom, 'Oral history interview with Bruce Conner, 12 August 1974'. Archives of American Art, Smithsonian Institution, Washington.

95 *Ibid.*

96 Conner, quoted in Boswell, 'Bruce Conner', p. 41.

97 Karlstrom 'Oral history interview'.

98 John Bowles, '"Shocking 'Beat' Art Displayed": California Artists and the Beat Image', in Stephanie Barron, Serie Bernstein and Ilene Susan Forst (eds), *Reading California: Art, Image, and Identity, 1900–2000* (Berkeley: University of California Press, 2000), p. 239.

99 Paul Cummings, 'Oral history interview with Bruce Conner, 16 April 1973'. Archives of American Art, Smithsonian Institution.

100 Karlstrom, 'Oral history interview'.

101 John Canaday, 'A Mixed-up Show: "Art of Assemblage" Leaves Something to be Desired', *New York Sunday Times*, 8 October 1961, section 2, p. 19.
102 'Squaresville US vs Beatsville', p. 31.
103 Jack Kerouac, *The Dharma Bums* (1958) (London and New York: Penguin, 1986), p. 97.
104 The event is recounted in Hatch, *Looking for Bruce Conner*, p. 33.
105 Allan Kaprow, 'Letter to William Seitz', 25 January 1961. Los Angeles, Getty Research Institute, Allan Kaprow Papers, Box 6, File 9.
106 Allan Kaprow, 'Some Observations on Contemporary Art', in Alloway et al., *New Forms, New Media*, n.p.
107 Allan Kaprow, *Assemblage, Environments & Happenings* (New York: Harry N. Abrams, 1966), p. 169.
108 Unpublished typed score for *Stockroom*, 1960, p. 3. Reproduced in *Allan Kaprow – Art as Life*, p. 143.
109 Allan Kaprow, 'Notes on the Creation of a Total Art' (1958), in *Essays on the Blurring on Art and Life*, p. 10.
110 John Cage, 'An Autobiographical Statement' (1993), quoted in Kay Larson, *Where the Heart Beats: John Cage, Zen Buddhism, and the Inner Life of Artists* (London and New York: Penguin, 2012), p. 134.
111 John Cage, 'Indeterminacy' (1957), in *Silence: Lectures and Writings* (London: Marion Boyars, 1999), p. 10.
112 'To the Theater People', unpublished text, 1959. Allan Kaprow Papers, Box 5, Folder 12.
113 Allen Ginsberg, 'Prologue', in Phillips (ed.), *Beat Culture*, p. 19.
114 Unpublished score for *Laughs and Balloons, A Happening in One Night*, 25 November 1959. Allan Kaprow Papers, Box 5, file 13.
115 Page 2 of the score for *Stockroom*, p. 141.
116 Kaprow, 'Legacy of Jackson Pollock', p. 5.
117 Kaprow, *Assemblage, Environments & Happenings*, p. 182.
118 Fairfield Porter, 'Art', *The Nation*, 24 October 1959. Reproduced in *Allan Kaprow – Art as Life*, p. 131.
119 Unpublished draft for a lecture at the Smolin Gallery, New York, 1962. Allan Kaprow Papers, Box 46, Folder 16.
120 Jill Johnston, 'Boiler Room', *Village Voice*, 29 March 1962. In Kaprow's *Scrapbook, 1959–1962*, p. 31. Allan Kaprow Papers, Box 36.
121 Letter to Jill Johnston, 12 April 1962. Jean Brown Archive, Getty Research Institute, Box 28, File 9.
122 Kaprow, 'Some Observations', n.p.
123 Kaprow, *Assemblage, Environments & Happenings*, p. 169.
124 Seymour Krim, unpublished interview with Allan Kaprow, 1960, p. 29. Allan Kaprow Papers, Box 53, Folder 14.
125 Arendt, *Human Condition*, p. 99.
126 Krim, interview with Allan Kaprow, p. 23.
127 *Ibid.*, p. 31.
128 *Ibid.*, p. 32.

129 Allan Kaprow, '"Happenings" in the New York Scene' (1961), in *Essays on the Blurring of Art and Life*, p. 20.

130 *Ibid.*, p. 18.

131 *Ibid.*, pp. 21, 24.

132 *Ibid.*, p. 25.

133 *Ibid.*, p. 24.

134 *Ibid.*, p. 25.

135 Arendt, *Human Condition*, p. 181.

136 *Ibid.*, p. 2.

137 Daisetz Teitaro Suzuki, 'Love and Power' (1958), in *The Awakening of Zen*, ed. Christmas Humphreys (Boulder, CO: Prajná Press, 1980), p. 68.

138 Arendt, *Human Condition*, p. 324.

139 Alan Watts, 'Beat Zen, Square Zen, and Zen' (1959), in *This is it and Other Essays on Zen and Spiritual Experience* (New York: Vintage Books, 1973), p. 85.

140 William Barrett, 'Introduction: Zen for the West', in D.T. Suzuki, *Zen Buddhism: Selected Writings of D.T. Suzuki*, ed. W. Barrett (New York: Doubleday, 1956), p. xvi. See also William Barrett's review of Arendt's book. '"To Think What We Are Doing!"', *Partisan Review*, 25:4 (1958), pp. 610–12.

141 Watts, 'Beat Zen', p. 92. The two subsequent quotations are from the same page.

142 *Ibid.*, p. 101.

143 Lin-Chi, quoted in *ibid.*, p. 84.

144 *les théories orientales qui préconisent de prendre conscience de tout ce qui paraît naturel.* Jean-Jacques Lévêque, 'Allan Kaprow: On peut faire de sa vie un happening', unidentified newspaper clipping (1963). Allan Kaprow Papers, Box 38, Folder 11.

145 Typed manuscript of Moira Roth, 'Oral history interview with Allan Kaprow', 5–18 February 1981, p. 60. Archives of American Art, Smithsonian Institution.

146 Watts, 'Beat Zen', p. 94.

147 Typescript account of *Service for the Dead*, 1962. Allan Kaprow Papers, Box 7, Folder 1; Kaprow, *Assemblage, Environments & Happenings*, p. 183.

148 Untitled statement for *Environments, Situations, Spaces* (New York: Martha Jackson Gallery, 1961), n.p.

149 Alan W. Watts, *The Way of Zen* (1957) (London: Thames and Hudson, 1958), p. 120.

150 Kaprow, '"Happenings" in the New York Scene', p. 20.

151 Untitled statement for *Environments, Situations, Spaces*, n. p.

'At the point of imperceptibility'

In a 1961 text, published in the first issue of the Fluxus magazine *cc V TRE* in 1964, American artist George Brecht introduced the term 'borderline' art. Titled 'Events: Scores and other occurrences', this rather cryptic editorial consisted of a collage of lists, quotes and pithy sentences, which included two examples of 'borderline' art: 'Sounds barely heard. Sights barely distinguished.'[1] Earlier reflections on 'borderline' art in Brecht's notebooks and correspondence give us a more precise definition of this 'art verging on the non-existent' or 'at the point of imperceptibility'.[2] Significantly, borderline art was capable, according to Brecht, of 'dissolving into other dimensions, or becoming dimensionless, having no form'.

Before being associated with the international grouping of artists known as Fluxus from 1962 onwards, Brecht's work was received in the context of junk and assemblage art, as it was included in exhibitions such as *New Forms, New Media* and *Environments, Situations, Spaces* at the Martha Jackson Gallery in 1960 and 1961, as well as in the 1961 *Art of Assemblage* travelling show organised by the Museum of Modern Art. Around that time, Brecht had also started to send friends and acquaintances his 'event scores', verbal instructions for performances, presented on individual cards, which would be brought together in the first Fluxus monographic anthology, *Water Yam*, in 1963. The event scores were partly influenced by John Cage's classes on composition, which Brecht had attended in 1958 along with fellow student Allan Kaprow. Shortly before, Brecht, Kaprow and Robert Watts had proposed a collective research project entitled 'Project in Multiple Dimensions'. In the first part of this chapter, I will situate Brecht's practice in the context of the junk art discussed in Chapter 1, with specific reference to Kaprow's environments and happenings, in order to trace the evolution of his work from a 'project in multiple dimensions' to a 'dimensionless' borderline art, from participatory objects and scores to a practice 'verging on the non-existent'.

A few years after Brecht's remarks on borderline art, and on the other side of the Atlantic, the Signals Gallery in London started planning an exhibition titled *Towards the Invisible*. The Signals Gallery was initially created in 1964

as an association of London-based artists and critics, which grew, through acquaintances and friendships over the next two years, into an international community of like-minded artists from Europe, Asia and Latin America, whose works were presented at the gallery and in the gallery's news bulletin, *Signals*.[3] Organised by Paul Keeler and Guy Brett, two of the founders of Signals, the 1965 exhibition project for *Towards the Invisible* highlighted a *'search for dynamic structures underlying the visible world'*.[4] This search started from the modern sculpture of Constantin Brancusi and Naum Gabo and extended to the more recent kinetic works presented at the Signals Gallery, such as those by other fellow founders Sergio Camargo and David Medalla, or by invited artists including Takis, Lygia Clark and Jesus Rafael Soto. For Keeler, the artists in *Towards the Invisible* were united in a common 'exploration of natural phenomena and formal relationships normally unperceived by the unaided human eye'.[5] Recent scientific discoveries, argued Brett as he was preparing the exhibition catalogue, had led to a 'search for a new order' that involved 'the disintegration of separate objects with their different names, visible nature, and static structures'.[6] Although this ambitious exhibition never took place and the catalogue was never published, the Signals Gallery would stage a series of smaller shows under the title *Towards the Invisible*, alongside solo exhibitions by the above-mentioned contemporary artists. Between 1964 and 1966, the Signals Gallery and news bulletin, I will demonstrate, identified a specific brand of kinetic art involved in the exploration of 'invisible' forces, energies and structures, and in the 'disintegration of static forms' through the use of new materials, space, movement and spectator participation.[7] In the second part of this chapter, I will map out some of the characteristics of Signals kineticism, and focus in particular on the work of Brazilian artist Lygia Clark, who shared with George Brecht an interest in spectator participation.

If there were some points of convergence between assemblage and kinetic practices in the 1960s – in exhibitions such as *New Forms, New Media*, *The Art of Assemblage* or the 1961 *Bewogen Beweging* (*Art in Motion*) – the comparison I wish to present in this chapter will focus less on such art historical intersections than on a set of broader theoretical and experimental concerns shared by New York based artists Brecht and Kaprow, on the one hand, and, on the other hand, some of the artists belonging to the international network radiating from the Signals Gallery. For example, the 'Project in Multiple Dimensions' grant proposal, written by Brecht, Kaprow and Watts in 1957–58, mapped out a field of interests similar to that of Signals. The 'disintegration of static forms' highlighted in the *Towards the Invisible* project was also singled out by Brecht, Kaprow and Watts as a key characteristic of the new avantgarde in the 1950s, which heralded, according to them, 'a general loosening of forms which in the past were relatively closed, strict, and objective' in favour

of 'more personal, free, random, and open' forms.[8] Crucially, Brecht noted in his statement for the project that the new direction proposed by the project 'reflects fundamental aspects of contemporary vision',[9] just as Guy Brett would suggest that *Towards the Invisible* intended to give 'an idea of how our conception of reality has changed recently, and how this change has made us aware of a new order which involves us very strongly'.[10] Brecht listed some of the characteristics of this 'new order' as concerns with 'space-time', the 'inseparability of observer-observed, indeterminacy … relativity, and field theory'.[11] As a consequence of this new conception of the world, Brett argued, 'we no longer think that man is the centre of the universe', thus leading to a radical 'shift from an egocentric to a cosmic view of life'.[12] Similarly, Brecht claimed in his statement: 'I conceive of the individual as part of an infinite space and time.' Affinities between such 'cosmic' perspectives and conceptions of the world found in Taoist and Zen Buddhist philosophies emerge from Brecht's writings, like Kaprow's, as well as the pages of *Signals*.

Significantly, the desire to reflect this new 'order' or 'vision' was grounded, in both artistic projects, in an exploration of new materials available to artists. When Signals was initially created in 1964 as a 'Centre for Advanced Study in Science in Art' its intended goal focused on research into industrial materials, and natural elements such as water, foam, wind and smoke, as well as less tangible phenomena such as sound, light, heat and magnetism. Signals also planned to study the underlying processes that create 'relationships' between such materials. Likewise, the 'Project in Multiple Dimensions' proposed a study of new industrial and natural materials, light and sound, with a similar focus on space and movement, and a particular interest in combining more than one medium or material. This chapter will demonstrate how, in both Brecht's borderline art and Signals practices oriented 'towards the invisible', a combined interest in new materials, scientific developments and Zen Buddhism led to an interrogation of the art form as a fixed, static entity. In the final part of this chapter, I will argue that such a 'disintegration' of forms announced the dematerialisation of the art object that would come to be perceived as a key feature of late 1960s conceptual practices.

'Modes of apprehension'

At the time of the 1957–58 'Project in Multiple Dimensions', Brecht was experimenting with 'electronic systems for creating light and sound structures which change in time', in particular flashing lights.[13] In 1958, he created with Robert Watts an environment of 'flashing lights and collage elements glued to the windows' of a classroom at Rutgers University, where both were teaching along with Kaprow. While attending Cage's class that same year, Brecht composed instructions for a piece inviting performers to hit gongs

and a piano according to three coloured lights flashing at different intervals and for different durations. A work planned but not realised for his first solo exhibition, *Toward Events*, at the Reuben Gallery in 1959, involved a light moving across an aluminium foil surface. The moving and flashing lights introduced a temporal, processual dimension crucial to Brecht's experiments with chance. In earlier works from 1956 to 1957, the artist had used random number tables, or had poured ink on to wet, crumpled bedsheets, in order to create paintings. As Brecht noted in a 1957 essay on chance, Kaprow was also starting to experiment with indeterminate methods in Cage's class around that time (by using a roulette wheel to compose a piece).[14] Brecht's earliest scores, composed during Cage's class a year later, mobilised chance effects in order to ensure that the sequence of actions was determined neither by the artist nor the participants: flashing lights and playing cards served as random cues, while instruction cards were often shuffled before being displayed or distributed among the performers. In *Time-Table Music*, performed with Kaprow and other students of the Cage class in Grand Central Station in 1959, participants used the time indications of railway timetables ('in terms of minutes and seconds [e.g. 7:16 = 7 minutes and 16 seconds]'), and stopwatches, to calculate the duration of their selected actions (figure 21). The rows or columns of timetable times served to randomly determine the sequence of the actions.

Although Brecht would continue to use random number tables when choosing materials for some of his works, and when composing certain texts such as the above-mentioned 'Events: Scores and other occurrences', he would increasingly leave such 'methodological' uses of chance behind from 1959 onwards. In *Toward Events*, some chance paintings were exhibited alongside more recent three-dimensional works such as *The Cabinet*, *The Case* or *Dome*, which Brecht described as 'more temporal, "process-like"'.[15] *The Case*, for example, was a wooden case filled with various objects including a shell, a candle and a glove, as well as a number of toys (a skipping rope, a racket, rubber balls…) (figure 22). According to the exhibition invitation, this work 'is approached by one to several people and opened. The contents are removed, and used in ways appropriate to their nature. The case is repacked and closed.'[16] The reason Brecht called such objects 'events' is that they invited the spectator's participation. As he noted: 'The event (which lasts possibly 10–30 minutes) comprises all occurrences between the approach and the abandonment' of *The Case*. The term 'event', which Brecht would adopt in 1961 for his scores – previously titled 'music' or 'pieces' – brought together scientific terminology and the Cagean vocabulary of composition. A flashing light, in a scientific experiment, constitutes an event; a noise, for Cage, was a musical event just like sound or silence. Above all, an event occurs in space and time.

<div style="border:2px solid black; padding:1em;">

TIME-TABLE MUSIC

For performance in a railway station.

The performers enter a railway station and obtain time-tables.

They stand or seat themselves so as to be visible to each other, and, when ready, start their stopwatches simultaneously.

Each performer interprets the tabled time indications in terms of minutes and seconds (e.g. 7:16 = 7 minutes and 16 seconds). He selects one time by chance to determine the total duration of his performing. This done, he selects one row or column, and makes a sound at all points where tabled times within that row or column fall within the total duration of his performance.

George Brecht
Summer, 1959

</div>

21 George Brecht, *Time-Table Music*, 1959

When *The Cabinet* was to be presented at *The Art of Assemblage* Dallas venue, Brecht insisted in a letter to the Museum of Modern Art that:

> The aspect of this work which (to me) is of most interest is not the object-like part, that is, the cabinet and its contents, but rather what occurs when someone is involved with its object-like part. That is, the work to me is more in the nature of a performance (music and dance) than of an object.[17]

Brecht insisted on the role of spectator participation in works such as *The Case*, and was not pleased that viewers could not handle the objects in his participatory *Repository* when it had been shown in *The Art of Assemblage* at the Museum of Modern Art. His objections led exhibition curator William Seitz to conclude that this type of assemblage 'demonstrates the inadequacy of the museum' – much like Allan Kaprow's environments which, as we saw in Chapter 1, were not accommodated by Seitz in the exhibition.[18] Like Kaprow's, Brecht's works belonged to the category of assemblage practices that most

George Brecht, *The Case*, 1959 **22**

radically challenged 'the limitations of painting and sculpture', according to Seitz. In fact, in a letter to Seitz, Brecht had objected to the term 'assemblage' itself, preferring instead the word 'arrangement', which 'more suitably' suggested a temporal, rather than a spatial, dimension.[19] 'Assembly suggests continuity in time', remarked Brecht in his notebook, whereas to 'arrange' and to 'derange' work together, thus suggesting 'change in time'.[20] Here Brecht's concerns seem to echo directly Kaprow's preoccupations with change discussed in the previous chapter. In their 'Project in Multiple Dimensions', the artists had explicitly praised the 'endless changefulness and boundlessness' of new art forms.[21] Such transformability resulted, in fact, less from the use of new industrial materials than from their modes of assemblage or arrangement. In their invitation to visitors to actively participate in their works, Kaprow's environments such as *Stockroom* (figure 19) or *Chapel*, which he had proposed to Seitz for *The Art of Assemblage,* resemble Brecht's arrangements. In both cases, the formal composition of the works reflected the cumulative decisions of individuals other than the artists themselves; 'change in time', as Brecht had called it, was thus guaranteed. Both Brecht and Kaprow relied on museum or gallery staff to participate in the maintenance of the participatory works: materials in Kaprow's environments were to be replenished, while broken or lost objects in Brecht's arrangements could be replaced.

The objects included in Brecht's arrangements do not, however, easily fit into the category of junk outlined in the previous chapter. As Lawrence Alloway noted, participation was the central feature of Brecht's essentially game-like brand of 'junk culture'.[22] Moreover, most of the objects used by Brecht were new, or only slightly used. The artist's notes reveal a greater concern with different types of objects – and the kind of participation that they require – than with associations of junk and obsolescence. Notes for one of the arrangements exhibited at the Reuben Gallery, *The Dome*, show Brecht classifying the different objects which he planned to include according to three categories: 'symbols' (including numbers, letters, words, pictures, signs, stamps and maps); what he called 'formalisms' such as cellophane, pins, map tacks, paint and sticks; and finally 'things in their Suchness' like a match, a stone, a glass chip, a shell, a leaf, hair, a piece of cloth, marks and a hole.[23] If Brecht had focused, in 1957, on the chance event as 'a selection' from a 'universe of possible results', and on random processes as ways 'in which we structure our universe',[24] he subsequently became increasingly interested in what he called in 1960 our 'modes of apprehension' of the world around us.[25] At the time, Brecht was reading Ernst Cassirer's *Philosophy of Symbolic Forms* (1923–29) which sought to analyse how language, science and myth were used by the human mind to 'structure' reality. Brecht's use of letters, puzzles, numbers, images and maps in his arrangements thus evoked scientific ways of measuring and representing the world, whereas 'things in their Suchness' seemed to appeal to a more direct, tactile relation to nature and materials.

Brecht's research into what he termed the 'structure of experience' arose from two related fields of interest: on the one hand, a reflection on scientific innovation, developed in the context of his education and work as a chemist (and further complemented by philosophical readings such as Cassirer's), and on the other hand, his early attraction to Zen Buddhism. His 1960 essay on 'Innovational [*sic*] Research', sent to companies such as Johnson & Johnson (where he worked at the time) and Bell Telephone Laboratories, singled out the importance of 'form' in interdisciplinary scientific research.[26] From Cassirer's affirmation that '[t]he combination or separation of perceptual data depends upon the free choice of a frame of reference' that is not rigidly fixed, Brecht deduced that forms 'are abstractable from their content' and, once abstracted, can be manipulated and transformed.[27] To support this argument, Brecht also quoted anthropologist H.G. Barnett who, like Cassirer, insisted that: 'We tend to regard a table as a unit because it has substance and because it is segregated from other things around it. Actually, however, the existence of the table is real only because we have mentally segregated it and given a discrete reality to it.'[28] Thus, by handling, arranging and rearranging the objects contained in Brecht's arrangements, such as *The Case*, *The Dome*, *Cabinet* or *Repository*, participants become aware of their active role in giving shape to reality.

The idea of '[o]bjects and events as units of thought' also made an appearance in Brecht's above-mentioned 1961 essay 'Events: Scores and other occurrences', in a quote attributed to Zen populariser Alan Watts. As we saw in the previous chapter, Zen Buddhism presented itself as an alternative to scientific thought precisely because it appeared to reject the way that science tends to impose 'units of thought' on reality. Thus, while Brecht's interest in Zen Buddhism may have stemmed from the same interrogations as his preoccupations with scientific innovation, these two ways of approaching experience diverged radically. Indeed, in an earlier draft of the 'Events' article, Brecht insisted on the importance of things that are specifically '[b]eyond apprehension', and thus beyond the abstracting processes of science.[29] At the same time as he wrote his hymn to form in 'Innovational Research', Brecht formulated the opposite Zen ideal of 'no-grasping', of letting things be themselves, of respecting 'their suchness'. In this sense, Brecht shared with Cage, Kaprow and junk artists a desire to find a more 'concrete' relationship to the world, at odds with the abstracted logic of capital deplored by Hannah Arendt.

'Nothing special'

An 'image of a concrete moment in life' is how Alan Watts described the Japanese poem form of the haiku.[30] Since Japanese haiku tend to focus the reader's attention on natural, mundane 'things in their "suchness", without comments', according to Watts, they presented themselves as models for Brecht's event scores.[31] For example, a haiku by Buson quoted by Brecht in an unpublished text reads:

> The old temple:
> A baking pan
> Thrown away among the parsley.[32]

The haiku, like the *koan* exercises which some of Brecht's scores also resemble, was presented by Zen philosophers such as Watts and D.T. Suzuki as a tool for a 'direct method' bypassing language and thought. 'The idea of direct method appealed to by the masters is to get hold of this fleeting life as it flees and not after it has flown', explained Suzuki.[33] In his 1961 text 'Events', Brecht quoted Watts's description of the haiku as an 'image of a concrete moment in life', only to specify that he conceived his event score rather like a 'signal preparing one for the moment itself': it exists in the present and in the future, as well as the past.

Since perception is already a way of structuring reality, Brecht concluded that it could also be defined as an 'act'. *Three Chair Events* (figure 23) for example, indicates as equally valid 'occurrences' the act of sitting on a black chair, that of perceiving or sitting on a 'yellow chair', and that of

THREE CHAIR EVENTS

● Sitting on a black chair
 Occurrence.

● Yellow chair.
 (Occurrence.)

● On (or near) a white chair.
 Occurrence.

Spring, 1961
G. Brecht

23 George Brecht, *Three Chair Events*, 1961

performing an action 'on (or near) a white chair', presumably by sitting, standing near, or placing an object on it or close by. Written in April 1961, the score for *Three Chair Events* established the format of Brecht's subsequent event scores. Bullet-points are used to indicate distinct 'occurrences' described by single nouns, or gerunds, along with additional prepositions in some cases, thus allowing readings that could include both action and perception.

Brecht's event scores range from the most prosaic, involving everyday activities such as sitting on chairs, turning lamps on and off, or opening and closing windows, to more poetic and enigmatic sequences – like *Three Gap Events*, which states:

- missing-letter sign
- between two sounds
- meeting again

Recalling the tripartite structure of many haikus, *Three Gap Events* lets the reader connect the dots between the occurrences and decide how, when and where to perform the score. For Brecht, as for Kaprow, the desire to avoid 'grasping' reality, to let the events 'simply occur', was inspired by nature, which offers us 'things exactly themselves'. In one of his texts Brecht cites

the Chinese *Book of Changes*, or *I-Ching*, which notes that 'nature creates all beings without erring … Therefore it attains what is right for all, without artifice or special intentions.'[34] The use of chance methods, he had written in 1957, served to liken the artist's processes to those of nature, and thus 'to get away from the idea that an artist makes something "special" and beyond the world of ordinary things'.[35] Just as Kaprow spoke of the natural cycles of growth, decay and growth that his changeable works imitated, Brecht explained to the Museum of Modern Art that it 'is within the spirit of' a work such as *The Case* or *The Cabinet* 'that (as in life in general) parts may be lost, broken, spilled, stolen, replaced, contributed, soiled, cleaned, constructed, destroyed…' Thus, if and when this happened, they should simply be replaced 'without fuss' – like nature, the works requires no 'special intentions'.[36]

I would like to argue that Brecht was exploring the field designated by the Zen principle of *wu-shih*, which can be translated as 'no fuss', 'nothing special' or 'without artifice' – casual, natural and 'self-evident'. Recalling in a 1960 interview his participation in the performance of Brecht's above-mentioned 1959 *Time-Table Music* at Grand Central Station, Kaprow reflected on the difficulty of achieving such a non-artificial character. In this version of the event, the participants (mostly fellow students from Cage's class) had decided to use the timetabled score not to produce noises, as the score suggested, but to perform chosen activities such as asking directions at the ticket booth, buying a Coke, or addressing random passersby. The performance suffered from 'goofballism', according to Kaprow, because it interrupted the everydayness of the railway station with an artificially staged action.[37] For Kaprow, the artificiality of the timetable cues lent an overly 'cute' and 'self-conscious' feel to the whole event – precisely the opposite, one might say, of *wu-shih*.

Brecht may have agreed with Kaprow's conclusions concerning *Time-Table Music*, since he moved away from such chance scores in 1961. For example, when he realised the score for *Three Chair Events*, under the title *Iced Dice*, for the exhibition *Environments, Situations, Spaces (Six Artists)* at the Martha Jackson Gallery in March–June 1961, Brecht placed three (white, black and yellow) chairs in different locations in the exhibition; the white chair, for example, stood just outside the gallery entrance (figure 24). Although the score for *Three Chair Events* was handed out to visitors, many of them failed to perceive the chairs as artworks. To use H.G. Barney's and Alan Watts's above-mentioned terms, gallerygoers could not give them 'a discrete reality', did not succeed in constructing them as 'units of thought'. Some visitors casually sat on them, thus unknowingly performing the score. The first line of Brecht's statement for the exhibition catalogue reads: 'Nothing special.'[38]

A year later, Fluxus chairman George Maciunas would write to Brecht that some of his event scores had passed unnoticed when they were performed

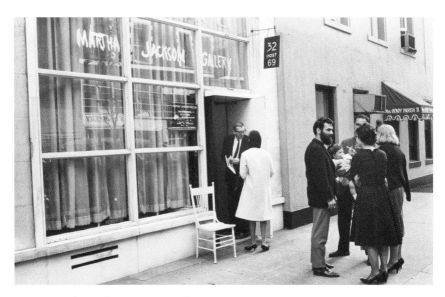

24 George Brecht, *Iced Dice*, 1961. Installation view at *Environments, Situations, Spaces (Six Artists)*, Martha Jackson Gallery, New York, 1961

during the first Fluxus concerts in Germany in 1962, because the audience could not identify them as art. For example, very few spectators believed that the realisation of the score for the 1962 *Piano Piece* was 'meant to be a piece'.[39] The score reads:

- a vase of flowers
 on(to) a piano

Once the title of *Piano Piece* had been announced, reported Maciunas, the audience in the concert hall waited 'for a "piece" to follow', instead of observing the vase of flowers on the piano as an event in itself. Maciunas, who was developing at the time a theory of concrete art opposed to the artificial, admired Brecht's scores: 'The more lost or unnoticable [*sic*]', he noted approvingly, 'the more truly non artificial' they were – and thus the more truly 'concrete'. In this way, argued Maciunas, Brecht's scores, like Zen, do not 'impose' on reality forms created by the human mind. In Maciunas's eyes, Brecht's event scores could serve as a model for Fluxus practices as a whole.

As Kaprow would recall in a retrospective reflection on John Cage, 'the sheer magnitude of unforeseeable details and outcomes for any projected event in the real world was so much greater than what a chance score might provide that devising a method to suspend taste or choice became superfluous'.[40] In the late 1950s, both Brecht and Kaprow moved away from chance methods such as those used in *Time-Table Music* to embrace 'the sheer

magnitude of unforeseeable details and outcomes' of an event, and both turned to participation as a way of focusing the spectator's attention on these everyday details. The means by which each artist sought to inflect the viewer's attention during this period were, however, very different. While Brecht focused on the precise moment of attention, the moment at which one encounters an event, Kaprow was more concerned with providing, in his environments, impressions of a sprawling and changing continuum, and, in his happenings, a snapshot of multiple kinds, and different levels, of experience. Only such differences can explain why Kaprow did not hesitate to stage one of his own happenings – *Calling* – in Grand Central Station, six years after Brecht's *Time-Table Music*. Since propping people 'tied into laundry bags' against the station's information booth was even more 'self-conscious' and artificial than buying a bottle of Coke or addressing oneself to a passerby, only Kaprow's search for intensity and contrasts within the everyday could justify introducing such a striking image within the banal setting of the railway station. As Alex Potts has demonstrated, Kaprow's early happenings are precisely characterised by this 'almost arbitrary-seeming yet oddly suggestive conjuncture of disparate items that alternate between being utterly flat and mundane in tenor and having an intensity that is often disturbing as well as blatantly melodramatic'.[41] Caught up in a narrative scenario involving dramatic situations (such as propping people 'tied into laundry bags' against the information booth, or dumping bodies wrapped in aluminium foil in public wastebaskets), participants in *Calling* would experience the tension between the happening and its mundane settings. Thus participants could walk along the 'tightrope' between art and life where, as Kaprow described it in his statement for *Environments, Situations, Spaces*, 'a certain drama' can be found.[42]

In contrast, Brecht probed the relation between art and life by creating points at which both intersect. Like the bullet-points in his scores, his events pierce through the heterogeneous, multifarious fabric of the everyday like a needle. Instead of such a vertical cut, Kaprow followed the everyday horizontally, both in spatial and temporal terms (sprawling environments and the staged duration of happenings). This horizontal movement is precisely what allowed Kaprow to juxtapose the mundane and the melodramatic, which were for him both involved within the same patterns of growth, decay and natural change. Rather than the contrasts privileged by Kaprow, Brecht emphasised above all an inherent continuum between his works and the everyday, whether in his endlessly changing, re-arrangeable arrangements, or in his event score as 'signal preparing one' for the 'concrete moment of life'. Whereas Kaprow remained faithful to the spatial collage-aesthetic of assemblage, Brecht pursued the temporal logic of the arrangement. In a 1960 note, Brecht established a hierarchy ranging from the most 'special' artistic forms to the least 'special' 'everyday' activities. Happenings such as Kaprow's, Brecht

suggested, are closer to 'special' art forms such as theatre, dance and music than event scores like *Time-Table Music* (figure 21). But these early scores nevertheless remain more removed from the everyday than works such as *The Case* (figure 22) or *The Cabinet*. Brecht's event score, as it would be fully developed one year later in works such as *Three Chair Events* (figure 23) or *Three Gap Events*, would no doubt come even closer than *The Case* or *The Cabinet* to the 'non-special' everyday, thus acquiring the status of borderline art.

For Brecht, the more 'special' an artwork, the more 'formal', 'structured' and 'expressive' it was; conversely, less 'special' occurrences were informal, unstructured and inexpressive. While 'special' occurrences are characterised by multiplicity, a greater simplicity can be found in less special, mundane events. Indeed, simplicity – in the sense of unaffectedness – is another meaning of *wu-shih*, nothing special. In Zen aesthetics, simplicity was pursued to the point of being able, as Hung Yin-Ming noted, to find 'the ebb and flow of life' in even 'a decayed tree or withered grass, an inaudible sound or a savorless taste'.[43] That Brecht included this quotation in his musings about borderline art establishes a crucial link between the decaying and the imperfect, the imperceptible and the 'savorless'. While the decaying and the imperfect could characterise Kaprow's work as well as junk assemblages such as Bruce Conner's, the tendency towards simplicity and savorlessness was unique to Brecht's arrangements and events in the early 1960s, as he became interested in a borderline art of 'Sounds barely heard. Sights barely distinguished.' Brecht's original pursuit of the 'nothing special' appears far removed from qualities of dramatic contrast, 'multiplicity' and 'expressive' intensity (emerging at the crossroads of action painting and the Artaudian 'theatre of cruelty'), all typical of assemblages, environments and happenings of the time.

Like *Iced Dice* (figure 24) or the *Piano Piece* discussed by Maciunas, Brecht remarked of borderline art that: 'It should be possible to miss it completely.'[44] Events extend 'the limits of form' because they include a temporal as well as a spatial dimension, which allows them to merge with the 'nothing special' of everyday experiences. Indeed, as Suzuki had explained: 'Suchness is … formlessness'.[45] Brecht's perspective on borderline art thus establishes a clear relation between the artwork's precarious existence 'at the point of imperceptibility' and the everyday in its 'suchness': it is because life itself, like nature, has no form that a 'nothing-special' artwork that seeks to grasp it will inevitably teeter on the point of 'becoming dimensionless, having no form'. In fact, Brecht would go so far as to wonder: 'Can art not be in form and still be art?'[46] In a 1962 letter to a curator regarding the group exhibition *Art 1963*, Brecht seemed to provide a partial answer to this question when he stated his desire to create an art that has 'no definite form'.[47] For example, the catalogue reproduced a photograph of a door in Brecht's house, bearing the sign 'exit', as a realisation of the 1962 *Word Event* (the score for which simply reads:

'exit'). Works by Brecht in the exhibition itself included a painted ladder, and an installation of two chairs and a table bearing a specific arrangement of everyday objects, both of which also existed in the form of event scores that could allow anyone to realise the works themselves.

The uncertain, indefinite status of the object as event, or the event as object, was further exemplified in three advertisements that Brecht placed in the *Village Voice* in 1963. In one ad, a white sink in 'excellent condition' was offered for sale to the customer making the 'best offer', while in another the white sink was sold as a 'sculpture' for $750. The third ad proposed, for a negotiable $300, a white sink accompanied by a 'certificate entitling you to all the events in which it takes part'.[48] These three occurrences are all realisations of the following score:

SINK

- on a white sink
 toothbrushes
 black soap

As a sculpture, the sink becomes art; as a useable sink it remains hardware. As an event score it exists in between: 'See which way it goes', Brecht simply advised in his remarks on borderline art.[49] Objects and events are equally considered as 'processes', with varying balances in the emphasis of 'space-time elements': objects 'have mainly spatial properties', whereas events are as temporal as they are spatial.[50] In this way, Brecht not only explored the range of properties of things 'in their suchness'. As Benjamin Buchloh remarked, his events and 'performative objects' also 'promised to transform at least the symbolic organization of object relationships' in the age of accelerated consumption.[51] Indeed, Brecht's borderline art could even go so far as to offer a glimpse into how 'to reorganise the actually existing conditions of social exchange and communication'. Such conditions, as Arendt noted, were directly threatened by the socio-economic shifts ushered in by an organised society driven by the cycles of planned obsolescence, as we saw in the first chapter.

'Towards the invisible'

'Unlike electric motors or electric lights, "movement" is not material. It means simply that the work extends in time as well as space.'[52] Guy Brett's definition of kinetic art in his 1968 *Kinetic Art: The Language of Movement* foregrounded the singularity of the Signals Gallery's vision. Though published two years after the Signals Gallery had closed, Brett's book brought together some of the ideas and practices consistently defended throughout the exhibitions and

publications of the gallery that the author had co-founded. The 1968 book contains one significant addition to the reflections that Brett had developed in *Signals*, alongside his co-founders and associated artists: a reference to the happening, which 'involves the spectator in an assemblage which extends in time as well as space and is open to all materials and media'.[53] The quotation included by Brett apropos of happenings is drawn from none other than the above-mentioned 1957–58 'Project in Multiple Dimensions' that Kaprow had co-written with Brecht and Robert Watts. In the statement quoted by Brett, Kaprow had listed new materials ('Words, sounds, human beings in motion, painted constructions, electric lights, movies and slides – and perhaps in the future, smells') and emphasised a 'continuous space *involving* the spectator or audience'.[54] As I pointed out earlier in this chapter, the use of new materials was a defining interest of Signals at its beginnings; in this passage, however, Brett highlights less this research into possible materials than the shared spatio-temporal dimensions of happenings and kinetic art, and the central role of the spectator in both types of practices. The 'dimension of time', remarks Brett in *Kinetic Art*, 'deprives the work of an isolated permanent existence'.[55] Thus the kinetic work unfolding in time and space contributed to the 'disintegration of separate objects with their different names, visible nature, and static structures' that Brett had underlined in the planned Signals exhibition *Towards the Invisible*, as we saw at the beginning of this chapter.

As it was planned, *Towards the Invisible* would survey the different ways in which contemporary artists performed such a 'disintegration' by delving into invisible phenomena and relationships. As exhibition co-curator Paul Keeler explained to a journalist, five general directions could be singled out in this exploration, each connected to a distinctly invisible phenomenon: energy, growth, vibrations, light and 'the animation and total involvement of space'.[56] The works of Takis and David Medalla were cited by Keeler as examples of the first instance: in Takis's works, energy is magnetic, while in Medalla's 'Bubble Machines' or *Cloud Canyons* (figure 26), it is gaseous. Sergio Camargo's wood reliefs embodied the movement of growth, according to Signals (figure 25), while Jesus Rafael Soto's works explored the effects of optical vibrations. Light was a key concern for Signals co-founder Marcello Salvadori as well as for Liliane Lijn. Spectator participation, crucial to the works of Lygia Clark, was initially perceived as an 'animation' of space. *Towards the Invisible I*, held at the Signals Gallery in 1965, would include examples of works by Clark, Camargo, Soto and Alejandro Otero, which were all considered to involve space. The second instalment of *Towards the Invisible* was a solo exhibition of Antonio Calderara's abstract paintings. Subtitled 'Light in Motion', the final exhibition *Towards the Invisible III*, in 1966, comprised light works by Medalla, Liliane Lijn, Gianni Colombo, Gerhard von Graevenitz, Takis and Groupe de Recherches d'Art Visuel members Julio Le Parc and François

Morellet. Although it is unlikely that they included light components, works by Lygia Clark, Mathias Goeritz and Hélio Oiticica were also on display.

The term 'dematerialisation' was often associated, in *Signals*, with what was considered as the 'disintegration' of forms. According to Keeler, Camargo's work was characterised by 'dematerialisation' as well as growth;[57] Karl Ringstrom supposed for his part that Camargo 'wants to destroy form, volume, material and design'.[58] Camargo's reliefs suggest movement and growth in their swirling compositions of proliferating wooden cylinders, all cut at a forty-five degree angle, fixed on to a plane and painted white (figure 25). The way light falls on the rounded volumes and the sharp edges of the cylinders creates an impromptu ballet of shadows. According to Brett, Camargo 'uses the form of the relief to disintegrate volume, to shatter it with light'.[59] The organic dimension of this dematerialisation is repeatedly observed in the pages of *Signals*. According to Ringstrom, for example, Camargo's 'conception of art is based on his conception of life which he finds unstable, intangible and in perpetual fluctuation'.[60]

In an interview for *Signals*, Soto also claimed to be interested in 'the *trans-*

Sergio Camargo, *Large Split Relief no. 34/4/74*, 1964–65 **25**

formation of elements, the *dematerialisation* of solid matter'.[61] According to the artist, the incorporation of 'the *process of transformation* in the work itself' occurs when 'the pure line' is transformed into 'pure vibration, the material into energy'. As the viewer moves, the lines of Soto's composition create optical effects that generate the illusion of movement. Each work by Soto, in Brett's words, 'contains a tiny drama of material dematerialized continually re-enacted'.[62] Brett concludes his essay on Soto with a quotation from Eugene Herrigel's 1948 book *Zen and the Art of Archery*, which evokes the 'intoxicating' 'vibrancy' of the 'event' that 'is communicated to him who is himself a vibration'.[63] The movement of the viewer is intrinsically linked to the movement of Soto's lines, in the same way as a Zen 'state of mind' lets itself be completely traversed by cosmic forces (precisely because it refrains from 'grasping' the world, as Brecht would put it). In order to further explore the specific relation between invisible forces and the disintegration of forms, between dematerialisation and the immaterial, at the heart of Signals, I will now turn to three examples that rank among the gallery's most experimental practices: first, the works of David Medalla and Mira Schendel, and, in the next section, the works and writings by Lygia Clark published in *Signals*.

In the first issue of *Signals* (titled *Signalz*) Medalla defined himself as 'an hylozoist' who, according to pre-socratic philosophers, thinks that 'matter' is 'alive'.[64] In this issue, Medalla disclosed future projects for 'smoke machines' or 'sand, wind and rain sculptures', as well as perspiring sculptures and paintings that respond to 'the warmth of human breath'. A few months earlier, the first Signals 'Pilot Show' had included Medalla's first 'thermal sculpture': *Cloud Canyons* (figure 26). Inspired by clouds as well as beer, these 'bubble mobiles' appear to give life to matter, as foam slowly emerges from a simple cube, fizzes and dribbles, before dissolving, floating away in the breeze, and evaporating. The microscopic plays an important role in the exploration of imperceptible phenomena in *Signals*. In the special issue on Camargo, one of his wood reliefs was juxtaposed with a photograph of skate teeth 'enlarged approximately 15 times'.[65] Similarly, in Soto's work, it is through the 'minute changes' of colour and angle that 'stillness *begins* to yield movement',[66] according to Brett, just as the microscopic modulations of Medalla's bubbles produce transformations that shape the continually changing works. Indeed, Medalla would explain that he was searching for materials 'that would be analogous to the smallest biological unit, the cell; materials that would be capable of multiplication'.[67]

It is no coincidence that one of the historical essays published in *Signals*, an extract from Laszlo Moholy-Nagy's *The New Vision*, encouraged artists to use water as a new medium. Moholy-Nagy listed in this text the great variety of forms, shapes and states that water can take, thus underlining its possibilities for infinitely transformable works. Moreover, Moholy-Nagy reminded us that

David Medalla, *Cloud Canyon*, c.1964 **26**

water had been used in the past as a 'medium of expression', 'from the calm lakes of the baroque parks to gushing fountains, or to a chain of foaming cascades'.[68] Such 'efforts', argued the artist, all involved processes of 'dematerialization'.

Fountains, as Jean-Yves Jouannais has remarked, can be read as manifestations of human idiocy as well as of human intelligence.[69] In his 2003 book on idiocy in contemporary art, Jouannais read the craze for baroque fountains as a means to exorcise the fear of the void – a void discovered in 1643 by Evangelista Torricelli as he asked himself why water jets could never rise higher than ten metres. Spluttering and dysfunctional fountains speak to us of man's failure to control nature and its invisible forces. Jouannais invokes for example the garden fountain in Jacques Tati's 1958 film, *Mon Oncle*, which embodies in turn the pretensions of its owners and the breakdown of their carefully ordered lifestyle, thus reflecting the dynamics of order and disorder that characterise the household and the film as a whole. Medalla's *Cloud Canyons*, described by Camargo as 'modern-day fountains',[70] belong, according to Jouannais, to the same family of 'idiotic' fountains as the one in *Mon Oncle* because they 'exhaust themselves in the movement of their apparition'.[71] Unlike the straight lines of the fountain's soaring water jet, which challenge gravity and demonstrate man's mastery over matter, Medalla's bubbles fizz hesitantly and dribble comically before vanishing altogether; they

disappear almost as soon as they appear. As Brett put it, the bubble machines succeed in being both 'a material "something" and an immaterial "nothing"'[72] – in other words, a virtuoso success and an idiotic failure.

Mira Schendel's practice offers another variation on this movement between something and nothing. What counted for her above all, as she explained to Brett, was 'the void'.[73] One of her drawings bears the following Italian inscription: 'nel vuoto del mundo' (in the void of the world). In her drawings on rice paper, the artist used a specific technique. First she placed her paper on a glass plate covered in ink and in a powder that slows down the paper's absorption of the ink. Then she used sharp tools, or her nails, to trace lines and letters on the page, sometimes inscribing it on both sides, in which case we can see the back of the artist's drawing. Imprinted in layers of ink and powder, and in the thickness of the rice paper, each line physically animates the fragile void of the page.

This empty space, according to Brett, is 'active', full of 'energy': it is 'a field of possibility'.[74] From this void – in which Medalla perceives 'the chaos of the universe' – will spring forms, language and the very conditions of existence.[75] This conception of an active void calls to mind the Buddhist definition of emptiness, which is very different from the nothingness of Western nihilism. In the Buddhist vision of the world, the void is full of possibilities, it is the starting point for all existence, which is why it connects human beings to nature and to each other. Here we find again the 'cosmic view of life' central to the new art, according to Brett; here again invisible forces set off vibrations, as Soto would put it.

For another series of works, Schendel used rice paper in a different way: by rolling, knotting and braiding it into limp nets and withered balls (figure 27). The works in this series extend the fragility and energy of the drawings, but question their status as artworks – they present themselves as *Droguinhas*, 'little nothings' in Portuguese. Schendel found their insignificance amusing. As she wrote to Brett, it is as difficult to 'protect' a *Droguinha* as it is to preserve a bubble from one of Medalla's machines.[76] In the *Droguinhas*, material and immaterial are intertwined and entangled to the point that one cannot tell where one starts and the other ends. As Brett noted regarding the *Towards the Invisible* exhibition project, the invisible has two qualities: 'one is physical and directly affects the body' and 'the other, completely inseparable from the first, is the spiritual force which makes you aware that you are placing yourself in harmony with the workings of nature as these forces are *revealed* to you.'[77] The combination of lightness and density contained in the *Droguinhas* suggests both qualities.

Signals kineticism, as I see it, presented an aesthetics of the almost nothing oscillating between the something and the nothing, the physical and the spiritual. Its overall lightness arose from both the absurd forms of humour and

Mira Schendel, *Droguinha*, c.1965 **27**

the intangible forces that characterise many works discussed in *Signals*. Such a complex combination stemmed partly from a marked ambivalence towards technological progress. 'Anything is possible', exclaimed Jean Tinguely in *Signals*; he could imagine how dematerialisation would 'enable people to travel by becoming sound waves'.[78] On the same page of the journal, however, a darker, more destructive vision of technological progress is suggested by a photograph of the apocalyptic 'suicide-machine' that Tinguely had exploded in the Nevada desert in 1962, as well as images of a 1963 London performance by Gustav Metzger, in which he melted nylon works as a manifestation of his 'auto-destructive art'.

The use of nuclear physics lay at the heart of an article published in *Signals* by physicist Werner Heisenberg – who was also a key reference for George Brecht's discussion of chance and indeterminacy. Acknowledging that scientists could not control the ways in which their discoveries were used, Heisenberg nevertheless believed that modern physics could indirectly impact international politics through a new vision of the world in which acknowledging uncertainty would lead to a greater respect for nature and for the spiritual, and a greater tolerance towards other cultures and ideas. In particular, Heisenberg highlighted the affinity between quantum physics and 'philosophical ideas in the tradition of the Far East'[79] (which was also

central, as we saw, to Brecht's conception of borderline art). Heisenberg's openness to other fields was certainly welcome at Signals, whose news bulletin reflected a wide breadth of interests, ranging from art and poetry to scientific discoveries and Zen philosophy as well as a dizzying array of social, political and anthropological topics including disarmament and contraception, the living conditions of Canadian Eskimos and those of the homeless in Britain. Furthermore, Heisenberg's call for tolerance of other cultures was reflected in Signals' exceptionally international network of artists coming from Europe and the United States as well as Asia and Latin America. In addition to establishing a similar link between physics and 'oriental thought', Brecht, Kaprow and Watts had drawn a parallel, analogous to that suggested by Heisenberg and Signals, between art's 'attempt to break down artificial boundaries' and other endeavours aimed at overcoming divisions, whether 'unified science', 'comparative religion and anthropology' or the United Nations itself.[80]

Although conceived seven years after the 'Project in Multiple Dimensions', Signals was born, in my eyes, from the same socio-political and intellectual context. Like borderline art and some forms of junk art, Signals kinetic art responded to the new imbalances in the human condition condemned by Arendt at the end of the 1950s. Instead of reinforcing our distance from and our control over the world of things and other fellow humans, scientific progress, according to Signals, could be used positively to point to the close interrelations between man and nature, and among human beings. To the extent that Signals also suggested more activist directions and an interest in the socio-political, the gallery and news bulletin also document a transition from a late 1950s Cold War climate to the counterculture that would develop a decade later (and which I will be discussing further in the next chapter). Paul Keeler's American father, who owned the building in which Signals was housed, effectively put an end to the gallery in 1966 when he evicted the group following the publication, in *Signals*, of a speech by Lewis Mumford criticising the American presence in Vietnam. After the gallery's closure, Medalla would go on to create the Exploding Galaxy, a countercultural collective experimenting with art, theatre, dance and demonstrations.[81]

'Art without art'

In the context of Signals, few practices had heralded this transition from Cold War kineticism to 1960s countercultural experiments as well as Lygia Clark's. Her 1965 exhibition at Signals, and the news bulletin issue dedicated to her work, presented the evolution of Clark's practice between 1957 and 1965, from geometric paintings and reliefs to her participatory hinged sculptures known as *Bichos* (*Animals* or *Beasts*) to the metal *Trepantes* (*Climbing*) and *Obras Moles* (*Soft Works*), both described as *Grubs* in Signals. The *Bichos* were open to the

viewer's manipulation thanks to their hinged metal planes that could be folded and unfolded – *Signals* indicated this by publishing images of a single *Bicho* in various 'phases'. As demonstrated by a review from the *New Scientist* reproduced in the subsequent issue of *Signals*, the geometric structures of the *Bichos* appealed to mathematicians in their clarity: a diagram of a *Bicho* shows how a simple drawing can yield a profusion of variations and combinations through the addition, multiplication and division of its surfaces enabled by the hinges.

The *Bichos*' animation of space – to use the Signals terminology – was linked to a cosmic perspective on the world akin to that of other Signals artists: this is what Clark described as a 'cosmic longing' in one of her texts.[82] The artist's writings in *Signals* also refer to an emptiness that appears at first sight as an existential and spiritual void left behind by a Nietzschean refusal of God and of transcendence. The artist sought to counter this Western vision of the void, however, by turning her attention to what she called the 'empty-full' (*vazio-pleno*)[83] – an 'active' void, like Schendel's, which Clark also related to 'oriental thought'.[84] The empty-full, according to Clark, comes to exist when human beings open themselves to the infinite possibilities of their acts. For the second time, Eugen Herrigel's *Zen and the Art of Archery* was cited in a *Signals* article: Clark includes a quotation from the book, in French, as an epigraph to one of her texts. The quoted passage from Herrigel's study refers to the 'art of swordsmanship' according to Zen master Takuan, who claimed that a good swordsman must achieve a state of 'emptiness' in which there is no thought of 'your own self, the flashing sword, and the arms that wield it'. The citation that appears in Clark's text is Takuan's conclusion: 'From this absolute emptiness comes the most wondrous unfoldment of doing.'[85] The 'empty-full' is thus the state that makes possible an 'unfoldment of doing' (or the 'blossoming of a pure act', as the literal translation from the French would read).

Indeed, 'the act' occupied a central role in the new work that Clark had created around the time that she wrote her texts: the *Caminhando* (*Going* or *Walking Along*) consists precisely in a single performative action. Published for the first time in an article by Walmir Ayala in the Brazilian newspaper *Tribuna da Imprensa*, the instructions for the *Caminhando* were first translated into English for *Signals*, and new diagrams were added to the text. The three diagrams (which can be 'cut out' by the reader) show different 'samples' with which to create a Möbius strip (figure 28). The simplest consists of a strip of paper, with the letters A-B written on one extremity, and B-A written at the other. The reader can 'twist the strip and glue the ends together', in such a way that AA and BB coincide. Once this Möbius strip is created, the viewer is invited to 'Start cutting always in the same direction, until the strip becomes so narrow that it is impossible to continue.'[86] A final note calls our attention to the work's purpose: 'bear in mind that the expression is your own, and it consists entirely in cutting, that is *the act*'. Like Herrigel's 'unfoldment of doing' enclosed in an

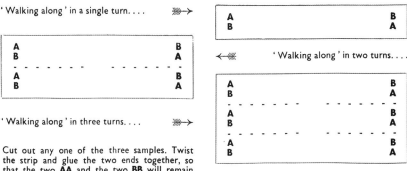

LYGIA CLARK

'WALKING ALONG' **— DO IT YOURSELF**

'Walking along' in a single turn. . . . »»→

A	B
B	A
- - - - - - - - - - - - -	
A	B
B	A

'Walking along' in three turns. . . . »»→

Cut out any one of the three samples. Twist the strip and glue the two ends together, so that the two **AA** and the two **BB** will remain side by side. **(Moebius loop.)** Start cutting *from inside* at any place you choose, and go on cutting always in the same direction until the strip becomes so narrow that it is impossible

| A | B |
| B | A |

←« 'Walking along' in two turns. . . .

A	B
B	A
- - - - - - - - - - - -	
A	B
B	A
- - - - - - - - - - - -	
A	B
B	A

to continue.
Attention: bear in mind that the expression is your own, and it consists entirely in cutting, that is **the act.**

28 Lygia Clark, 'Walking Along: Do-it-yourself', *Signals*, 1:7 (1965), 7

'empty-full', like the Zen state of mind vibrating with cosmic forces (in Soto's works), the *Caminhando* contained for Clark an range of potential 'possibilities', which could emerge from a new incorporation, within human beings, of previously externalised spiritual forces.[87] While the *Bichos* had introduced the temporal dimension in the interaction they required, there still remained, according to Clark, a dualism in the separation between the spectator and the hinged sculptures. With the *Caminhando*, in contrast, this separation 'between subject and object' disappeared into 'a unique, total, existential reality'.[88] Because it is the act that characterises the *Caminhando* above all, it is purely 'immanent'.[89] The work takes the form of a 'becoming' (*vir-a-ser*).[90]

Although central to the writings published in *Signals*, the *Caminhando* does not appear to have been included in Clark's retrospective at the Signals Gallery, and its status as an artwork remained uncertain during the artist's lifetime. Before it was exhibited for the first time in 1966, it existed only in the form of instructions, and the few published photographs were, in fact, misleading. In *Signals*, for example, the *Caminhando* is shown as a paper Möbius strip hanging limply from a nail after having been cut out, much like Clark's rubber sculptures of the time, the *Obras Moles*. The series of photographs of a woman (presumably the artist) performing the instructions, through which it is disseminated today, were not taken until 1980, when Beto Felicio shot them for the first monograph on Lygia Clark (figure 29).

At the crossroads of sculpture, instruction, performance and participa-

Lygia Clark, *Caminhando (Walking)*, 1963 **29**

tion, the *Caminhando* thus occupied a truly precarious, indeterminate space. It was precisely in this very precariousness that its importance for the artist lay at the time. This precariousness was inextricably linked its total reliance on spectator participation: it 'only exists' when the participant experiences it.[91] It is in this sense that the *Caminhando* is even more precarious than Medalla's 'bubble machines' or Schendel's *Droguinhas*, which remain objects even as they teeter on the verge of insignificance and disappearance. It was at the moment when Clark gave over the existence of the work to the spectator that she proposed that we 'learn how to live on the basis of precariousness'.[92]

The term 'precariousness' or 'precarious' (*precário*) itself appeared in Clark's writings before the *Caminhando*. As early as 1960, in unpublished notes, she had explained how her *Bichos* had revealed 'the precariousness of the concept of a fixed plane and of sculpture with a base (a reverse)' because with them she had 'destroyed the fixed plane that has a reverse side and reconstructed it, freestanding in space, and without support or reverse side'.[93] Participants playing with the *Bicho* by folding and unfolding its hinged planes would in turn learn to detach themselves from 'everything that is fixed and dead'. Clark's growing awareness of the fixed plane's 'precariousness' was also strengthened by her interest in topology, a non-quantitative geometry that studies spatial properties according to the way in which we move along a surface, rather than in terms of shape or size. 'Time and Space are one and the same: the two are distinct only when volume is considered as a simple geometric space and not a surface-in-process (*superfície-processo*).'[94]

If this 1958 note coincided with the artist's early attempts to open painting

to the space around it, Clark further visualised these more complex topologi-cal spaces by including folds and twists in her work, first in her *Cocoons*, and then in her hinged *Bichos*. The last two *Bichos* that Clark made around the same time as the *Caminhando* best exemplify the 'surface-in-process' that she had in mind: *The Inside is the Outside* and *The Before is the After* are topologi-cal sculptures whose curving lines and continuous surfaces were left uninter-rupted by the hinges of the earlier *Bichos*. Similarly, the 1964 metal *Trepantes*, like the rubber *Obras Moles*, were cut directly out of the material, their limp, sinuous shapes 'climbing' and hanging from pedestals or tree trunks. (As it happens, topology is also known as 'rubber sheet geometry'.)

The Möbius strip is a key figure in topology, as it is a uniquely con-tinuous surface that literally has no reverse: it has neither front nor back, neither inside nor outside. Although Clark never mentions it in her texts, it is likely that the *Caminhando* was, in fact, directly inspired by a book on mathematics that she was reading around 1957: Edward Kasner and James Newman's 1940 *Mathematics and the Imagination*. In their discussion of the Möbius strip, Kasner and Newman invite the reader to enact the following exercise:

> Take a long rectangle (ABCD) made of paper, give it a half-twist and join the ends so that C falls on B, and D on A. This is a one-sided surface […].
>
> There is a good bit of amusement and interest in making such a strip for yourself. When you have studied the properties described, cut it in half with a pair of scissors along the line drawn down the centre. The result will be astounding![95]

Clark would certainly have found in this invitation to make and cut a Möbius strip a logical conclusion to her exploration of a paradoxical 'surface-in-process' where 'time and space are the same'. The results of this experi-ment are 'astounding' because the relation between the original figure and the spiralling loops that the cut engenders are too complex for the mind to comprehend.

In the *Caminhando*, the 'fixed and dead' plane of painting is twisted and cut open, revealing a precariousness to be lived in the instant. From the *Caminhando* onwards, Clark would seek to radically undermine the reli-ance of art on a fixed, stable, durable object. The *Sensory Objects* that would follow, from 1966 onwards, were made out of throwaway materials such as plastic bags and nets, elastic bands and stones. Unlike the 'pure act' of the *Caminhando*, the *Sensory Objects* exist as ordinary objects, triggering a range of sensory experiences for the participant who handles them. Like the *Caminhando*, however, and unlike the *Bichos*, the *Sensory Objects* can no longer exist independently from the viewer. For example, the 1966 *Air and Stone* (figure 30) takes shape only as the participant fills a plastic bag with air,

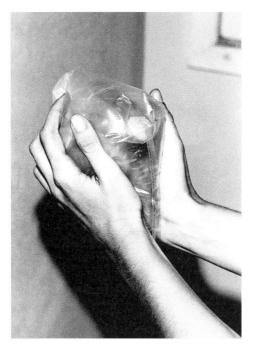

Lygia Clark, *Air and Stone*, 1966 **30**

closes it with an elastic band, places a small stone in one of its corners, and holds this improvised assemblage in his or her hands.

Crucially, this major shift in Clark's practice coincided with her new formulation of what she called an 'art without art'.[96] As it is mentioned in *Signals*, Clark's idea of an 'art without art' initially appeared as a description of the 'moment', the 'present', to be lived in itself 'as a new reality',[97] once traditional frameworks of values and spirituality had been 'introjected' instead of being projected on to either God or the picture plane.[98] When Clark returned to the expression 'art without art' (*arte sem arte*) in a related 1965 text (not included in *Signals*), she described it as a 'singular state' in which viewers can 'be themselves'.[99] This state is conceived as an alternative to 'the loss of individuality … imposed on the modern object', since the *Caminhando* offers 'the opportunity for finding oneself again'.[100]

The expression 'art without art' may have been inspired by Herrigel's discussion of Zen and the practices of archery and swordsmanship, where the author repeatedly uses the term 'artless art'. In the French translation cited by Clark this term appears alternatively as *art dépouillé d'art* ('art stripped of art') and *art sans art* ('art without art').[101] Art without art, in this context, is associated with the 'pure act' (discussed by Herrigel and Clark), which is considered to be 'purposeless'. Crucially, 'art without art' in Herrigel's account carries

two additional associations: 'egolessness' and 'effortlessness'. If the former resonates with Brett's above-mentioned observation of a radical 'shift from an egocentric to a cosmic view of life', the latter converges with the 'nothing special' that appealed, as we saw, to George Brecht and Allan Kaprow.

Like Brecht's 1961 turn to the event, Clark's move towards time, performance and process around 1963 stemmed from an initial reflection on our perception of the world, related to both scientific discourses (physics in Brecht's case, mathematics in Clark's) and Zen Buddhist philosophy as it was being popularised in the West at the time. Clark's 'disintegration' of fixed and static forms (to use a Signals category) stemmed like Brecht's from an interrogation of our 'mode of apprehension' of the world, in particular the spatio-temporal character of perception. Like Brecht, Clark was drawn to a 'no-grasping' of the world, a continuity between the perceiver and the perceived. On the one hand, Brecht's and Clark's approaches differed from the 'science of the concrete' at the heart of the junk aesthetic, to the extent that they did not dismiss scientific methods altogether: although Clark was evidently less directly involved with science than Brecht the professional physicist, both artists used elements of scientific thinking in order to undermine traditional beliefs. As Guy Brett pointed out, both science and art were equally concerned with the 'disintegration of separate objects with their different names, visible nature, and static structures'. On the other hand, however, by reaching beyond certainties, Clark wished to offer a way of 'finding oneself' in her participatory works – much like the Beat subculture and junk aesthetics we saw in Chapter 1. Similarly, Brecht would recall in 1970 that his event scores were 'like little enlightenments' which he 'wanted to communicate' by sending them to his friends around 1961.[102] In both cases, then, a shift from the object to participatory performances proffered both a challenge to the fetishised status of the commodity and a liberatory programme to live 'on the basis of the precarious', freed from the constraints of an organised society bent on profit and efficiency.

A similar evolution to Lygia Clark's can be found in Hélio Oiticica's practice, which was also presented, though less prominently, in *Signals*. Oiticica, who had participated with Clark in the Neoconcrete group in Rio de Janeiro, similarly moved away around 1964 from his participatory works in the tradition of geometric abstraction. His new works made out of ready-made objects included, firstly, the *Bolides* – transparent glass or plastic containers filled with various materials including earth, sand, shells, coloured pigment, water and fabric, which the participant could touch and handle. Secondly, his *Parangolé* capes, roughly sewn together from different painted, printed or raw fabrics, sometimes with additional objects and texts, were to be worn by the spectator (figure 31). The articles concerning Oiticica in *Signals* described both types of works in spatial terms, following the logic initiated in the *Towards the*

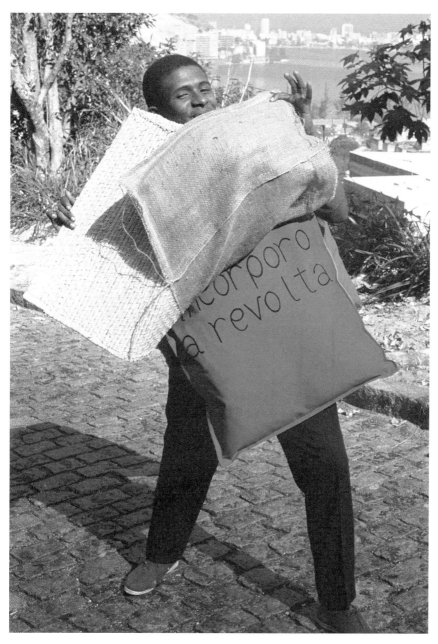

Nildo of Mangueira wearing *Parangolé P15 Cape 11 Incorporo a revolta ('I embody Revolt')*, by Hélio Oiticica, 1967 **31**

Invisible exhibition project. For example, the '*unified dimensions of time and space*' at play in the manipulation of the *Bolide*, as well as this work's ability to 'palpably' alter its surroundings through this participation, were underlined.[103] Meanwhile Medalla observed how dancing participants wearing the brightly coloured *Parangolés* 'created aerial sculptures', new 'forms in space: billowing forms, enveloping forms, and colours in motion'.[104]

In addition to these formal concerns, however, Medalla's note about the *Parangolés* also pointed to their socio-political dimension, as he recounted how Oiticica had invited his friends from the Mangueira shanty town to wear them at an exhibition opening at the Museum of Modern Art in Rio de Janeiro. The samba-dancing *favelados* 'scandalised' the bourgeoisie and were thrown out of the museum, leading Rio dealer Jean Boghici to observe: 'Hélio Oiticica is our Flash Gordon. He doesn't fly through the sidereal spaces. He flies through the layers of our social structure.' Following this quote, Medalla concluded his article by expressing his support: 'We at SIGNALS hope Oiticica's work will help in breaking down those constricting layers, divisions, boundaries of an uneven, unequal, unhealthy social structure.'[105] For Oiticica, as for Clark and Signals in general, the challenge to the status of the artwork as a fixed, static form went hand in hand with a consideration of other fixed and static orders to be undermined.

As Brett would point out in 1968, Clark and Oiticica developed a 'kineticism of the body' distinct from other forms of kinetic art in its use of human intervention rather than natural energy.[106] If both forms of energy could be read as equally 'invisible' at the time, I would like to insist that the distinction between these different forms of kinetic art represents a radical shift, from the ephemeral to the precarious, from the natural to the social. For both Clark and Oiticica, this 'kineticism of the body' opened the way to both an 'art without art' – an art than only exists at the moment in which the spectator engages with it – and a general reflection on the place of the spectator in the world of things, and in society. Trying to 'fly through sidereal spaces', it seems, eventually involved an encounter with the very concrete 'layers' of society. The political dimension of Clark's and Oiticica's precarious works will be discussed in the next chapter. In the meantime, the final section of this chapter will address the transition from the early to the late 1960s in more general terms, by focusing on the dematerialisation performed by Brecht's borderline art and by Clark's 'art without art', with additional remarks concerning Kaprow's new forms of 'lifelike' art.

The 'disappearing work of art'

Speaking at the 1961 symposium on *The Art of Assemblage*, art critic Lawrence Alloway described assemblage as a 'kind of border art' because it exists 'out on the edges' of traditional media such as painting or sculpture, thus prompting

radical questions concerning its status, such as 'Is it art? How is it art?'[107] As Alloway and exhibition curator William Seitz acknowledged in their writings on junk art, some forms of assemblage raised these issues more clearly than others: Brecht's participatory 'arrangements', as well as Conner's or Kaprow's junk practices, as we saw in the previous chapter, were singled out in particular for their ability to 'violate' art's 'limitations' (Seitz) or 'borders' (Alloway). Unaware of Brecht's theorisation of borderline art, Alloway would pursue this critical interest in 'border art' into the late 1960s, as he formulated in 1969 a definition of conceptual art as an exploration of the 'interface (cross-over point, junction) of art and other things'. In this 1969 essay on 'The Expanding and Disappearing Work of Art', Alloway defined the first meaning of 'interface' as 'a surface forming a common boundary of two bodies or two spaces' – in this case, the 'problematic boundaries of art's zone and our space'.[108] The second meaning of the term 'interface' chosen by Alloway was 'the changeover from one system of communication to another', which refers to the proliferation of different media in the 1960s, whether performance, Land Art, language, documentation or photography.

From Jack Burnham's 1968 definition of a contemporary 'systems aesthetic' which 'deals in a revolutionary fashion with the larger problem of boundary concepts', to Robert Smithson's avowed purpose, stated a year later, to 'locate' art's 'elusive limits', boundaries and borders appeared to be a central concern for artists and critics at the end of the decade.[109] Contemporary art practices challenged, in many different ways, the formalist model of the self-contained, autonomous artwork as a 'united, composed, stable' object characterised by an inherent 'compactness', as Alloway described it.[110] This compactness that had been the 'minimum requirement of esthetic identity in a work of art' was being challenged by recent practices, whose 'non-compact art forms' were often 'diffuse or nearly imperceptible'. This is why, as we saw in this book's introduction, Alloway spoke of an 'expanding and disappearing work of art' instead of the 'dematerialization' of the art object described by John Chandler and Lucy Lippard a year earlier.

My interest in Alloway's lesser-known reading of dematerialisation as an 'expansion and disappearance' of the compact art object hinges on its close relations to Brecht's and Kaprow's 1960s practices, as well as to Brecht's concept of borderline art. Indeed, Kaprow had already predicted, in his 1960 text for the *New Forms, New Media* exhibition, a 'shift in general from a concern for the work of art as a thing to be possessed, i.e., a valuable object upon which highly specialised care has been lavished, to the work of art as a situation, an action, an environment or an event'.[111] Unearthing a lineage of conceptual art in practices developed earlier in the decade, I also wish to propose a vocabulary of dematerialisation originating in the 'diffuse or nearly imperceptible' works discussed in this and the preceding chapters.

While Chandler and Lippard only mentioned George Brecht's work in passing in their 1968 article, it would figure more prominently as the first entry in Lucy Lippard's 1973 landmark compendium, *Six Years: The Dematerialization of the Art Object from 1966 to 1972* which opens with one of Brecht's 1961 event scores, *Three Aqueous Events*:

- ice
- water
- steam

The second entry in Lippard's book concerns Kaprow's book *Assemblage, Environments & Happenings*, which the artist had started to write in 1959 but which was only published in 1966. As Alloway remarked in a 1967 review of the book, Kaprow's own practice had developed considerably during this lapse of time; by the end of the decade, suggests Alloway, Kaprow's works had in fact come closer to Brecht's events. In another text about Kaprow, which Alloway also included in his reflections on the 'expanding and disappearing work of art', the author cited as an example of Kaprow's new aesthetic one of the artist's *Six Ordinary Happenings* (1969), *Pose*, which involves:

Carrying chairs through the city
Sitting down here and there
Photographed
Pix left on spot
Going on.

To arrive at such a minimal score had required successive shifts in Kaprow's work. If, by 1962, the artist had left behind the gallery setting of the happenings (figure 20), he would abandon by 1965 the theatrical separation between performers and audience, so that his new 'activities', as he would call them, only involved participants (figure 6). As Kaprow organised these activities, in various venues, with volunteers whom he only met on the day of the performance, rehearsal time was radically reduced, so that scores had to become more 'simple' and the performed actions 'more "unartistic"', 'more natural and easy to do', as he explained.[112] By 1966, any traces of 'symbolic' 'archetypes' or 'ritual' meanings contained in the earlier happenings seem to have been eliminated. As the artist explained, their format tended towards 'activities scattered over diverse spaces and time units'.[113]

When Kaprow returned, for a third performance, to Grand Central Station in 1966, it was with his wife and children, who gave out 'paper flowers to people with pleasant faces' as part of *Self-Service*, an activity that took place in three cities over four months, and involved over thirty other such small, discreet interventions or brief, momentary disruptions, taking place in every-day spaces such as stations, supermarkets, parking lots, streets, roads, woods

and beaches.[114] Giving passersby paper flowers was both less artificial than the randomly programmed events performed during Brecht's 1959 *Time-Table Music*, and less spectacular than the bodies wrapped in laundry bags dumped in the station for the 1965 *Calling*. Indeed, while some of the activities in *Self-Service* may have been noticed by a few passersby (those who received the children's paper flowers, for example, or those present in a supermarket when a number of performers started to all whistle together at once), others were 'completely private' (such as eating a sandwich in a phone booth or watching traffic and counting 200 red cars). Yet others were so ordinary as to be imperceptible, as when 'couples kiss in the midst of the world, go on'.

According to the artist, a work like *Self-Service* was in fact directly influenced by scores such as Brecht's, which, as Kaprow recalled, 'prompted the idea that performance could be simply a cluster of events of varying length and in any number of places'.[115] While more minimal than previous scores by Kaprow, the instructions in *Self-Service* retain a basic narrative dimension inherent to their sentence format. After experimenting with sentences in the passive voice in 1967, Kaprow finally settled in 1968 for the gerund construction, combined in simple sequences with nouns, as in the above-cited *Pose* and the five other *Ordinary Happenings* – a format used systematically in most of the artist's subsequent work of the next decades.

Unlike the early happenings, Kaprow's activities from the mid- to late 1960s displayed, according to Alloway, a 'diffuseness' that went 'beyond any form of compactness'. This is why Alloway compared Kaprow's activities to Brecht's scores: both required a 'mode of intimacy' on the part of their participants, and were 'known only incompletely to those taking part'.[116] As Kaprow developed his activities, he started to reflect further on their 'paradoxical position of being art-life or life-art',[117] which recalls Brecht's definition of borderline art. Discussing *Self-Service*, Kaprow noted: 'The whole thing teetered on the edge of not-quite-art, not-quite-life.'[118] It is because they occupy this precarious position that 'activities' are 'risky', according to Kaprow: they risk either falling back into 'conventional art' or becoming 'so indistinguishable from daily events that participation degenerates into routine and indifference'.[119] As Brecht had noted concerning his borderline art, it is a matter of seeing 'which way it goes'.

Even as his works came closer to Brecht's borderline art, however, Kaprow's vision of the everyday remained distinct in his continued emphasis on contrasts and intensity. Returning to a topic that he had addressed in his 1960 interview with Seymour Krim (quoted in Chapter 1), Kaprow pointed out to another interviewer seven years later that his activities were not just a matter of 'digging the scene': the 'meaning cluster' in which ordinary gestures are placed lends them a significantly new dimension.[120] For example, one of the instructions in *Self-Service*, in which 'bouquets are tucked in with

products' at a supermarket, had been directly inspired by observing a little girl putting daisies between cans in a shop. In the context of *Self-Service*, however, it resonated within a constellation of consecutive, simultaneous or parallel events, such as whistling or placing 'transistor radios playing rock' on the supermarket shelves, or giving out paper flowers at Grand Central Station. Kaprow's attitude differed from Cage's (and Brecht's), in that, as the artist explained: 'I feel I've got to say "Gee, that was pretty good. Now, watch my trick," not so much to put it down but to join in the dance.'[121] While Brecht's event scores 'may be enacted but need not be (and often are not)', as Kaprow noted elsewhere,[122] *Self-Service* emphasised the communal and inter-personal efforts involved in *doing*, in participating together in the activities. The gerund's continuous present used by Kaprow in his scores appealed to his desire to 'join in' the incessant 'dance' of the world. In contrast, the nouns privileged by Brecht focus on the possibility of simply noticing it.

Opening a new field of borderline and lifelike art in the 1960s, Brecht's and Kaprow's works, however different, stand as important proto-conceptual practices. Alloway's interest in their practices, from the early 1960s onwards, evidently anticipated and contributed to his theory of art and interface, which explains the 'disappearance' of the traditionally conceived art object by means of its 'expansion', rather than as the result of successive reductive or subtractive moves proposed by Chandler and Lippard's model of dematerialisation. Alloway thus shifted the focus away from the 'art' boundaries defining the 'compact' artwork, to the interface of art and 'life' understood as the 'nothing special' (to use Brecht's terms) of nature and the everyday. According to Alloway, scatter, spread and discontinuity, diffuseness and near imperceptibility, all characterise these new practices which go 'beyond the compactness' of traditional forms.

While Alloway spoke of the 'degree of compactness' that constitutes a 'minimum requirement of esthetic identity', Lucy Lippard briefly drew attention, in a 1969 interview which I discussed in this book's introduction, to the 'degree of acceptance' of 'non-art' reality that distinguished 'acceptive' conceptual practices from their 'rejective' counterparts.[123] I would like to argue that Brecht's borderline art exists precisely at the interface between these two frameworks, and can vary according to various 'degrees' of both 'compactness' and 'acceptance'. In other words, I would suggest, the more an artwork is open to 'non-art' reality, the less compact and thus less legible it becomes as a form or art object.

Although they do not figure in either Lippard's or Alloway's accounts, Lygia Clark and Hélio Oiticica participated in a similar movement towards an 'expanding and disappearing' work of art, a similarly 'acceptive' rather than 'rejective' approach. Like other Signals artists pursuing a 'disintegra-

tion of static forms', Clark's and Oiticica's 'art without art' explored 'non-compact' forms that are less legible than traditional art forms. Like Brecht's and Kaprow's practices, such 'diffuse' works cannot be perceived without the participation of the spectator. Kaprow's description of his and Brecht's activities could be applied to Clark's *Caminhando* as well as Oiticica's *Parangolé*: 'The artist and his artist-public are expected to carry on a dialogue on a mutual plane through a medium which is insufficient alone and in some instances non existent before this dialogue but is given life by the parties involved.'[124] Or, as Clark put it more simply: 'Nothing exists before and nothing after.'[125]

Some of the characteristics of borderline art, according to Brecht, are its 'gentleness, frugality, reticence'.[126] The 'reticence' of participatory works – also noted by Alloway apropos Brecht's events[127] – lies precisely in the fact that they give themselves up to perception *only* when coaxed by the participant. Rather than encroaching on our space and overwhelming us, they lie in wait, coming to life only through a 'dialogue on a mutual plane' in Kaprow's terms.[128] Interestingly, such 'reticence' offers a useful alternative to the 'aloofness' discussed by Lippard and Chandler as a characteristic of dematerialised practices in their 1968 essay. While 'reserve' is a synonym for both terms, aloofness suggests a superiority and coldness that are foreign to reticence, which is more closely related to shyness and discretion. For Lippard and Chandler, the aloofness of dematerialised works is related to their 'self-containment' and their 'hermeticism' 'manifested as enclosure or monotonality and near invisibility, as an incommunicative blank façade or as an excessive duration'.[129] In contrast, the 'near invisibility' of borderline artworks does not derive from their 'self-containment': they seek instead to open and blend in with their surroundings, offering windows on to the world rather than 'incommunicative blank façades'.

The 'frugality' of Brecht's scores and of Kaprow's scripts from 1966 onwards lie in their economy: most can be summarised in a few words. The economy of Clark's and Oiticica's participatory works, for their part, stems from their lineage in geometric abstraction and constructivism. However sensuous, their tactile appeal remains structured by architectural forms (in Oiticica's work) and oppositions, between weight and lightness, or empty and full (in Clark's practice). Finally, the 'gentleness' of borderline practices is closely related to their reversibility, to the fact that there is 'nothing before, and nothing after' them. Thus for example, in many of Kaprow's works, products of an activity are left to disappear (erased by natural elements or dismantled by unknown strangers), or the activity involves reversing the process itself so that there is nothing left at the end. Thus they follow the throwaway logic of Kaprow's earlier environments constructed with chicken wire and crumpled newspaper (figure 14), as fragile as Mira Schendel's rice-paper *Droguinhas*. Like Medalla's

self-exhausting 'bubble machines', Kaprow's activities and environments disappear almost as soon as they appear (see figure 6).

The 'instant' celebrated by Clark was also crucial for both Kaprow and Brecht. Whether 'borderline', 'lifelike', 'quasi-art', or 'art without art', many practices in the 1960s shifted in form in order to propose new ways to 'live'. Just as Kaprow remarked, in a 1963 interview, that he wished to 'give meaning to our gestures' which had become 'mechanical',[130] Clark was wondering around that time if the *Caminhando* could allow each one of us to 'rediscover' our 'gestures' and fill them 'with new meaning'.[131] Thus, such a performative turn allowed Clark, Brecht and Kaprow to recapture the 'genuine experience of and love for the world' which was being lost, according to Arendt. For Arendt, this 'experience' was intrinsically linked 'to a genuine experience of action', both equally threatened by the rationalising organisation of capitalism.[132] It also ushered in a new expanded conception of art as a way of living, which I shall explore in the next chapter. The questions raised by early 1960s practices such as assemblage, Fluxus event scores, or the kinetic art of the Signals Gallery – 'Is it art? How is it art?' – will be shown to raise other questions: Is it life? How is it life? Following Arendt, we will also wonder: what makes life meaningful?

Notes

1 George Brecht, 'Events: Scores and other occurrences', 12/28/61, *cc V TRE No.1 FLUXUS* (January 1964), 2.
2 An earlier version for 'Events: Scores and other occurrences' (written some time between 20 April 20 and 19 May 1961) appears as 'Events (assembled notes)', in George Brecht, *Notebook VI, March 1961–June 1961*, ed. Dieter Daniels (Cologne: Walther König, 2005), pp. 75A–75C.
3 For further information about Signals, see Isobel Whitelegg, 'Signals Echoes Traces', in Guy Brett (ed.), *Hélio Oiticica in London* (London: Tate, 2007), pp. 89–92.
4 John Gardiner, 'Stop Press', *Signals*, 1:6 (February–March 1965), 11. (Italics in the original.) A complete facsimile box set edition of *Signals* was edited by David Medalla and published by the Institute of International Visual Art, London, in 1995.
5 *Ibid.*, 12.
6 Guy Brett, 'The Takis Dialogues: V. Towards the Invisible Part One', *Signals*, 1:8 (June–July 1965), 5.
7 *Ibid.*
8 George Brecht, Allan Kaprow and Robert Watts, 'Project in Multiple Dimensions' (1957–58), in Joan Marter (ed.), *Off Limits: Rutgers University and the Avant-garde, 1957–1963* (Newark, DE: Newark Museum, 1999), p. 155.
9 George Brecht, 'Statement', in *ibid.*, p. 159.
10 Brett, 'The Takis Dialogues: V', 5.

11 Brecht, 'Statement', p. 159.

12 Brett, 'The Takis Dialogues: V', 5.

13 Brecht, 'Statement', p. 159.

14 George Brecht, *Chance Imagery* (New York: Something Else Press, 1966), p. 12.

15 George Brecht, notes for the *Toward Events* press release, 1959, in *Notebook IV, September 1959–March 1960*, ed. Dieter Daniels (Cologne: Walther König, 1998), p. 29.

16 George Brecht, 'Announcement for the Exhibition *Toward Events*' (1959), reprinted in Alfred M. Fischer (ed.), *George Brecht Events: A Heterospective* (Cologne: Ludwig Museum, 2005), p. 42.

17 'Notes on Shipping and Exhibiting MEDICINE CABINET (ALTERNATIVE TITLES: MEDICINE CABINET, CABINET), 1960', in Fischer (ed.), *George Brecht*, p. 230.

18 William Seitz, 'Assemblage: Problems and Issues', *Art International*, 6 (February 1962), 30.

19 'Letter to William Seitz, June 7, 1961', in Fischer (ed.), *George Brecht*, p. 230.

20 Brecht, *Notebook VI*, p. 84.

21 Brecht, Kaprow and Watts, 'Project in Multiple Dimensions', p. 155.

22 Lawrence Alloway, 'Junk Culture', *Architectural Design*, 31 (March 1961), 122.

23 George Brecht, *Notebook II, October 1958–April 1959*, ed. Dieter Daniels (Cologne: Walther König, 1998), p. 148.

24 Brecht, *Chance Imagery*, p. 2.

25 George Brecht, 'Statement for James Goldsworthy', in *Notebook V, March–November 1960*, ed. Dieter Daniels (Cologne: Walther König, 1998), p. 151

26 George Brecht, 'Innovational Research' (Autumn 1960), unpublished manuscript. Los Angeles, Getty Research Institute, Dick Higgins Papers, Box 4.

27 *Ibid.*, pp. 9, 8.

28 *Ibid.*, p. 8.

29 Brecht, 'Events (assembled notes)', p. 75C.

30 Alan Watts, quoted in *ibid.*, p. 75A.

31 Alan Watts, *The Way of Zen* (1957) (London: Thames and Hudson, 1958), p. 185.

32 Brecht, unpublished document, 1961, quoted in Gabriele Knapstein, *George Brecht: Events – über die Event-Partituren von George Brecht aus den Jarhren 1959–63* (Berlin: Wiens Verlag, 1999), p. 177.

33 D.T. Suzuki, *Zen Buddhism: Selected Writings of D.T. Suzuki*, ed. William Barrett (New York: Doubleday, 1956), p. 129.

34 George Brecht, 'Paragraphs, quotations, lists', *Notebook VI*, p. 9.

35 Brecht, *Chance Imagery*, p. 7.

36 Brecht, 'Notes on Shipping and Exhibiting MEDICINE CABINET…', p. 230.

37 Seymour Krim, unpublished interview with Allan Kaprow, 1960, p. 22. Allan Kaprow Papers, Box 53, Folder 14.

38 George Brecht, untitled statement for *Environments, Situations, Spaces* (New York: Martha Jackson Gallery, 1961), n.p.

39 George Maciunas, Letter to George Brecht, n.d. [October–December 1962].

Los Angeles, Getty Research Institute, Jean Brown Papers, 'George Maciunas archive', Box 30, Folder 31.

40 Allan Kaprow, 'Right Living' (1987), in *Essays on the Blurring on Art and Life* (Berkeley: University of California Press, 1993), p. 224.

41 Alex Potts, 'Writing the Happening: The Aesthetics of Nonart', in Eva Meyer-Hermann, Andrew Perchuk and Stephanie Rosenthal (eds), *Allan Kaprow – Art as Life* (Los Angeles and London: Getty Research Institute and Thames and Hudson, 2008), p. 26.

42 Brecht, untitled statement for *Environments, Situations, Spaces*, n.p.

43 Quoted by Brecht, unpublished document, 1961, quoted by Knapstein, *George Brecht*, p. 182.

44 Brecht, 'Events: Scores and other occurrences', p. 2.

45 Suzuki, *Zen Buddhism*, p. 190.

46 Brecht, 'Events (assembled notes)', pp. 74/75A.

47 George Brecht, 'Letter to Audrey Sabol, 18 July 1962', in *Notebook VII*, p. 227.

48 George Brecht, *Notebook X*, quoted by Julia Robinson, 'In the Event of George Brecht', in Fischer (ed.), *George Brecht*, p. 64.

49 Brecht, 'Events (assembled notes)', p. 75A.

50 George Brecht, draft for an article entitled 'Objects/Events/Situations', *Notebook V*, p. 239.

51 Benjamin Buchloh, 'Robert Watts: Animate Objects – Inanimate Subjects', in Benjamin Buchloh and Judith Rodenbeck (eds), *Experiments in the Everyday: Allan Kaprow and Robert Watts – Events, Objects, Documents* (New York: Miriam and Ira D. Wallach Art Gallery, Columbia University, 1999), p. 14.

52 Guy Brett, *Kinetic Art: The Language of Movement* (London: Studio Vista, 1968), p. 9. Brett revisited some of the practices and issues discussed in this study in an exhibition that he curated. Guy Brett (ed.), *Force Fields: Phases of the Kinetic* (Barcelona and London: MACBA and South Bank Centre, 2000).

53 Brett, *Kinetic Art*, p. 59.

54 Allan Kaprow, statement in 'Project in Multiple Dimensions', p. 157. Quoted in *ibid.*, p. 59.

55 Brett, *Kinetic Art*, p. 25.

56 Gardiner, 'Stop Press', 12.

57 See Denys Chevalier, 'Camargo's Art of Lyrical Light' (1964), *Signals*, 1:5 (December 1964–January 1965), special issue on Sergio Camargo, 11.

58 Karl K. Ringstrom, 'Camargo's Wood Reliefs', *ibid.*, 12.

59 Brett, *Kinetic Art*, p. 49.

60 Ringstrom, 'Camargo's Wood Reliefs', 12.

61 'Dialogue: J-R Soto and Guy Brett', *Signals*, 1:10 (November–December 1965), special issue of Jesus Rafael Soto, 13.

62 Guy Brett, 'Pure Relations', *ibid.*, 20.

63 Quoted by Brett, *ibid.*

64 'Medalla: New Projects', *Signals*, 1:1 (August 1964), 4.

65 *Signals*, 1:5 (December 1964–January 1965), 4.

66 Guy Brett, 'Pure Relations', 20.

67 David Medalla, 'Biokinetics: A Memoir on Motion' (1967), quoted in Guy Brett, *Exploding Galaxies: The Art of David Medalla* (London: Kala Press, 1995), p. 53.

68 Lazlo Moholy-Nagy, 'On Dematerialization', *Signals*, 1:8 (June–July 1965), 13.

69 Jean-Yves Jouannais, *L'Idiotie: art vie, politique-méthode* (Paris: Beaux Arts Magazine éditions, 2003), ch. 7.

70 Camargo, cited by Brett, *Exploding Galaxies*, p. 64.

71 *s'épuisent dans le mouvement de leur apparition.* Jouannais, *L'Idiotie*, p. 190.

72 Brett, *Exploding Galaxies*, p. 53.

73 Schendel, quoted by Brett, *Kinetic Art*, p. 47.

74 *Ibid.*

75 David Medalla, 'Mira Schendel', *Signals*, 1:9 (August–September 1965), 13.

76 Schendel, quoted by Brett, *Kinetic Art*, p. 47.

77 Brett, 'The Takis Dialogues: V', 5.

78 Jean Tinguely, 'Some Statements' (1962), *Signals*, 1:2 (September 1964), 14.

79 Werner Heisenberg, 'The Role of Modern Physics in the Present Development of Human Thinking', *Signals*, 1:9 (August–September 1965), 8.

80 Brecht, Kaprow and Watts, 'Project in Multiple Dimensions' (1957–58), p. 156.

81 For more information about Medalla, and a comparison of his works with those of Clark and Oiticica, see Guy Brett, 'Three Pioneers', in Anna Dezeuze (ed.), *The 'Do-it-Yourself' Artwork: Participation from Fluxus to New Media* (Manchester: Manchester University Press, 2010), pp. 25–46.

82 Lygia Clark, 'V. 1964', *Signals*, 1:7 (April–May 1965), special issue on Lygia Clark, 3. Because the English translations in *Signals* are quite poor, I have checked them against the original Portuguese wherever possible.

83 The expression *vazio-pleno* is translated as 'substantial void' in Lygia Clark, 'II. "Going" 1964', *ibid.*, 2.

84 Clark, 'V. 1964', 3.

85 *D'un tel vide absolu naît le plus merveilleux épanouissement de l'acte pur.* Lygia Clark, 'III. 1964', *ibid.*, 2.

86 Lygia Clark, '"Walking along": do it yourself', *ibid.*, 7.

87 See Lygia Clark, 'IV. 1964: Poetics in art, religion, and time and space', *ibid.*, 2–3.

88 Clark, 'II. "Going" 1964', 2.

89 *Ibid.* The term 'immanent' is misspelled as 'imminent'.

90 Clark, 'III. 1964', 2.

91 Clark, 'II. "Going" 1964', 2.

92 *Vamos aprender a viver na base do precário.* This expression is translated in *Signals* as 'We will learn to live in the relative'. Clark, 'IV. 1964', 3. For a more substantial discussion of the *Caminhando* and the precarious, see my 'How to Live Precariously: Lygia Clark's *Caminhando* and Tropicalism in 1960s Brazil', *Women & Performance: a journal of feminist theory*, 23:2 (2013), special issue on 'Precarious Situations: Race, Gender, Globality', edited by Tavia Nyong'o, 226–47.

93 Lygia Clark, 'Do Ritual' (1960), in Guy Brett et al., *Lygia Clark* (Marseilles: Musée d'Art Contemporain, 1997), p. 123. I have translated the original Portuguese texts included in the Portuguese/French edition of this catalogue.

94 *Livro-Obra* (Rio de Janeiro: Lygia Clark, 1983), n.p.

95 Edward Kasner and James Newman, *Mathematics and the Imagination* (London: G. Bell and Sons, 1949), pp. 284–6.

96 Clark, 'V. 1964', 3.

97 *Ibid.*

98 See Clark, 'IV. 1964', 2–3.

99 Lygia Clark, 'Da magia do objeto' (1965), in Brett et al., *Lygia Clark*, p. 154.

100 *Se a perta da individualidade é de certa maneira imposta ao homem moderno, o artista lhe oferce uma revanche e a ocasão de encontrar-se. Ibid.*

101 Eugen Herrigel, *Zen in the Art of Archery: Training the Mind and Body to Become One* (1953), trans. R.F.C. Hull (London: Penguin, 2004), pp. 18, 30, 106.

102 George Brecht, 'The Origin of Events' (August 1970), in Hans Sohm (ed.), *Happenings and fluxus* (Cologne: Kölner Kunstverein, 1970), n.p.

103 Anon., '*Metamorphosis*, 1965: Glass "bolide"', *Signals*, 1:8 (June–July 1965), 11. Italics in original.

104 David Medalla, 'Space Suit by Fischer, Parangolé by Oiticica', *Signals*, 1:9 (August–September–October 1965), 14.

105 *Ibid.*

106 Brett, *Kinetic Art*, p. 65.

107 Lawrence Alloway, 'On Popular Culture', presentation at 'The Art of Assemblage' symposium, Museum of Modern Art, 19 October 1961. In Alloway et al., 'The Art of Assemblage: a Symposium', ed. Joseph Ruzicka, in John Elderfield (ed.), *Essays on Assemblage* (New York: Harry N. Abrams, 1992), p. 140.

108 Lawrence Alloway, 'Art and Interface' [introduction to the book section of this title], in *Topics in American Art* (New York: Norton, 1975), p. 193.

109 Jack Burnham, 'Systems Esthetics', *Artforum*, 7:1 (1968), 32; Robert Smithson, 'Interview with Patricia Norvell, June 20, 1969', cited in Lucy Lippard, *Six Years: The Dematerialization of the Art Object from 1966 to 1972* (1973) (Berkeley: University of California Press, new edn, 1997), p. 90.

110 Lawrence Alloway, 'The Expanding and Disappearing Work of Art' (1969), in *Topics in American Art*, p. 207.

111 Allan Kaprow, 'Some Observations on Contemporary Art', in *New Forms – New Media* (New York: Martha Jackson Gallery, 1960), n.p.

112 Allan Kaprow, 'Statement', in Michael Kirby (ed.), *Happenings: An Illustrated Anthology* (New York: E.P. Dutton, 1965), p. 49.

113 *Ibid.*

114 See Score and 'Final Scheme' for *Self-Service*, in *Allan Kaprow – Art as Life*, pp. 182–4.

115 Allan Kaprow, 'Participation Performance' (1977), in *Essays on the Blurring of Art and Life*, p. 186.

116 Alloway, 'The Expanding and Disappearing Work of Art', p. 207.

117 Allan Kaprow, 'Pinpointing Happenings' (1967), in *Essays on the Blurring of Art and Life*, p. 87.

118 Richard Schechner, 'Extensions in Time and Space: an Interview with Allan Kaprow', *The Drama Review*, 12:3 (1968), 153.

119 Kaprow, 'Pinpointing Happenings', pp. 87–8.

120 Richard Kostelanetz, [Conversation with Allan Kaprow], in *The Theater of Mixed Means: An Introduction to Happenings, Kinetic Environments, and Other Mixed-Media Performances* (New York: Dial Press, 1968), p. 120.

121 *Ibid.*, p. 121.

122 Kaprow, 'Pinpointing Happenings', p. 85.

123 Lippard, 'Preface', *Six Years*, p. 7.

124 Allan Kaprow, *Assemblage, Environments & Happenings* (New York: Harry N. Abrams, 1966), p. 172.

125 Lygia Clark, 'Caminhando' (1964), in Brett et al., *Lygia Clark*, p. 151.

126 Brecht, 'Events (assembled notes)', p. 74B-C.

127 Lawrence Alloway, 'Allan Kaprow: Two Views' (1967/1969), in *Topics in American Art*, p. 96.

128 Kaprow, *Assemblage, Environments & Happenings*, p. 172.

129 John Chandler and Lucy Lippard, 'The Dematerialization of Art', *Art International*, 12:2 (1968), reprinted in Lippard, *Changing: Essays in Art Criticism* (New York: Dutton, 1971), pp. 257, 271.

130 *nous avons perdu le sens du réel de nos gestes. Ils sont devenus quelque chose de machinal … Je veux donner un sens à tous nos gestes.* Jean-Jacques Lévêque, 'Allan Kaprow: On peut faire de sa vie un happening', unidentified newspaper clipping (1963). Allan Kaprow Papers, Box 38 Folder 11.

131 *redescobrir […] seu próprio gesto revestido de uma nova significação.* Clark, 'Da magia do objeto', p. 153.

132 Hannah Arendt, *The Human Condition* (1958) (Chicago: University of Chicago Press, 2nd edn, 1998), p. 324.

3 'Good-for-nothing'

Sixteen years after Hans Namuth's famous photographs of Jackson Pollock at work were published in the *Art News* series showcasing artists in their studios, Bruce Conner decided to demonstrate, in an *Artforum* article, how to make a sandwich, with bread, bacon, cheese, lettuce, a banana, Miracle Whip mayonnaise and peanut butter (figure 32). In his 1951 *Art News* feature on Pollock, Robert Goodnough had highlighted the pastoral context of the painter's Long Island studio, and described it as 'another world, a place where the intensity of the artist's mind and feelings are given full-play'.[1] In contrast, the 1967 text in *Artforum* consists entirely of deadpan descriptions, starting with the following: 'The artist's kitchen is on the third floor of a Brookline, Massachusetts apartment house. The room has a north window and a west window, a north door to the porch and an east door to the hallway and a south door to a small pantry passageway.'[2] Where Goodnough explained how Pollock developed his painting over weeks, and even months of work, as the artist alternated feverish painting, slow deliberation and hours of contemplation, Conner observed during twenty minutes each ingredient in turn, assembled his sandwich with deliberation in twelve minutes, and contemplated the end result for five minutes. Whether he ate it or not is not mentioned.

Are we invited, in this feature, to look at Conner's sandwich in the light of his general collage aesthetic, developed both in his assemblages (which I discussed in Chapter 1) and in his films started in the mid-1960s? The timings, in hour and minutes, used to list each step in the sandwich-making process seem to frame each stage as a potential film sequence. Indeed, critic Thomas Garver's 1965 description of Conner's films as collages in which the 'theme is developed tangentially by dense thickets of images which build the events and associations by accretion, overlaying one another' evokes a sandwich-making process.[3] More recently, Kevin Hatch has compared the 'repellent and inedible' sandwich made by Conner in the *Artforum* article to the 'maniacally built up' abject textures of his early 1960s assemblages, going as far as to describe both as equally 'menacing'.[4] Although the parodic nature of 'Bruce Conner Makes a Sandwich' pursues the critique of the institutional, East Coast establishment

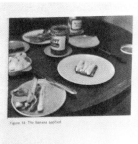
Figure 14: The banana applied.

Figure 15: Miracle Whip placed on the underside of bread slice

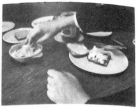
Figure 16: Lettuce picked up

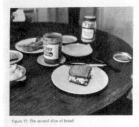
Figure 17: The second slice of bread.

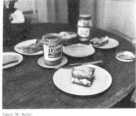
Figure 18: Butter.

11:46:10 — The banana applied. (Fig. 14)
11:46:38 — Miracle Whip placed on the under-side of bread slice. (Fig. 15)
11:47:27 — Lettuce picked up. (Fig. 16)
11:47:50 — The second slice of bread. (Fig. 17)
11:50:15 — Butter. (Fig. 18)
11:50:32 — Peanut butter.
11:51:00 — The cheese folded once.
11:51:35 — Swiss cheese. (Fig. 19)
11:52:01 — Picking up the bacon. (Fig. 20)
11:52:25 — The bacon. (Fig. 21)
11:53:45 — The sandwich completed in twelve minutes exactly.
11:57:40 — The sandwich.
11:58:40 — The sandwich. (Fig. 22) ∎

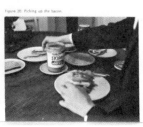
Figure 20: Picking up the bacon.

Figure 21: The bacon.

Figure 19: Swiss cheese.

that the artist had initiated with his assemblages, the artist had abandoned this technique by 1967. Conner stopped making assemblages because, he explained, he 'didn't want to glue anything down any more'.[5] This led him to develop, alongside his films and among other forms, an interest in performance – already suggested by some of his assemblages, as we saw in Chapter 1. As he moved away from assemblages in 1964, Conner performed a number of one-off, stunt-like actions such as planning a 'Bruce Conner Convention' that would bring together all the Bruce Conners of America in 1964, painting the word 'love' on a baby elephant in 1967, or running for city supervisor in San Francisco that same year, during which he read out a policy speech consisting of a list of desserts.

Rather than a specific turning point in the artist's heterogeneous experimental work, however, I would like to consider the article 'Bruce Conner

Makes a Sandwich' as a marker for a broader shift in 1960s art towards every-day life as a central concern for a range of artistic practices. Unlike Pollock's *Autumn Rhythm*, illustrated in 'Pollock paints a picture', Conner's sandwich, which similarly occupies the last page of the *Artforum* article, does not exist as an artwork in itself. Indeed, the only apparent justification for including the sandwich-making demonstration in an art magazine in the first place was the description of Conner as an artist at the text's beginning. Is the sandwich art simply because it is made by an artist? Where does one locate the 'artistic': in Conner's chosen method of assembly, the 'repellent' conjunction of ingredi-ents, or the artist's deadpan text-and-photograph layout?

'Funk art, so prevalent in the San Francisco-Bay Area, is largely a matter of attitude.'[6] Thus did curator Peter Selz attempt to define, in a 1967 exhibi-tion at the University of California Art Museum in Berkeley, a tendency in Californian art which he called 'funk art', and whose pioneer was none other than Conner. 'Attitude' could perhaps be what unites Conner's sandwich-making with his earlier assemblages or his contemporary experimental films. Attitude was certainly seen by Peter Selz as the connection between Conner's work and that of younger artists such as William Wiley or William Geis. A word borrowed from jazz, 'funk' would be repeatedly used to characterise a West Coast 'attitude' to art-making: it was unsophisticated, 'unknowing' and improvised. In a contemporary article about the San Francisco art scene for *Art News* (published in the summer of 1967), Joseph Raffaele would similarly attempt to define the attitude of four artists, including Wiley, Geis, as well as William Allan and their recently graduated student, Bruce Nauman. 'Trying to live in the moment,' noted Raffaele, 'these artists are involved with the flow of making, as much as the conclusion.'[7]

Similarly elusive was a new 'spirit' of art, which George Brecht and fellow artist Robert Filliou were exploring in their project *La Cédille qui sourit* (*The Cedilla that Smiles*), in the southern French town of Villefranche-sur-Mer, between 1966 and 1968. Having initiated his research into what he termed 'bor-derline' art, Brecht decided to collaborate with French artist and friend Robert Filliou on a project that would push his enquiry into the limit between art and everyday life even further, in a joint work that would become, for both artists during this period, a way of life in itself. The *Cédille qui sourit* was conceived as a centre for 'permanent creation' that used the conceit of a gallery/shop (selling artworks, books and multiples) as a space in which the artists could experiment with new forms of borderline art – whether games, jokes, films, or the 'non-school of Villefranche', which involved conversing with the town's residents 'on the beaches, in cafés, at home, in the street'.[8] As Filliou would explain: 'it is the spirit in which things are done which interests us. If the spirit is right, so will be results, we feel (if any, of course, it is not necessary that there should be any).'[9] Brecht and Filliou were associated with the loose grouping of artists

known as Fluxus, and this 'spirit' could also be found in the work of other Fluxus artists, who were similarly using, at the time, Brecht's event score as a starting point to explore new ways of engaging with the everyday.

Starting with these two constellations of artists – the 'funk' artists on the American West Coast, and members of the international grouping of artists known as Fluxus, including Brecht and Filliou on the Côte d'Azur as well as Alison Knowles in New York – this chapter will reflect on a general shift, in the mid-1960s, towards a new type of intangible practice defined as an attitude or 'spirit': in other words, ways of living and being. My reflection will also extend to other contemporary practices – such as Allan Kaprow's and Tom Marioni's, in the United States, as well as works by Hélio Oiticica and Lygia Clark in Brazil. Here I will map out a tendency that focused on activities and processes as much as objects and results. Attitude, spirit, ways of doing, style: the new terms that emerge at this interface are certainly difficult to define – like Bruce Conner, the artists discussed in this chapter refused 'to glue anything down'. Rather than a specific artistic programme, such terms as 'attitude' or 'spirit' designate a certain *je-ne-sais-quoi*, at the crossroads of an art of living and an art of noticing, of the specific and general. Such borderline practices require us to pay attention to the artists' lifestyles and statements as well as their works, and to discover new interfaces between objects, actions and documentation. The narrative proposed here focuses on one type of dematerialisation of the art object that lies at these interfaces: what Alloway described as an 'expansion and disappearance' of the art object into 'other things' – in this case, into the everyday.

In the precarious figure of the 'good-for-nothing' – understood as an incompetent worker as well as a useless layabout – coalesce recurrent concerns that accompany these new forms of precarious practices: a desire to resist contemporary capitalist values of efficiency, productivity and success, an affirmation of the modern artist's traditionally marginal status in society, an exploration of the political valence of leisure and laziness. Such practices and concerns, I wish to argue, emerged organically from the junk aesthetics and borderline art discussed in the two previous chapters. If the status of the artwork as a closed, fixed and stable object had been challenged by these early 1960s practices, in response to the abstracting logic of an increasingly productive capitalism, the new re-materialisations of art as performative activities later in the decade – by some of the same artists as well as a younger generation – would further address the human alienation involved in capitalist production and consumption. It is in the context of this evolution that I will return to Hannah Arendt's 1958 analysis of the 'human condition'. In particular, I will draw on her definition of the 'human condition' as a balance between labour (the activities necessary for survival, such as cooking, cleaning or childcare), work (the production of durable objects and buildings)

and action (which she connected to speech, thought and the sphere of politics). These terms will help us shed light on the shifts in the political positions of precarious practices at these two different moments in the decade.

'Wu-shih' …

As mentioned in the previous chapter, Fluxus organiser George Maciunas praised Brecht's borderline event scores because they were 'concrete', rather than abstract or artificial. In a 1962 text, Maciunas argued that such event scores opened the audience's eyes to 'life', 'nature' and 'true reality'.[10] Fluxus anti-art, according to him, was only a means to encourage each viewer to 'experience the world' around them 'in the same way' as he or she 'experiences art': once this is achieved, 'there would' in fact be 'no need' for either art or artists. One of the Fluxus manifestoes, published by Maciunas a year later, listed one of following objectives: to 'Promote living art, anti-art, promote NON ART REALITY to be fully grasped by all peoples, not only critics, dilettantes and professionals.'[11]

Brecht's event scores (figure 23), as we saw in Chapter 2, rendered the artwork's borders porous to the space and time around it, and can thus serve as a tool to rediscover everyday objects and experiences in their 'suchness', without integrating them within a set composition. In contrast to Brecht's scores, which often consist in a few words only, Maciunas's own scores frequently took the form of grids including long, inventory-like lists, sometimes printed on transparent paper. In the 1962 *Solo for Sick Man*, for example (figure 33), Maciunas listed all the possible activities associated with having a cold or the flu – coughing, taking pills, blowing one's nose, spraying one's nose or throat, etc. Each performer is invited to complete the grid with numbers indicating, firstly, the order of each action or event, and secondly, the duration of each. (A transparent sheet allowed for the possibility of letting chance decide this

33 George Maciunas, *Solo for Sick Man*, 1962

order, using the Cagean method of superimposing it on marks found on another support.)

Other Fluxus scores took the form of sentences, in the imperative mode, like orders or a recipe. 'Draw a straight line and follow it', invited La Monte Young in his *Composition 1960 #10*, while Dick Higgins instructed: 'Work with butter and eggs for a time' in his 1962 *Danger Music #15*. Such everyday events would find their place in Fluxus concerts, from 1962 onwards, alongside scores more closely inspired by the instruments and conventions of classical music and other works that called for a stage and a clear separation between audience and performers. Scores involving everyday objects and activities opened the possibility of a context other than a Fluxus concert situation: they suggest that anyone could perform them in their own space and time, without a concert framework or audience. This possibility was more clearly foregrounded in Fluxus publications, where scores were often packaged as little cards contained in plastic boxes that could be bought via mail order, thus suggesting a private domestic use. As Maciunas pursued the format of the Fluxbox, he completed some of the scores with objects (to be used as props): for example, the box for Benjamin Patterson's 1966 *Instruction no. 2* contains a small soap and a face-towel on which is printed the instruction: 'wash your face'. Maciunas also developed a new kind of Fluxbox, which literally hinged on the relation between the title, printed on the box, and its contents. Robert Watts's *Flux Time Kits*, for example, are full of devices to measure time, ranging from clock mechanisms to seeds, bullets, candles and a measuring tape. Yoshimasa Wada's 1969 *Smoke Fluxkit* offers would-be smokers an array of incense cones and sticks, orange peel and a leather shoestring.

Such toy- and game-like objects, which contain small ordinary objects and refer to everyday activities, emphasise the gag-like nature of what George Maciunas called 'Fluxus art-amusement' – 'simple, amusing, unpretentious, concerned with insignificances', this art would 'have no commodity or institutional value', thereby demonstrating that 'anything can be art and anyone can do it'.[12] It is because it playfully explored such 'essential questions of life' as time, change, death, health and happiness that Fluxus can be considered, as Jacquelynn Baas has convincingly argued, 'less an art-making activity than a philosophical activity to open minds to the many-faceted reality of life'.[13]

While the gag-like dimension of Fluxus concerts and objects was crucial to Maciunas's political objective to challenge the status of the 'serious' artwork and the role of the professional artist, I would like to focus here on more 'borderline' art forms produced by Fluxus artists in the lineage of Brecht's event scores. Such practices certainly intersected with the Fluxus activities organised by Maciunas, who published Brecht's first collection of scores, *Water Yam*, as a Fluxbox in 1963. A number of more 'borderline' Fluxus experiments with everyday life were published, however, in more traditional book-forms by the

Something Else Press, set up by Fluxus artist Dick Higgins in 1964. Thus, early scores by Fluxus artist Alison Knowles (who was married to Higgins at the time) were published as a 'Great Bear Pamphlet' by the Something Else Press in 1965, which also published the 1967 anthology recording the activities of the *Cédille qui sourit* set up by Brecht and Filliou in Villefranche-sur-Mer, under the title *Games at the Cedilla, or the Cedilla Takes Off*. From 1966, Higgins used a rubber stamp that stated that Fluxus was simply 'a way of doing things', as well as 'a way of life and death'.[14]

One of Knowles's early scores, the 1962 *Proposition*, embodies the kind of borderline event that frames art as 'a way of doing' and 'way of life': it simply reads 'Make a salad'. First performed at a concert at the Institute of Contemporary Art in London in 1962, the score was included in the Something Else Press publication *By Alison Knowles*. 'What I realised about the event score [is that] it would allow me to use my everyday experience and make it into something I could present to other people – that was a big step for all of us.'[15] This retrospective account by Knowles emphasises how Fluxus scores such as *Proposition* were inscribed within the everyday experience of the artist, who wanted to similarly encourage the viewer/reader to inscribe it into theirs. This 'big step' had been contained in Brecht's definition of the event score to the extent that he had noted that *noticing* an event or object was as important as performing it, either on stage or elsewhere. With Knowles's *Proposition*, an everyday activity is explicitly framed as a score, and the score acts a means of actually 'supporting', as the artist put it, such daily 'occurrences in life': it underlines the artistic potential of everyday activities such as making a salad. 'Whatever it is you have to touch and work with,' argues Knowles, 'you can make a kind of performance of it.'[16] Crucially, however, Knowles insists that 'it has to be stripped of the hangings and accoutrements of theater'. This is where the artist maintains the 'nothing special' (*wu-shih*) aesthetic, which shared with Brecht's borderline art a search for simplicity and lack of artifice. Indeed, Knowles spoke of Zen when insisting on the fact that the 'action' in her scores 'is direct and precise with nothing added. It is an attitude we were after of not promoting anything within the action.'[17] Where Brecht, as noted in the previous chapter, spoke of the 'gentleness, frugality, reticence' of borderline art, Knowles insisted on actions performed 'exactly, precisely and modestly'.[18] When an audience watches Knowles making a salad on stage, they 'are watching almost nothing going on,' she explains. It is in the space of this 'almost nothing' that a 'kind of revelation' can occur, as an 'emptiness' opens up and a 'quality inhabits the room'.[19]

What, then, is this 'quality'? In what way can performing *Proposition* be a 'revelation'? When I make a salad, I can do it mechanically, in a rush, because I'm hungry, while thinking of the other things I need to do. Or I can listen to my knife chopping against the board as I slice ingredients; I can inhale the

pungent smell of an onion and be once more surprised by the tears it draws from me; I can lick my fingers and appreciate the (increasingly rare) pleasure of finding a truly sweet tomato. This quality is that of *wu-shih*, this 'nothing special' that gives a brief access to concrete experience in its suchness. In one Zen story, a monk comes to the Chinese Buddhist master Tai-chu Hui-hai and asks him what kind of method should be used to find 'the way' or path to enlightenment. Hui-hai answers: 'When hungry, one eats; when tired, one sleeps.' But, the monk exclaims, 'That is what other people do; is their way the same as yours?' 'No it isn't,' replies Hui-hai, because 'When they eat, they do not just eat, they conjure up all kinds of imagination; when they sleep, they do not just sleep, they are given up to varieties of idle thoughts.' This is a major difference, he explains, before concluding: 'That is why their way is not my way.'[20]

The same year that *Artforum* published 'Bruce Conner Makes A Sandwich', Knowles started to eat on a regular basis, at her local New York diner (Riss's), a far more banal and edible meal than Conner's: it consisted of a tunafish sandwich on wheat toast, with lettuce and butter, no mayo, accompanied by either a glass of buttermilk or a cup of soup. At some point, her friend, the composer Philip Corner, who often ate with her, remarked to her that she seemed always to eat exactly the same meal: this is when, she notes, 'the experience was elevated into a formal score'.[21] The *Identical Lunch* started as a journal by Knowles in 1968 of her tunafish sandwich meals at Riss's Diner. It was further developed as the artist invited friends and acquaintances to share this meal with her, or to perform the score without her. Published in 1971, the *Journal of the Identical Lunch* includes passages from Knowles's diary, as well as documentation of performances by other contributors (figure 7). Corner went on to perform a range of variations on the score, all recorded in his own *Identical Lunch* publication of 1973. As a composer, Corner set out to use the menu board at Riss's as a score to be systematically played, so to speak, by following its sequence and consuming a different meal on every visit – his diary reveals concerns with order, variables, permutations, counterpoint and structure, all involving a range of performer choices and decisions. In contrast, Knowles stuck to the basic structure of the *Identical Lunch* as an event, and her journal is much more minimal. In it she records the varying qualities of the food itself, as well as fleeting impressions, and the comments and reactions of the cook, waitresses and other customers at Riss's. The reader takes pleasure in the tiny variations of Knowles's performance, as well as the range of responses from other performers, which vary in form as well as content. Dick Higgins, for example, adopted the style of a police report, while Tom Wasmuth focused on the diner's patterns of square white marble tiles. One author mentioned his digestive problems, while Bici Hendricks remembered eating a tunafish sandwich after the birth of her daughter Tyche. John Giorno invited his Beat

friends to join him for lunch with Knowles; some of them were on acid, and none of them seems to have enjoyed their tunafish sandwiches.

In an exchange published in the *Journal of the Identical Lunch*, Higgins compares Knowles's work to a 1966 documentary, entitled *The Endless Summer*, about surfers touring the world 'in search of the perfect wave'.[22] Knowles objects to this comparison, emphasising that the *Identical Lunch* 'has nothing to do with the pursuit of perfection'. Indeed, I would suggest that this may have been the reason why Giorno's group of friends could not enter into the spirit of the *Identical Lunch*: like the surfers, they were in search of intensity, rather than the 'nothing special' of Knowles's aesthetics. Unlike Conner's excessive sandwich, the tunafish-sandwich lunch was chosen by Knowles because it was 'the simplest and most accessible known in these parts', as she explains in her note to Higgins. Rather than the *Endless Summer*, a more appropriate parallel for the *Identical Lunch* could be found, according to Knowles, in a work by composer Steve Reich 'that dealt with all middles no extremes and varieties arising therefrom'. All middles, no extremes: the *Identical Lunch* is not endless so much as continuous with the participants' ordinary experiences.

In this exchange, Knowles admits that the *Identical Lunch* could also be compared to Raymond Queneau's 1947 *Exercices de style*, although she remarks that she is less 'interested' in language than 'in what people do with the problem'. In *Exercices de style*, Queneau recounted the same everyday, insignificant incident (an argument between two men in a bus) in 99 different styles of writing, thus playing with the variations of tone and perspective that each confers to the same story. *Identical Lunch* displays such variations, but the individual experiences themselves vary as much as their style of presentation, as they are inscribed in the performer's everyday life, and in a social network of daily interactions with the diner's staff and customers, and among friends who shared the meal, in person or through their contribution to this collective experiment. As Kristine Stiles appositely put it: '*Identical Lunch* negotiates sameness, unity, and homogeneity, all aspects of the individual identity unmitigated by the social, simultaneously with the foil of opposition, counterpoint and heterogeneity characteristic of the communal.'[23]

For her part, Hannah Higgins (a Fluxus historian who happens to be the daughter of Dick Higgins and Alison Knowles) has linked Fluxus performances such as *Identical Lunch* to John Dewey's 1934 definition of art as an experience.[24] A specific experience can stand out within the everyday continuum, argued Dewey, because it is 'so rounded out that its close is a consummation and not a cessation'. Examples of such a 'situation' given by Dewey include finishing a piece of work 'in such a way that it is satisfactory', as well as 'eating a meal', 'carrying on a conversation' or 'writing a book'. The semantic link between the terms 'consummation' and 'consume', I would suggest, lend

the action of eating a meal an inbuilt capacity for Deweyian experience on a par with art. Making a salad can involve a similarly 'satisfactory', 'rounded out' situation as eating it. Consummation, in Dewey's and Knowles's sense, suggests less perfection – how can a conversation be perfect? – than a sense of completion, a bracketed moment within the individual's everyday experience.

… and 'wu-wei'

In 1965, Knowles participated in a performance of Robert Filliou's 1964 *Yes: An Action Poem* at the Café Go-Go in New York. While a cross-legged Filliou sat still on stage, Knowles read out his description of the 'adult male poet' as a body, mentioning specific body parts such as his blood and brain, as well as bodily functions including breathing, excreting and reproduction. The section concerning 'the Necessity of Alimentation', for example, reads:

> The first thing a poet does with food is to chew it. This consists of breaking the food into small pieces, mixing it up with his saliva, thus making it easier to swallow and to digest, and chewing it well … Once his food is chewed, the poet swallows it, and it passes down the gullet (or 'aesophagus' [*sic*]) into the stomach of the poet.[25]

In the second part of the poem, Filliou stood up and announced that the score for his 'action poem' involved 'not deciding, not choosing, not wanting, not owning, aware of self, wide awake, SITTING QUIETLY, DOING NOTHING'. Whereupon he sat down again and waited, with Knowles, for the audience to grow tired and leave.

Filliou's list of refusals and this desire to sit 'quietly, doing nothing' reveal that he was directly seeking a state of *wu-wei*, a related term to *wu-shih* in Zen thought. *Wu* in both cases means 'no'; 'wei' means making, action, but also striving, straining or 'business', according to Alan Watts. *Wu-wei* thus means 'not-making', doing nothing, not having any goal or purpose. 'Sitting quietly, doing nothing' is a verse from a poem from the Zenrin Kushu anthology, which is quoted by Alan Watts, who also uses it as the title of a chapter in his 1957 *Way of Zen*.[26] Like *wu-shih*, *wu-wei* involves a deliberate refusal to interfere with the everyday. Moreover, *wu-wei* implies a refusal of all goals or objectives, just as in Knowles's *Identical Lunch* there is no search for the 'perfect sandwich'.

Filliou's *Yes: An Action Poem* thus brings together both the act of being aware – of one's breathing, one's way of chewing food – and the act of 'doing nothing', in a desire to reveal the potential of this apparent 'nothingness'. Indeed, according to Filliou, 'sitting quietly, doing nothing' could in fact hold the 'absolute secret of permanent creation'.[27] After describing himself as early as 1962 as a 'good-for-nothing' in the leaflet for the *Misfits* exhibition in

London, Filliou would observe, in a later text, that the 'good-for-nothing' is, in fact, 'good-at-everything'.[28]

When George Brecht and Robert Filliou joined forces in their non-shop and non-school of Villefranche-sur-Mer, they further experimented with the art of *wu-wei*, not making. The shop-cum-gallery was generally closed, while the artists were at a café drinking and chatting with artist friends as well as the locals (figure 34), whether Alfred the bricklayer, Antoine the fisherman, Fernand the plumber, or Claude Berge, the mathematician. Very few attempts seem to have been made to produce or sell artworks. As Filliou explained, it was 'not necessary' to aim for specific 'results', as long as 'the spirit in which things are done' was 'right'.[29] Unsurprisingly, the shop was not a commercial success. Reproduced in *The Games at the Cedilla*, one photograph shows

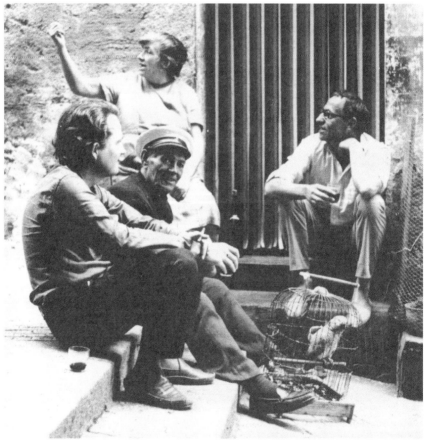

34 Photograph of George Brecht and Robert Filliou in Villefranche-sur-Mer, c.1965–67.
From *Games at the Cedilla or the Cedilla Takes Off* (New York: Something Else Press, 1967)

Brecht and Filliou standing in the street in front of the shop, with the following caption: 'how we gonna pay the rent this month?'[30]

A 'found poem', as Filliou called it when he included it in his book *Teaching and Learning as Performing Arts* (started in 1967 and published in 1970), helps situate the origins of his thinking about *wu-wei* in the development of 1950s American capitalism. The 'poem' is a 1960 magazine advertisement from a self-help book, which promises to teach any American how to gain new personal and professional skills in order to 'sell himself to big money'.[31] The ad provides a striking insight into the new modes of being that were emerging in the booming economy of unprecedented production and consumption which we discussed in Chapter 1. The keywords here are productivity and efficiency, profit and upward mobility: the self-help book promises tips on how to increase sales, make the most of your time, relate to your colleagues and superiors… Furthermore, the historical appearance of the self-help book during the 1950s highlights the increasing specialisation and organisation of work that put pressure on each individual to perform efficiently within the system, requiring their full psychological and affective engagement. The efficient American businessman knows, for example, 'how to develop poise, presence and self-assurance' as well as 'how his wife can help him to succeed'. Evidently, Filliou's good-for-nothing stands as the counterpart of this successful organisation man: he is a failure precisely because he refuses to be either efficient or productive, because he is not striving for economic and social gain.

In this sense, Filliou was rehearsing the very contrast first set up by the Beat generation in 1950s America (an influence acknowledged by the French artist himself) between the 'Square' and the 'Hip'. As we saw in Chapter 1, a passage from Kerouac's 1958 autobiographical novel *The Dharma Bums* explicitly counters the meaninglessness of working in order to consume with the freedom of taking to the road and 'wandering around with rucksacks'. In this logic, which would become widespread in 1960s counterculture, doing nothing was conceived as dropping out of the waste economy cycle of frenetic consumption and production. Filliou was a proud dropout, who decided to give up a career as an economist and refused to participate in an 'economy of prostitution', as he called it, which involved working for a profit.[32] In the course of his non-career as an artist, Filliou suffered periods of great poverty, often relying on the support of friends and patrons. Socially and economically he was a loser, he admitted, 'a nobody and nothing but a nobody'.[33] In addition to calling for a 'homage to failures' (*ratés*), whose 'success' lies in the fact that they challenge stifling notions of 'admiration' and 'leadership', Filliou praised 'mediocrity' as a revolutionary power.[34]

Having studied economics at Berkeley in 1948, Filliou had decided to oppose the 'economy of prostitution' with an 'economy of poetry', and

to dedicate his time to the pursuit and dissemination of the latter. 'If we want to be free … we must not only tolerate but welcome lack of discipline, laziness, spontaneity, fantasy and improvisation', he explained.[35] Thus, Brecht and Filliou adopted the role of lazy dropouts in Villefranche-sur-Mer by spending their time doing nothing. Mainly, this involved hanging out (figure 34), and promoting the principles of 'poetical economy' which included innocence, imagination, freedom and integrity. Sharing the secrets of 'permanent creation' (achieved by doing nothing), they believed, could generally make people happier. Ultimately, Filliou believed that the function of the artist was to help people to find their own 'way of life, an art of living', and thus become artists in their own right.[36] This would involve incorporating 'the lesson of art as freedom of the spirit into the fabric of everyone's life', by developing fresh ways of looking at the world around them.[37] Borderline art could thus become an art of living.

Seeking *wu-shih* and *wu-wei* in Taoism entails setting aside, according to Alan Watts, the 'conscious intellect' which is always 'frantically trying to clutch the world in its net of abstractions'.[38] In other words, as Watts explained, one has to try and become 'stupid'. Filliou's *Ample Food for Stupid Thought*, published in 1965 by the Something Else Press, anticipated the games that he would develop with Brecht at the *Cédille qui sourit*. *Ample Food for Stupid Thought* is a collection of 100 questions, each printed in large font on individual cards. Questions range from the specific ('isn't the cuckoo a strange bird?') to the general ('isn't art a remarkable thing?'), from the personal confession ('can you sleep with two men at once?') to the personal reflection ('why did you do that?', 'do you often mean what you say?'), from the speculative ('why not walk away ?') to the downright silly ('if your aunt were a man would she be your uncle?'). Conceived as a 'tool of self-awareness' according to Filliou, this collection of apparently naïve, if not stupid, questions sought to open the players' minds up to its creative potential.[39]

Similarly, Filliou and Brecht imagined games in the spirit of Surrealist *cadavre exquis* such as the *Game of the Conditional*, which invites one player to write a sentence beginning with the conjunction 'if', while the other, without looking at the other's proposition, completes the sentence starting with 'then…', before combining both parts to create an absurd sentence. Other games challenged critical terms such as 'important' or 'new', and debunked traditional definitions of art by offering, with the *Mystery Games* for example, foolproof recipes for creating music or sculpture compositions, by putting together one thing with another and repeating the operation four times. Other items in *Games at the Cedilla* include *One-minute* scenarios – visual one-liners – and correspondence either with members of the artworld or with other interlocutors. Such exchanges were related to speculative projects (such asking Lloyd's to insure the artists against senility) as well as everyday

incidents (such as applying for a refund on a roast chicken that had been left to burn in the oven because of a misdirected bus trip).

In a 1964 letter to Thomas Schmit, Maciunas had specified that 'Fluxus should become a way of life, not a profession. Fluxus people must obtain their "art" experience from everyday experiences, eating, working, etc.'[40] Like Knowles and other Fluxus artists, Brecht and Filliou envisaged art as a way of life that did not include the production of art objects to be exhibited and sold on the art market. Unlike Knowles and Maciunas, however, Brecht and Filliou had given up any attempt to hold down a paying day job, and sought in Villefranche-sur-Mer to incorporate the very refusal to work into their way of life itself. For Maciunas, since all daily experiences could become Fluxus art, and artists would eventually disappear, there was no reason for the artist to withdraw from the space of work. As he explained: 'Fluxus way of life is 9am to 5pm … earning your own living, 5pm to 10pm, spending time on propagandizing *your* way of life among idle artists & art collectors.'[41]

Brecht and Filliou's choice to spend their whole day propagandising their 'way of life' in Villefranche-sur-Mer abolished the distinction between work and leisure altogether. In this sense, I agree with Natilee Harren's analysis of the *Cédille qui sourit* experiments in light of Arendt's distinction between work, labour and action. According to Harren, the *Cédille* questioned *both* work (the production of goods) and labour (efforts that do not result in objects but are necessary to keep oneself fed and clean), and proposed a move, instead, in the direction of action. As Harren explains: 'Their efforts to cultivate an artistic practice as near as possible to the realm of action threatened to depart from the realm of work altogether and, subsequently, that of the art object too, threatening the visibility of their practice.'[42] This risk of invisibility is, of course, a characteristic of borderline art.

In fact, I would like to extend such an analysis to practices such as Knowles's *Identical Lunch*. As we saw previously, the drive of precarious practices towards a concrete, 'non-art reality' (to use Maciunas's words) sought to break the closed cycle of consumption and production that threatened to reduce the space for action in capitalist society, according to Arendt. Once this cycle had been interrupted by artists, a new space for action and experience became available as material for newly redefined precarious practices. Although Knowles had to work in order to buy her tunafish sandwiches (among other necessities!), the *Identical Lunch* opened up a space for discussion and self-awareness that resonated with the 'permanent creation' of the *Cédille qui sourit*.

Art, according to Arendt, is an activity that operates at the intersection of work and action, since it makes tangible, through durable forms, the intangible activities of speech, action and thought. The 'expanding and disappearing' work of art as action (as Alloway called it) certainly shifted the focus away

from the tangible and the durable towards increasingly intangible forms, redefined as we saw as experiences and attitudes. One may turn, however, to Arendt's thoughts on poetry in order to further relate precarious artworks to the field of action. For Arendt, 'poetry is closest to thought, and a poem is less a thing than any work of art': this relative intangibility of poetry as an art form may explain why Filliou defined art as a 'poetical economy'.[43] As Steven Harris has summarised it, poetry appealed to Brecht and Filliou as a 'non-instrumental mode of thought, one capable of offering a viable alternative to a self-interested instrumental reason used to dominate nature and other human beings'.[44] Although neither the *Games at the Cedilla* nor Knowles's *Identical Lunch* took on the form of traditional or avant-garde poetry, their literary nature certainly brings them closer to the operations of thought, speech and action, as they were defined by Arendt. If all art is purposeless, as Arendt affirmed, poetry may come to embody, as it did for Filliou or Knowles, a way of life which is no longer goal-driven – a *wu-wei*. Once the refusal to work, produce and succeed is set up as the precondition of a precarious art on the verge of disappearing into the everyday, a central question arises: what do we do, exactly, when we do nothing?

'Bien fait, mal fait, pas fait'

'The place between art and life is really the most important area to me right now', explained Bay Area artist William T. Wiley in his 1967 interview with Joseph Raffaele for *Art News*.[45] 'It's not entirely art, or entirely life. It keeps you aware of the transitional moment.' This 'transitional moment' described by Wiley clearly located his mid-1960s practice within the elusive, borderline space outlined by Brecht. Like Brecht, Filliou and Knowles, Wiley was in fact also interested in Zen Buddhism.[46] In particular, Wiley was aware of the work of Shinryu Suzuki, a Zen master who lectured in San Francisco between 1959 and 1971, and who emphasised, like Alan Watts, the *wu-shih* quality of Zen. For example, Shinryu Suzuki explained that 'instead of having some object of worship, we [Zen Buddhists] just concentrate on the activity which we do in each moment'.[47] Observing Wiley, Geis, Allan and Nauman, Rafaelle remarked that '[t]heir subject matter is closely tied to everyday life' – those activities 'which we do in each moment', according to S. Suzuki.[48] This might be why the four photographic portraits in Rafaelle's article give us a glimpse into the artists' everyday lives. While Wiley is pictured discussing one of his works with Rafaelle, Nauman leans casually in the doorway of his San Francisco studio, which, as the sign above the doorway indicates, used to be a grocery shop. Meanwhile, Geis smokes a cigar and Allan shows off the four fish that he has caught. These four artists' shared lifestyle – described by Rafaelle as 'classic Western in its nonchalance' – permeated their collaborations.[49] For example, Nauman had

filmed Allan fishing for Asian carp, an activity that no doubt resonated with the latter's avowed interest in 'non-doing', as he called this form of *wu-wei* in his interview for *Art News*. As Nauman also explained to Rafaelle, Allan and he were interested in choosing an activity that would determine the length of the 1966 *Fishing for Asian Carp* – 'When he caught the fish, it ended.'[50] It is a very simple film about non-doing, which involved an absence of decisions on the part of either the director or the protagonist. Releasing the fish after it had been caught ensured that the action itself was not goal-driven.

A 1974 film by Robert Nelson, *Deep Westurn* [*sic*], would reflect the 'un-urban, relaxed' lifestyle described by Rafaelle seven years earlier. Just as Rafaelle had picked up on the artists' 'big drinking, slow talk, cowboy boots, blue jeans, whiskers, etc.',[51] the film shows Wiley, Nelson, Geis and another friend sitting on chairs and drinking from a jug. One after another, each one falls backwards; in the final shot, wooden tombstones stand where the four men had sat. Although the cowboy boots and whiskers situate the West Coast artists in their rural habitat of Marin county, just outside San Francisco (and within the clichés of the Western film genre), the way of life described by Rafaelle also recalls the image of Filliou and Brecht hanging out in Villefranche-sur-Mer. Indeed, just as the Bay artists interviewed by Rafaelle demonstrated that 'every part of life has equal value, to themselves and poten- tially to their work',[52] Filliou believed that artists should teach us that 'each and every moment of one's life is art', that we are all involved in an 'art of life'.[53] In the same way as Knowles was interested in an uninterrupted flow of experiences in the *Identical Lunch*, Filliou refused to distinguish between 'the extraordinary' and the 'ordinary'. As Fluxus artist Benjamin Patterson remembered, Filliou's work was concerned with a 'continuum of banality',[54] which was also a 'permanent creation', as the artist called it.

The idea that every aspect of life has 'equal' value certainly challenged accepted definitions of art as a 'special' kind of activity. The *wu-shih* approach to the world privileged by Zen similarly questioned definitions of value. A fable included in Paul Reps's 1957 collection of stories, *Zen Flesh, Zen Bones*, involves Zen master Bazan walking through a market. Bazan, we are told, overheard a conversation at the butcher stall. 'Give me the best piece of meat you have', said the customer, to which the butcher objected: 'Everything in my shop is the best … You cannot find here any piece that is not the best.' At these words, the story goes, Banzan became enlightened.[55] This story, which was known to Wiley (who had discovered Reps's book in the late 1950s), was also quoted by Filliou in his above-mentioned *Teaching and Learning as Performing Arts*. With his background as an economist, Filliou was particu- larly concerned with the notion of value. The artist posited in 1967 a 'principle of equivalence' which stated that there is in fact no hierarchy between the *bien fait, mal fait, pas fait*: he established an equation between what is well made,

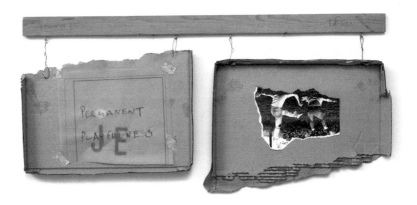

35 Robert Filliou, *Permanent Playfulness*, 1973

what is badly made and what is not made at all. Some of Filliou's assemblages literally embody this equation by simultaneously presenting all three states within a single work, by using a simple unit – such as a red sock in a yellow wooden box – and demonstrating how it can be declined (potentially infinitely): to the first unit is added the two variations of 'well-made' and the 'badly made', and the three variations together can then be used, in turn, as a unit to be replicated in 'badly made' and 'not made' formats. According to Filliou, the 'well-made' was the hallmark of the professional artist, participating in an 'economy of prostitution'. Most of Filliou's assemblages, cobbled together out of scraps of cardboard, string and cheap objects, are characteristically badly made (figure 35). Having never received any form of artistic education, Filliou often stated that he could neither paint nor draw, but created works only to encourage others to do the same. As he put it in a 1970 interview: 'Anything I do, I do it simply so that anybody can do it.'[56] His conception of permanent creation started from the principle that hierarchical notions of talent and skill serve only to stifle everyman's natural genius.

According to critics and artists, one of the characteristics of West Coast funk from Bruce Conner to William Wiley was its badly made aspect. Writing in *Artforum* in 1964, John Coplans commented on the artists' 'sloppy attitude toward craft and materials'.[57] This 'ungainly', 'irreverent' art was, according to Peter Selz, opposed to the 'slick' forms of either East Coast Minimalism, southern California Finish Fetish or Pop art;[58] it was closer to a Dada and Surrealist aesthetic, but incorporated the directness of Abstract Expressionism. Thus, objects were loosely held together in makeshift arrangements that could convey processes and ideas. Among the works illustrated in the *Art News* article, a jar labelled 'ashes from the silver shield burned,

September 30, 1966' is included in Wiley's work of that title, while another jar contains the 'book juice' extracted from a dictionary in William Allan's *Book Life Restoration* contraption. Sculptural materials included fibreglass, wax, fired clay and plaster; surfaces, as Raffaelle noted, were 'frequently irregular, messy, rough' – like William Geis's formless painted plaster and fibreglass sculpture which vaguely recalls two crab claws.[59] Messy forms were sometimes combined with mysterious titles that often read like private jokes (figure 36). Wiley's bulging *Enigma's Weener Preserved in Wax*, made out of wax over marble paper and wood, with a lead label bearing the work's title, found its convex counterpart in Bruce Nauman's *Wax Impressions of the Knees of Five Famous Artists*, which consist of five imprints in a block of fibreglass and polyester resin (figure 37). As Nauman would put in retrospectively: 'Funk art allowed one to make things, and not to worry how they looked.'[60]

The 'nonchalant' character of West Coast assemblage was attributed, by Conner among others, to the absence of an art market and audience in 1960s northern California. Speaking of the 'funk' works of fellow artists Joan Brown and Manuel Neri, Conner explained that there was no reason to make an artwork that was permanent. 'What were you going to do with it if it was more solid? You'd show it to your friends and that was it.'[61] Though very different in appearance from Conner's assemblages, the 'funk' objects produced by the younger generation of Californian artists shared the same disregard for polished productions, privileging instead loose, sloppy constructions. At times, they oscillated between the sensuous and the viscous; at others, between an idea and its casually executed material embodiment.

'There is distrust of too much logic or thought' among these artists, argued Rafaelle in his article.[62] Knowles has also recalled that in her experience, art on the West Coast during the 1960s and 1970s was imbued by a different attitude than on the East Coast: over there, she felt, artists 'somehow' felt that they could 'try … things out', without having 'to make a big deal out of what they *mean*'.[63] For Knowles, that tied in precisely with her search for the 'nothing special' of *wu-shih*. The *Identical Lunch* 'doesn't *mean* anything' in itself, either: it all 'depends what you make of it, what you *do* with it'.

The ongoing experimentation at the heart of West Coast practices also exceeded the boundaries of the sculpted or assembled object. For example, Wiley mentioned in his interview with Raffaelle a work in which he had asked various contributors, including artists Terry Fox and Ray Johnson, to exchange dust from specific locations with him via mail. (Filliou would create a similar series of works in 1977, as he collected dust from famous paintings; each of this series' cardboard boxes includes a soiled duster along with a photograph of the artist dusting the painting.) Although Wiley's work was never concluded or exhibited, it exists as an entry in Lucy Lippard's 1973 inventory of conceptual practices, *Six Years: The Dematerialization of the Art Object*

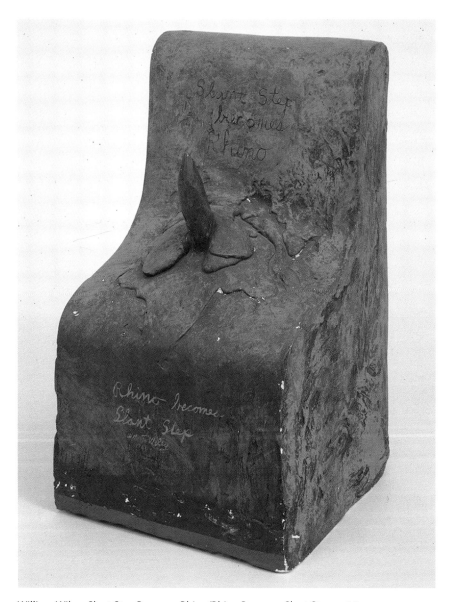

36 William Wiley, *Slant Step Becomes Rhino/Rhino Becomes Slant Step*, 1966

from 1966 to 1972:[64] the text thereby established, in effect, an equivalence between the 'made' and the 'not-made' which would become central to the very definition of conceptual art.

Around the same time, Wiley thought of making a work using flour that would revolve around the pun on 'Japanese flower arrangement'. Since he

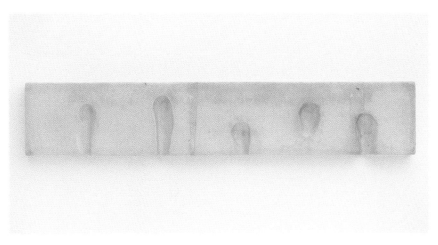

Bruce Nauman, *Wax Impressions of the Knees of Five Famous Artists*, 1966 **37**

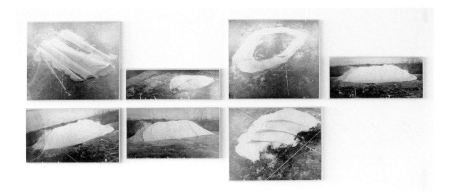

Bruce Nauman, *Flour Arrangements*, 1966 **38**

could not find a way of arranging flour on a metal grid covered with white felt as planned, he answered positively when Nauman asked for his permission to use the concept. Nauman made his 1966 *Flour Arrangements* by going into his studio every day, arranging some flour on the floor, and taking photographs of the arrangement (figure 38). Is the flour arrangement well made or badly made? What counts is the duration that it records, the way the artist used this task to fill his time in the empty studio, every day for a month.

Time was definitely on the mind of the artists interviewed by Raffaelle. Wiley's 'dust sculptures', as the artist called them, were inspired by an experience of looking at the dust on top of a cabinet in his house. '[U]p high where something had been lying,' he recalled, 'there were different layers of dust and different shades of dust.'[65] When Raffaele suggested to Wiley that 'dust is a way of describing the recent past of inanimate objects', the artist agreed

that these layers could be seen as 'dust records'.[66] Similarly, Geis imagined a scenario in which you could live in a room made out of wet clay where your imprints would be captured. 'After a week's time,' he imagined, 'someone could walk into that room and they could cast the room in bronze, and they'd pretty much have a replica of your existence in it.'[67] His work with plaster similarly acted as a record of the artist's involvement with the material, and the time he spent reworking its form. Nauman also appeared interested in traces, records and imprints such as the *Wax Impressions of the Knees of Five Famous Artists* (figure 37) which he showed to Raffaele. Imprints, films and photographs, dust and flour records (figure 38), all explore a field of residues that speak of time wasted. The semantic shift from waste or junk to the 'waster' or good-for-nothing who wastes his time points to a growing concern with capturing experiences as they flow.

According to Wiley, his idea for a dust exchange between artists was partly inspired by Alain Robbe-Grillet's novel *In the Labyrinth* (published in 1959, and first translated into English in 1960), which starts with an extensive description of a room covered in dust, in which can be observed the silhouettes of absent objects.[68] Nauman was also reading Robbe-Grillet at the time, along with an artist's book that was associated with Robbe-Grillet's *nouveau roman*: the *Anecdoted Topography of Chance*, by Daniel Spoerri, initially written in 1962,[69] with the encouragement of his 'very dear friend Robert Filliou'.[70] Spoerri started by making a map of the objects on the tabletop of his Paris apartment/studio, numbering each object, and writing remarks and thoughts related to each. For example, noting a silhouette on the map numbered 23, you can consult the table of contents that informs you that it is a plastic bag, and you can go to page 45 to read Spoerri's entry about it. Drawings of each object were made by Topor for the 1966 English edition, published by the Something Else Press in a translation by Fluxus poet Emmett Williams, who took this opportunity to add his notes to Spoerri's remarks. (Another artist friend, Dieter Roth, would further annotate Spoerri's and Williams's entries as he translated the book into German in 1968.) Thus, Spoerri's annotations became annotated in turn. For example, shell debris left over by his girlfriend reminded Spoerri of a children's story, and led Emmett Williams to muse on the way their respective mothers (as well as Filliou's) felt disappointed by their sons' apparent waste of their artistic talents – the connection between waste and wasters is thus made explicit. Blurring the boundary between their artworks and their ways of living, discussions of these artists' exhibitions, collaborative projects, ideas and influences are woven into prosaic descriptions of objects and everyday events as well as biographical information.

Spoerri, who was associated with the French Nouveaux Réalistes, considered the *Topography* to be a kind of ghost version of his 'snare pictures' (included in the *Art of Assemblage*, as we saw in Chapter 1), in which he glued

the remains of a meal to various table tops which he then exhibited vertically, like paintings (figure 15). The *Anecdoted Topography of Chance* adopts the trapping logic of the 'snare picture', but leaves only the outlines of the absent objects, like the traces in the dust of Robbe-Grillet's novel. Like a detective investigating a crime scene, the reader of the *Topography* must reconstruct a past event – indeed, Spoerri compared himself to Sherlock Holmes in his introduction.[71] Rather than glue, it is storytelling and biographical detail that fix the contours of objects and debris into a more mobile, potentially infinitely expanding, composition. In *The Labyrinth*, Robbe-Grillet juxta-poses his description of dust records in the house with the shifting patterns of snow outside. The relation between dust and snow in Robbe-Grillet's novel is echoed by Spoerri, who was delighted when Surrealist artist Meret Oppenheim imagined a map of the objects of his table, as if covered by 15 cm of snow, further frozen in time.[72]

In an exchange included in the *Topography*, Robert Filliou suggested to Spoerri that instead of mapping and annotating the tabletop in his studio-flat, he could simply 'send a letter to people … and say: "Look at what you have on your table at this moment"'.[73] Filliou's advice brings up the alterna-tive model of the Brechtian event score and the *Cédille qui sourit*. As Dieter Roth pointed out, the *Games at the Cedilla* publication is a counterpart to the *Anecdoted Topography of Chance*: as the subtitle of the former suggests – 'the Cedilla takes off' – it is about the immaterial lightness of ideas and thought, in contrast with the former, which pins down reality in a specific time and place.[74] This contrast is also visible when comparing Spoerri's 'snare pictures' and Filliou's freer, makeshift assemblages (figure 35), which retain the poetry of his games and performances.

Nauman's 1967 work, *William T. Wiley or Ray Johnson Trap* (figure 39), involved a play of presence and absence similar to the *Anecdoted Topography*: while its description as a trap brings to mind Spoerri's 'snare pictures', the objects presented here are photographic traces. As Nauman explained to curator Jane Livingston, Wiley had been present in the artist's house when a package arrived from the artist Ray Johnson, whose mail art practice involved sending friends and acquaintances a range of objects, texts and col-lages. Nauman asked Wiley to lie on the floor, and arranged the contents of Johnson's package around him. When Wiley got up, Nauman photographed the objects.

As Nauman put it: 'It had to do with the primitive idea of being encap-sulated by artefacts and gaining psychic control over them.'[75] Are the traces, imprints and spaces in between objects characteristic of Nauman's early work somehow related to those spaces and artefacts that 'encapsulate' us? Alongside his imprints of knees, and the spaces between two boxes or under a chair, the photographic document emerged in Nauman's early work as a light

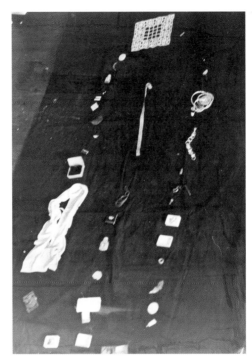

39 Bruce Nauman, *William T. Wiley or Ray Johnson Trap*, 1967

trap for elusive, impermanent traces and arrangements. The Something Else Press edition of the *Anecdoted Topography of Chance* bore on its cover a composite photograph of the Spoerris' apartment/studio, taken by Vera Spoerri at the request of the artist. It may be no coincidence that Nauman also chose the composite photograph format to document the 'messes' littering his studio in his 1967 *Composite Photo of Two Messes on the Studio Floor*.

Another kind of 'snare' was briefly developed by Filliou and Spoerri in 1964 as they collaborated on an exhibition of what they called 'word traps' – commonplace expressions and proverbs visualised through assemblages of cheap objects. The 1964–69 *Raining Cats and Dogs*, for example, consists of two plush figures of a white cat and a poodle lying on a black wooden base at the feet of two plastic doll's chairs underneath a pink umbrella (figure 40). (As in some of Wiley's works, the title of the piece is inscribed on a label affixed to the base.) Such works demonstrate the logic of 'sticking and nailing and tying things tight' observed by Roth in joint projects by Filliou and Spoerri, as we saw earlier.

Wiley, Nauman and their friends similarly used puns as the starting points for their works, from the above-mentioned *Flour Arrangements* (figure 38)

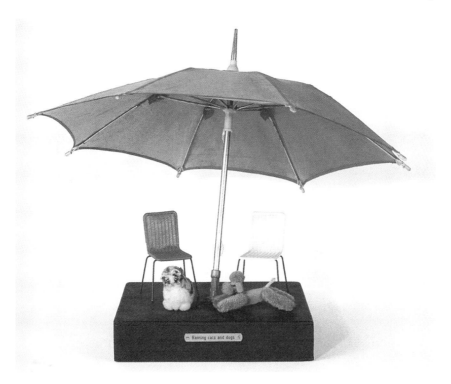

Robert Filliou and Daniel Spoerri, *Raining Cats and Dogs*, 1964–69 **40**

to Nauman's 1967 *From Hand to Mouth* (a wax cast of an arm and lower face), or some of his 1966 *Eleven Colour Photographs* which literally visualise expressions such as 'feet of clay', 'eating my words', 'waxing hot' and 'bound to fail'. Rather than puns, the 1966 *Slant Step Show* at the Berkeley Gallery in San Francisco, which included works by Allan, Wiley (figure 36), Nauman and their friends, was inspired by a mysterious object that Wiley and Nauman had discovered in a local thrift shop.[76] The object looked like a small stepladder or footstool, but with a slanted, rather than horizontal, top. (Wiley would find out, many years later, that it was used in the late nineteenth century to elevate one's feet to facilitate bowel movements.) Allan and Nauman started to make an educational film purporting to demonstrate how to build a new slant step. Although the film was left unfinished, Nauman used the object they had produced to make his *Mould for a Modernized Slant Step*, a plaster mould sliced in half. As with the *Wax Impressions of the Knees of Five Famous Artists* (figure 37), Nauman often used moulds at the time to suggest absent objects and bodies.

This interest is also visible in Nauman's 1966 *Neon template of the left half of my body taken at ten-inch intervals*, reproduced in Raffaele's article.

This absurd measure of the artist's body recalls an idea by Filliou, realised by Emmett Williams with the collaboration of Alison Knowles, Dick Higgins, Benjamin Patterson, his spouse and both couples' children. The 1966 *8 Measurement Poems* involved measuring the height of each participant with a different unit of measurement, including teabags and mousetraps (figure 41). Thus, for example, it was revealed that Knowles was 7½ shoe-soles tall.

Whereas Filliou's title describes these objects as poems, Nauman's work is more directly related to the tradition of sculpture. As Anne Wagner has aptly demonstrated, Nauman was busy, at the time, 'dismantling' sculpture as a 'system of representation' 'deeply bound with solidity, presence, coherence, thingness, and embodiment'.[77] Indeed, Nauman and Wiley would be included in the landmark exhibition *When Attitudes Become Form*, which brought together post-Minimalist sculptural experiments and early conceptual art at the Kunsthalle Bern in 1969. In such works, argued curator Harald Szeemann, art objects were replaced by processes, situations, information or gestures. The inclusion of Nauman and Wiley in such an exhibition points to a major difference between the two directions that I have been outlining in this section. However marginal their productions may have been in the late 1960s Californian context, sculptural and conceptual works by Nauman would promptly be assimilated within the art world, unlike Fluxus projects, which remained for some time largely underground. Nonetheless, I would like to argue here that the brief intersection between Nauman's anti-sculptural aesthetic and Filliou's poetic assemblages constituted a space in which emerged, in that period, a specific type of dematerialisation of the art object that teetered precariously on the borderline between art and life. Challenging the artwork's static identity as a durable artefact, such works introduced heterogeneous elements such as language and poetry, process and action. Looking at the convergences and divergences among Fluxus artists' 'attitudes' and those of Nauman or Wiley, and developing further comparisons with other contemporary precarious practices, can help us map out different variations on Arendt's work/labour/action triad that were developed during this period.

Wasters

'Being an artist has to do with a way of life, because you can choose what to do every day.'[78] Bruce Nauman's observation, in a 1970–71 interview with Marcia Tucker, sets out the general framework for our enquiry into ways of doing nothing in the late 1960s. Whereas Filliou and Brecht chose to spend their time inventing games and chatting with locals in Villefranche-sur-Mer, Knowles and Maciunas each held a day job and made art in the margins of their paying work. Nauman, who started teaching straight after graduating,

Robert Filliou, Emmett Williams, Alison Knowles, Dick Higgins and Benjamin Patterson, **41**
8 Measurement Poems, 1966

was busy reflecting on ways to fill his time in his studio, reaching in the process his well-known insight: 'My conclusion was that if I was an artist and I was in the studio, then whatever it was I was doing in the studio must be art.'[79] Since he was earning a living, Nauman felt that he could experiment freely, adopting the role of an amateur dabbling in a wide range of pastimes. For example, he used photography in his *Eleven Colour Photographs* because he 'didn't know enough about photography to get involved in trying to make a really interesting or original photograph'.[80] Having failed at hand-modelling figures such as *Henry Moore Bound to Fail*, he turned instead to casts and moulds (figure 37) – 'traditional tokens', as Wagner pointed out, 'of sculptural de-skilling'.[81] As to his experiments with dance, which are displayed in the videos that he filmed in his studio, Coosje van Bruggen has rightly pointed out that their appeal 'stems from … the continuous threat of collapse, of losing his balance or otherwise failing technically, that comes from his amateur status in a professional field'.[82] The amateur is at once intensely involved in the process and not good enough to be able to control the process entirely.

The amateur can be accused of both idleness and incompetence. Nauman admitted that he presented his early sculptures 'in a straightforward way, without bothering to shine them and clean them up'.[83] Indeed, Lippard described them as 'carelessly surfaced' and 'wholly non-sculptural',[84] whereas Mel Bochner negatively commented on the artist's 'not-work', which suggested, in his eyes, a kind of 'tiredness'.[85] Wagner extrapolates on Bochner's complaint: 'When "work" merely "looks like a lot of rags thrown on the ground or draped on the wall," [as Bochner remarked] the problem can be traced back to the artist's actions: he isn't doing an adequate job, and "not-work" results.'[86]

The deliberately 'badly made' aspect of Nauman's studio 'not-work' of the period between 1966 and 1968 resonates with the willed stupidity of Filliou's *wu-wei*. Yet the voluntary idiocy of Filliou's *Ample Food for Stupid Thought* or the obvious daftness of Spoerri and Filliou's joint 'word traps' (subtitled 'three-dimensional platitudes'), like the *Anecdoted Topography of Chance*, all conjure a more sociable image than that of Nauman pacing around alone his studio. It is, rather, an image of friends hanging around in an atmosphere of humorous banter, more akin to that permeating Nauman's *Light Trap for William Wiley or Ray Johnson*, or collaborative films such as *Fishing for Asian Carp* or *Deep Westurn*, as well as the *Slant Step Show* and the puns shared by Wiley, Nauman and their circle of friends. In a film about Wiley, Nelson, Geis, Allan and Robert Hudson (directed by Wiley's and Nelson's film-maker wives, Dorothy Wiley and Gunvor Nelson), a voice-over informs us that 'they share a love of the absurd and silliness, and nonsense, and stupidity'.[87] Although this atmosphere certainly encouraged the young Bruce Nauman in his early 'funk' experiments, his reflections on what happens when the artist

chooses to spend his day trying to work shifted the focus from the absurd activities in the artists' living rooms and gardens to the historically loaded framework of the artist's studio. The 'good-for-nothing', in Nauman's case, is an artist who makes inadequate or badly made work in order to challenge the very definitions of art. By adopting the role of the amateur messing around in his studio, Nauman's project echoed Filliou's desire to challenge 'talent' and skill as values. Whereas Nauman held on to the traditional role of the artist, however, Filliou sought to encourage viewers to each take on the role of the artist for themselves.

When another artist based on the West Coast, Tom Marioni, declared in 1970 that *The Act of Drinking Beer with Friends is the Highest Form of Art* he challenged the definition of art, much like Nauman. Marioni's drinking beer with friends at the Oakland Museum (figure 42), and displaying, the next day, the remainders for visitors to contemplate over the course of the exhibition, was certainly a demonstration of the artist's 1970 definition of conceptual art as 'ideas-oriented situations not directed at the production of static objects'.[88] Indeed, the work has existed in a variety of forms since 1970: as a performance in other museums, as a display including a refrigerator, a

Tom Marioni, *The Act of Drinking Beer with Friends is the Highest Form of Art*, Oakland Museum, California, 1970 **42**

hanging yellow light-bulb and beer bottles neatly aligned on shelves to form a rectangle (*Free Beer [The Act of Drinking Beer with Friends Is the Highest Form of Art]*, 1970–79), as a regular meeting in Bream's Bar in San Francisco, and as weekly gatherings in the artist's studio. Rather than the fields of sculpture, the event score or poetry, inspirations cited by Marioni for *The Act of Drinking Beer with Friends* range from the Catholic communions of his childhood to his student drinking, as well as a specific type of space, other than the studio favoured by Nauman, traditionally inhabited by the modern artist: the café.

Marioni traced the history of the café back to social spaces such as the salons of Madame de Rambouillet in eighteenth-century France, the 'café scene of artists and writers in Paris in the 20s' or the Cedar Bar where the Abstract Expressionists went to drink.[89] Artists and intellectuals had indeed congregated in cafés since the late nineteenth century – whether Gustave Courbet at the Brasserie Andler, the Impressionists at the Café Guerbois, or the Cubists at the Lapin Agile cabaret. The polite eighteenth-century salon may be a far cry from the Cedar Bar, where the notoriously macho Abstract Expressionists got drunk, swore and fought, but the lineage from salon to café to bar is one of the few consistent features in the modern history of bohemia. The eighteenth-century salon, in which food and drink were consumed, defined itself against the courtly mores of the monarchy, and served as a platform bringing together, through art and philosophy, women and men, intellectuals and professionals from different social classes. In the last years of the nineteenth century, as the status of and respect for the aristocracy dwindled, artists and intellectuals moved to the café. If intellectuals and artists had had to sometimes literally sing for their supper in their patrons' salons, the café was open to anyone, and everyone paid for their own drinks. Nevertheless, according to Roger Shattuck, both salon and café required equally demanding performances 'on a small and intense scale from a group of highly trained actors'.[90] This is because these figures had by that time acquired the status of bohemians performing their resistance to bourgeois conventions in their very way of life – in the clothes they wore, the relationships they had, and their apparent scorn for the bourgeois institution of work, demonstrated by spending all day drinking and talking in cafés and cabarets instead of producing commodities. The term 'bohemian', originally applied to gypsies, was extended to artists and intellectuals to describe their nomadic existence outside the norms of society, including their perceived rejection of stable and honest employment. In light of the public's ongoing mystified and often hostile response to the bohemians' mixture of idleness and provocation, one can imagine how a few eyebrows would have been raised when Marioni used a grant from the National Endowment for the Arts to offer free beer to his friends (a system implemented through the distribution of 'artists credit cards'). Marioni's humorous gesture thus dramatised one of the central

ambivalences of the bohemian myth: is the bohemian/avant-garde artist a poseur, a fake, an idle loser, or is he or she a sincere guide who can show us how to live our lives differently?

Roger Shattuck's 1958 account of the early French avant-garde, tellingly entitled *The Banquet Years*, argues that café and cabaret life, as well as drunken parties and dinners, epitomised what the author calls 'the combination of festivity and conviction' that was crucial to the development of Western modern art in the period between 1885 and 1918.[91] 'Conviction' was the avant-garde's cachet, distinguishing it from other types of bohemians. As Jerrold Seigel has explained, cafés served for artists such as the Impressionists 'not only as places of meeting and escape from the struggle and isolation of daily artistic work, but as a substitute society'.[92] Such a community of artists could overcome 'the negative opinions of the outside world' by uniting in a 'shared confidence in the rightness of what its members were undertaking'. This led to the creation of the Salon des Refusés, where the Impressionists found an alternative to the official academic salons, and later to the Société des Indépendants, set up by the post-Impressionists Seurat and Signac among others. One of the more recent names for Marioni's gatherings in his studio – the Society of Independent Artists – made direct reference to the American branch of the Société des Indépendants to which Duchamp famously submitted his *Fountain* in 1917. The avant-garde 'conviction' which drove the first Société des Indépendants and which survived, albeit with less *joie de vivre* perhaps, into the 1950s atmosphere of the Cedar Bar is difficult to detect in Marioni's drink receptions, which suggest neither the embattlement nor the passionate experimentation of the bohemian avant-garde. In Marioni's salon, bohemian performance has been scaled down to such a conceptual, task-based and almost austere minimum that it does not fit into the romantic tropes of the passionate, theatrical or even eccentric artist. A trace of avant-garde ambitions still lingers, however, in Marioni's thoughts about his piece; having admitted that wanting to 'recreate' this atmosphere of Parisian cafés around 1910 was 'romantic', he explained: 'I thought of Café Society as drunken parties where ideas are born.'[93]

Filliou established a similar connection between 'drunken parties' and creativity when he posited the 'rehabilitation of the Café geniuses' as one of the principles of his 'poetical economy'. Referring to the bohemian tradition of modern art, Filliou acknowledged: 'People used to make fun of wild, picturesque, tortured artists sounding off in drinking places and leaving their work unattended. Some still do.'[94] According to Filliou, this perception was based on a fundamental misunderstanding. For what those scornful critics cannot realise, he argued, is that we are all 'café-geniuses'. This is because the café-genius typically has 'more ideas than possibilities of realizing them', and we are all in that situation. Most importantly, the café-genius affirms a strong stance of refusal: 'Many of us,' explained Filliou the café-genius, 'don't

even try anymore. Better, we think, to make my life consistent with my ideals, than to trade them up for some money and illusory fame.' This is a matter of choosing 'poetical economy' over an 'economy of prostitution'. Just as café-geniuses were an integral part of the development of a bohemian avant-garde, they were also, according to Filliou, important 'precursors of the whole, beat, hippy and other movements' in the 1950s and 1960s, who also refused to compromise their ideals, and chose, instead, to drop out.

Filliou favoured games and sometimes drunken exchanges as ways of developing the potential of the café-genius without talent. Mentioned in Spoerri's *Anecdoted Topography of Chance* is a performance in the local café near Spoerri's Paris studio, which involved Filliou covering Emmett Williams's bald skull with a variety of so-called 'wigs' ranging from an open book to a sieve and a lettuce, much to the puzzled amusement of local bystanders. Unlike *Thirteen Ways to Use Emmett Williams' Skull*, or *Ample Food for Stupid Thought*, Filliou's 1976 *Leeds* was modelled on a traditional card game. Blindfolded, and using a set of double-sided cards, players in this game must rely on the audience to guide them. Filliou's raucously messy game of cards thus mobilises the silliness of bar atmospheres and drinking games.

In contrast, Marioni focused on the subtleties of mood, music, social chemistry and the ever-elusive problem of what makes a good party (a question that also figures, as it happens, in Filliou's *Ample Food for Thought*). Interested in the visual and gustative qualities of the chosen beer, as well as light and space, Marioni's attention to detail evokes, at times, the minutiae of the Japanese tea ceremonies that he would discover in the 1980s. This is why, for example, Marioni would start hiring a barman instead of inviting guests to help themselves directly from the refrigerator, and would design his bars himself. In the parties at his studio, he has been concerned with finding the 'right mix of new people and regulars, the right music, the quality of light and overall ambiance'.[95] Delving into the nuances of the everyday, Marioni's gesture exceeds its initial parodic function, just as Nauman's dismantling of sculpture opened up a rich field of experimentation. Although Marioni's formal aesthetic remains distinct from Filliou's or Knowles's poetics, he similarly redrew the line between work and leisure by proposing that the artist turn the field of non-work into an artwork. When Marioni speaks of a 'Zen style' that has always been present in San Francisco, he seems to be referring to a *wu-shih* attitude of casualness.[96]

Useless work

In 1970, the same year that Marioni declared *The Act of Drinking Beer with Friends* to be 'the highest form of art', Allan Kaprow published *Days Off*, a

'calendar of past events' that he had organised across the United States between 1967 and 1969. The days, which corresponded to the days if not the years of the activities, 'were days off', he explained, because during these events '[p]eople played'. The cheap paper of the calendar encouraged owners of the calendar to throw away each page as time passes, just as these activities or events 'were throwaways'.[97] They had taken place '[o]nce only' and there was '[n]othing left' afterwards – except 'leftover thoughts in the form of gossip' that could circulate through photographs, programs, reviews and personal accounts. 'As the calendar is discarded like the Happening,' explained the artist, 'the gossip may remain in action.' Bringing together notions of play and free time, as well as action and gossip, *Days Off* points to shifts in Kaprow's work from the mid-1960s onwards. As highlighted in Chapter 2, Kaprow's work had come closer to Brecht's 'borderline' scores in performances such as the 1966 *Self-Service*, which involved simultaneous performances of whimsical, absurd and ordinary activities, inserted into the fabric of everyday life. (Kaprow remarked on their 'in-and-out-of-your-daily-lifeness'.)[98] Retrospectively, however, Kaprow would reflect that Brecht's model as it was applied in *Self-Service* had at times 'degenerate[d]' into 'indifference' because the performers 'felt arbitrarily isolated' from one another, and thus 'unmotivated'.[99] Kaprow would seek to remedy this isolation by emphasising the communal and interpersonal relationships among participants in subsequent activities. Significantly, this often involved introducing effort through a work- and labour-like activity. Activities in *Days Off* include, for example, using ice blocks to build architectural structures in Los Angeles (*Fluids*, 1967 – see figure 6); unrolling tar paper along a road near Saint Louis and setting up concrete blocks on the tar paper, in two different directions, before removing them (*Runner*, 1968); or digging tributaries, bucketing out water, carrying it upstream and pouring it back into a river in Iowa (*Course*, 1969).

As mentioned in Chapter 2, Kaprow's activities partake of the 'gentle' nature of borderline art in that there is 'nothing left' after them. Ice structures melt in the Los Angeles sun, tar paper is removed after having been unrolled, water is drawn from and then returned to the same river. Following on from his use of 'obviously perishable' materials in the 1950s, Kaprow continued to acknowledge in his activities the 'planned obsolescence' characteristic of capitalist society, while pursuing his celebration of change and 'continuous renewal' as a positive value of America's 'springtime philosophy'.[100] The shift from waste materials to wasted time, typical of the 'good-for-nothing' practices discussed in this chapter, is best exemplified in the work illustrated on the cover of the *Days Off* calendar: *Round Trip*, performed at State University New York in 1968. This work involved two groups each rolling, simultaneously – though from opposite ends of the same street – a ball of paper, cardboard and string. One of the balls was progressively enlarged

by one group, until it was 'too large' to roll, while the other was conversely reduced 'until there' was 'no ball' left.[101] These actions were performed in a passageway on the university campus, thus mingling with the everyday experience of passing students and lecturers, and introducing a gratuitous, absurd activity within the busy life of a campus. The combination of effort and pointlessness embodied in *Round Trip* is characteristic of the scores included in *Days Off*, which mostly consisted in what Kaprow called 'useless work': work that ends up producing nothing.[102]

Such 'useless work' was often articulated through symmetrical structures that involved reversals (as in *Runner*), repetitions (as in *Course*), parallels (the tar paper road in *Runner* ran parallel to a real road) and asymmetrical mirroring (small ball becomes big, big ball becomes small in *Round Trip*). Entropic operations underlined the uselessness of such efforts. By using sentences that start with 'until' – 'until there is no ball' (*Round Trip*), 'till no more tributaries' (*Course*)[103] – the duration and structures of such activities were determined by concrete, physical or biological constraints, suggesting a kind of natural exhaustion. In the same way that Kaprow modelled the cycles of birth and decay of his environments and happenings on those of the seasons or the act of eating, his 'useless work' most closely approximated Arendt's definition of labour (as opposed to work) as an extension of our biological needs. Through labour, Arendt pointed out, human beings can 'swing contently in nature's prescribed cycle, toiling and resting, labouring and consuming, with the same happy and purposeless regularity with which day and night and life and death follow each other'.[104] Unlike work, labour yields no tangible or lasting result, much like the 'throwaway' activities in *Days Off*.

By transforming work into labour, Kaprow challenged the productivity and efficiency involved in building durable objects – whether roads (in *Runner*) or architecture (in *Fluids*). With this transformation, Kaprow was not only extending the equation initiated with his junk aesthetic of planned obsolescence and cycles of natural decay, thus resonating with Arendt's critique of consumer society as a frenetic cycle of production and consumption which has turned all work into labour. Most importantly, Kaprow was also linking work and labour to the field of action. Like Brecht and Filliou's *Cédille qui sourit* experiment, Kaprow extended the sphere of borderline art to the sphere of non-work, collective experience and play. Brecht and Filliou's idleness and Kaprow's useless work, I would argue, thus inhabited the same sphere of *wu-wei*. As Kaprow pointed out in a 1969 interview, he too was interested in the 'value of non-striving' and of 'purposelessness' encountered in 'Eastern religions'.[105] The connection to nature (implied in *wu-wei* as well as *wu-shih*) re-emerged most explicitly in works such as *Course*, in which Kaprow compared the 'absurd' nature of the performance (bucketing water out of a river and pouring it into a ditch to 'watch it go back into the river')

to the absurdity of nature itself, in which water 'evaporates' 'and drops back down again'.[106] (A year later, William T. Wiley would film *Man's Nature* in which footage of a running stream, accompanied by the sound of laughter, alternated with footage of the artist sitting in his studio laughing, the murmurs of the stream replacing the sound of his merriment.)

Kaprow's absurd, useless activities, he argued, participated in a programme of 'converting a work ethic into one of play'.[107] Kaprow was amused to come across a story in a 1970 edition of the *New York Times* about workmen in New England who placed a new layer of tar on a street, shortly before another gang of workmen had to dig it up again: as useful work becomes useless, it turns into a gag, a performance. For Kaprow, useless work became gratuitous play, thus helping us shed our hang-ups about 'wasting time' as well as abandoning competitive models of play that set up a hierarchy between 'winners and losers'.[108] While Filliou would consistently celebrate the deliberate 'mediocrity' of losers and geniuses without talent, Kaprow emphasised that the free play of useless work went beyond traditional definitions of art, and addressed specifically 'those who do not care' about art.[109] Indeed, like Maciunas and Filliou, Kaprow believed that 'the pedigree "art"' was eventually doomed to 'recede into irrelevance'.

The task of the artist-as-player, then, was to open up 'a carefree' space;[110] Filliou similarly described the programme of the 'non-school of Villefranche' as the 'carefree exchange of information and experience'.[111] This carefree state could only be achieved once there was no more striving after a specific goal or result. Interviewed by Filliou for *Teaching and Learning as Performing Arts*, Kaprow highlighted that artists in the 1960s were 'working in the streets, in their kitchens, in the stores, on the subway: in their ordinary world', in order to show everyone how to live 'in a completely integrated way' – or, to use Filliou's terms, how to live 'poetically'.[112]

Among Kaprow's papers can be found a notebook that bears the title 'Events 1940 through September 1944'.[113] The first entry, on 28 July 1940, reads: 'As I have not kept a "daily happenings" book for some months I will herewith write the more important back events as I remember them.' This diary, it seems, was written by a 1940s American dentist's wife, whose 'daily happenings' included cooking, cleaning, gardening, taking care of her mother, visiting and receiving visitors, as well as more eventful occasions such as deaths and marriages, against the background of the Second World War. It is uncertain at what point in his life Kaprow acquired this diary, and I do not wish to suggest here that his term 'happenings' was derived from this document. More interesting to me are the connections suggested by this diary between such 'daily happenings' and Kaprow's works. For example, the diary included a 1937 newspaper clipping detailing the daily, weekly and monthly cleaning schedule required for a dentist's office (it appears that this dentist's

wife cleaned her husband's office as well as their house). Such activities ranged from dusting the furniture and arranging magazines to washing the steriliser, mopping the linoleum floor and cleaning the backs of pictures and diplomas. As it turns out, cleaning was also a recurring motif in Kaprow's work, as a few selected examples demonstrate.

In an early 1962 happening entitled *Sweeping*, for example, visitors arrived in a clearing (in the woods) strewn with debris (figure 20); they watched as workmen figures armed with wheelbarrows dumped further junk on to the pile, before being ordered by the workmen to sweep up the clearing in turn. At one point children covered in sheets ran into the clearing and interrupted the cleaning; at another buckets of red paint were thrown on to the debris, and a screaming man suddenly jumped out of a junk pile – under which he had been buried all along. If the mythical connotations in this early happening such as references to youth (children) as well as rebirth (screaming man) would soon disappear from Kaprow's work, the ritualistic binary between dirtying and cleaning would survive in his later works. Among Kaprow's later activities, the 1965 *Soap*, for example, articulated a balancing rhythm between dirtying clothes (by urination) and washing them (in the sea, as well as in a Laundromat) on the first day, followed by a morning during which cars were dirtied with jam before being cleaned, and an evening when the same operation was enacted on the bodies of the performers, who would end up lying in the sea waiting for the tide to clean them. Although this happening was cancelled, one student performed it nevertheless, and sent his account to Kaprow. The student appears to have been touched by the ritualistic dimension of the score, and the 'presence, awareness, involvement' it had required, which he compared to a Zen experience of 'digging' the instant.[114] Stripped of any of the symbolic archetypes of the earlier *Sweeping* or *Soap*, the 1969 *Charity* – one of the artist's *Six Ordinary Happenings* – involved washing 'in all-night Laundromats' piles of old clothes bought from charity shops, before 'giving them back to used-clothing stores'.[115] Here washing is presented as an act of care, a brief interruption in the endlessly banal cycle of dirtying and cleaning laundry; it also acts to momentarily suspend the cycle of buying and selling in which the used-clothing stores participate.

Ten years later, Kaprow's *Standards* would focus on behaviours and manners relating to cleanliness, in the context of the artist's interest at the time in the *Presentation of Self in Everyday Life* described by Erwin Goffman in 1959. Turning his attention to rules of politeness, and the boundaries between the private and the public, Kaprow proposed in *Standards* an equivalence between 'tidying up' a 'messy place' and 'improving one's appearance', both mediated by photographs documenting states of 'before' and 'after'.[116] A final example, the 1981 *Meditation 1* involved sweeping and replacing dust, as well as raking and replacing leaves, in a score which implicitly referred

to traditional Zen stories such as that of Kyogen, who became enlightened when he heard the sound of a pebble hitting a bamboo as he was weeding and sweeping the ground.[117] At the time, Kaprow was more interested in Zen than ever, as he had started to practise regular meditation in a Buddhist centre on the West Coast.

This greater involvement confirmed Kaprow's interest in the relation between Zen and the everyday. As he explained: 'Zen's emphasis upon the ordinary, the common event, must be understood … as a recognition of the essential naturalness of *everything*: nature in all its parts *exists* and man, being part of nature, exists also.'[118] His later texts thus invite us to pay attention to everyday activities such as washing the dishes, brushing our teeth or making coffee in the morning. Art meant simply 'doing life, consciously'. And it is precisely by 'paying attention to this continuum' that art can become, according to Kaprow, an 'introduction to right living' – with nature, with others, and with oneself.[119]

Kaprow's reliance on language, like the 'leftover thoughts in the form of gossip' mentioned in relation to *Days Off*, crucially linked his investigations of useless work and daily labour to the collective, public sphere of action. As we saw in Chapter 1, Kaprow had argued as early as 1961 that his precarious happenings were associated to myths and rumours, like the stories that are told about an action, according to Arendt. With absurd activities such as the above-mentioned *Fluids*, this mythical, fable-like aspect of the happenings came to the fore. For example, Kaprow penned mock journalist articles speculating on the ice structures that appeared in Los Angeles during *Fluids* (figure 6). Were they an advertisement for a new type of 'throwaway house'? Propaganda for a 'civil rights' demonstration? Temples for a new 'religious sect'?[120] This 'gossip-mongering', as Kaprow called it,[121] not only further disseminated the artwork into the sphere of the everyday: it intersected with other actions, stories and experiences. A clear example of this operation, in my eyes, was Kaprow's 1970 *Sweet Wall* which was built in Berlin, close to the Berlin wall, with cement blocks bound together with bread and jam, before being toppled by the participants (figure 43). Just as a wall can be built and toppled, suggested Kaprow, 'symbols could be produced and erased at will'.[122] 'Useless work' opened a space for a new fable that intersected with a historical account.

'Be marginal'

The political character of the 'good-for-nothing' also came to the fore with the figure of the tramp. In Chapter 1, we encountered Beat vagrants and 'rucksack wanderers', as well as the San Francisco scavengers and the half-naked Mexican ragpicker who fascinated Bruce Conner. Similarly,

43 Allan Kaprow, *Sweet Wall*, Berlin 1970

Filliou's celebration of losers and mediocrity found him identifying himself as a 'nobody' urinating in public lavatories along with 'bums, drunks, and assorted nightbirds'.[123] The vagrant was perceived as the most radical drop-out, unable to find a place in a capitalist society where literally owning nothing could make one invisible, if not disposable. Furthermore, the aesthetics of the marginal constructions, objects and spaces that such figures created was a source of formal inspiration for precarious works in the 1960s. As Allen Ginsberg celebrated madmen pushing carts in the streets and sitting 'in boxes breathing in the darkness under the bridge' (in his 1955 poem *Howl*), Kaprow explained that his 1961 *Yard* was inspired by 'dumps, and the shanty-huts built by those strange madmen who divide their world with rats'.[124] When Hélio Oiticica sought to leave behind the language of geometric abstraction, the Brazilian artist was similarly moved by his encounters, in Rio de Janeiro, with the 'organic architecture' (*arquitetura orgânica*) of shanty towns, with the 'spontaneous, anonymous constructions' (*construções espontâneas, anônimas*) he found in the street,[125] which included those 'improvised' shelters or shacks built by beggars.[126]

For Oiticica, the street offered a precarious vocabulary of forms, characterised by spontaneity, improvisation, incompleteness, instability and the free appropriation of found objects. A photograph shows Oiticica and the artist Jackson Ribeiro coming across an intriguing tent, suspended from a telephone wire and covered in words, which resonated with Oiticica's *Parangolé* tents and capes mentioned in the previous chapter. Indeed, the

very word 'parangolé' (a *carioca* slang word suggesting a messy situation) was a found object in itself: Oiticica is said to have discovered it on a construction of wooden slats, ropes, barbed wire and burlap erected by a tramp on the Praça da Bandeira in Rio.[127] Samba costumes, *carnaval* and festival decorations provided other sources of inspiration for Oiticica. What shanty-town architecture, carnival decorations and homeless shelters shared was a combination of fragility and energy, derived from the will to construct something in a hasty and/or unskilled fashion, often driven by urgency or desire: they are all 'badly made' (to use Filliou's term) because their goal lies outside any artistic preoccupation with skill or talent. Similarly, Oiticica's *Parangolé* capes (figure 31), made out of casually sewn, glued and painted fabrics and materials, were not meant to be looked at: they were conceived, above all, to be worn by participants, who could move and dance in them.

This freedom of movement was encouraged by the loosely constructed heterogeneous structures of the *Parangolés*, whose folds, hidden pockets and banner-like extensions invited participants to discover them manually as well as visually. Oiticica found in *favela* architecture a model for such a 'structural organicity' (*organicidade estrutural*): there are no abrupt passages between the bedroom and the kitchen, he noted, but a continuity in the construction.[128] It was for the same reasons that Kaprow, in his 1966 *Assemblage, Environments & Happenings*, praised the outsider architecture of Clarence Schmidt in which 'space is slowly continuous and unwinding, rather than crisply delimited as in the usual house'.[129] Such alternative structures suggested a freer, more spontaneous use of space, allowing for improvisation. In her book on the relations between Oiticica's work and shanty-town architecture, Paola Berenstein singled out three formal characteristics shared by both: the fragment, the labyrinth and the rhizome. In Oiticica's *Parangolés*, as in Kaprow's early environments, the rhizomatic extension of architecture suggested the dissolution of fixed and stable forms, as they constantly evolve and disappear.[130]

As Kaprow shifted, as we saw, from environments and happenings to more minimal 'activities', he tried to focus on the experience shared by the participants, in the same way as the formal freedom of Oiticica's *Parangolés* was meant to be invested with the participants' *vivências* or lived experiences. Oiticica deemed that the feeling of freedom experienced by each wearer of the *Parangolé* could be the first step in a realisation of his or her creative potential, just as Filliou conceived his games and objects as so many types of 'mind openers'. As we saw in the previous chapter, for Oiticica, as for Lygia Clark, questioning fixed formal structures went hand in hand with subverting fixed rules. From 1964, Brazil was under the rule of a dictatorship, and such a search for freedom took on strong political undertones. Indeed, for Oiticica, a search for liberation in such circumstances could even justify violence. The 1966 *Bolide*

'Homage to Cara de Cavalo' (an outlaw whom Oiticica had known before he was gunned down by the police) embodied the artist's sympathy for such marginal criminals. Oiticica's 'anarchic attitude against all kind of armed forces', be they army or police, led him to condemn the shooting of Cara de Cavalo and to similarly celebrate another outlaw, Alcir Figueira da Silva, who chose to kill himself rather than be arrested during a bank robbery.[131] The image of Figueira da Silva's dead body was reproduced by Oiticica on a banner above the motto *seja marginal, seja herói* (be marginal, be a hero), which was displayed at the Sucata Club for a 1968 concert by Tropicalist musicians Caetano Veloso and Gilberto Gil. In a 1968 text about marginal 'anti-heroes', Oiticica compared common bandits such as Cara de Cavalo and Alcir Figueira da Silva to heroic historical figures such as the *cangaceiro* Lampião, the leader of the armed peasants who wreaked havoc in north-eastern Brazil between 1920 and 1940, as well as the most heroic of his contemporaries, according to him: Che Guevara. Such 'visceral, auto-destructive, suicidal' revolts 'against the fixed social context (social "status quo")' were all denunciations, according to Oiticica, of what is 'rotten' in society, and what needed to be radically changed.[132] On the evening of Veloso's and Gil's concert, the police tore down Oiticica's banner.

The motto on the banner made explicit the connection between marginality and freedom that was present in Oiticica's 1960s works. The precarious sphere of an 'art without art' had become for Oiticica an area in which marginality and liberation, fragility and energy, could be brought together. Oiticica's motto 'Da adversidade vivemos' ('on adversity we live', or 'thrive') – which he inscribed on one of his *Parangolé* capes, and included as the conclusion of a 1967 essay – celebrated the marginality of his country, and of Brazilian artists, in order to turn these weaknesses into a strength.[133] This process was also embodied in Oiticica's 1968 *Bed Bolides*, which may have been inspired by a shelter improvised by the homeless with cardboard boxes and a burlap bag, pictured in a newspaper clipping collected by Oiticica in 1968. In the *Bed Bolide*, a bed enclosed in a rectangular tent, the artist invited participants to lie down and experience a kind of purposeless drifting and contemplation. Daydreaming was also encouraged in Oiticica's 1969 *Eden*, an environment where participants were free to walk barefoot in sand or water, lounge about in areas covered in straw or leaves (figure 44), as well as sit in a tent listening to music by Veloso and Gil, or lie in a *Bed Bolide*.

To describe this open space of experience, Oiticica coined the concept of 'crelazer', or 'creleisure', a word that brings together leisure and creativity. *Eden* is a space free of all constraints, including that of producing, doing something, or even thinking in a rational way. In his texts on 'crelazer' and on *Eden*, Oiticica mused on a 'vagabond' lifestyle of laziness and pleasure, awakening our imagination, creativity and awareness of 'the salad of life' (*salada da vida*).[134] Referring to the experience of Zen enlightenment, Oiticica spoke of

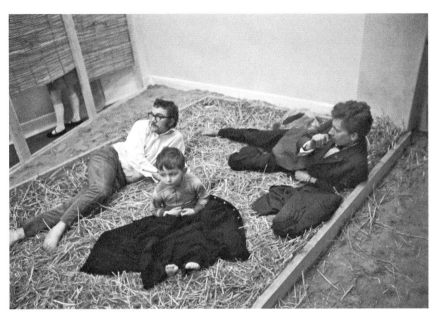

Hélio Oiticica, *B55 Area Bolide 2*, 1967. Installation in *Eden*, Whitechapel Gallery, London, **44**
1969

a 'revelation' of 'a new totality between self and the world' – his works aimed, above all, to transform their participants.[135] In this way, *Eden* offered exactly the 'non-repressive' conditions necessary to counter the repressive violence condemned by the artist in his celebration of marginal outlaws. After all, Alcir Figueira da Silva and Cara de Cavalo had died, according to the artist, because of their own 'desperate search for happiness; in opposition to false, established, stagnant social values'.[136]

Like Oiticica, Lygia Clark explored from the mid-1960s onwards an 'art without art' that focused less on objects than on experiences, as we saw in Chapter 2. Even more than Oiticica's roughly stitched capes and fragile shelters, the *Sensory Objects* begun by Clark in 1966 were very obviously 'badly made'. If Filliou's or Oiticica's assemblages were loosely crafted, and 'funk' artists stretched contemporary definitions of artistic skill, Clark's ordinary objects were barely modified at all. Plastic bags are filled with water or air and closed with elastic bands (figure 30); knots are tied in onion net bags and nylon tights; seashells, pebbles and pingpong balls are placed in these temporary pockets; a rubber tube is closed into a loop. The properties of these materials are only revealed through the participant's attentive sensory discovery, yielding sometimes contrasting sensations of weight, temperature and sound. As Suely Rolnik has observed, this kind of 'fragile, rudimentary and badly defined form' resists an overall objectifying 'apprehension'.[137] Instead,

they call for a 'micro-perception' of 'textures and continual metamorphoses' that resemble our bodies' 'sensual rhythms', like breathing.[138] Thus, argues Rolnik, such objects not only resisted an easy assimilation into the alienating regime of the commodity: they also encouraged participants to encounter the 'micro-sensoriality' of what she calls their 'vibratile' bodies. With her *Sensory Objects* and subsequent collective experiments, Clark set up a sphere of sensory experience in which participants were invited to discover their relations to a repressed bodily subconscious, as well as a lost relationship to nature, play and their own 'sensory potential'. Access to these sometimes powerful, even frightening, experiences could help participants liberate themselves from fixed patterns, and open themselves to the world around them. Similarly, Oiticica explained that madness could result from the conformism of 'not experimenting', of experiences that are 'dead' because they are totally regimented and repressed.[139] Instead, Oiticica wanted to offer participants the means to experience 'a continuous transformation'. Clark likewise wished to offer 'an exercise' so that each participant can 'live in a deeper, freer way'.[140]

Although the term 'adversity' implies a confrontational stance distinct from the gesture of supplication at the heart of the 'precarious', Oiticica's motto 'on adversity we thrive' described a process of dynamic negotiation similarly embodied in Clark's desire to 'live on the basis of the precarious'. Just as Oiticica inscribed his programme of liberation within heroic acts such as Che Guevara's, Clark perceived in the 1968 student revolts across the world the 'same existential attitude' that she was exploring in her own works.[141] For his part, Filliou suggested in *Teaching and Learning as Performing Arts* that his thinking had prefigured the student movement's revolt in May 1968 in Paris. For Filliou, students in 1968 had protested against the alienation produced by a general 'overspecialisation … loss of creativeness, lack of a gift for living'.[142] Their rebellion was driven by a 'lack of training in self-expression', and the absence 'of ways to keep the system at bay'. According to Filliou, 'professional artists must participate in the collective dreams' of their times. Such collective dreams were none other than 'SOCIAL REVOLUTION, SEXUAL REVOLUTION and POETICAL REVOLUTION'.

What Clark, Oiticica and Filliou shared with Maciunas's theorisation of Fluxus, and even Kaprow's reflections on the 'un-artist', was the belief that their marginal practices would come to disappear once society had changed. This is where, ultimately, their practices are at their most precarious. The blurry line between art and the everyday, between art and play, between art and self-discovery, is embodied in the 'borderline' status of their art objects – intangible experiences conveyed through barely material assemblages, photographic documents, scores, texts and publications (including Something Else Press books and Fluxkits, as well as Kaprow's posters or *Days Off* calendar). Brecht's and Knowles's *wu-wei* aesthetic certainly suggested this potential

disappearance without articulating it explicitly, while Nauman and Marioni located their transitional experimentations with incompetence and idleness within more recognisable frameworks such as the studio and the café, respectively. The formal and political spectrum of late 1960s practices covered in this chapter is certainly wide, since it ranges from redefinitions of sculptural quality in funk art to Knowles's poetic attention to everyday experiences, from Kaprow's celebration of play to Oiticica's and Filliou's revolutionary projects. What is common to all these practices is their recourse to art to interrogate the ways in which work, labour and action structure our lives.

In communist societies, Marx predicted in his 1844 *German Ideology*, people would no longer be constrained to one profession, and the division between work and leisure would disappear. One would be able 'to do one thing today and another tomorrow, to hunt in the morning, fish in the afternoon, rear cattle in the evening, criticize after dinner'.[143] There would no longer be any professionals: only amateurs. As Chris Gilbert has pointed out, Marx's youthful vision (suppressed in his later work) was revived in the 1960s writings of Herbert Marcuse, who dreamed of a society in which technology would satisfy all needs, and individuals could dedicate themselves to 'self-fulfilling activities'. Only 'the end of an unnecessary social system based on repression and exploitation' as well as 'a new sensibility' were required to bring about this radical change.[144] The works of Marioni, Filliou and Kaprow, like Fluxus practices and the books published by the Something Else Press, actively participated in both the critique of the exploitative, repressive order of capitalist work, and the promotion of this 'new sensibility'. As Filliou indicated after the bankruptcy of the *Cédille qui sourit*, artists would continue to 'spread' the 'spirit' of permanent creation in an 'eternal network' extending beyond any specific location.[145] Indeed, in spite of their differences and divergences, all the practices discussed in this chapter could be seen to be participating in this late 1960s 'eternal network'.

Citing the same passage by Marx in her 1958 study *The Human Condition*, Arendt warned, however, that transforming work into 'hobbies' risked isolating people within 'strictly private' 'activities'.[146] This would thus further imperil the 'public realm' required for action, already threatened by the relentless cycles of production and consumption.[147] Venturing into the field of leisure, the artist could indeed run the risk becoming yet another type of consumer, or, as Lygia Clark remarked in a 1971 text, a potential 'engineer of leisure', participating in an increasingly prominent service industry.[148] It is in this sense, I believe, that the insertion of such borderline activities within a socialised sphere of speech, ideas and interactions was essential. Thus, when Filliou defined 'poetry' as 'the creative use' of 'leisure', or when Oiticica celebrated 'creleisure', they were thinking less of entertainment than of the 'freedom of spirit', imagination and creativity that free time could

encourage.[149] Both Lygia Clark and Hélio Oiticica explicitly situated the lived experiences mobilised in their works as alternatives to the 'fake' experiences of the leisure industry. Similarly, as Rosemarie O'Neill put it, Brecht and Filliou 'engaged' with the *Cédille qui sourit* 'in a form of utopian leisure, where work and play were integrated into a poetic of the everyday'.[150] The 'good-for-nothing' not only resisted an alienating field of productivity and work: he or she also tried to check the advances of these alienating forces into the field of leisure, by transforming this free time into a space of action and creation rather than consumption.

In a 1961 text, Arendt compared the 'space of appearances' of political action and speech that she had outlined in *The Human Condition* to the stage required by performing artists: 'Performing artists, dancers, play-actors, musicians, and the like need an audience … just as acting men need the presence of others before whom they can appear … both depend upon others for the performance itself.'[151] Significantly, she noted that 'Such a space of appearances is not to be taken for granted wherever men live together in a community.' Indeed, such spaces could be threatened by the exclusive channelling of human activities into the cycles of production and consumption typical of capitalism. The artists discussed in this chapter, I would argue, sought to locate new spaces of appearance within the marginal spaces and wasted time of doing nothing. Thus they developed practices at the intersection of poetry and politics, which – like the performing arts as well as action – 'depend on the presence of others' in order to appear and take shape.

Notes

1 Robert Goodnough, 'Pollock Paints a Picture', *Artnews*, 50:3 (1951), http://www.artnews.com/2012/11/26/pollock-paints-a-picture/ (accessed 9 May 2015).

2 Thomas H. Garver [Bruce Conner], 'Bruce Conner Makes a Sandwich', *Artforum*, 6:1 (1967), p. 51. Kevin Hatch believes that Conner, rather than Garver, wrote the article. Kevin Hatch, *Looking for Bruce Conner* (Cambridge, MA: MIT Press, 2012), p. 23.

3 Thomas H. Garver, *Bruce Conner: Sculpture/Assemblages/Drawings/Films* (Waltham, MA: Brandeis University, 1965), n.p.

4 Hatch, *Looking for Bruce Conner*, p. 25.

5 Paul Karlstrom, 'Oral history interview with Bruce Conner, 12 August 1974'. Archives of American Art, Smithsonian Institution, Washington.

6 Peter Selz, 'Notes on Funk', in Peter Selz (ed.), *Funk* (Berkeley: University of California Press, 1967), p. 3.

7 Elizabeth C. Baker and Joseph Raffaele, 'The Way-Out West: Interviews with Four San Francisco Artists', *Art News*, 66:4 (1967), 39.

8 Robert Filliou, *Teaching and Learning as Performing Arts* (Cologne and New York: Koenig, 1970), p. 200.

9 *Ibid.*, p. 199.

10 George Maciunas, 'Neo-Dada in Music, Theater, Poetry, Art' (1962), in Achille Bonito Oliva (ed.), *Ubi Fluxus ibi motus 1990–1962* (Venice: Biennale, 1990), p. 216.

11 George Maciunas, 'Fluxus Manifesto' (1963), in Jacquelynn Baas (ed.), *Fluxus and the Essential Questions of Life* (Hanover, NH, and Chicago: Hood Museum of Art, Dartmouth College, and University of Chicago Press, 2011), p. 22.

12 George Maciunas, 'Fluxus Broadside Manifesto', in Bonito Oliva (ed.), *Ubi Fluxus*, p. 219.

13 Jacquelynn Baas, 'Introduction', in Baas (ed.), *Fluxus and the Essential Questions of Life*, p. 8.

14 This stamp is referred to by Ken Friedman, 'Fluxus: A Laboratory of Ideas', in Baas (ed.), *Fluxus and the Essential Questions of Life*, p. 36.

15 Alison Knowles, interview with the author, New York, 17 March 2011.

16 Estera Milman, 'Road Shows, Street Events and Fluxus People: A Conversation with Alison Knowles', in E. Milman (ed.), *Fluxus: A Conceptual Country*, special issue of *Visible Language*, 26:1–2 (1992), 103.

17 *Ibid.*, 104.

18 *Ibid.*, 103.

19 *Ibid.*

20 Recounted in D.T. Suzuki, *Zen Buddhism: Selected Writings of D.T. Suzuki*, ed. William Barrett (New York: Doubleday, 1956), p. 207.

21 Alison Knowles, 'Introduction', in Philip Corner, *The Identical Lunch* (San Francisco: Nova Broadcast Press, 1973), n.p.

22 These notes were exchanged on cards that are reproduced in Alison Knowles, *Journal of the Identical Lunch* (San Francisco: Nova Broadcast Press, 1971), n.p.

23 Kristine Stiles, 'Tuna and Other Fishy Thoughts on Fluxus Events', in Cornelia Lauf and Susan Hapgood (eds), *FluxAttitudes*, exh. cat. Buffalo, Hallwalls Contemporary Arts Center, Buffalo (Gent: Imschoot, 1991), p. 27.

24 Hannah Higgins, 'Food: The Raw and the Fluxed', in Baas (ed.), *Fluxus and the Essential Questions of Life*, p. 15.

25 Robert Filliou, 'Yes – an Action Poem', in *A Filliou Sampler* (New York: Something Else Press, 1967), p. 8.

26 Alan W. Watts, *The Way of Zen* (1957) (London: Thames and Hudson, 1958), p. 134.

27 Wolfgang Becker, 'Interview with Robert Filliou', in *Robert Filliou: Commemor* (Aachen: Neue Galerie im Altern Kunsthaus, 1970), n.p.

28 Filliou, *Teaching and Learning*, p. 79.

29 *Ibid.*, p. 199.

30 George Brecht and Robert Filliou, *Games at the Cedilla; or, The Cedilla takes off* (New York: Something Else Press, 1967), n.p.

31 Filliou, *Teaching and Learning*, p. 84.

32 *Ibid.*, p. 45.

33 *Ibid.*, p. 69.

34 *Ibid.*, pp. 74, 12.

35 *Ibid.*, p. 19.

36 *Ibid.*, p. 69.

37 *Ibid.*, p. 24.

38 Watts, *The Way of Zen*, p. 19.

39 Filliou, *Teaching and Learning*, p. 46.

40 George Maciunas, 'Letter to Tomas Schmit, January 1964', in Emmett Williams and Ann Nöel (eds), *Mr. Fluxus: A Collective Portrait of George Maciunas, 1931–1978* (London, Thames and Hudson, 1997), p. 103.

41 *Ibid.*, p. 104.

42 Natilee Harren, 'La Cédille qui ne finit pas: Robert Filliou, George Brecht and Fluxus in Villefranche (deregulated version)' (2012), http://www.artandeducation. net/paper/la-cedille-qui-ne-finit-pas-robert-filliou-george-brecht-and-fluxus-in-villefranche/ (accessed 9 May 2015).

43 Hannah Arendt, *The Human Condition* (1958) (Chicago: University of Chicago Press, 2nd edn, 1998), p. 170.

44 Steven Harris, 'The Art of Losing Oneself without Getting Lost: Brecht and Filliou at the Palais Idéal', *Papers of Surrealism*, 2 (Summer 2004), 7.

45 Joseph Raffaele, 'Interview with William Wiley', in 'The Way-Out West', 73.

46 See Graham W.J. Beal, 'The Beginner's Mind', in G.W.J. Beal et al., *Wiley Territory* (Minneapolis: Walker Art Center, 1979), p. 21.

47 Shunryu Suzuki, *Zen Mind, Beginner's Mind: Informal Talks on Zen Meditation and Practice*, ed. Trudy Dixon (1970) (London and Boston: Weatherhill, new edn, 1999), p. 75.

48 Joseph Raffaele, 'Introduction', in 'The Way-Out West', 39.

49 *Ibid.*, 67.

50 Joseph Raffaelle, 'Interview with Bruce Nauman', in 'The Way-Out West', 40.

51 Raffaele, 'Introduction', 67.

52 *Ibid.*, 66–7.

53 Filliou, *Teaching and Learning*, p. 77.

54 *Les choses n'étaient pas vues séparément comme extraordinaires ou comme ordinaires, mais plutôt comme un continuum de banalité.* Benjamin Patterson, quoted in French by Pierre Tillman, *Robert Filliou: nationalité poète* (Dijon: Presses du Réel, 2006), p. 161.

55 'Everything is Best', in Paul Reps, *Zen Flesh Zen Bones* (Garden City, NY: Doubleday, 1961), p. 32. Also recounted in Filliou, *Teaching and Learning*, p. 213.

56 Becker, 'Interview with Robert Filliou', n.p.

57 John Coplans, 'Circle of Styles on the West Coast', *Art in America*, 52 (June 1964), 30.

58 Selz, 'Notes on Funk', p. 3.

59 Raffaele, 'Introduction', 66.

60 Nauman, quoted in Jane Livingston, 'Bruce Nauman', in J. Livingston and Marcia Tucker, *Bruce Nauman: Works from 1965 to 1972* (Los Angeles and New York: Los Angeles County Museum of Art and Praeger, 1972), p. 10.

61 Karlstrom, 'Oral history interview with Bruce Conner'.

62 Raffaele, 'Introduction', 39.

63 Interview with the author.

64 Lucy Lippard, *Six Years: The Dematerialization of the Art Object from 1966 to 1972* (1973) (Berkeley: University of California Press, new edn, 1997), p. 23.

65 Raffaele, 'Interview with Wiley', 40.

66 *Ibid.*, 72.

67 Joseph Raffaele, 'Interview with William Geis', in 'The Way-Out West', 73.

68 William T. Wiley, interview with the author, Washington, DC, 3 October 2009.

69 'Funk' artist James Melchert remembered both him and Nauman reading Robbe-Grillet and Nauman being quite 'attracted' to Spoerri's *Anecdoted Topography of Chance*. Renny Pritikin, 'Oral history interview with James Melchert', 18 September 2002, Archives of American Art, Smithsonian Institution. In an interview, Robbe-Grillet, who was working at the Editions the Minuit at the time, remembered that he 'wanted' them to publish *An Anecdoted Topography of Chance*, but they refused. 'I was very interested in his book at the time and we had a lot of discussions.' Hans-Ulrich Obrist, 'Interview with Alain Robbe-Grillet' (2001/2004), in *Interviews, volume 2* (Milan: Edizioni Charta, 2010), p. 184.

70 The reference to Filliou was added to the title in the English version. See Daniel Spoerri, *An Anecdoted Topography of Chance* (1962–66) (London: Atlas Press, 1995).

71 *Ibid.*, p. 23.

72 It was made in March 1962. See *ibid.*, p. 203.

73 *Ibid.*, p. 81.

74 *Ibid.*, p. 209.

75 Nauman quoted in Livingston, 'Bruce Nauman', p. 15.

76 See Phil Weidman, *Slant Step Book* (Sacramento, CA: The Art Co., 1969); and Price Amerson and Cynthia Charters, *The Slant Step Revisited* (Davis, CA: Richard L. Nelson Gallery, University of California Davis, 1983).

77 Anne M. Wagner, 'Nauman's Body of Sculpture', in Constance M. Lewallen (ed.), *A Rose Has No Teeth: Bruce Nauman in the 1960s* (Berkeley: University of California Press, 2007), p. 124.

78 Nauman quoted in Marcia Tucker, 'Bruce Nauman', in Livingston and Tucker, *Bruce Nauman*, p. 31.

79 Ian Wallace and Russel Keziere, 'Bruce Nauman Interviewed, 1979 (October 1978)', in *Please Pay Attention Please: Bruce Nauman's Words: Writings and Interviews*, ed. Janet Kraynak (Cambridge, MA: MIT Press, 2002), p. 194.

80 Michele de Angelus, 'Interview with Bruce Nauman, May 27 and 30, 1980', in *ibid.*, p. 267.

81 Anne Wagner, 'Henry Moore's Mother', *Representations*, 65 (Winter 1999), 94.

82 Coosje van Bruggen, *Bruce Nauman* (New York: Rizzoli, 1988), p. 50.

83 Willoughby Sharp, 'Interview with Bruce Nauman, 1971 (May 1970)', in *Please Pay Attention Please*, p. 115.

84 Lucy Lippard, 'Eccentric Abstraction' (1966), quoted in Wagner, 'Nauman's Body of Sculpture', p. 122.

85 Mel Bochner, 'Eccentric Abstraction' (1966), quoted in *ibid.*, p. 124.

86 Wagner, 'Nauman's Body of Sculpture', p. 124.

87 Gunvor Nelson and Dorothy Wiley (dirs), *Five Artists: BillBobBillBillBob* (San Francisco: Canyon Cinema, 1971). 16mm film, 70 min.

88 Tom Marioni, 'Definition of Conceptual Art' (1970), in *Writings on Art, 1969–1999* (San Francisco: Crown Point Press, 2000), p. 10.

89 Tom Marioni, *Beer, Art, and Philosophy: A Memoir* (San Francisco: Crown Point Press, 2003), p. 118; Guillaume Désanges and Tom Marioni, 'Tom et moi (exchanging emails with a stranger is the highest form of art criticism)', *Trouble*, 6 (2006), 231; Tom Marioni, interview with the author, San Francisco, 8 January 2009.

90 Roger Shattuck, *The Banquet Years; The Arts in France, 1885–1918: Alfred Jarry, Henri Rousseau, Erik Satie, Guillaume Apollinaire* (London: Faber and Faber, 1958), p. 11.

91 *Ibid.*, p. 68.

92 *Ibid.*, p. 297.

93 Désanges and Marioni, 'Tom et moi', 131.

94 Filliou, *Teaching and Learning*, p. 73.

95 Désanges and Marioni, 'Tom et moi', 134.

96 Tom Marioni, interview, January 2009, http://www.guggenheim.org/new-york/exhibitions/video/past-exhibition-videos/interview-with-tom-marioni (accessed 5 June 2009).

97 Kaprow, 'Preface', in *Days Off* (New York: Museum of Modern Art, 1969), reprinted in Eva Meyer-Hermann, Andrew Perchuk and Stephanie Rosenthal (eds), *Allan Kaprow – Art as Life* (Los Angeles and London: Getty Research Institute and Thames and Hudson, 2008), p. 212.

98 Richard Schechner, 'Extensions in Time and Space: An Interview with Allan Kaprow', *The Drama Review*, 12:3 (1968), 153.

99 Allan Kaprow, 'Pinpointing Happenings' (1967) and 'Participation Performance' (1977), in *Essays on the Blurring of Art and Life* (Berkeley: University of California Press, 1993), pp. 88, 186.

100 Richard Kostelanetz, [Conversation with Allan Kaprow], in *The Theater of Mixed Means: An Introduction to Happenings, Kinetic Environments, and Other Mixed-Media Performances* (New York: Dial Press, 1968), p. 121.

101 The handwritten score is reproduced in *Allan Kaprow – Art as Life*, p. 202.

102 This expression is used by Kaprow in notes for a talk concerning the work *Runner*, around February 1968. The notes are reproduced in *ibid.*, p. 198.

103 Score for *Course*, May 1969, reprinted in *ibid.*, p. 209.

104 Arendt, *Human Condition*, p. 106.

105 Allan Kaprow, quoted in Thomas Albright, 'What would happen if…?', *San Francisco Examiner & Chronicle*, 18 May 1969, p. 38.

106 Allan Kaprow, quoted by William Simbro, 'Dig Ditches to Hail Debut of Museum', *Des Moines Register*, 10 May 1969, p. 3.

107 Allan Kaprow, 'The Education of the Un-Artist, Part II' (1972), in *Essays on the Blurring of Art and Life*, p. 122.

108 *Ibid.*, pp. 121, 119.

109 *Ibid.*, p. 125.

110 *Ibid.*, p. 122.

111 Filliou, *Teaching and Learning*, p. 200.

112 Allan Kaprow, 'Interview with Robert Filliou', in *ibid.*, p. 127.

113 Los Angeles, Getty Research Institute, Allan Kaprow Papers, Box 34, Folder 6.

114 Letter from Robert Carter, student at Florida State University, regarding his performance of *Soap* (1965). Allan Kaprow Papers, Box 9, Folder 6.

115 The poster (with scores) for *Six Ordinary Happenings* is reproduced in *Allan Kaprow – Art as Life*, p. 207.

116 Score in *ibid.*, pp. 273–4.

117 Score in *ibid.*, p. 178. The tale of Kyogen is recounted in D.T. Suzuki, *Introduction to Zen Buddhism* (New York: Grove, 1964), p. 91.

118 Unpublished typed manuscript, entitled 'Zen Buddhism and the American Avant-garde', n.d., p. 2. Allan Kaprow Papers, Box 49, Folder 13.

119 'Performing Life' (1979), in *Essays on the Blurring of Art and Life,* pp. 195, 196; 'Right Living' (1987), in *ibid.*, p. 225.

120 Handwritten notes, Allan Kaprow Papers, Box 12, Folder 9.

121 Kostelanetz, conversation with Kaprow, p. 118.

122 Statement in *Sweet Walls/Testimonials* (Berlin: Editions Rene Block, 1976), reprinted in *Allan Kaprow – Art as Life*, p. 187.

123 Filliou, *Teaching and Learning*, p. 69.

124 Untitled statement for *Environments, Situations, Spaces* (New York: Martha Jackson Gallery, 1961), n.p.

125 Hélio Oiticica, 'Tropicália, 4 de Março de 1968', in Guy Brett et al., *Hélio Oiticica* (Paris: Galerie nationale du Jeu de Paume, 1992), p. 124. (My translations from the Portuguese in this French/Portuguese version of the catalogue.)

126 Hélio Oiticica, 'Bases fundamentais para uma definição do *Parangolé*' (1964), in *ibid.*, p. 87.

127 Hélio Oiticica 'Interview with Jorge Guinle Filho' (1980), quoted by Celso Favaretto, *A invenção de Hélio Oiticica* (São Paulo: Editora da Universidade de São Paulo, 1992), p. 117.

128 *Ibid.*

129 Allan Kaprow, *Assemblage, Environments & Happenings* (New York: Harry N. Abrams, 1966), p. 170.

130 Paola Berenstein Jacques, *A estética da ginga – a arquitetura das favelas através da obra de Hélio Oiticica* (Rio do Janeiro: Casa da Palavra and Rioarte, 2001).

131 [Untitled texts], in *Hélio Oiticica* (London: Whitechapel Gallery, 1969), n.p.

132 Hélio Oiticica, 'O Heroi anti-heroi et o anti-heroi anônimo' (25 March 1968). Unpublished typescript. Hélio Oiticica archives, Projeto Hélio Oiticica, Rio de Janeiro. My thanks to Ariadne Figueiredo for sending me this text.

133 For more on this motto and this process of reversal, see my 'How to Live Precariously: Lygia Clark's Caminhando and Tropicalism in 1960s Brazil', *Women & Performance: a journal of feminist theory*, 23:2 (2013), special issue on 'Precarious Situations: Race, Gender, Globality', edited by Tavia Nyong'o, 12–18.

134 See, for example, 'Crelazer', an unpublished manuscript dated 14 January 1969. Hélio Oiticica archives.

135 [Untitled texts], in *Hélio Oiticica*, 1969, n.p.

136 Hélio Oiticica, 'Parangolé: da antiarte às apropriações ambientais de Oiticica – Posição e Programa' (1966), in Hélio Oiticica, *Aspiro ao Grande Labirinto*, ed. Luciano Figueiredo et al. (Rio de Janeiro: Rocco, 1986), p. 82.

137 *une forme fragile, rudimentaire et mal définie.* Suely Rolnik, 'Enfin, qu'y a-t-il derrière la chose corporelle?', in Corinne Diserens (ed.), *De l'œuvre à l'événement: Nous sommes le moule. A vous de donner le souffle* (Nantes and Dijon: Musée des beaux arts et Presses du Réel, 2005), p. 19.

138 *dont les textures et les métamorphoses continuelles engendrent des rythmes corollaires aux rythmes sensuels. Ibid.*

139 Hélio Oiticica, 'The Plot of the Earth that Trembles: The Avant-garde Meaning of the Bahian Group' (1968), in Carlos Basualdo (ed.), *Tropicália: A Revolution in Brazilian Culture, 1967–1972* (Chicago: Museum of Contemporary Art, 2006), p. 253.

140 *Isso um exercicio para que éle … vivesse de uma maneira mais profunda, mais livre.* Bruno Paraiso, 'Lygia Clark: a coragem e a magia de ser contemporâneo', *Correio da Manhã*, 10 November 1971, p. 1.

141 Lygia Clark, 'Estamos domesticados?' (1968), in Guy Brett et al., *Lygia Clark* (Marseilles: Musée d'Art Contemporain, 1997), p. 233.

142 Note from 1967, in Filliou, *Teaching and Learning*, p. 19.

143 Marx and Engels, *German Ideology*, quoted by Chris Gilbert, 'Herbie Goes Bananas: Fantasies of Leisure and Labor from the New Left to the New Economy', in Helen Molesworth (ed.), *Work Ethic* (Baltimore and University Park, PA: Baltimore Museum of Art and Penn State University Press, 2003), p. 70. This same passage is quoted, in another translation, by Arendt, *Human Condition*, note 65, p. 118.

144 Gilbert, 'Herbie Goes Bananas', p. 71.

145 Filliou, *Teaching and Learning*, p. 203.

146 Arendt, *Human Condition*, p. 118.

147 *Ibid.*, p. 117.

148 *ingénieur des loisirs du futur.* Lygia Clark, 'L'Homme, structure vivante d'une architecture biologique et cellulaire' (1971), in Brett et al., *Lygia Clark*, p. 248.

149 Filliou, *Teaching and Learning*, pp. 14, 24.

150 Rosemary O'Neill, *Art and Visual Culture on the French Riviera, 1956–1971: The Ecole de Nice* (Aldershot and Burlington, VT: Ashgate, 2012), p. 154.

151 Hannah Arendt, *Between Past and Future: Six Exercises in Political Thought* (New York; Viking, 1961), p. 154.

The light years, 1991–2009

At the 1993 *Aperto* group show at the Venice Biennale, Mexican artist Gabriel Orozco installed an empty white shoebox in the space that he had been allocated (figure 45). Every time he placed it on the ground, it was removed and thrown out as trash. Orozco responded by keeping a large number of replacement boxes at hand. On the day of the opening, oblivious visitors accidentally kicked the box around as they were looking for the art. When exhibition curator Francesco Bonami suggested to Orozco that he glue down his *Empty Shoe Box* to avoid this, the artist refused, arguing that the box would be 'most likely to survive' if it did not offer resistance to kicks.[1] Paris-based Swiss artist Thomas Hirschhorn also used the term 'survival' when he declared in 1994 that he liked his work to 'fight for its own existence', to 'defend itself in any surroundings', in any difficult situation.[2] In 1992, for example, he displayed some of his works – cardboard sheets adorned with variously arranged pasted lines and shapes – leaning against a wall in the street. Would a passerby come along and take one home? The photographs of *Jemand kümmert sich um meine Arbeit* show how dustmen disposed of the works (figure 46).

When the New York Museum of Modern Art acquired British artist Martin Creed's 2000 *Work No. 227*, which simply involves the lights in a room turning on and off at five-second intervals, I watched as many museum visitors walked right through without even registering the work's presence, just as visitors had trampled Orozco's *Empty Shoe Box*. First conceived in 1995 (*Work No. 127*, at 30-second intervals), this work arose from the artist's desire to 'balance the making of something and the not making of something':[3] the room is left as it is, nothing has been added. Francis Alÿs's 1997 'paradox of practice' – 'sometimes doing something leads to nothing' and 'sometimes doing nothing leads to something' – embodied a similarly dynamic movement. The 1997 video entitled *Paradox of Praxis I* shows the Belgian artist pushing a block of ice through the streets of the Mexico City neighbourhood where he works, until it melted (figure 47, and cover image).[4] Creed's work exists in the binary movement between the lights going on and off, just as Alÿs's performance operates in the interval between the moment where he

45 Gabriel Orozco, *Empty Shoe Box*, 1993

started to push the rectangular block of ice and the moment at which it is reduced to a small puddle, about to evaporate.

Like Creed and Alÿs, Hirschhorn and Orozco focused on what the latter termed the 'moment between appearance and disappearance': the moment, however brief and ephemeral, during which an object exists as an independent identity.[5] All these four artists, I would like to argue, were interested in plumbing the interval between something and nothing in their works in the 1990s. The terms used to describe such works often directly recall the 'borderline'

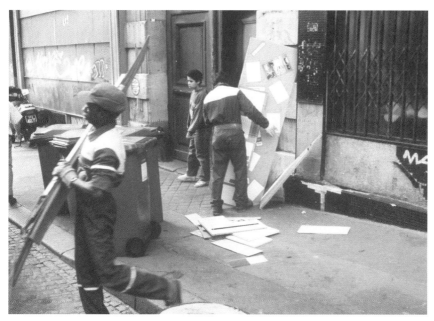

a and b: Thomas Hirschhorn, *Jemand kümmert sich um meine Arbeit*, Paris, 1992 **46**

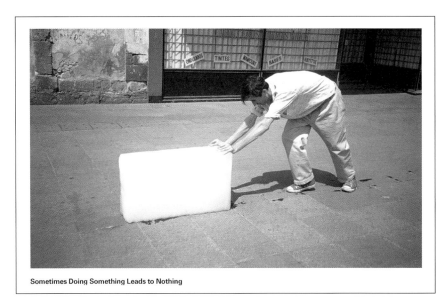

Sometimes Doing Something Leads to Nothing

47 Francis Alÿs, *Paradox of Praxis I*, Mexico City, 1997

space outlined by George Brecht, as we saw in Part I. Briony Fer, for instance, remarked of Creed's works that: 'There could hardly be less to them, yet there are still things to be looked at. It is as if they become art by accident.'[6] Similarly, Jean Fisher had observed in 1993 that Orozco's work 'is sometimes so discreet that it almost seems not to be there – the inattentive might easily miss it'.[7] Indeed, a number of Fisher's terms resonate directly with those used by Brecht to describe 'borderline' art. For example, she wrote that 'Orozco's is a practice of considerable reticence'[8] – a feature explicitly listed by Brecht as a character-istic of this art 'verging on the imperceptible'. Just as Brecht, as we saw, asked whether art could 'still be art' when its boundaries as an identifiable form were stretched to extend to the everyday, Fisher noted that Orozco's work raised the question of 'what may constitute the limit of recognisability of a work – that unstable border between something and nothing, order and chaos'.

The indeterminate borderline space between value and detritus, between the perceptible and the imperceptible, between doing something and doing nothing, is, of course, that of the precarious works developed in the 1960s, as we have seen in the first part of this study. Orozco's or Hirschhorn's use of fragile materials like cardboard may recall the junk aesthetic of the late 1950s (see figure 19), or Clark's paper *Caminhando* (figure 29), while Creed's work could be a realisation of Brecht's 1961 score for *Three Lamp Events* mentioned in Chapter 2. Alÿs's *Paradox of Praxis* involves the same kind of 'useless work' staged by Kaprow from the mid-1960s – the use of an ice block naturally brings to mind the ice structures of Kaprow's 1967 *Fluids*, which similarly

required some effort (in their construction), before being left to melt (figure 6). This chapter will bring out such similarities by accounting for the return to precarious practices in the years between 1991 and 2008, as well as pointing to some of the shifts and ruptures that have intervened between this period and the 1960s, in tune with socio-political developments. Rather than specific one-to-one comparisons between the two periods, however, I will analyse some of the characteristics of the borderline interval that preoccupied artists in the 1990s. Thus I will try to trace the changing contours of what Lawrence Alloway described as the 'expanding and disappearing' work of art when it emerged in the 1960s, as they were further shaped by artists at the turn of the twenty-first century.

The shifting values of dematerialisation during this period will be situated in the context of what sociologist Zygmunt Bauman described in 2000 as 'liquid modernity'. As I noted in the introduction to this book, the advent of this 'fluid modernity' effected, according to Bauman, 'profound changes to the human condition'.[9] Not only was Arendt's 1958 study cited, as I mentioned earlier, by thinkers of these changes such as André Gorz, Giorgio Agamben and Judith Butler. The term 'human condition' itself also came to be casually used by artists such as Hirschhorn and Alÿs.[10] How, then, did this 'human condition' evolve since the 1960s? How and why did artists show interest in such questions at the turn of the millennium? In this chapter, I will situate the 'borderline' works of these four artists in relation to updated versions of Arendt's critique of the increasing abstraction of relations between individuals, and of human interactions with nature.

The 'return of the real'

Recalling Orozco's *Empty Shoe Box*, Francesco Bonami suggested that it stood as an example of the practices developed by a 'generation of artists that emerged after the Black Monday crash in the financial markets in 1987' and that conceived 'art as a way of living rather than a production of objects'.[11] *Empty Shoe Box* at Aperto in 1993 was nothing less than 'a monument to now', according to Bonami; it 'glorified in their momentary existence' both the 'now' and the 'everyday'. One year later, Orozco would exhibit a single (transparent, round) yoghurt lid on each of the four walls of the otherwise empty Marian Goodman Gallery in New York. The artist's photographs, begun in 1990, revealed a similar vocabulary of the 'momentary' everyday. One image, for example, shows a burst football filled with water (*Pinched Ball*, 1993), while in another can be detected circular tyre marks left on the tarmac by a bicycle driving through a puddle (*Extension of Reflection*, 1992) (figure 48).

According to Bonami, Rirkrit Tiravanija's 1992 *Untitled (Free)* at the 303 Gallery in New York heralded a similar return to the everyday. Turning the

48 Gabriel Orozco, *Extension of Reflection*, 1992

exhibition into an event, the Thai artist moved the gallery offices into the main exhibition space and used the back rooms to serve Thai food to visitors, leaving the cooking material on display when he was absent. The parallel between Tiravanija's meals and Marioni's 1971 *The Act of Drinking Beer with Friends is the Highest Form of Art* (see figure 42), as well as the Zen-inflected celebration of the 'now' and of art as a 'way of living' in Bonami's analysis or in Tiravanija's statements, certainly call to mind the 1960s precarious practices.

French critic Nicolas Bourriaud's 1998 collection of essays, entitled *Esthétique relationnelle*, explicitly inscribed the work of Tiravanija, Orozco and other 1990s artists in the lineage of 1960s practices such as those of Fluxus. This new generation of artists, argued Bourriaud, were producing works that served in a 'concrete' way to connect people; such practices sought to operate in the participants' here and now, their 'real' space and time, their everyday life.[12] Similarly, some critics observed a return to the 'banal' or the 'derisory' at the turn of the twenty-first century,[13] while others noted a renewed interest in assemblage, *bricolage* and the makeshift.[14]

In a 2008 anthology, Stephen Johnstone commented on the 'widespread appeal of the quotidian to curators and artists' since the mid-1990s. A desire to focus on an overlooked everyday that 'exists below the threshold of the noticed', and to bring art closer to everyday life, were some of the characteristics of this interest, highlighted by Johnstone, that harked back to the 1960s 'borderline' practices that we looked at in Part I.[15] Another feature singled

out by Johnstone was a general 'distrust of the heroic and the spectacular'. Indeed, some works in the 1990s presented themselves as modest, humble, anti-heroic, anti-monumental.[16] In Orozco's photograph of an *Island within an Island* (1993), found debris casually propped in a line against a concrete road block offers a gentle parody of the spectacular Manhattan skyline behind it, which included at the time the monumental Twin Towers visible in the image. Similarly, from 1997 onwards, Hirschhorn erected his anti-monumental *Altars* in the street itself (figure 4). These precarious constructions, dedicated to one of the artist's favourite thinkers, writers or artists, were modelled, as I mentioned in the introduction to this book, on the improvised shrines to victims of fatal accidents. As the counterparts of official, permanent monuments erected to heroes and great men, Hirschhorn's *Altars* are personal, temporary homages, left to evolve and disappear.

In another of Bourriaud's books, the 2002 *Postproduction*, the author would compare Hirschhorn's works to those by Tiravanija and Orozco. As Bourriaud argued, these artists' focus on the 'concrete', the 'real' and the everyday was typical of other 1990s practices, which all contrasted with the dominant forms of 1980s practices, which Bourriaud would subsequently describe as a 'frozen aesthetic' (*esthétique glacée*).[17] Analysing retrospectively, in 1996, the slick aesthetic of the 1980s embodied in Jeff Koons's shiny objects as much as in Sherrie Levine's photographic appropriations, art historian Hal Foster had concluded that both had been caught up in the then-dominant 'commodity signs' of an exploding consumer society – whether by celebrating them (Koons) or by trying to recode them (Levine).[18] The 1990s 'return of the real' outlined by Foster signalled a reaction to such signs of conspicuous consumption and spectacle, as well as to the post-modernist celebration of the simulacrum. In her 1993 text on Orozco, Jean Fisher similarly pitted the artist's invocation of the maker's body, as well as his interest in tangible 'reality' and 'human agency', against 'the dominant debates of the previous decade, in which "reality" [had] disappeared into Jean Baudrillard's hyperreal to emerge as the infinity of mirrors that is simulation'.[19] Many artworks in the late 1980s and early 1990s were clearly 'meant to be "read" as texts', remarked Thomas McEvilley in 1994.[20] In contrast, Alÿs's early work betrayed, according to McEvilley, a 'fascination' for 'immediate presence'.

Like Bonami, Bourriaud attributed this turn, at least partly, to the post-1987 economic crisis. After this date, argued Bourriaud, artists traded shopping trips to the mall (think of Koons's vitrines) for strolls around charity shops and flea markets. Indeed, I would suggest that the 1980s 'frozen esthetic' was embodied in the lifestyle of Brett Easton Ellis's 'American psycho', while scruffiness and squalor were embraced in the 1990s by a new 'grunge' culture in fashion and music. Correspondingly, the 'flea market' as a 'temporary and nomadic gathering of precarious materials' had become, in Bourriaud's eyes,

the 'dominant' model for 1990s art.[21] This flea market aesthetic involved both the selection of everyday, sometimes shabby objects, and their mode of display in disordered, non-hierarchical, often sprawling arrangements. As Benjamin Buchloh would remark retrospectively (in 2011), a number of sculptors at the beginning of the twenty-first century had indeed sought to 'organize objects as mere arrangements, and simulate objects relations and spatial situations as though they were the outcome of chance encounters, found constellations that are haphazardly assembled at best'.[22]

This tendency outlined by Buchloh was mapped out in a 2007 exhibition at the New Museum in New York entitled *Unmonumental: The Object in the Twenty-first Century*, which surveyed a new sculpture 'of fragments' that was 'profoundly modest, radically anti-heroic', according to the curators.[23] Such works appeared to 'proudly proclaim their fragility' through 'debased, precarious, trembling' forms. Like the 'funk' art discussed in Chapter 3, the 'unmonumental' label was considered by the exhibition curators to be less a 'style' than an 'attitude'.[24] Explicitly citing Seitz's 1961 *Art of Assemblage* as a reference point, the contributors to the catalogue similarly attempted to relate this return to assemblage to contemporary socio-political developments. Massimiliano Gioni revisited the early 1960s opposition between waste and the 'affluent society' that produces it; like some 1960s critics, he perceived in the twenty-first-century works hints of 'the voiceless dispossessed, the wasted lives' necessary for this society to operate.[25] For her part, Laura Hoptman discussed at some length the *Art of Assemblage*,[26] before taking up the motif of the 'fracture', which she traced back to its defence by Dada artist Richard Huelsenbeck during his talk at the 1961 'Art of Assemblage' symposium. According to Hoptman, assemblage was symptomatic of a society's 'stylistic and ideological fractures', which had only further multiplied since the 1960s.[27] The *Unmonumental* catalogue accounts for this multiplication of fractures by citing the disappearance of alternative ideological models since the fall of the Berlin Wall in 1989, a permanent state of distraction induced by an overwhelming glut of media, and the rise of the Internet, which had served to exponentially fragment and individualise culture and consumption.

By 2009, Bourriaud could retrospectively note in *Radicant* that the 'ephemeral' performances and 'fragile materials' of the 1990s had heralded a more widespread shift: 'from now on', he announced, 'precariousness permeates contemporary aesthetics as a whole'.[28] Alongside German artist John Bock, who had figured in the *Unmonumental* exhibition, Bourriaud included the works of Alÿs as well as Hirschhorn and Orozco in his very long list of so-called precarious works, highlighting their common 'celebration of instability' (*exaltation de l'instabilité*) and embrace of the transitory, fugitive nature of an increasingly global modernity.[29] In 2009, Hal Foster would also extend his account of the art of the two previous decades by observing that

much art of the new century's first decade could be described as 'precari-ous', in response to a climate of 'social instability' and a generalised 'state of uncertainty'.[30] In his 1996 study, Foster had singled out two main tendencies as instances of the 1990s 'return of the real': an 'ethnographic turn' and an appeal to the 'abject'. In his 2009 article for *Artforum*, Foster drew directly on Hirschhorn's definition of precariousness (as distinct from the ephemeral), which I discussed in this book's introduction; he also cited Hirschhorn's work among other contemporary declensions of the 'precarious'. Returning to two artists who had figured as key examples of the 'abject' tendency that he had outlined in *The Return of the Real*, Foster noted the 'mournful' precarious-ness of a 2005 exhibition by Robert Gober, while mentioning in passing the 'outlandish' works of Mike Kelley.[31] In contrast, Orozco's precarious practice was more 'poetic', according to Foster, while Isa Genzken's precarious works (which were also included in *Unmonumental*) tended to be 'desperate'.[32]

Like Bourriaud, who considered 'precariousness' to be a reflection of the global expansion of capitalism, Foster related the increased visibility of such precarious practices to the 2008 collapse of the 'financial house of cards' which had been the culmination of the ongoing 'charge of neoliberalism' begun in the 1980s.[33] Furthermore, Foster also accounted for the artists' sense of 'heightened insecurity' in the light of global political events including the 9/11 attacks and subsequent war in Iraq. Foster argued, as I do, that in pre-carious works this 'social instability is redoubled by an artistic instability', to the point that 'precariousness seems almost constitutive' of these works. Bourriaud went so far as to suggest that precariousness in art is no longer simply a matter of using 'fragile materials' or creating short-lived works: 'from now on', it could be seen to 'saturate the whole of artistic production'.[34]

What, then, is the relationship between Bourriaud's 'relational' and 'radi-cant' aesthetics, between 'unmonumental' forms of assemblage and Foster's definition of 'precarious' practices? From a reaction against the 'frozen aes-thetic' of 1980s practices after the 1987 financial crash, to a response to a grow-ing sense of 'insecurity' at the beginning of the twenty-first century, I would argue that the central features of the return to the 'concrete' and the everyday in the 1990s, and its subsequent developments in the next decade, were above all a search for alternative forms of non-spectacular display, circulation and experience. Whether the global flows of capital or migration, terrorist attacks or unjustified wars, the Internet or the ecological disasters of the 'affluent society', precarious works of this period were intrinsically embedded in their contemporary context. The chapters in the second part of this book seek to shed light on this relationship, by focusing specifically on the borderline prac-tices of Orozco, Creed, Hirschhorn and Alÿs. In the next chapter, the political resonances of the terms 'precarious' and 'precarity' will be addressed directly. This chapter will take as its starting point the 1990s return to the 'concrete'

practices of the 1960s in order to shed light on the new articulations that were set up, once again, between something and nothing, between appearance and disappearance.

Joins

Orozco's *Empty Shoe Box* embodies the artist's conception of art as a vessel, a receptacle for an encounter with the everyday, to be further completed by the viewer's encounter with the world. The artist adopted this attitude partly in reaction to what he called the 'melodramatic' and 'heroic' rhetoric of his artist father's muralist tradition in Mexico, and of the avant-garde in general, thus countering macho melodrama with disciplined self-effacement.[35] The discovery of Zen Buddhism, and of John Cage's Zen-inspired practice and writings about chance, encouraged Orozco to further explore ways of emptying the ego and accepting the unpredictable. His 1992 *Yielding Stone* functioned as a kind of manifesto for such a definition of art (figure 49): a plasticine ball equivalent to the artist's weight, it was rolled in the streets by Orozco and continues to collect dust every time it is exhibited. Its yielding plasticity speaks of adaptability and receptivity – a willed vulnerability, an openness to the everyday world.

Some of Martin Creed's early works similarly evoke this openness by mobilising the very materials with which objects are stuck together or affixed

49 Gabriel Orozco, *Yielding Stone*, 1992

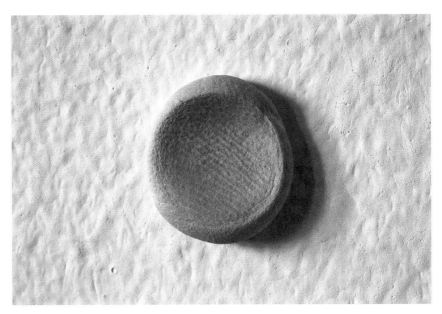

Martin Creed, *Work No. 79 Some Blu-tack kneaded, rolled into a ball, and depressed against a wall*, 1993 **50**

to the wall. 'The minimum a work needs to do is hang on a wall',[36] Creed noted, as he started to create a series of pictorial compositions made with the metal brackets habitually used to hang paintings (as in *Works Nos. 6, 7, 18*, or *No. 52*, from the late 1980s). In the 1992 *Work No. 67*, squares of masking tape were piled up by the artist 'to form a 1" cubic stack', like a tiny Minimalist sculpture. *Some Blu-tack kneaded, rolled into a ball, and depressed against a wall* (*Work No. 79*, 1993) is nothing but a 'join', as the artist calls it (figure 50).[37] This work arose directly from Creed's reflection on the act of creation: 'when you do something or make something it's always something extra for the world'.[38] Hesitating about what he wanted to 'stick' to the world, he decided to add nothing. The Blu-tack was left standing on its own, a receptacle like Orozco's *Empty Shoe Box* or *Yielding Stone*.

The 'join' 'between the thing you do and the world', as Creed called it, was made visible in a mathematical formula written by the artist in 1996 (*Work No. 143*) and subsequently displayed on various supports, including a billboard in *Work No. 143b*, 1998, and in white neon letters on the front of Tate Britain in 2000 in *Work No. 232* (figure 51): 'the whole world + the work = the whole world'. This equation recalls George Brecht's definition of borderline art: verging on the imperceptible, such work may pass unnoticed in the world. This could equally apply to the piece of Blu-tack depressed on the wall or the crumpled ball of A4 paper which constitutes the 1995 *Work No. 88* (figure 52),

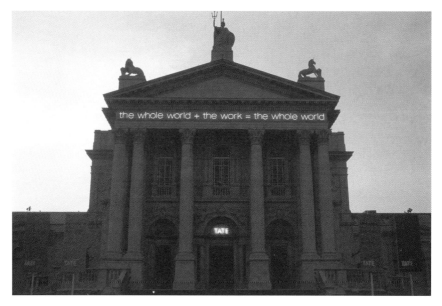

51 Martin Creed, *Work No. 232 The whole world + the work = the whole world*, 2000.
Installation at Tate Britain, London, 2000

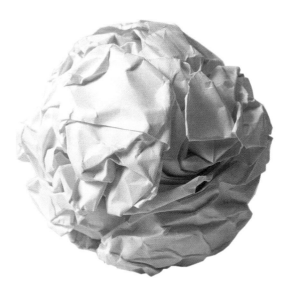

52 Martin Creed, *Work No. 88 A sheet of A4 paper crumpled into a ball*, 1995

which, as Fer observed, 'we could miss … if we weren't observant' since it 'is so near nothing'.[39] Borderline art, as Brecht had noted, risks disappearing because it comes as close as possible to the 'nothing special' of the everyday. This is certainly the case in Creed's works involving insignificant, everyday objects such as a crumpled sheet of paper, Blu-tack, or the lights going on and off.

Furthermore, the + sign in Creed's equation operates like the join of the Blu-tack as much as the 'and' of his *Work No. 96* (1994) which involved setting in bold type every instance of this word as it appeared in a given text. Darian Leader singled out such 'forms of attachment' as essential to Creed's work, whether in the masking-tape cube of *Work No. 67* or in the two looped videos of a ferryboat docking in a harbour (*Work No. 494*, 2005). Even the bell-like protrusions made out of plaster or brass that appear in Creed's early work, noted Leader, are akin to a mother's nipples, which constitute the first point of human attachment. Indeed, Leader, who is a psychoanalyst, emphasised that '[l]inks and joins imply investments: emotional and libidinal'.[40] When Creed speaks of his 'anxiety about making something totally separate from anything else', he invests the join with a fear of adding something to the world, and a desire for his work to disappear.[41] At the same time, however, attachment inherently posits a separation, a detachment as well. For Creed, explained Leader: 'Things must be separated and not separated.'[42] This is why Creed seeks to 'balance', as mentioned earlier, 'the making of something and the not making of something'. Like the light switch in works such as *Work No. 127* or *Work No. 227*, the join serves to articulate a number of binaries which frame an interval between two extremes, ranging from marked oppositions in this case (on/off) and what Creed has called 'little limbo moments' (a crumpled ball of paper suspended between art and trash),[43] to progressive scales or inventory-like accumulations, like the thirty-nine mechanical metronomes ticking unstintingly, each to its own distinct tempo, in *Work No. 112* (1995–2004).

As Leader pointed out, Creed often starts from a set of objects, whether the lights in a room or the tempi of a metronome. 'What is added', observed Leader, 'is already contained within the initial set … It is separated but at the same time contained.'[44] Another of the artist's strategies to create something that is both attached and detached involves the choice of strictly non-hierarchical forms of order. This is evident in the works involving metronomes as well as the sequence of every key on a piano played one after another (in the 2007 *Work No. 736*), or the pyramidal arrangement, according to scale, of objects such as planks of wood (*Work No. 395*, 2005), cacti (*Work No. 587*, 2006) or cardboard boxes (*Work No. 870*, 2008) (figure 53). Joachim Pissarro has partly attributed Creed's refusal of hierarchies and his search for equality to the artist's Quaker upbringing. As Pissaro noted, Quakers

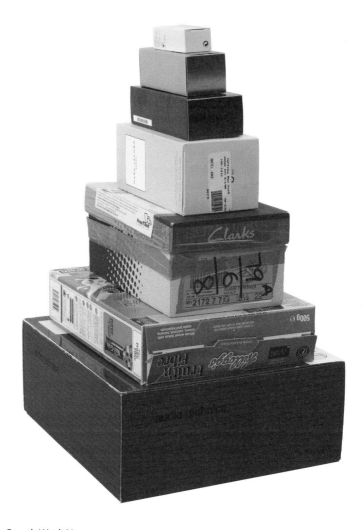

53 Martin Creed, *Work No. 870*, 2008

refuse to designate either a sacred place or a leader – a refusal that can be seen as downright 'anarchistic'.[45] For her part, Fer concluded that Creed's almost compulsive search for binaries that cancel each other out, as well as non-hierarchical modes of ordering the world, point to the 'fine line between order and randomness'.[46] Like Brecht's, Creed's borderline art is thus intrinsically connected to the ways in which we perceive and order the world of things. Where Brecht framed this question in terms of forms, Creed believes that rhythm helps us structure the mess of the world, however tentatively.

Moreover, rhythm is infinitely extendable. The dimensions of light- and sound-based works, like those of object series, accumulations and repetitive actions, are literally variable: they can be adapted to fit the contours of any space, like music filling a room, or Creed's drawings that involve finding different ways of simply filling a page of A4 paper.

Strikingly, Creed's work weaves together natural, mechanical, habitual and bodily rhythms. The ticking thirty-nine mechanical metronomes of *Work No. 112* provide a quicker counterpart to the daily arrivals and departures of ferries that punctuate everyday life on a remote island (in *Work No. 494* that I mentioned earlier). Just like the ascending and descending scales produced as every key is played one after another on a piano in *Work No. 736*, a penis rises and falls in the film *Work No. 1029* (2007–10). When, for his Duveens' Commission (*Work No. 850*) at Tate Britain in 2008 (figure 54), Creed invited runners to sprint down the length of the central neoclassical gallery, one at a time, every thirty seconds, he imagined that 'the runners were like waves lapping up on the beach, with the audience like people walking along the beach'.[47] This evocation of nature recalls both Allan Kaprow's and George Brecht's Zen-inflected desire to introduce change in their works in emulation of a natural world where things appear, grow and disappear 'without artifice or special intentions', as Brecht put it: this is, of course, the 'nothing special' to which borderline art aspires.

A similarly dynamic ambiguity between nature and culture can be found in Orozco's work. In the above-mentioned photographs such as *Pinched Ball* or *Island within an Island*, it is often uncertain whether the arrangements were found or created by the artist, by nature, or by some anonymous passerby. 'Nothing special', here, raises the very question of agency. Where Creed turned to rhythmic musicality to produce artefacts without the 'special intentions' attributed to the artist, Orozco both looks for and produces doublings, symmetries and geometrical shapes in the world. Indeed, drawing is a key to Orozco's practice, as if the straight line in itself could imprint order on the world as much as on a piece of paper. He is interested in the 'line that crosses, a line that cuts, a line that shapes' – a practice that cuts across collage, sculpture and painting as well as drawing and photography.[48] A 1992 entry in one of Orozco's notebooks illustrates this perpetual mobility, as the artist compared discarded gobs of chewing gum on a pavement to the stones placed on a board in the Asian strategy game of Go.[49] In this note, Orozco's thoughts continue to wander to found bottle caps as well as fallen tree leaves and a constellation of stars. (Similarly, Alÿs photographed, between 1994 and 1997, eighty different constellations of chewing gum wads that he had found stuck under tables as well as on walls and trees, across Mexico and the United States, while his 1995 *Milky Way* shows what the artist termed a 'galaxy' of bottle caps embedded in the pavement.) Like the *Empty Shoe Box*, the Go stones, stars

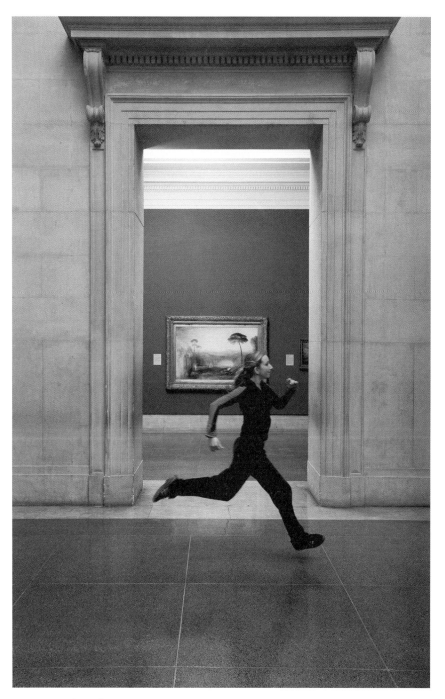

54 Martin Creed, *Work No. 850*, 2008. Tate Britain, London, 2008

and litter mentioned by Orozco occupy and cut out space. Like the knight's progress on the chessboard favoured by the artist, such drawings demarcate a territory according to specific patterns of chance and intention. Found, drawn or constructed by the artist, patterns map out spaces like constellations; an incision opens up a plane; a line intersects a natural form.

It is important to note that Orozco's and Creed's arrangements tend not to involve extraneous forms of articulation (glue, screws, welding…). In Creed's works, as we saw, the compositional logic proceeds through minimal attachment and (sometimes infinitely extendable) additions and progressions, by simply placing, juxtaposing or stacking elements. Orozco's objects are also often juxtaposed, as well as cut, folded, stretched, superimposed and propped. In the 1998 *Penske Work Project*, for example, Orozco travelled around Manhattan in a Penske rental truck, improvising his sculptures directly in the street with objects he found by the road or in dumpsters, without using any tools (figure 55). (As he drove along, the artist loaded each work into the truck and brought them back to the Marion Goodman Gallery for his solo exhibition.) *Penske Work Project* thus included works such as a horizontally displayed door, slit in two, its interior propped open with a stick; three plastic buckets morphed together into a clover-like shape; strips of an aluminium

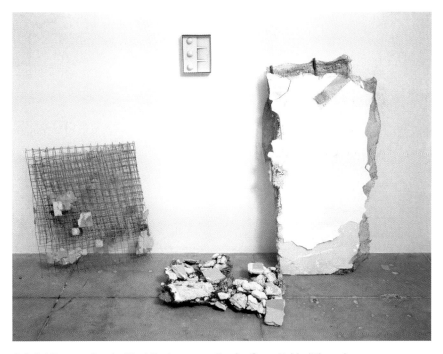

Gabriel Orozco, *Penske Work Project*, 1998. On the floor: *Folded Thread* **55**

blind bent and stuck into a rubber mat like crawling insect legs. At times, Orozco's assemblages look like the result of some kind of inter-organism symbiosis, as if in *Seed* (2003), for example, two Styrofoam balls had somehow been naturally absorbed by a steel mesh sculpture, like parasitic bacteria integrating with their host body's cellular structure.

As he explained, Orozco seeks to open 'bridges' with reality as a means to 'let things be themselves' (*dejar ser las cosas*).[50] Letting things be themselves, as we saw in Chapters 1 and 2, was one of the objectives of Cagean students such as Kaprow and Brecht. Unsurprisingly, the *koans* copied by Orozco in his notebooks[51] are precisely those that were quoted by Suzuki and Watts as examples of the Zen 'supreme matter-of-factness'. As we saw earlier, haiku, riddles and parables were means developed by Zen masters to achieve a 'direct method' which sought to 'get hold of this fleeting life as it flees and not after it has flown', as D.T. Suzuki put it.[52] The reason Orozco emphatically insists that he 'hates' the glue and screws traditionally associated with some modes of assemblage[53] may be that they are obstacles to capturing 'fleeting life as it flees', in that they suggest that time has stopped. The more casual, nonchalant, inventive approach to assemblage favoured by Orozco not only recalls Brecht's preference for the term 'arrangement', or Bruce Conner's desire to 'stop gluing things down'. It also extended the deskilling of sculpture initiated with Kaprow's environments and developed in Bruce Nauman's late 1960s studio works. In Orozco's *Penske Work Project* a grouping entitled *Folded Thread* includes a piece in which bits of plaster are suspended in a metal mesh (figure 55), an arrangement that echoes a 1989 photograph by the artist which shows stones inserted in a fence (*Stones in a Fence*). In both cases, one is reminded of Kaprow's use of chicken-wire in his earlier environments and assemblages (figure 14), whose particular brand of 'looseness', as we saw in Chapter 1, was noted by William Seitz: 'fragile' like Orozco's more recent works, elements in Kaprow's constructions had appeared to the curator 'barely joined to each other at all'.

Above all, a new brand of assemblage in the 1990s resonated with Robert Filliou's principle of equivalence, which refused any distinction between what is 'well made', 'badly made' and 'not made'. Orozco has acknowledged that he is an admirer of Filliou's, in particular of the way that he 'managed to communicate a lot in every object he made'.[54] When Hirschhorn saw Filliou's work for the first time, he was similarly struck by how materials mattered less than the desire to express a form of poetry. Filliou cobbled his assemblages out of scraps of cardboard, wire, metal hooks, pasted papers and photographs. Just as Hirschhorn described his *Altars* as cheap, temporary, 'quickly made, spontaneous, without design',[55] Filliou explained that he made his work 'spontaneously' with 'objects that are around'.[56] As we saw earlier, Filliou's objects contributed to the artist's wider project to promote an 'art of living' available to all. It is Filliou's drive to transmit ideas and concepts, with spontaneous, 'badly made' arrangements

of cheap objects and found images at hand (figure 35), that both Orozco and Hirschhorn have found 'very touching'.[57] Thus Filliou's practice served as one of the reference points – along with works by Kaprow and Nauman – in what Buchloh has called 'the historical project of deskilling sculpture' pursued in the 1990s with works such as Hirschhorn's *Altars* and Orozco's *Penske Project*.[58] According to Buchloh, Orozco's and Hirschhorn's practices were both involved, though in two distinct ways that can be read as 'dialectical', in defying 'even the slightest reminiscence of criteria, competence, and artistic or artisanal skills' required in 'the production of the sculptural object'.[59]

Just as Hirschhorn was 'moved' by Filliou's combination of poetry and shabbiness, he was also inspired by the 'powerful', joyous 'sensuality' of Oiticica's work.[60] As we saw in the previous chapter, the makeshift energy of Oiticica's *Parangolé* capes (figure 31) was inspired by the everyday reality of his native Rio de Janeiro, in which he singled out samba dancing, carnival and festival decorations, as well as the 'organic architecture' of shanty towns and the 'spontaneous, anonymous constructions' he encountered in the street. Similarly, Hirschhorn has long been fascinated with improvised designs, ranging from demonstration placards or banners used during political dem-onstrations and sporting events, to a beggar's scrawled sign asking for money, or the aluminium foil used to decorate 'rural discos'.

Writing about Orozco in 1998, Guy Brett also pointed to possible paral-lels with Oiticica's works, in terms of their relation to found objects and improvisation, for example. Crucially, Brett argued, artists such as Oiticica (and Filliou as well, I would add) proposed 'models for reciprocity, as a means to avoid the dogmatic and formulaic and stay close to life experience'.[61] Innovative forms of 1960s assemblage, then, gave permission to artists in the 1990s to create precarious works made out of found bits and bobs, with an energy conveying a renewed sense of urgency, indifferent to preoccupations with formal design, skill or quality. The 'joins' in such assemblage look so fragile that their diffuse and discreet forms threaten to disappear as suddenly as they have appeared. Such 'reciprocal' propositions, as Brett termed them in his text on Orozco, suggest that 'objects and situations in the street that seem to be objectified by the artist are simultaneously creating him'.[62] This is precisely the place of the encounter that Fisher noted in 1993, as she described Orozco's work 'as a quiet presence inhabiting, rather enigmatically, a space and a moment of negotiation between the world and the viewer'.[63]

The man in the street

Like Oiticica, Francis Alÿs has expressed his admiration for 'the way people can build themselves a shelter, using just three pieces of cardboard and two ends of string'.[64] For Alÿs this type of improvised construction serves to mark

out a personal, architectural spot or corner; it 'constitutes an extraordinary lesson on the redistribution of the public space'.[65] Inspired by such ways of 'using and abusing the city', Alÿs pieced together in 1994 electoral posters promising 'housing for all' (*vivienda para todos*) in order to create a shelter-like structure fastened over a subway air duct. In his slide show *Sleepers*, started in 1999, Alÿs alternates pictures of sleeping dogs and men, which he takes in the streets of Mexico City, favouring a horizontal point of view that positions the viewer at their level. (The slides are sometimes projected in a small format on the lower part of a wall, thus inviting viewers to crouch in order to look at them.) These sleepers, according to Alÿs, use public space for their own 'private' purpose, thus creating 'pockets in time and space in the midst of the continuous movement of the city', just like improvised shelters.[66] The creation of such 'pockets' embodies Alÿs's conception of the 'join' between his work and the space of the city.

Though trained as an architect, Alÿs's 'impulse' on moving to Mexico City in 1986 was 'not to add to the city', but rather 'to insert into the city a story rather than an object'.[67] This involved, above all, responding to the fabric of the city, in order to 'absorb' what was already there. Indeed, as he explained with regard to the 1990–92 *Collector*, the city of Mexico became for him the place from which to 'extract' 'materials to create fictions, art and urban myths'.[68] In this work, Alÿs walked around the streets, pulling on a string a dog-shaped magnetised construction mounted on rubber wheels. This metal construction would attract all the scraps of metal encountered along the way: it served as a chance assemblage that documented the artist's walk and the city's waste. *The Collector* is the equivalent of Orozco's *Yielding Stone* (figure 49) as both involved creating objects as receptacles that bear the residues of their trajectories, thus making visible their existence in time a well as space. The figure of the walker, according to Alÿs, is a receptacle itself, open to impressions, observations and encounters. Many of his works involve walking – with an unravelling sweater or a leaking pot of paint (in the 1995 *Fairy Tales* and *The Leak* respectively), under the influence of drugs (*Narcotourism*, 1996), or pushing a block of ice, in the above-mentioned *Paradox of Praxis* of 1997 (figure 47). The walker is a figure who produces nothing but ephemeral gestures that may pass unnoticed in the space of the city. Like the *Sleepers*, the walker, while lost in his private thoughts, creates temporary, mobile, almost imperceptible 'pockets of time and space'. (Similarly, Orozco photographed a *Sleeping Dog* because it appeared to him so utterly peaceful, as if 'floating'.)[69]

It is in the space at the intersection of the walker's private 'pocket' and the world that he traverses that art can happen, as a 1994 photograph by Alÿs entitled *The Moment when sculpture happens* reveals. It shows the artist's foot stepping in a wad of chewing gum, a string of this elastic material stretching out from his shoe with the next step. The chewing gum recalls Martin Creed's

original Blu-tack 'join': the work exists as a moment of encounter with the world – expectant in Creed's work, accidental in Alÿs's. Accidents are, indeed, to be expected by the walker. *If you are a typical spectator what you are really doing is waiting for the accident to happen*, a 1996 video by Alÿs, equates the role of the artist with that of the expectant spectator. Waiting for something to happen, Alÿs started to film an empty plastic bottle pushed by the wind along the paving stones of the Zócalo, the main square in the Mexico City centre. The artist followed the bottle's movements, and the ways in which some passersby kicked it along – an action probably encouraged by the presence of the camera. The video came to an abrupt end when Alÿs, preoccupied with the bottle, was hit by a car. Accidents and art happen to those who, like the walker/artist/spectator, make themselves vulnerable to the world around them.

For Alÿs, as for Orozco and Hirschhorn, the street emerged as a privileged space for the deskilling of art and a direct encounter with the everyday. In a 1962 text initially titled 'L'Homme de la rue' (the man in the street), later re-titled 'La Parole quotidienne' (everyday speech), Maurice Blanchot cast the street as the space *par excellence* of the everyday.[70] The unknown passerby, according to Blanchot, is by definition the anonymous, generic, faceless figure of the everyday. In its pervasive banality, the everyday is in fact characterised by the 'corrosive force of human anonymity' (*force corrosive de l'anonymat humain*): a 'destructive capacity' (*capacité destructrice*) to dissolve all form, truth or meaning.[71] This is why the man in the street, while indifferent and oblivious, is always potentially threatening, according to Blanchot. The every-day, like the man in the street, can never be heroic: indeed, Blanchot surmises, it is the very fear of everyday banality that drives the hero. By intervening in the space of the street, I would argue, Alÿs, Orozco and Hirschhorn give their work over to the everyday's 'power of dissolution' (*puissance de dissolution*). This is why their practice tends to the unheroic and unmonumental, and why it may pass unnoticed. In many of Orozco's above-mentioned photo-graphs, as we saw, the artist's gestures may be confused with the operations of other agents, be they natural accidents or passersby. His 1993 *Home Run* was directly addressed to the random passerby who might have been able to notice, perhaps by accident, that a single orange had been placed in the win-dows of several apartments in a building across from the Museum of Modern Art in New York (figure 56). Visitors to the artist's exhibition at MoMA were invited to discern this hidden pattern of repeated orange balls by looking out of the museum's windows into the building across the street. Similarly, one of Alÿs's earliest works involved simply placing pillows in the broken windows of a building. As Thierry Davila has written, these two works by Orozco and Alÿs test the very limits of perception.[72] Neither authoritarian nor spectacu-lar, they rely on a most acute form of attention, of the kind that is lost in the generic state of distraction and anonymity of the everyday.

56 a and b: Gabriel Orozco, *Home Run*, 1993. Temporary installation

Hirschhorn also voluntarily courted the 'corrosive force of human ano-
nymity'. The artist has used the French phrase *m'exposer*, which is a reflexive
form of *exposer*, which means both 'to exhibit' and 'to expose' (to danger, for
example).[73] When Hirschhorn claims that he wants to 'expose' himself, then,

he expresses his desire to exhibit his work, to seek a confrontation with reality that may expose him to criticism and judgement, and to expose his work to vandalism and destruction. *S'exposer* means above all to give up protecting or shielding the work from these possible risks, in a drive to encounter reality as directly as possible. This desire could be partly explained by the fact that Hirschhorn, as he confided in 1998, originally came from a 'background where art was not considered to have any importance, it had no social role'.[74] This goes some way towards explaining both his wish to address what he has called a 'non-exclusive' audience and his refusal to take an artwork's status 'for granted'.[75] Once a work is exhibited in a museum or gallery, argues Hirschhorn, it no longer needs to fight for its existence: the white cube presumes a hierarchy bent on keeping a viewer in his or her place and presupposes an audience that shares its conventions and values. Instead, he prefers to place his work 'in a difficult situation',[76] where it has to 'constantly assert its raison d'être, and defend its autonomy as an artwork'.[77]

In Hirschhorn's early works, such a 'difficult situation' was often to be found outside the gallery, in the street. For *4 Terrains vagues* (1990), Hirschhorn exhibited four works in four different vacant lots in Paris. In the same city, his *Travaux abandonnés* (1992) were abandoned on the ground among paper and cardboard debris; other works of this period were photographed casually leaning against a heap of rubbish or a skip. In *Colonel Fabien* (1992), Hirschhorn slipped his works under the windshield wipers of parked cars, while in the video *Fifty-Fifty à Belleville* (1992) he is seen handing out his works to passersby exiting the Belleville metro station in Paris. Uncertainly oscillating between autonomous art objects and junk, such early works were 'in movement', according to the artist.[78] Sometimes this mobility was literal, as when dustmen threw the works in their truck (in the 1992 *Jemand kümmert sich um meine Arbeit*, which I mentioned earlier, figure 46) or when the artist pasted one of his works to his car's rear-view mirror and drove around the Paris ring road (*Périphérique*, 1992). In 1994, Hirschhorn displayed his works in an Italian market on the bonnet of the car in which he had travelled around Europe (*Auto-Markt-Ausstellung*). The night version of this car-as-gallery model, the 1994 *Auto-Nacht-Ausstellung*, in which works could be viewed through the car's lit windows, heralded the artist's exploration of alternative forms of display mimicking in a debased form the 'exclusive' space of the gallery. Like the closed car, subsequent temporary galleries such as the 1996 *Kunsthalle Prekär* could not be entered: works could be viewed through flimsy partitions made up of transparent plastic sheeting.

With the *Altars* (figure 4), the partitions are removed altogether. Without roofs or walls, the objects on display can easily be damaged by the weather. And because there is no architectural separation between the work and the

street, the objects are even more vulnerable to vandalism. The *Altars'* appeal is immediate and direct, physical as well as affective. Actively soliciting 'petty theft', as Buchloh pointed out,[79] they become vulnerable to the unpredictable actions of the unknown 'man in the street'. The average life of his *Altars*, the artist has observed, is two weeks; they are particularly vulnerable to the everyday's 'power of dissolution'.

With the 2000 *Deleuze Monument*, Hirschhorn went one step further in 'exposing' his work to risk. Here, instead of courting the indifference or malice of passersby, as he had with his 1999 *Spinoza Monument*, the artist decided to situate his work in the very living space of a low-income housing estate and to involve residents in the construction and maintenance of the work itself. In the *Deleuze Monument* (figure 57), and in subsequent projects in this kind of residential space, Hirschhorn confronted his work directly with a potentially 'difficult' environment that did not usually house contemporary art. In search of a 'non-exclusive' audience, Hirschhorn was ready to accept all the practical difficulties that might arise in this context – including opposition, vandalism and even, in this case, an assault on two visitors. Crossing into the space of the *cité* with the *Deleuze Monument* marked the first, crucial step from the anonymous space of 'the man in the street' to a precarious public sphere involving a more active participation and potential antagonism. It is everything that happens in the interval between the appearance and the disappearance of these temporary works that constitutes the work, according to the artist.

57 Thomas Hirschhorn, *Deleuze Monument*, Cité Champfleury, Avignon, 2000. View of the library and the sculpture

Give-and-take

Like Alÿs and Orozco, Hirschhorn thus sought to insert his works in the everyday itself. Like Creed, these three artists have reflected on the responsibility involved in adding a work to the world, on the ways each of their works operates as a 'join' with the everyday. Their works appear contingent, almost accidental, hovering on the borderline between structure and chaos, order and randomness, appearance and disappearance. 'Everything has happened', according to Orozco, who admitted: 'I only want to continue it. For a moment.'[80] The street, like the everyday, is the space of the 'everything has happened'. The everyday is, according to Blanchot, an *il y a*, a 'there is': it is always already there, without ever having been created by anyone specific.[81] In the above-mentioned *Extension of Reflection* (figure 48) Orozco encountered a puddle and decided to drive his bicycle in circles in the water, thus extending it. The found puddle served as both a painterly material and a reflective surface for the nearby tree branches, which delicately echo, in the photograph, the lines traced by the bicycle tyres. The idea of the artist extending what is already there resonates with Orozco's definitions of the universe as 'an accumulation of accidents which happen moment after moment', or, following Jorge-Luis Borges, as simply 'all these things that are next to each other'.[82] Indeed, extension, contiguity, proximity and juxtaposition appear as the guiding principles of Orozco's compositions. This is particularly evident in his *Working Tables*, started in 1996, which bring together found objects with the failed experiments and half-finished objects that litter his studio (figure 58). As long as they are all next to each other, why not connect the dots between experiments in Styrofoam sculpture, found pieces of moss and a stone, an unfinished clay sculpture, dry pizza dough, a painting of concentric circles, and a straw hat?

The title of a 1993 series of drawings, *First Was the Spitting*, suggests a liquid genesis for Orozco's universe, from the mouth of a drooling demiurge. In this series, toothpaste spit produces organic shapes reworked with pencil and ink patterns on A4 sheets of graph paper: order and disorder, geometry and matter, mingle elegantly. 'What I'm after is the liquidity of things, how one thing leads you on to the next', explained Orozco in relation to a 1997 series of videos.[83] For each of these works, the artist left his apartment one morning with a digital camera, and decided to start filming whatever intrigued him as he walked along the street, switching the camera off and on again as he came across the next thing to catch his attention. Thus edited in real time, these videos show objects, gestures and events that 'are related, but through proximity rather than narrative'.[84] As documents of the artist's formal obsessions as much as his chance encounters, the videos suggest 'the flow of totality in our perception'[85] and the way we fragment and structure this flow through our attention and concentration. In Orozco's videos, this

58 Gabriel Orozco, *Working Table*, 2000–05

involved seeking out, for instance, recurring motifs (puddles), lines (on the road, drawn by an aeroplane is the sky), geometrical patterns (circles on a façade, beer mats), accidents (a plastic bag flying around in the wind), or anecdotal traces of shared human behaviour (protecting bicycle seats from the rain with plastic bags). In general, Orozco's works are moments of fleeting reality captured through action or perception. Ranging from sculpture to drawing, from photographs to painting, his work is itself caught up in a constant, peripatetic movement. In a 1992 note, the artist asked: 'If the earth is wandering, why don't you?'[86]

Orozco's question recalls Kaprow's desire, which we saw in Part I, to 'join in the dance' of the world by tapping into the energy and flow of everyday reality, which is comparable to that of nature. Similarly, Hirschhorn claims that his work says 'yes to the world in which we live' – including its problems, injustices and cruelty.[87] Just as Orozco acknowledges his acceptance of 'disappointments' as much as 'the real and its accidents',[88] Hirschhorn claims that being in agreement with reality implies neither approval nor disapproval: it involves being open to what happens, and taking responsibility for one's actions. A work can be vandalised and destroyed as much as it can serve to open a spectator's eyes to the beauty of art or philosophy. Above all, it must exclude no one,

it must treat everybody as equal. This is why Hirschhorn resolutely refuses artistic or precious materials: like Kaprow, who chose 'neutral' materials in his assemblages, Hirschhorn favours cheap, readily available objects such as plastic bags, cardboard, aluminium foil, sheer plastic sheeting or brown packing tape. Kaprow had noted that 'no one can mistake the fact that the work will pass into dust or garbage quickly'; Benjamin Buchloh spoke of Hirschhorn's use of *negative ready-mades* of containers and wrapping materials' that are usually thrown out once objects have been unpacked.[89] In addition to evoking what Buchloh calls the 'infinite production of waste' which was a key referent for the junk aesthetic in the 1950s,[90] I would like to emphasise that such materials allowed Hirschhorn, like Kaprow, 'to link himself to what others do', in the Swiss artist's words.[91] Somewhere, tape is being used to repair a broken suitcase, a plastic bag provisionally replaces a broken car window – just as it is used, as Orozco noted in his videos, to protect bicycle seats from the rain. Here Hirschhorn is joining in the dance of emergency repairs, of making do.

This impression of urgency is compounded by the loose composition of Hirschhorn's sprawling and fragmented displays. In the *Altars*, for example, strewn objects such as furry toys, candles and photographs, fragmentary citations, and signs composed in various styles of handwriting all serve to suggest a spontaneous collective homage that exceeds any single, fixed, centralised subjectivity (figure 4). The work appears to be in a constant state of becoming, multiplicity and difference, driven by an unstoppable desire to proclaim a fan's unconditional love. A sense of energy, then, is suggested by the use of open compositions, as much as in the materials and modes of display themselves. In a 2000 interview with Hirschhorn, curator Okwui Enwezor noted that the new 'sculptural language' being developed by contemporary artists such as Jason Rhoades, Pascale Marthine Tayou, Georges Adéagbo and Bjarne Melgaard shared with Hirschhorn's work similar concerns with 'spatial arrangement … accumulation, or fragmentation', embodied in sprawling, decentred displays.[92] As we saw earlier in this chapter, Nicolas Bourriaud had related this type of display to the 'disordered, proliferating and endlessly renewed conglomeration' of 'disparate' objects laid out on flea-market stalls, also comparing Hirschhorn's work to that of Rhoades and Adéagbo.[93] Horizontality, heterogeneity and sprawl characterised a broader trend in 1990s sculpture, described by some as 'scatter art'. All these works seemed to extend beyond the boundaries of Rauschenberg's combines and other 1950s forms of junk art, as if these earlier, more layered and compact objects had exploded in space, leaving fragments scattered on the floor. Without glue, nails or screws, the juxtapositional logic that had cemented the relation between the parts and the whole in collage and 1950s assemblage was left undone.

By 2007, *Unmonumental* co-curator Massimiliano Gioni could speak of a new 'fluid definition of sculpture that understands itself not as a self-sufficient,

complete form but rather as a receptacle, an intersection of disparate materials and images'.[94] As with 1960s assemblage, attention was focused on what happens in the articulation *between* the heterogeneous elements. The difference, however, is that substantial intervals came to separate the elements one from another in 1990s works: the 'joins' (to use Creed's term) they display are so tenuous as to have disappeared altogether, and only a contingent space of encounter and the spectator's gaze serve to hold them together. Indeed, I would like to argue here that it is the articulation between the work and the world that is of most interest in 1990s practices such as Hirschhorn's. Hirschhorn's decision to locate some of his earliest work in the street, next to bins or heaps of rubbish, like his *Altars*' precarious occupations of the pavement, point to their vulnerable status as objects inserted in public space. Buchloh has suggested that Hirschhorn's work could be read as combining forms of assemblage with the formal preoccupations of late 1960s 'distribution sculpture' – such as Robert Morris's *Untitled (Scatter Piece)* (1968–69) or other post-Minimalist practices by Michael Asher and Dan Graham – in order to address very real circuits of commodity distribution and disposal.[95] Similarly, a work such as Orozco's above-mentioned *Home Run* (figure 56) 'differs', according to Buchloh, 'from the emphasis on randomness' in late 1960s 'distribution sculpture' in that Orozco's work set up 'a more explicitly structured yet still highly ambiguous relation between a seemingly arbitrary scattering of non-descript materials/objects' – the oranges in the apartment windows – 'and the focused reflection on the relationship between site-selection and object choice'.[96] In particular, according to Buchloh, *Home Run* sought to articulate the relation between the institution (MoMA), the private space of the neighbouring apartments and the street as a public space.

It is in this sense that Hirschhorn's and Orozco's works are perhaps less comparable to the 'scatter' sculptures and neo-assemblages included in *Unmonumental* than to Francis Alÿs's more performative works such as *The Swap* or *The Seven Lives of Garbage*, both carried out in Mexico City in 1995. Such works were directly inspired, according to Cuahtémoc Medina, by the economic crisis in Mexico, during which decreased consumption, 'distrust of the national currency and a lack of liquidity' led to the widespread use of barter.[97] In *The Swap*, Alÿs travelled on the underground and repeatedly exchanged one object for another (including shoes, a flashlight and a bag of peanuts), photographing each transaction in turn. As he noted: 'In the beginning, there is a given situation where many people cross paths. The protagonist enters the situation with an object.'[98] As with *The Collector*, it is these encounters that constitute the work's materials. In *The Seven Lives of Garbage* Alÿs also entered a given situation with an object, as he dropped seven small bronze snails in seven different rubbish bags in seven different neighbourhoods, so as to test the common belief that 'all garbage in Mexico City goes

through seven stages of sifting from the moment it is thrown on the street until its final destination at the garbage dump on the outskirts of the city'.[99] The work includes photographs of the two snails that Alÿs managed to spot in flea markets in the following months.

As with *The Collector* or the *Paradox of Praxis* (figure 47), both *The Swap* and *The Seven Lives of Garbage* operate as traces of different encounters as much as material objects or performances in themselves. In the same way, McEvilley commented in 1994 on the 'back and forth reciprocity involved' in Alÿs's series of paintings of that year, *The Liar/The Copy of the Liar*.[100] In this series, the artist asked different local sign-painters to copy his original images, themselves inspired by the signs still used as advertisements in Mexican shops. Through such mechanisms of translation, Alÿs thus set off a dynamic process of 'reciprocity' between a popular, everyday medium and the world of high art. Thus, as McEvilley noted, this series of paintings appears less as a post-modern reflection on the pairing of original and simulacrum than as the result 'of a series of social transactions',[101] which, I would argue, could find their counterpart in works such as *The Swap*. Like Hirschhorn, Alÿs refused to take for granted art's place in society. As the artist simply put it: 'The socio-political reality of Mexico does not allow one to take the role of art too seriously.'[102]

As we saw in Chapter 1, Kaprow encouraged artists to 'shake hands' with the concrete world, at which point 'life and art' could 'begin flowing together in an easy give and take'. Crucially, Alÿs has also repeatedly referred to the 'give and take' (*renvoi de balle*) at the heart of his work, and emphasised his desire to maintain a 'direct relation to reality'[103] – a 'contact' which recalls Orozco's 'bridges' with reality, these spaces of reciprocity and negotiation evoked by Brett and Fisher as well as McEvilley. Alÿs's 2003 *Gringo* may be the most extreme example of his search for a 'direct relation to reality': the artist was literally attacked, and bitten, by a pack of dogs as he tried to cross their territory with a camera. Alÿs adopted the vulnerability of the 'foreigner' (*gringo*) as a means to engage with the world around him.

Like Orozco's extensions of what has already happened, Alÿs often starts from a 'given situation' – be it an urban space or an everyday practice like sign-painting, barter or sifting through rubbish. Some of his works are about 'flagging up' everyday practices, as in *Sleepers*, like an observer who takes notes.[104] Here the artist can take advantage of a 'suppleness, a flexibility, a fragility' – typical of the walker, one might add – that would not be available to a journalist, for example.[105] Alÿs can choose the slide format (as in *Sleepers*) or intervene directly in an everyday space (as in *The Swap*, for example). The documentation can remain incomplete; the experiments may be left unfinished (as in *The Seven Lives of Garbage*), while some works appear to be potentially infinite.

In other cases, the artist can go so far as to try 'provoking a situation' in order 'to step out of everyday life and start looking at things again from a different perspective – even if it is just for an instant'.[106] In the *Paradox of Praxis I*, for example, Alÿs started from a common practice that he had observed – of pushing a block of ice in the street to transport it, for example to a shop for refrigeration purposes – but pushed it, literally, to an absurd conclusion (figure 47). At what moment, then, did Alÿs push the block of ice just far enough to transform this everyday gesture into art? Like the chewing gum in which he stepped, this 'moment when sculpture happens' can be as elusive as it is instantaneous. Perhaps it is only after the fact, through the telling of the story, that this crucial shift occurs. Like Kaprow who, as we saw, was interested in the 'gossip' generated by his activities, Alÿs has favoured storytelling, fables and rumours. Indeed, the *Paradox of Praxis I* was first presented in the form of a postcard, before being edited as a video. Other works exist only as postcards, such as *Fairy Tales*, in which the artist walked along the street while unravelling his woollen sweater, simultaneously unravelling a string of tales, from Hansel and Gretel's trail of breadcrumbs to Rapunzel letting down her hair from the top of a tower, from Ariadne's thread in the labyrinth to Penelope unpicking her daily work at the loom every night. In Alÿs's postcards, a single image is captioned with a few lines. For the *Collector*, the action is described in three sentences; for the *Paradox of Praxis I*, an image of Alÿs pushing the block of ice is simply captioned with the paradox 'sometimes doing something leads to nothing': the reader can guess the outcome of Alÿs's action. In the postcard for *Fairy Tales*, the immediately graspable image is accompanied with a more general thought: 'Whereas the highly rational societies of the Renaissance felt the need to create utopias, we of our times must create fables.' The verbalisation of the work, according to the artist, requires a 'self-discipline' in order to reduce an action to a single image and a few lines – a 'minimal format' that recalls Brecht's event scores or Kaprow's scripts. As was the case for Brecht's scores and Kaprow's posters and publications, the postcard for Alÿs is also a means of dissemination that is, according to the artist, 'very free, very cheap, and very generous'.[107]

Like Kaprow's 'gossip', Alÿs's postcards partake in the logic of storytelling as well as that of rumour mongering. *The Rumour* from 1997 is perhaps the most immaterial of Alÿs's works. This piece started with the same 'given situation' as *The Swap*: 'In the beginning, there is a situation where many people cross paths.' Instead of an object, however, Alÿs introduced in a small Mexican town a rumour concerning a missing person. As he had hoped, through the rumour's typical mechanism of propagation, by 'the end of the day, something' was being 'talked about' in the town, 'but the source' had 'been lost along the way'.[108] Three days later, the police was issuing a 'missing person' poster, complete with identikit portrait. According to Blanchot, rumours are

as light and irresponsible as the man in the street who spreads them – nobody ever claims the authorship of a rumour, which travels fast and indefinitely, without ever being confirmed, contradicted or accurately recorded. Thus it partakes in the 'corrosive anonymity' of the everyday described by Blanchot. As Alÿs puts it, 'a little story that can be transmitted' 'no longer belongs to anyone': 'it can spread like an oil stain'.[109] Crucially, it only spreads if 'it hits a certain place at a certain moment of its history, if it manages to materialise a fear or corresponds to an expectation', argues Alÿs: it is the materialisation of an encounter with an elusive, yet potent, collective imagination.[110]

An increased dematerialisation, then, in the 1990s practices of Hirschhorn, Creed, Alÿs and Orozco appeared to reduce each of their work to a moment, a fragile join, a temporary bridge with an everyday reality which is conceived as a material as much as a 'corrosive' agent threatening the work's very existence, and thus allowing a fluid 'give and take'. Such works seem to respond and insert themselves in a broader context, in wider networks of exchange, circulation and dissemination, suggesting a nomadic mobility and a peripatetic practice of art as a way of living as much as looking and making. Orozco's *Crazy Tourist* playfully decides to place a single orange on each of the tables of an empty market and to photograph this arrangement during a trip to Brazil in 1991, whereas Alÿs's *Turista* (figure 59) advertises his services as a 'tourist', alongside those of various repairmen, by standing next to a plumber and a house painter on the Zócalo (in 1994). Both Alÿs and Orozco were performing their role as artists who are at once part of and slightly apart from their context – they might be considered a little 'crazy', at odds with the society in which they mingle.

Such anti-spectacular, anti-monumental constructions and gestures tend towards the minuscule, the provisional, the furtive and the secretive; they are often described as fragile, tenuous, light and fluid, as occupying in-between, 'infra-thin' spaces, whether 'joins', 'bridges' or 'interstices'. The 'expansion and disappearance' of the autonomous, self-sufficient art object into the everyday, initiated in the 1960s, evolved to such a point in the 1990s that new terms were developed to describe the elusive spaces of encounter that they set up. Bourriaud, for example, coined the term 'relational aesthetics' to describe a type of practice that focused on 'human relations and their social context', citing one of Orozco's works as an example among others.[111] As Orozco suspended a hammock among the sculptures in the MoMA sculpture garden (*Hammock hanging between two skyscrapers*, 1993), argued Bourriaud, he defined art as 'a state of encounter' (*un état de rencontre*) with the other, thus potentially suggesting models for 'human interactions'.[112] Writing in 2007, Ina Blom preferred the term 'atmosphere' to designate this space of encounter, since atmospheres 'are in-between phenomena that exist between subjects and objects'.[113] Such atmospheres are produced, among

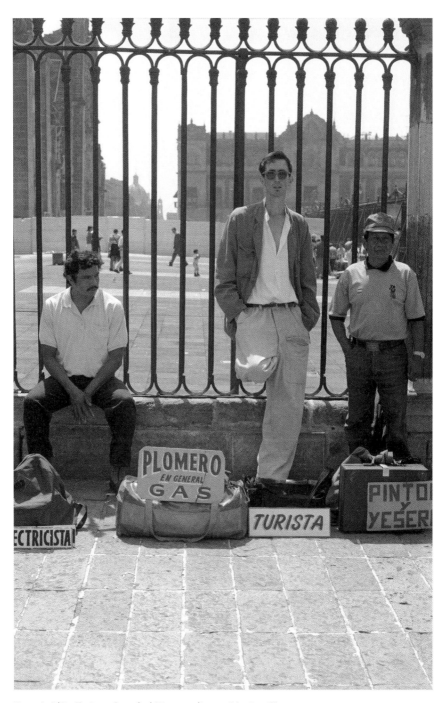

59 Francis Alÿs, *Turista*, Catedral Metropolitana, Mexico City, 1994

other factors, by what the author calls 'style', which she defined as the new 'site' for 1990s practices.

In her brief comparison of Brecht's 1961 event score for *Three Lamp Events* (described in my introduction) and the lights going on and off in Creed's aforementioned 'lamp works', Blom singled out both of these works' '[u]ncertain material boundaries, dubious visual status, and lack of prede-fined duration', which make borderline art 'seem quasi-non-existent'.[114] This type of work, she argued, can 'only come alive as a work through situational encounters with this non-existence, which would obviously have different implications in different settings'. This is where the particular singularity, the *je-ne-sais-quoi* of an atmosphere and style need be analysed in detail. While she only mentions in passing Creed's works involving 'lights going on and off', Blom dedicates a whole chapter to the widespread use of lamps in 1990s practices, which she connects to a general attempt at 'framing atmos-pheric and environmental styles rather than distinct media contents'.[115] In other words, such works demonstrate an interest in the ways our bodies are inscribed within a global network (electric, in this case), which impacts our domestic, 'personal lifestyles'.[116] Where Blom attempted to locate the specifi-cities of such elusive styles, Thierry Davila emphasised the fundamental sin-gularity of Orozco's and Alÿs's gestures. Such works introduced, he argued, 'a singular rhythm' into the city – an interval or 'displacement' in which an everyday gesture could be invested with a kind of 'density' and 'intensity', thus standing out from the anonymous banality of the everyday in discreet, almost imperceptible ways.[117] Ever more flimsy or surreptitious, the 'expand-ing and disappearing' borderline works of the 1960s thus appear to have fur-ther dematerialised to the point of becoming almost intangible.

Light, liquid, fluid

'How much does your life weigh?' Asking this question while pointing to his backpack, inspirational speaker Ryan Bingham, the character played by George Clooney in the 2009 film *Up in the Air*, introduces his lecture on the need to travel light – both literally and metaphorically.[118] Bingham, the film's main protagonist, stands as the caricature of today's expert consultant who revels in the perks of first-class air travel and high-end hotel accommodation. He aspires to a weightless life, always on the go, free of care and commitment. Bingham has to travel all the time for his job because he is hired by companies across the United States to fire their employees. Throughout the film, we see him using the same celebration of weightlessness to convince workers that losing their jobs represents an opportunity for change, the freedom to pursue their true dreams. In today's world, he suggests, loyalty is a burden rather than an advantage. Similarly, one's backpack must be emptied, made as light as

possible in order to be competitive and efficient. It is of course much easier for Bingham to deploy this vacuous rhetoric than the employees' own bosses – he knows that he will shortly jump on a plane and disappear. 'Make no mistake', Bingham dramatically concludes one of his talks: 'moving is living.'

Clooney's Ryan Bingham embodies a new form of capitalism that started to develop in the late 1980s and throughout the 1990s. We now live in a 'weightless world', Diane Coyle announced in 1997.[119] Weightless outputs such as services, information and communication technologies make up the most important growth in a new economy dominated by 'non-material' products. Like the financial derivatives that would be largely responsible for the 2008 financial crisis, these weightless products do not, in fact, exist anywhere. As Jeremy Rifkin explained in 2000: 'If the industrial era was characterised by the amassing of physical capital and property, the new era prizes intangible forms of power bound up in bundles of information and intellectual assets.'[120]

That same year, Zygmunt Bauman described this dominant form of capitalism as 'fluid', 'liquid', 'lean' and 'buoyant'. He spoke of the 'new lightness and fluidity' of a now 'increasingly mobile, slippery, shifty, evasive and fugitive power'.[121] By 2000, outsourcing, downsizing, short-term contracts and leases had all become familiar features of this new 'liquid modernity'. Constant change and transformation, evasion and escape were the new capitalism's weapons of choice. It is those who travel lightest, this 'nomadic and extraterritorial elite', who are the winners.[122] As Bauman analysed how the 'liquidizing powers' of contemporary capitalism could dissolve all forms of stable order, he seemed to be confirming Hannah Arendt's worse fears; indeed, the contemporary disintegration of all remaining community bonds or collective action described by Bauman were all by-products of the new capitalism's quest for ever-bigger, faster profits, modelled on the consumer's instant gratification that Arendt had first singled out in the 1950s.

The main difference between Arendt's and Bauman's diagnoses, however, is that in the new liquid modernity, even the durability of capitalist structures appeared to have been destroyed, as the new fluid capitalism favoured short-term tactics of risk-taking and evasion. Indeed, as Luc Boltanski and Eve Chiapello's 1999 study *The New Spirit of Capitalism* demonstrated, a new intelligent capitalism was able to learn directly from its 1960s and 1970s countercultural critics and to modify and transform itself. In order to become all the more powerful, this new 'spirit' of capitalism ended up embracing those very qualities that were developed by 1960s precarious artistic practices: fluidity, flexibility, mobility, lightness, transience and contingency. This explains why Ryan Bingham's 'rucksack' speech in *Up in the Air*, in which he argues that 'moving is living', so eerily recalls that of Beat character Japhy Rider, cited in Chapter 1, as he encouraged young people to leave all material possessions behind and take to the road in Kerouac's *Dharma Bums*. Indeed, Bauman's

claim that today 'running after things, catching them in full flight when still fresh and fragrant, is in'[123] resonates with D.T. Suzuki's description of the Zen master's desire to get hold of life 'as it flees and not after it has flown'. Yet Bauman is describing the tactics of liquid capitalism, rather than the artist's poetic attempts to resist the rationalising organisation of solid modernity.

In this new context, the very term 'dematerialisation' has taken on a different meaning. 'The key is dematerialisation', Coyle noted in 1997, both in terms of 'weightless', 'non-material' commodities, but also in relation to '"high value added" services such as currency trading, creating financial derivatives, software development, gene research or making programmes for satellite television'.[124] Such services started to be described by some as 'immaterial labour'. Defined by autonomist philosopher Maurizio Lazzarato in 1996 as the production of immaterial goods in the new liquid capitalism (whether a service, knowledge, communication or culture), immaterial labour was considered to extend beyond the traditional sphere of work into the realms of exchange and consumption.[125] Our time and experience themselves have become commodities, argued Lazzarato, while our very affects and feelings are mobilised in the production of commodified experiences, be they entertainment or a sense of well-being.

If André Gorz's 1988 study had inscribed the 'metamorphoses' of contemporary work in the direct lineage of those outlined by Arendt and American sociologists in the 1950s (as we saw in the first chapter), his 2003 book would focus on 'immaterial labour' as a specific shift in 1990s capitalism. (He refers to studies such as Jeremy Rifkin's.) Although immaterial labour appeared more complex than the simple task-based units of fragmentary, organised, rationalised work that had become widespread with 1950s capitalism, it could nevertheless be read, according to Gorz, as a continuation of the same abstracting process that severed work from concrete experience and the 'art of living' – an alienation rather than an emancipation. The same emphasis on efficiency, and the same need to create ever more superfluous desires rather than satisfying basic needs, that had characterised the 1950s capitalism continued to animate its 'new spirit' in the 1990s. Crucially, however, the personal time, movement and way of living of each individual, already threatened by the transformation of work into labour outlined by Arendt in the 1950s, had become, forty years later, entirely subordinated to a new form of fluid, flexible work.[126]

This is nowhere more visible than in what Michael Hardt and Antonio Negri named 'affective labour', a form of work involved in the 'creation or manipulation of affect'.[127] In Ryan Bingham's case, for example, this involves consoling, or reassuring, the employees whom he is invited to fire on behalf of their bosses. Since affect is traditionally associated with the private realm of the intimate, its instrumentalisation in 'affective labour' can be deeply

alienating. This, according to Ian Fraser, is the main conclusion of *Up in the Air*, during which Bingham becomes himself subjected to an affective manipulation which will lead him to doubt his previous celebration of the empty backpack: by the end of the film, this object ultimately comes to remind him of the alienated nature of his life.[128]

'As it becomes the basis for value production based on innovation, communication and continual improvisation,' argues Gorz, 'immaterial labour ultimately tends to become confused with the work of producing oneself.'[129] When Bingham asked 'how much does your life weigh?' he encouraged individuals engaged in immaterial labour to shed all sense of individual or collective responsibility and gear all their personal time, intelligence, emotions, creativity and experiences to serving an ever more intelligent capital. By 1996, Paolo Virno could observe that immaterial labour had 'absorbed the distinctive traits of Action' in the Arendtian sense, to the point that the 'dividing line' between them had 'disappeared'.[130] Even the 'presence of others' necessary to create a 'space of appearance', according to Arendt, had become 'both the material and the object' of such new forms of labour which commodify collective knowledge and affective bonds, and colonise the space of free time as well.

As a number of authors noted, the figure of the artist emerged in this context as the very model for the immaterial labourer. As 'creative industries' and the 'digital bohemia' were celebrated as drivers of the new economy, the artist's creativity was considered as the 'most advanced expression of the new modes of production and new labour relations generated by capitalism's recent transformations', as Pierre-Michel Menger observed in a 2002 study.[131] Not only is the artist used to working alone without a salary and to living precariously on an unreliable income, which fluctuates according to the notoriously unpredictable art market which rewards only a few among a wide population of peers. The modern artist's way of organising his or her time has also proved exemplary in terms of 'a productive commitment of personal resources (effort, energy, knowledge)', as Menger put it.[132] Alÿs's above-mentioned *Turista* similarly embodied, according to Medina, a 'conflation of the worlds of leisure and work' and 'suggests a degree to which his own wanderings as a visitor had become a way of life'.[133] The works of Orozco, Creed and Hirschhorn, which seem to join Alÿs's in the dance of the world, as we have seen, could then also be seen to participate in this 'continual improvisation', 'innovation' and 'engagement' of personal 'effort, energy, knowledge' and affect required by immaterial labour. Are the 'light', 'fluid', 'liquid' and mobile practices of 1990s artists such as Alÿs, Orozco, Creed and Hirschhorn little more than exemplary forms of immaterial labour? In trying to capture reality 'as it flees and not after it has flown', are these artists aligning themselves with the new spirit of capitalism? Are 'global pedestrians' Orozco and Alÿs (as Davila described them)[134] not at risk of being identified with the nomadic elite

who had also come, as Bauman put it, to 'cherish the transient'? Does Creed's or Hirschhorn's rejection of forms of hierarchies not replicate global capital's homogenisation of the world?

Nicolas Bourriaud's 2009 *Radicant*, which sought to address 'an aesthetic of globalisation', purported to address those very questions. As well as including, as we saw earlier, examples drawn from Orozco's, Alÿs's and Hirschhorn's practices, Bourriaud's book made passing references to Bauman's and Rifkin's studies. Bourriaud's study provides a portrait of the contemporary artist as a wandering nomad without any fixed roots or identity: in botany, the term 'radicant' describes plants, like ivy, which develop their roots as they move along, rather than being rooted in a single location. Bourriaud acknowledges that the space inhabited by this figure is that of global capital, and he repeatedly tries to situate such practices in this specific context. From the passing observations scattered throughout his book emerge two interconnected strategies available to the artist today, both linked by the image of the vaccine. On the one hand, Bourriaud argues, the artist must 'inoculate duration and extreme slowness at the very heart' of a 'global imaginary' 'dominated by flexibility' and speed.[135] On the other hand, Bourriaud proposes that art set out to 'insert itself and inoculate itself in the very networks that stifle us', by being 'even more mobile' than global 'nomadism'.[136] Bourriaud thus uses the image of inoculation in two apparently contradictory ways, the first allopathic, the second homeopathetic. In the first case, artists are invited to try and 'invent new meanings' for the flexibility that dominates the 'global imaginary', by producing new rhythms that are radically heterogeneous from those of global capital flows. In the other, artists must seek to capture globalised 'fluxes, movements of capital, the repetition and distribution of information' in order to make them visible as 'arbitrary' constructs to be dismantled.[137]

The second option presents obvious difficulties, in my eyes, which are all the more evident in Bourriaud's discussion of what he calls 'an art of transfer' (*art du transfert*), which involves, according to him, such 'radicant' practices as translating, 'transcoding' and displacing signs.[138] For example, Bourriaud has emphasised in a related essay how images by Kelley Walker or Wade Guyton 'are unstable' and 'perpetually transcoded'.[139] In the same text, he highlighted 'the total equivalence between different modalities of making visible' embodied in Wolfgang Tillmans' work or Thomas Ruff's *Jpegs* series. The author seems to be returning here to the arguments that he developed in his 2002 *Postproduction*, in which he compared the activities of artists to those of DJs and web surfers. All are 'semionauts', he explained, who 'navigate' the world of available signs and recombine them 'in original scripts'.[140] This conception of art as 'an editing computer' appears to me to resonate with economist Robert Reich's description of the new, powerful elite that emerged with the immaterial labour of liquid modernity: those he

called 'symbolic analysts'. These 'symbolic analysts' are engineers, lawyers, consultants, managers, advertisers and 'other "mind workers" who engage in processing information and symbols for a living'.[141] Their task involves, above all, 'manipulating symbols' in order 'to simplify reality into abstract images that can be rearranged, juggled, experimented with, communicated to other specialists'.

If artists have long been in the business of manipulating symbols, the light-footed semionaut excels at it. In the *Jpegs* series, Ruff adds value to an image by blowing up its pixels until it is barely legible; in a work such as *Black Star Press* (2006), Kelley Walker rotates an image by 90° and silk-screens pseudo-expressionist toothpaste or chocolate drips on it. Bourriaud explicitly aligns 'postproduction' practices with the 'age of access' described by Rifkin, in which value lies in the use of content, rather than any material object. One of the inherent features of weightless products is that more than one user can access them at once – as economist Danny Quah put it, they are characterised by an 'infinite expansibility', which also appears typical of the potentially endless chains of signification developed by radicant artists, which link one medium to another, one place to another,[142] in a series of reversals, 'extensions and declensions' as Bourriaud described them.[143] As artist Melanie Gilligan has suggested, such practices seem to 'extend art production ad infinitum much like those which expand the autonomy of exchange in finance'.[144] These financial products create 'modes in which money can be expanded, proliferated, stretched, and layered'.[145] And such modes are precisely, according to Gilligan, 'what constitute the newest stages of abstraction in finance capital' since the 1990s.

The main reason, then, that I cannot agree with Bourriaud that practices such as Ruff's or Walker's operate in the same way as those of Alÿs, Orozco or Thomas Hirschhorn is that the works of these three latter artists cannot so easily be subsumed within the symbolic analysts' abstract systems of value. I cannot consider these artists as 'semionauts', who exchange and create symbols which, like those of the symbolic analyst, flow freely and easily (from the Internet to the gallery, from the maker to the viewer…).

Translation is a key model for Bourriaud, and the ideal translation is attentive to the singularity of the original, while addressing itself to a new, expanded audience. Bourriaud does not, however, remark on another feature of translation: the self-erasure or voluntary invisibility to which it aspires, which gives the illusion that the content has not been affected by the passage from one language to another. It is in part because of this characteristic yearning for invisibility that Sandro Mezzadra has likened the very operations of capital to those of translation. As global capital encounters a 'multiplicity of languages (that is, of forms of life, of social relations, of "cultures")', it constantly needs to impose its own language of value.[146] These moments of

articulation are, according to Mezzadra, the locations of resistance – it is in the refusal to be translated, rather than in the act of translation, that resistance can be found. Similarly, I would like to argue that in the 1990s artists such as Alÿs, Orozco, Hirschhorn and Creed sought to redefine the 'join' between art and global flows of capital as a rub, a moment of opacity, of friction, of blockage.

Thus, I would like to suggest that a distinction between *liquids* and *fluids* (which include gases as well as liquids), and between the *flowing* and the *volatile* (a term that is only applicable to gases), may help us map out different speeds and various degrees of friction that have been mobilised by artists at the turn of the twenty-first century. Just as Bauman seems to conflate liquidity and lightness, I would argue that Bourriaud makes no distinction between his two models of 'radicant' practices. In contrast, I would like to propose that the image of liquidity allows for the possibility of setting up obstacles within the unstoppable flow of capital, unlike lightness, which aspires to a flight from, and totalising erasure of, materiality and its implied resistance. While the practices of some of the semionauts celebrated by Bourriaud could be described as fluid and volatile, the precarious practices of artists such as Alÿs, Hirschhorn, Orozco and Creed could be termed liquid and flowing. It is precisely in the 'join', 'bridge' or borderline space between something and nothing that an accident can occur which may serve to impede the semionaut's instant translation, to block the symbolic analyst's smooth operations or slick language of advertising. This is why, although they appear more dematerialised and weightless than their 1960s predecessors, such precarious practices nevertheless participate, in new ways, in the same desire to develop a new 'science of the concrete'.

Rubs

Indeed, Bourriaud's 2002 *Postproduction* itself appears divided between material and immaterial, concrete and abstract: though the majority of the chapters deal with the figure of the semionaut, whom he compares to a DJ freely sampling styles and traces of the avant-garde, the first chapter of his book proposes the flea market as the model for 1990s practices, as we saw earlier. In that chapter, Bourriaud convincingly demonstrates that the flea market in the 1990s 'embodies and makes material the flows and relationships that have tended toward disembodiment' under the pressure of global capitalist abstraction.[147] I would like to argue that the 'joins' that articulate the networked practices of Orozco, Creed, Hirschhorn and Alÿs serve precisely to materialise those 'flows' of circulation, distribution and disposal. It is their inherent materiality that thickens and constitutes an obstacle to the fluidity of capital, that weighs down its volatility.

Orozco has explained that he likes dust because it is 'pure matter *par excellence*': inexorably, this accumulation of residues will cover everything with a light yet opaque veil, and convert anything, including the greatest paintings and sculptures, into 'things'.[148] The above-mentioned *Yielding Stone* (figure 49) was conceived as a receptacle and container for this dust. In *Lintels*, another type of dust – lint – was collected from clothes driers and hung on clotheslines in the gallery. A mixture of hair, skin cells and fabric, this material both 'appalled' and appealed to the artist in its natural mix of the organic and non-organic, the 'super clean' and 'super dirty'.[149] First exhibited at the Marian Goodman Gallery in December 2001, *Lintels* evoked the dust that had filled New York after the 9/11 attacks on the World Trade Center, a cloud of particles that had also echoed, for the artist, the dust he remembered from the 1985 earthquake in Mexico. According to Fisher, dust and stones 'possess' in Orozco's work 'an enigmatic materiality that resists representation', thus leaving a space open for 'the act of dreaming or imagining'.[150]

This 'enigmatic materiality' that takes on an aerial physicality in *Lintels* is characteristic of many works by Orozco. The 1994 *Portable Puddle* involved another variation of the above-mentioned *Extension of Reflection* (figure 48). Instead of drawing with a puddle, the artist used it as the material for a series of sculptures of the most tenuous kind: having left transparent record sleeves floating on a puddle, he let the disks freeze overnight. A geometric shape, here, erupts from the skin of the puddle. More akin to swabs than to skin growths were Orozco's graphite rubbings, on large pieces of rice paper, of the patterned mosaic tiles at the Havre-Caumartin metro station in Paris. Like the *Penske Project* they are samples of the city's living body. Like his photographs, Orozco's *Yielding Stone*, *Penske Project*, *Portable Puddle* and the *Havre-Caumartin* series are thus all involved in registering, with the most acute sensitivity, the reality of the city – its dust and residues, its infra-thin details and seasonal moods.

> Oh! Ancient pond!
> A frog leaps in,
> The water's sound

In a 2002 entry in his notebooks, Orozco quotes in full D.T. Suzuki's discussion of this haiku by Basho.[151] According to Suzuki, the old pond only 'proves to be dynamic, to be full of vitality, to be of significance to us sentient beings' when the frog jumps into it. Orozco agrees that one needs to act, and even manipulate an object in order to truly understand it.[152] In a Zen parable, cited by Orozco, a master asks his disciples to describe a pitcher without saying what it is.[153] The best answer ends up being provided by the monastery's cook, who kicks the pitcher on his way back to the kitchen. Similarly, curator Francesco Bonami remembers how kicking the *Empty Shoe Box* (figure 45)

allowed him to understand it.[154] Like the pond in Basho's haiku, the *Empty Shoe Box* needs an attentive gaze – if not a kick – to exist. In a 2001 image-essay for *Artforum*, Orozco further developed his definition of Zen *satori* by showing artworks that could act as 'instruments of comprehension'.[155] Such works, argued Orozco, can have the effect of a cup of good coffee in the morning: 'you're opened to the void, prepared to be enlightened by the real'. Examples of works cited by Orozco include some of Lygia Clark's 1960s *Bichos*, which underline his constructivist approach. Indeed, Orozco empha-sises how rules and systems open the world to our perception, by playfully articulating binaries such as void and full, singular and total.

It is precisely the 'relation between structure and accident, between rules and their openness' that are of interest to Orozco, who constantly tests his geometries against the disorder of chance and matter.[156] Thus the rectangular *Empty Shoe Box* frames an empty space, while the spherical *Yielding Stone* gathers dirt. Orozco's above-mentioned interest in the 'liquidity of things', then, is also paired with a logic of 'friction' and dislocation, perceived by Briony Fer in both his use of drawing and the 'economy of leftovers' embod-ied in his *Working Tables* (figure 58). In his drawings, Fer suggests, 'the spaces between things become intensively animated'[157] – one thinks of the white toothpaste that stains the graph paper in *First Was the Spitting*, as we saw earlier. In the *Working Tables* 'the spaces between things, the air surrounding things' are likewise 'at least as material, at least as bodily, at least as "left over" as the things on a table'.[158] It is in this sense, according to Fer, that Orozco's work speaks of a 'sensual encounter with the world *at hand*', which, I would suggest, is at odds with the abstracting logic of rationalising classification and dematerialisation.[159] Furthermore, argues Fer, leftovers 'suggest fractured rather than continuous time': 'dislodged from the circuits they normally inhabit', the heterogeneous objects on the *Working Tables* are subject to 'a violent dispersal … that generates a tissue of shifting relations'.[160]

Like the frog jumping into the pond in Basho's haiku, Orozco's works act to momentarily dislodge and dislocate, like a skimming pebble that draws ephemeral circles in the water, as in his 1993 photograph *From Roof to Roof*. For the 2002 *Cazuelas* (*Beginnings*), the artist would repeat this disruptive act by throwing balls of clay on pots as they were being spun on the wheel by a potter. Orozco compared these shooting balls to meteorites, their accidental impact disfiguring the smooth surface of the clay pots.[161] Clay balls, footballs, pebbles thrown in the water, stones, bits of chewing gum spat out on the pavement: as well as drawing circles and constellations, then, the projectiles in Orozco's works rupture and puncture, they roll and get stuck. While some stones were placed by the artist in a fence (in the above-mentioned 1989 *Stones in the Fence*), he found others caught in the grooves of a tyre (*Stuck Stones*, 2005). Alÿs also observed these objects as they are used in children's games:

he filmed a boy kicking a stone up a hill along a road in Mexico (*Children's Games #1: Caracoles*, 1999) and other children skimming pebbles in Tangiers (*Children's Games #2: Ricochets*, 2007). Three of Alÿs's other works involve reporting the number, and location, of pebbles that got stuck inside the artist's shoes during different walks: in the park of the Serralves Foundation in Porto (in 2001), to a pre-Columbian pyramid in Teotihuacàn (in 2001), and in London's Hyde Park (in 2004).

As Thierry Davila has pointed out, the word 'scruple' is derived from the Latin *scrupulus*, which designated a sharp little stone before being used figuratively to mean 'worry, qualm'. 'The walker', according to Davila, 'in spite of his lightness, his idleness and his nonchalance, may be the scrupulous individual *par excellence*', as he collects residues and pays attention to overlooked details.[162] The irritating pebble rubbing against one's foot is a reminder as much as a residue and a sample of the terrain. It is a troublesome event, which approximates, in my opinion, Bourriaud's definition of the radicant's disruptive potential, like a 'grain of sand' in the 'global' 'machine' of capitalism.[163] While the semionaut, like Reich's symbolic analyst, may juggle and sample irresponsibly a heterogeneity of styles and signs, the scrupulous artist is wary of the impact on the world of his or her actions, insertions or additions. And this awareness, like the pebbles in Alÿs's shoes, can act as an irritant, like a rock diverting a stream's flow.

In the 2004 *Railings*, for example, Alÿs walked around London with a drumstick, with which he struck, like a xylophone, the railings that are typical of much of the British capital's architecture. This was not only 'a way of making contact, of connecting to the physicality' of a city that he was discovering:[164] it was also a means of highlighting the very materiality of the divisions instituted in urban space, since such railings serve to mark out a territory and exclude those who are not welcome. Alÿs has claimed to be interested in 'translating things instead of producing things'.[165] Here, he registers a zone of opaqueness in the encounter between the city and his body, between power and the individual.

Alÿs's adaptation of a children's game in *Railings* brings to light the power relations historically embedded in a specific type of architecture and urban planning. As we saw in Chapter 1, the move to control the flows of the city was perceived by artists such as Rauschenberg and Oldenburg as embodying the abstract forces of an organised, efficient capitalism that sought to produce a legible city in which neither refuse nor vagrants would be tolerated. In his physical contact with the railings, Alÿs puts his finger, almost literally, on the material and ideological operations of such architectural signifiers. The slowness of the walker, in comparison to that of the flying globetrotter, allows him to focus more closely on the details that make up this landscape of control. As Davila suggests, it is such 'details' that keep us from 'consuming the fluidity

of the megalopolis': instead, this scruple 'leads us to look at the mechanics of movements, the enormous cogs that drive it'.[166]

Like Alÿs's stick in *Railings*, the plus sign in Creed's aforementioned mathematical formula takes on the role of an irritant. Indeed, Creed appears in the 1990s to be plagued by scruples: doubts, uncertainty and qualms drive his work – sometimes to the point of paralysis – as he attempts to balance something and nothing, separation and non-separation, and to cancel out a form as soon as it is produced. 'I can't move', sings Creed in one his songs (*Work No. 209*, c.1997–99). In some works, he wedged a large object in front of a door, thus blocking all passage (*Work No. 142*, 1996–2002). In others, a doorstop keeps a door from opening beyond a 45° angle (*Work No. 115*, 1995). Viewers of the 1998 *Work No. 200* are invited to walk, with some difficulty, into a space half-filled with balloons: though very light, the balloons manage to constrain movement, to rub against bodies, attracting hair and stray threads, making friction literally tangible. Meanwhile, the 2004 *Work No. 371* synchronised the ascending and descending scales sung by a choir with the upward and downward movements of a lift, both caught up in the endless repetition of a movement that goes nowhere.

Such a comical synchronisation similarly characterises Alÿs's *Rehearsal I* of 1999–2001, in which the artist attempted to drive a Volkswagen Beetle to the top of a steep and sandy hill, while listening to a recording of a brass brand rehearsing a song. Every time the band pauses, the car stops; every time the band stops, the car slides back down. Both Creed's and Alÿs's works are equally absurd, but for different reasons. Unlike the prosaic self-sufficiency of Creed's work, Alÿs's *Rehearsal I* hinges on the time and effort required to reach an objective, which is never attained in the video. The physical effort involved in the *Paradox of Praxis I*, in which doing something leads to nothing, becomes the main focus of *Rehearsal I*. The irregular, start-and-stop sequence of the latter replaces the inexorable linearity of the former; instead of the melting ice's beautiful transparency, we contemplate clouds of dust under the car's spinning wheels. The physical rub between the wheels and the dirt road suggests a very concrete encounter, a challenge to the car's engine and its driver's will.

Such moments are both suspended in time and lost in the quicksand of inefficiency – they offer a break from, and an alternative to, the smooth operations of the symbolic analysts. As Davila rightly pointed out, the walker's aimless strolls, like the child's gratuitous play, counter any goal-driven efficiency: this kind of walk resists the city's frenetic activity and 'logic of profitability'.[167] Wasted time and effort are literalised by Alÿs as actual un-recycled waste in *Barrenderos* (*Sweepers*), in which the artist invited street-sweepers in Mexico City to stand next to each other in a street and push together all the day's scattered detritus with their brooms, 'until they are stopped by the mass of trash'.

However hard we try to keep the streets clear for the efficient circulation of goods and people, however hard we try to erase the traces of the rubbish we produce, the stubbornness of trash has the last word. Thus *Barrenderos* appears to pursue Oldenburg's and Rauschenberg's implicit critique of urban planning as a process of abstraction.

In the ambitious *When Faith Moves Mountains*, staged in 2002 outside Lima, Alÿs asked volunteers to make up a moving line in order to engage in a collective effort, as in *Barrenderos*. This time, however, the volunteers were 500 students armed with spades, who were asked to shovel a sand dune so as to move it (figure 60). Needless to say, the results of this huge enterprise, which involved recruiting, organising, transporting and directing this huge crowd, would remain imperceptible. The maxim embodied here was, according to Alÿs, 'maximum effort, minimal result' – a total inversion of the logic of progress and efficiency.

Alÿs's 'until they are stopped by the mass of trash' in *Barrenderos* directly echoes similar phrases used by Kaprow, as we saw in Chapter 3: 'until there is no ball' (in Kaprow's *Round Trip*), or 'till no more tributaries' (in his *Course*), determined these activities' durations with similarly concrete constraints. Like Kaprow, Alÿs seems to be exploring new relationships between work, labour and action. In his analysis of Alÿs's work, Medina directly cited Arendt's distinction between work and labour: labour is an 'endless task'

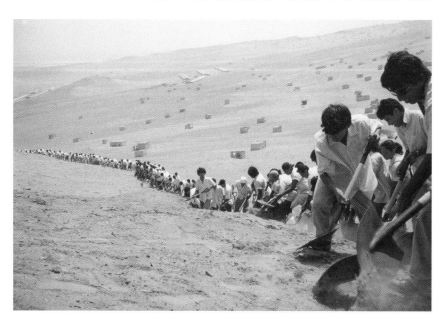

60 Francis Alÿs, *When Faith Moves Mountains* (*Cuando la fe mueve montañas*), Lima, 2002. In collaboration with Cuauhtémoc Medina and Rafael Ortega

which, unlike work, never yields any material product, in the same way that the results of pushing a sand dune remain invisible.[168] At the same time, however, Alÿs like Kaprow also brought into his practices the third type of human activity discussed by Arendt – action – through the use of storytelling. While I will be developing this point further in the next chapter, I would like to argue here that Alÿs's brand of 'useless work', like Kaprow's before him, bypasses the imperatives of productivity and consumption. In the context of immaterial labour and the weightless capitalism of the 1990s, this sought to impede the capitalist flows of 'homolingual translation' as Mezzadra called it.

The resounding resistance of metal railings, the unshakable inertia of junk, a hill or a sand dune in Alÿs's works, all echo the stillness at the heart of many of Creed's works. In both these artists' practices, the friction of the 'join' impels a movement, which can be at times pendulum-like, and usually fails to produce any new object. With the maxim of 'maximum effort, minimal result', Alÿs bridges the apparent aesthetic divide between excess and restraint. Indeed, while the script for *When Faith Moves Mountains* is minimal, its organisation and documentation were a major undertaking. Similarly, the works that I have been discussing in this chapter range from the almost imperceptible works of Orozco and Creed to Hirschhorn's large-scale sprawling displays and collective projects. In his writings, Hirschhorn explicitly endorsed a logic of excess which includes the unwavering devotion of the fan and the obstinacy of a 'fanatical' artist bent on a mission, as well as the overflowing energy that results from a sense of urgency, the overexertion necessary to put together a project, and the sheer, overwhelming quantity and heterogeneity of materials that assault the viewer of some of his large-scale works. Like Alÿs's concern with the 'unproductive waste of time', as Boris Groys has termed it,[169] Hirschhorn's excessive energy is comparable to the Bataillian entropic logic of expenditure (*dépense*) that tends towards an inexorable loss in the course of production.

In her 2012 study of art in the age of globalisation, Pamela M. Lee opposes Hirschhorn's work to the 'super-flat' production of Takashi Murakami in the context of what she calls 'globalization's marketplace of temporality', that is, the different speeds of accelerated production and consumption in liquid modernity.[170] Hirschhorn's grotesque forms, excessive quantities and illegible displays can all serve to block and resist, according to Lee, 'the ideology of smooth and untroubled flows' of contemporary capital.[171] What Bourriaud saw as a heterogeneous, flea-market-style sprawl is read by Lee as a 'critical' form of juxtaposition whose 'linkages demonstrate the affective capacity of information and things', and consequently their latent capacity to undermine the very networks in which they circulate.[172] By investing everyday materials with affect, as in his *Altars* or *Monuments*, Hirschhorn's displays seek to retrieve forms of memory, agency and action.

The other 'linkages' in Hirschhorn's work, as we saw, operate at the junction of his work with public space, as he 'exposes' his work to random passersby and a 'non-exclusive' audience. As Hirschhorn courts the unpredictable 'man of the street', he rejects criteria of efficiency and success, like Alÿs and Creed, as much as those of hierarchy and quality. Indeed, in the *Deleuze Monument* (figure 57), Hirschhorn underestimated the amount of time and effort required to maintain the project over the duration of its three-month exhibition.[173] Following a sequence of incidents and decisions by the residents, the artist decided that the work had to be dismantled one month earlier than planned. For the work to survive, the artist realised after the *Deleuze Monument*, he needed to be fully committed, and should be present continuously throughout the duration of a project. Only then would he be able to demand 'overtaxing' work from his collaborators in the *cité*, who also needed to be remunerated adequately for their efforts and presence. Only then could the energy and intensity of this commitment be transmitted to visitors, who would thus be able to partake in the artist's excessive homages to philosophy. Like Deleuze's conception of philosophy as a 'full-time' activity,[174] work in public space is, according to Hirschhorn, excessive by definition because it never closes, it never stops. There is no doubt that the collective commitment of everyone at the subsequent *Gramsci Monument*, which I visited in 2011 in the Forest Houses estate in the Bronx, is one of the main reasons that I felt like committing my time as a visitor: by looking at the displays, listening to the talks, speaking on the Monument's radio channel, reading the daily newspaper, eating, drinking and meeting the residents and other visitors, etc.

With his *Monuments*, then, Hirschhorn was able to involve others even further in the excessive enthusiasm that already drove his *Altars*. Unlike the intense effort of a great number of volunteers over a few hours involved in Alÿs's *When Faith Moves Mountains*, the challenge of Hirschhorn's *Monuments* is to maintain the work alive over the many months required to plan, build and exhibit it. Moments of intensity emerge from the routine of a regular schedule, boring maintenance tasks, periods in which no visitors come, in which nothing happens. The story of the preparation, construction, maintenance and incidents involved in each of Hirschhorn's works in public space is detailed in individual publications and constitutes an essential feature of their existence. Like Alÿs's works, they thus insert themselves in the collective imagination, and speak to different audiences: those who collaborated directly with the artist, those who saw the works, and those who only heard or read about them subsequently.

Although Buchloh has never compared them extensively, he has written about both Hirschhorn and Orozco in terms of what he has described as the contemporary 'conditions of a universally destroyed relationship to the

material world of object experience'.[175] Both artists, according to him, are involved in trying to reawaken this destroyed lived experience. This, argues Buchloh, is what sets Orozco's work apart from that of other artists, including Genzken and Rachel Harrison (both included in the above-mentioned *Unmonumental*) or Rhoades (mentioned by Enwezor as well as Bourriaud, as we saw earlier). Such artists, according to Buchloh, 'have handed over the construction of sculpture to the merely haphazard accumulation of the grotesque, comical agglomeration of trash'; they joyously embrace the 'ceaseless availability' and consumption of objects. In contrast, Orozco proposes a form of 'resistance' to this 'tragic destruction of object experience in the present', by evoking use value and labour, temporality and loss. This is achieved, in particular, through the 'dialectics of nature and culture' that the artist inscribes 'within the structure of his work'.

For his part, Hirschhorn resists this destruction by presenting us, according to Buchloh, with the 'memory traces and residues of resistance' lying buried in the excess of materials, and by giving us the possibility of finding forms of agency that could help us retrieve the 'object experience'.[176] As Lee might add, the promise of this experience is embedded in the blockages that Hirschhorn sets up in his appropriation of the 'smooth flows' of goods, information and capital. In contrast, I would suggest, the exploded assemblages of Rachel Harrison or Jason Rhoades risk mimicking the fluid circulation of goods and information in which they are embedded. In this sense, artists like Harrison tend to come closer to the semionaut's formal language of immediate transfer and transcoding described by Bourriaud.

Artists such as Orozco, Creed, Hirschhorn and Alÿs thus started to propose, in the 1990s, a vocabulary of precarious practices that could momentarily resist translation, by emphasising the obdurate materiality of time, effort and stuff. Instead of operating like semionauts smoothly navigating networks and fluxes, they are walkers who stumble on obstacles, are slowed down by trash, remain paralysed by uncertainty, become suddenly lost in thought, or encounter accidents or hostility. In this sense, they slow down or obstruct the speedy flows of liquid modernity with futile or unpredictable projects that do not conform to the logic of productivity and cost-effectiveness.

Alÿs followed Kaprow's 'useless work' in relating work, labour and action. As we saw in Chapter 3, other artists working in the 1960s, from Robert Filliou and George Brecht to Tom Marioni and Hélio Oiticica, were interested in exploring what happens when an artist refuses to 'work' in order to produce, preferring instead to dance, drink, day-dream, converse and hang out. Starting in the late 1980s, however, a 'new spirit of capitalism' sought to appropriate the countercultural spaces that had previously been invested by such artists in the 1950s and 1960s with a potential for liberation, if not revolution, at the margins of a conformist organisation geared towards efficiency

and productivity. Evidence of this shift could be observed in 1990s advertising which, as Nato Thomson noted in 2004, had systematically set out to co-opt the 'heroic alternative culture of the 1960s (the easy rider, the beatnik, the lonestar, the hippie, the drag queen, the revolutionary)' to sell anything from sportswear and junkfood to computers. 'If Che Guevara could be turned into a marketing-Chihuahua for Taco Bell,' remarked Thomson, 'left-leaning political artists had no more air to breathe.' As he concluded: 'The counterculture was out of room.'[177] Similarly, Hirschhorn felt compelled to admit, as he simply put it to Lee, that: 'You can't outsmart capital. Capital always wins.'[178] In this context, was it ever possible for artists in the 1990s to continue proposing new ways of life, like Filliou, Kaprow, Lygia Clark and Hélio Oiticica before them?

101 plastic bags and a plastic bottle

The 1999 film *American Beauty* appeared to many as a response to this turn-of-the-century sense of alienation in the absence of alternatives, of air to breathe.[179] A crucial scene in the film, which involves the adolescent Rickey showing his girlfriend his grainy video of a plastic bag flying in the wind, recalls at first sight the celebration of the insignificant everyday which links precarious practices in the 1960s and 1990s. As Rickey and his girlfriend sit watching the bag 'dancing' around in the wind, the young man's interpretation inflects his film differently, however, as he solemnly concludes: 'That's the day I knew there was this entire life behind things and this incredibly benevolent force that wanted me to know there was no reason to be afraid.' Conceiving the plastic bag in this scene as the marker of a 'dirty street', one enthusiastic critic heralded the scene as a positive reminder 'that even in the toughest place, and perhaps most often in tough places, beauty happens'.[180] For many, the character's belief in a 'life behind things' confirmed the barely veiled religious message of the film as a whole. Common terms used in the reception of *American Beauty* at the time included poetry and joy, as well as epiphany, transcendence, enlightenment and redemption. As critic Gary Hentzi pointed out, the film encourages us to identify with this scene's narrator and his adolescent combination of pretentiousness and naivety.[181] The fact that many reviewers happily did points to a widespread urge to find a pseudo-spiritual narrative of epiphany and redemption in the context of a general end-of-millennium malaise. Many were quick to read the film as a religious parable for troubled times.

A similar sequence involving a plastic bag blown around in the wind appears in Orozco's 1997 film, *From Dog Shit to Irma Vep*, from the above-mentioned series in which the artist left his apartment one morning with a digital camera and decided to start filming whatever intrigued him as he

walked along the street. There is certainly nothing 'behind' the plastic bag filmed by Orozco: it remains a chance encounter of the artist with the world, at a given place and time, in a series of many. Indeed, rather than searching for a 'benevolent force' animating the flying plastic bag, Orozco, as we saw earlier, described the universe as nothing more than 'all these things that are next to each other' and 'an accumulation of accidents which happen moment after moment'. Thus, in his films, he also focuses recurrently on the plastic bags used to protect the saddles of parked bicycles against the rain, as well as following, at different moments, the rucksack on someone's back as well as a large bag being carried by two people, each holding a handle. In each case, the bags catch his attention and direct his movements: they constitute articulations as much as spectacles, they exist through their contiguity with the other objects followed by the artist. Orozco's search for moments of *satori* is different from the 'enlightenment' proposed by *American Beauty* in that he lets things be themselves rather than vehicles of transcendence. Furthermore, as Briony Fer has pointed out, the intersections that the artist often maps out between a found object and 'an imaginary point of infinity' do not reveal that 'there is harmony in the universe, but on the contrary' that 'there is a dislocation at the heart of our experience of the world we inhabit'.[182] This is why, Fer argues, Orozco's drawings serve to '*ruin* rather than endorse a formal system', to disperse its elements and to 'dislocate the normal coordinates by which things are linked together in the world'.[183] Rather than a coherent unity, Orozco's universe is shifting and uncertain. As we saw, Orozco probes, according to Fisher, 'that unstable border between something and nothing, order and chaos', just as Creed reveals, in Fer's eyes, the 'fine line between order and randomness'.

Rather than a plastic bag, it is an empty plastic bottle that is the main protagonist in Alÿs's above-mentioned 1996 film *If you are a typical spectator, what you are really doing is waiting for the accident to happen.* Like Rickey's bag, Alÿs's bottle blows around in the wind, as well as being kicked along, on the Zócalo in Mexico City. The unpredictable event that puts an end to the film takes its place naturally in the 'accumulation of accidents' mentioned by Orozco. Beyond the risks of not paying attention to cars when walking in a city, Alÿs's film 'reveals' nothing but the central role of the spectator: as the artist films the bottle, passersby start interacting with it, and it is this focus on the bottle that leads the film-maker's eye astray. The artist becomes like the bottle, carried along by events, just as the walker is always already embedded in the reality that he passes through. Where Orozco singled out metonymy as the figure of speech that runs through his favoured logic of contiguity, proximity and analogy,[184] Alÿs's work increasingly favoured allegory, from the 2001 *Rehearsal I* and the 2002 *When Faith Moves Mountains* onwards. Unlike the post-modern 'allegorical impulse' detected by Craig Owens in

1980s practices, however, Alÿs's allegories are characterised by an 'immediate presence', already observed by McEvilley in the artist's early sculpture in 1994. This feature clearly resonated with the 'immediate appeal to emotions and senses' that Jean Fisher also noted in Orozco's work at the time, as we saw earlier. Whether a melting block of ice, a struggling Volkswagen or the efforts of a team of street-cleaners, Alÿs's allegories always remain 'rooted in physical reality', as Lorna Scott Fox put it.[185] She highlights the general ways in which Alÿs's works, whether sculpture, painting or video, 'speak to the deep sensuous cognitions that form our primal construction of aesthetics as we learn about the world', thus echoing Fer's emphasis on Orozco's 'sensual encounter with the world *at hand*'.

This direct appeal to the sensual, to immediate reality, is also a feature of Hirschhorn's work, in which rubbish bags also figure as materials. In fact, in a 1993 work, Hirschhorn displayed 99 plastic shopping bags filled with crumpled newspaper, each decorated by the artist with discrete stickers and collages. He aligned some along a street in Paris (like the cardboard works in *Jemand kümmert sich um meine Arbeit*, figure 46) and placed the others along the walls of a Brussels apartment. Plastic bags gather in herds, noted the artist in his text concerning *99 sacs plastiques*; they fall back in corners as if to prepare for action. Empty, they are only matter, Hirschhorn remarked: it is when they are full that they come to exist fully as bags. Their transformation, 'lightness' and energy are full of potential for the artist.[186] As if to preclude any misunderstanding, however, Hirschhorn insists in the same text: 'I want to make work that is impure, dirty, unclean, low', where '[e]verything is equivalent' and 'equal', where nothing is elevated above the rest.[187] (This affirmation of a total equality recalls Creed's rejection of all forms of hierarchy, discussed earlier.) Thus Hirschhorn, like Alÿs and Orozco, resolutely rejects the promise of transcendence or redemption invested in the hovering plastic bag of *American Beauty*.

The 1960s artists' search for immanence rather than transcendence, often influenced by Zen Buddhism, involved a turn against the abstractions of science and an organised society. The 'return of the real' in the 1990s similarly enacted a resistance to the ever more abstract flows of global capital, by mining its interstices and producing zones of friction. While in the 1960s, however, forms of immanence were situated on the margins of this capitalist system, such countercultural spaces had dissolved by the 1990s. 'There is no exteriority on which to fall back', Antonio Negri would conclude in 1999,[188] echoing Hirschhorn's verdict that 'You can't outsmart capital.' As Negri explained: 'Capitalism has invested the whole of life.'[189] The challenge, then, as Negri wrote with Michael Hardt in 2000, would be to imagine a new form of politics that 'cannot be constructed from the outside'.[190] Immanence itself, here, had become the field of politics.

Without going into an analysis of Hardt and Negri's main thesis, I would like to highlight here the unmistakable materialism of their 'political ontology', which may help us shed further light on the broader political conditions of 1990s precarious practices. Crucially, as Negri argued elsewhere, it is time itself that has become the essential component in such politics and, in particular, a specifically immanent time, the singular time of the here and now, described by the Greek word *kairos*, which I first evoked in this book's introduction. *Kairos* designates the opportunity, the occasion, in contrast to a transcendental *kronos* of past and future that is imposed from above. According to Negri, the *kairos* is the singular instant at which the archer releases the arrow – a moment of 'restless vacillation', of 'being on the brink'.[191] (We are reminded here of the importance of Eugen Herrigel's *Zen and the Art of Archery* for artists such as Lygia Clark.) This 'instant', argued Negri, is 'the moment of rupture and opening of temporality' that creates a space for action.[192] According to Negri, the 'hardness of matter' in which the *kairos* is embedded, 'against all transcendence', is specifically that which constitutes 'an irrepressible resistance and revolt at the edge of being'. Importantly, this resistance 'is always a positive affirmation of being'.[193] In Negri's definition of the *kairos*, then, are brought together some of the essential terms we have looked at in this chapter: the temporality of the instant, embedded in the obdurate hardness of matter, emerges as a form of resistance and an opportunity for action.

By way of Spinoza, Pamela Lee followed Hardt and Negri's focus on immanence in her analysis of Hirschhorn's work which, as she pointed out, is 'coextensive with a world to which it is immanent, one from which "there is no escape"'.[194] For Lee, it is Hirschhorn's appropriation and organisation of the global flows of commodities that allows him to block and divert them. Though not mentioned by Lee, Negri's analysis of the *kairos* appears to me to describe the very interstitial temporality of precarious works such as Hirschhorn's, as well as those of Alÿs, Orozco and Creed. In a 1974 study of the *mètis* or 'practical intelligence' in antiquity, Michel Destienne and Jean-Pierre Vernant described the ways in which this kind of intelligence aimed to seize the 'fugacious *kairos*' (*le kairos fugace*).[195] A tiny twist, a tactical rupture or a simple unpredictable step to the side: the 'ruses' of the *mètis* can either pass unnoticed or be outrageously bold.

The *kairos* is the instant of the event, the encounter, the improvised decision, the ruse of practical intelligence. It is the moment in which, as Hardt and Negri hoped, 'those powers of creation and imagination … can break through the barriers of this purported realism and discover real alternatives to the present order of things'.[196] This is why, as Laymert Garcia dos Santos has argued, each line drawn by Alÿs in his work – from the walker's trajectories with an unravelling sweater, to the alignments of street-sweepers or students armed

with shovels – can be read, in fact, as 'a breach, a fissure in the unbreathable space of the already-given' which opens it by 'reconfiguring time-space within a new perspective'.[197] This is perhaps also the case with Orozco's own lines which, as we saw, cross, cut and shape his work, or with Creed's rhythms and punctuations which similarly insert themselves in the 'space of the already-given'. Likewise, Hirschhorn's precarious sprawls configure 'time-space' differently, thus opening new perspectives.

Rather than added values of entertainment or redemption, of immaterial labour or symbolic analysis, precarious practices thus seek to insert rubs, gaps, frictions and detours in the hegemonic order of liquid modernity. Such 'kairological' temporalities, I would like to argue, act to preserve the possibility of Arendt's disappearing 'space of appearance'. The next chapter will focus more specifically on the modes of apparition of such spaces in the precarious practices developed by these artists in the period between c.1990 and 2010. In this period, the 'borderline' between art and the everyday, between something and nothing, took on an ethical, rather than a revolutionary, turn. As we have seen in this chapter, these artists' focus on the join between their work and the world suggested, above all, a sense of responsibility. This is why the next chapter will further analyse this join, breach or hiatus, as the interval between failure and survival, affirmation and resistance, precarity and liquid modernity.

Notes

1 Gabriel Orozco, 'Lecture' (2001), trans. E. Brockbank, in Yve-Alain Bois (ed.), *Gabriel Orozco* (Cambridge, MA: MIT Press, 2009), p. 88.

2 Thomas Hirschhorn, 'What I Want' (1994), in *Critical Laboratory: The Writings of Thomas Hirschhorn*, ed. Lisa Lee and Hal Foster (Cambridge, MA: MIT Press, 2013), p. 27.

3 Anon. (dir.), *Martin Creed* (London: Illuminations, 2001), 26 min.

4 Many of Alÿs's videos can be viewed on his website: www.francisalys.com/ (accessed 15 May 2015).

5 Gabriel Orozco, note dated 16 August 1994, reprinted in Ann Temkin (ed.), *Gabriel Orozco: Photogravity* (Philadelphia: Philadelphia Museum of Art, 1999), p. 163.

6 Briony Fer, 'Ifs and Buts', in Briony Fer, *Martin Creed* (Vancouver: Rennie Collection, 2011), p. 9.

7 Jean Fisher, 'The Sleep of Wakefulness' (1993), in Bois (ed.), *Gabriel Orozco*, p. 18.

8 *Ibid.*, p. 24.

9 Zygmunt Bauman, *Liquid Modernity* (Cambridge and Malden, MA: Polity Press and Blackwell, 2000), p. 8.

10 'The energy that fuels my work comes from my being a critic … of the human condition', observed Hirschhorn. Thomas Hirschhorn, 'Interview [with Okwui Enwezor] (5–6 January 2000)', in *Thomas Hirschhorn: Jumbo Spoons and Big Cake* (Chicago: Art Institute of Chicago, 2000), p. 29. For his part, Alÿs

explained: 'If there is a possible field of action it must pass through an acceptance that the human condition is the most immediate, the most tangible of spaces.' 'Walking the Line: Francis Alÿs interviewed by Anna Dezeuze', *Art Monthly*, 323 (February 2009), 4.

11 Francesco Bonami, 'Now is for ever, again', *Tate Etc.*, 15 (Spring 2009), http://www.tate.org.uk/context-comment/articles/now-ever-again (accessed 9 April 2011).

12 Nicolas Bourriaud, *Relational Aesthetics* (1998), trans. S. Pleasance and F. Woods (Dijon: Presses du réel, 2002), pp. 45, 13.

13 Thomas Hirschhorn's work is discussed in Eric Laniol, *Logiques de l'élémentaire (le dérisoire dans les pratiques contemporaines)* (Paris: L'harmattan, 2004). Paul Ardenne discussed a turn to the 'banal' in 1990s art in *Art, l'âge contemporain* (Paris: Editions du regard 1997).

14 The exhibition *Makeshift* (Brighton: University of Brighton Gallery, 2001) included works by Martin Creed, while Tom Sachs and David Leiber curated *American Bricolage* (New York: Sperone Westwater, 2000). Three art historical studies traced the evolution of assemblage from the 1960s to contemporary art: Jo Applin, Anna Dezeuze and Julia Kelly (eds), 'Forum: *Assemblage*/Bricolage', *Art Journal*, 67:1 (2008), 24–99; Stéphanie Jamet-Chavigny and Françoise Levaillant (eds), *L'Art de l'assemblage: Relectures* (Rennes: Presses Universitaires de Rennes, 2011); Gillian Whiteley, *Junk: Art and the Politics of Trash* (London and New York: I.B. Tauris, 2010).

15 Stephen Johnstone, 'Introduction: Recent Art and the Everyday', in Johnstone (ed.), *The Everyday* (London and Cambridge, MA: Whitechapel and MIT Press, 2008), p. 13.

16 *Ibid.*, p. 12.

17 Nicolas Bourriaud, *Radicant. Pour une esthétique de la globalisation* (Paris: Denoël, 2009), p. 96. Unless otherwise stated, all translations are the author's.

18 See Hal Foster, *The Return of the Real: Art and Theory at the End of the Century* (Cambridge, MA: MIT Press, 1996).

19 Fisher, 'Sleep of Wakefulness', pp. 20–1.

20 Thomas McEvilley, 'Francis Alÿs: Calling the Unaccountable into Account', in F. Alÿs et al., *Francis Alÿs: The Liar, the Copy of the Liar* (Guadalajara and Monterrey: Arena Mexico Arte Contemporáneo and Galeria Ramis Barquet, 1994), p. 37.

21 Nicolas Bourriaud, *Postproduction. Culture as Screenplay: How Art Reprograms the World*, trans. J. Herman (New York: Lukas and Sternberg, 2002), p. 28.

22 Benjamin Buchloh, '2007b', in *Art since 1900: Modernism, Antimodernism, Postmodernism* (London: Thames and Hudson, 2nd edn, 2011), p. 727.

23 Massimiliano Gioni, 'Ask the Dust', in Richard Flood et al., *Unmonumental: The Object in the 21st Century* (London and New York: Phaidon and the New Museum, 2007), pp. 65, 68.

24 *Ibid.*, p. 65. Anne Ellegood similarly spoke of a new 'attitude' in *The Uncertainty of Objects and Ideas: Recent Sculpture* (Washington, DC: Hirshhorn Museum and Sculpture Garden, Smithsonian Institution, 2006), which included works by two of the same artists: Isa Genzken and Rachel Harrison.

25 Gioni, 'Ask the Dust', p. 75.

26 Laura Hoptman, 'Unmonumental: Going to Pieces in the 21st Century', in Flood et al., *Unmonumental*, pp. 128–34.

27 *Ibid.*, p. 138.

28 *la précarité imprègne désormais la totalité de l'esthétique contemporaine.* Bourriaud, *Radicant*, p. 97.

29 *Ibid.*, p. 102.

30 'Precarious: Hal Foster on the Art of the Decade', *Artforum*, 48:4 (2009), 207.

31 *Ibid.*, 209, note 5, 260.

32 *Ibid.*, note 5, 260, 209.

33 *Ibid.*, 207.

34 *cette précarité … ne peut plus se résumer à l'utilisation de matériaux fragiles ou à des durées brèves, car elle imbibe désormais l'ensemble de la production artistique de ses teintes incertaines…* Bourriaud, *Radicant*, p. 97.

35 Gabriel Orozco, interview with the author, New York, 23 January 2009.

36 Martin Creed, quoted by Darian Leader, 'Forms of Attachment', in M. Creed et al., *Martin Creed: Works* (London: Thames and Hudson, 2010), p. xxxvi.

37 '[W]hen you are making something, how do you decide where the join is between that thing and the rest of the world?' Alex Coles, 'Martin Creed: A Case of the Irritating Critique?' [interview], *Documents*, 20 (Spring 2001), 25.

38 Anon. (dir.), *Martin Creed*.

39 Fer, 'Ifs and Buts', p. 9.

40 Leader, 'Forms of Attachment', p. xxxvii.

41 Martin Creed, quoted in *ibid.*, p. xxxix.

42 Leader, *ibid.*

43 Tom Eccles and Martin Creed, 'Interview', in Creed et al., *Martin Creed: Works,* p. xvi.

44 Leader, 'Forms of Attachment', p. xxxix.

45 Joachim Pissarro, 'The Innumerable Martin Creed', in Cliff Lauson (ed.), *Martin Creed: What's the point of it?* (London: Hayward Publishing, 2014), p. 128.

46 Fer, 'Ifs and Buts', p. 10.

47 Eccles and Creed, 'Interview', p. xv.

48 'Benjamin Buchloh interviews Gabriel Orozco in New York', in Francesco Bonami et al., *Gabriel Orozco: Clinton is Innocent* (Paris: Musée d'Art Moderne de la Ville de Paris, 1998), p. 103.

49 Gabriel Orozco, note dated 9 July 1992, reprinted in Ann Temkin (ed.), *Gabriel Orozco* (New York: Museum of Modern Art, 2009), p. 60.

50 Gabriel Orozco, 'Interview with Miguel Angel', in Juan Botella et al., *Gabriel Orozco en Villa Iris*, vol. 1 (Santander: Fundación Marcelino Botín, 2005), p. 6.

51 See Molly Nesbit, 'The Tempest' (2000), in Bois (ed.), *Gabriel Orozco*, p. 77.

52 D.T. Suzuki, *Zen Buddhism: Selected Writings of D.T. Suzuki*, ed. William Barrett (New York: Doubleday, 1956), p. 129.

53 Orozco, interview with the author.

54 *Ibid.*

55 Thomas Hirschhorn, 'Altar to Raymond Carver in Freiburg' (27 June 1998), http://thegalleriesatmoore.org/publications/hirsch/statement.shtml (accessed 18 November 2008).

56 Wolfgang Becker, 'Interview with Robert Filliou', in *Robert Filliou: Commemor* (Aachen: Neue Galerie im Altern Kunsthaus, 1970), n.p.

57 Orozco, interview with the author; Thomas Hirschhorn, interview with the author, Aubervilliers, 20 March 2009.

58 Benjamin Buchloh, 'Gabriel Orozco: Sculpture as Recollection', in Yve-Alain Bois et al., *Gabriel Orozco* (London: Thames and Hudson, 2006), p. 176.

59 *Ibid.*

60 Hirschhorn, interview with the author. A catalogue of Oiticica's work is included in Hirschhorn's 2003 *Emergency Library*, an edition by Ink Tree Edition first displayed at the Kunsthalle Basel on 17 June 2003, and subsequently illustrated in *Swiss Swiss Democracy Journal*, 47 (27 January 2005), and as a colour insert in *Old News*, 2 (2005). See also 'Artist's Choice', in Carlos Basualdo et al., *Thomas Hirschhorn* (London: Phaidon, 2004), pp. 112–17.

61 Guy Brett, 'Between Work and World: Gabriel Orozco' (1998), in Bois (ed.), *Gabriel Orozco*, p. 56.

62 *Ibid.*, p. 54.

63 Fisher, 'Sleep of Wakefulness', p. 18.

64 'La Cour des Miracles: Francis Alÿs in conversation with Corinne Diserens, Mexico City, 25 May 2004', in Annelies Lütgens and Gijs van Tuyl (eds), *Francis Alÿs: Walking Distance from the Studio* (Wolfsburg: Kunstmuseum Wolfsburg, 2004), p. 109.

65 *Ibid.*, p. 111.

66 *Ibid.*, p. 109.

67 'Rumours: a Conversation between Francis Alÿs and James Lingwood' (2005), in James Lingwood (ed.), *Francis Alÿs: Seven Walks, London, 2004–2005* (London: Artangel, 2005), p. 44.

68 Francis Alÿs, 'Collector' (1992), in Cuauhtémoc Medina (ed.), *Francis Alÿs: Walking Distance from the Studio* (Mexico City: Antiguo Colegio de San Ildefonso, 2006), p. 18.

69 *flotando*. 'Gabriel Orozco, entrevista con Molly Nesbit y Benjamin Buchloh, México, 2000', in Daniel Birnbaum et al., *Textos sobre la obra de Gabriel Orozco* (Mexico and Madrid: Conaculta and Turner, 2005), p. 176.

70 Maurice Blanchot, 'L'Homme de la rue', *Nouvelle Revue Française*, 114 (June 1962), pp. 1070–81, reprinted as 'La Parole quotidienne', in M. Blanchot, *L'Entretien infini* (Paris: Gallimard, 1969), pp. 355–66.

71 *Ibid.*, p. 365.

72 Thierry Davila, *De l'inframince: brève histoire de l'imperceptible de Marcel Duchamp à nos jours* (Paris: Editions du regard, 2010), pp. 15–16.

73 Thomas Hirschhorn, 'Ne pas s'économiser: Conversation entre Thomas Hirschhorn et François Piron', June 2001, *Trouble*, 1 (2002), http://troublelarevue. free.fr/TROUBLE%201/trouble1thomasha.html (accessed 3 April 2014).

74 Alison Gingeras, 'Striving to Be Stupid: A Conversation with Thomas Hirschhorn', in Alison Gingeras (ed.), *Thomas Hirschhorn: London Catalog* (London: Chisenhale Gallery, 1998), p. 6.

75 *L'art n'est jamais acquis.* Thomas Hirschhorn, 'Avant/Après: Entretiens avec Thomas Hirschhorn par Guillaume Désanges' ('Avant', April 2004), in Thomas Hirschhorn (ed.), *Musée Précaire Albinet* (Paris: Xavier Barral et Laboratoires d'Aubervilliers, 2005), n.p.

76 'Alison Gingeras in Conversation with Thomas Hirschhorn', in Basualdo et al., *Thomas Hirschhorn*, p. 14.

77 Thomas Hirschhorn, 'About the "Musée Précaire Albinet", about an artists' [sic] work in Public Space, and about the artists' [sic] role in public' (14 May 2004), in *Timeline: Works in Public Space* (2012), www.diaart.org/gramsci-monument/Timeline_Texts.pdf (accessed 3 April 2014).

78 Thomas Hirschhorn, 'My Videos' (15 December 1993), in *Critical Laboratory*, p. 13.

79 Benjamin Buchloh, 'Detritus and Decrepitude: The Sculpture of Thomas Hirschhorn', *Oxford Art Journal*, 24:2 (2001), 49.

80 Gabriel Orozco, note dated 16 August 1994, reprinted in Temkin (ed.), *Gabriel Orozco: Photogravity*, p. 167.

81 *Il y a du quotidien.* Blanchot, 'Parole quotidienne', p. 365.

82 Gabriel Orozco, 'Interview with Guillermo Santamarina', in *Gabriel Orozco* (Madrid: Museo Nacional Centro de Arte Reina Sofia, 2005), p. 143; Daniel Birnbaum, 'A Thousand Words: Gabriel Orozco Talks about his Recent Films', *Artforum*, 36:10 (1998), 115.

83 Birnbaum, 'A Thousands Words', 114.

84 *Ibid.*

85 *Ibid.*

86 *¿Si la tierra está divagando, porqué tu no?* Notebook, reproduced in Temkin (ed.), *Gabriel Orozco*, p. 48.

87 Thomas Hirschhorn, interview with the author.

88 Orozco, 'Lecture', p. 89.

89 Buchloh, 'Detritus and Decrepitude', p. 47.

90 *Ibid.*

91 Hirschhorn, interview with the author.

92 Enwezor, 'Interview with Hirschhorn', p. 32.

93 Bourriaud, *Postproduction*, p. 28.

94 Gioni, 'Ask the Dust', p. 65.

95 Buchloh, 'Detritus and Decrepitude', 48.

96 Benjamin Buchloh, 'The Sculpture of Everyday Life' (1996), in Bois (ed.), *Gabriel Orozco*, p. 39.

97 Cuauhtémoc Medina, in Medina (ed.), *Francis Alÿs*, p. 39.

98 Alÿs, 'The Swap' (1995), in *ibid.*

99 Francis Alÿs, 'The Seven Lives of Garbage' (1995), in *ibid.*, p. 40.

100 McEvilley, 'Francis Alÿs', p. 39.

101 *Ibid.*, p. 40.

102 *La réalité socio-politique du Mexique ne permet pas de prendre trop au sérieux le rôle de l'art*. David Torres, 'Francis Alÿs, simple passant', *Art Press* 267 (April 2001), 20.

103 *le renvoi de balle de tout ce monde … reste quand même la source d'inspiration principale de la plupart des projets*. Unpublished interview with the author, Mexico City, 23 September 2008. 'Walking the Line', 5.

104 'Walking the Line', 2.

105 *une souplesse, une flexibilité, une fragilité*. Interview with the author.

106 'Walking the Line', 3.

107 Interview with the author.

108 See Klaus Biesenbach, Mark Godfrey and Kerryn Greenberg (eds), *Francis Alÿs: A Story of Deception* (London: Tate, 2010), p. 89.

109 *Si on peut réduire le propos à une petite histoire qui se transmet, elle n'appartient plus à personne, elle se socialise et elle fait tache d'huile*. Torres, 'Francis Alÿs', 20.

110 'Rumours', p. 24.

111 Bourriaud, *Relational Aesthetics*, p. 113.

112 *Ibid.*, p. 18.

113 Ina Blom, *On the Style Site: Art, Sociality and Media Culture* (Berlin: Sternberg Press, 2007), p. 66.

114 *Ibid.*, p. 87.

115 *Ibid.*, p. 81.

116 *Ibid.*, p. 59.

117 See Thierry Davila, *Marcher, créer: Déplacements, flâneries, dérives dans l'art de la fin du XXe siècle* (Paris: Editions du Regard, 2002).

118 Jason Reitman (dir.), *Up in the Air* (2009). 109 min.

119 Diane Coyle, *The Weightless World: Strategies for Managing the Digital Economy* (Oxford: Capstone, 1997).

120 Jeremy Rifkin, *The Age of Access: The New Culture of Hypercapitalism, Where All of Life is a Paid-for Experience* (New York: J.P. Tarcher/Putnam, 2000), p. 30.

121 Bauman, *Liquid Modernity*, p. 14.

122 *Ibid.*, p. 13.

123 Zygmunt Bauman, 'Liquid Arts', *Theory, Culture & Society*, 24:1 (2007), p. 124.

124 Coyle, *The Weightless World*, p. xii.

125 See Maurizio Lazzarato, 'Immaterial Labor', in Michael Hardt and Paulo Virno (eds), *Radical Thought in Italy* (Minneapolis: University of Minnesota Press, 1996), pp. 133–47.

126 See André Gorz, *L'Immatériel: Connaissance, valeur et capital* (Paris, Galilée, 2003).

127 Michael Hardt and Antonio Negri, *Empire* (Cambridge, MA: Harvard University Press, 2000), pp. 292–3.

128 Ian Fraser, 'Affective Labor and Alienation in *Up in the Air*', in Ewa Mazierska (ed.), *Work in Cinema: Labor and the Human Condition* (New York: Palgrave Macmillan, 2013), ch.1.

129 *En devenant la base d'une production de valeur fondée sur l'innovation, la communication et l'improvisation continuelles, le travail immatériel tend finalement à se confondre avec un travail de production de soi*. Gorz, *L'Immatériel*, p. 20.

130 Paolo Virno, 'Virtuosity and Revolution: The Political Theory of Exodus' (1996), http://www.generation-online.org/c/fcmultitude2.html (accessed 5 May 2015).

131 *l'expression la plus avancée des nouveaux modes de production et des nouvelles relations d'emploi engendrés par les mutations récentes du capitalisme.* Pierre-Michel Menger, *Portrait de l'artiste en travailleur: Métamorphoses du capitalisme* (Paris: Seuil, 2002), p. 8.

132 *l'engagement productif de ressources personnelles (effort, énergie, connaissances).* Ibid., p. 6.

133 Cuahtémoc Medina, 'Fable Power', in Russel Ferguson et al., *Francis Alÿs* (London: Phaidon, 2007), p. 70.

134 *Piétons planétaires.* See the chapter titles in Davila, *Marcher, créer.*

135 *inoculons de la longue durée et de l'extrême lenteur au centre même de la vitesse.* Bourriaud, *Radicant*, p. 60.

136 *A la précarisation de notre expérience, opposons une pensée résolument précaire, qui s'insère et s'inocule dans les réseaux même [sic] qui nous étouffent. Ibid.*

137 *flux, mouvements de capitaux, répétition et distribution de l'information. Ibid.*, p. 66.

138 *Ibid.*, p. 157.

139 Nicolas Bourriaud, 'Precarious Constructions: Answer to Jacques Rancière on Art and Politics', *Open*, 17 (2009), special issue on 'A Precarious Existence: Vulnerability in the Public Domain', 33, 35.

140 Bourriaud, *Postproduction*, p. 18.

141 Robert Reich, *The Work of Nations: Preparing Ourselves for Twenty-first-century Capitalism* (New York: Vintage, 1992), p. 178.

142 Danny Quah, cited in Coyle, *A Weightless World*, p. xiii.

143 *extensions et déclinaisons.* Bourriaud, *Radicant*, p. 157.

144 Melanie Gilligan, 'Derivative Days: Notes on Art, Finance and the Un-Productive Forces', in Oliver Ressler and Gregory Sholette (eds), *It's the Political Economy, Stupid! The Global Financial Crisis in Art and Theory* (London: Pluto Press, 2013), p. 76.

145 *Ibid.*, p. 77.

146 Sandro Mezzadra, 'Living in Transition: Toward a Heterolingual Theory of the Multitude', *Transversal* (June 2007), http://eipcp.net/transversal/1107/mezzadra/en (accessed 13 May 2015).

147 Bourriaud, *Postproduction*, p. 29.

148 Buchloh, 'Interview with Gabriel Orozco', pp. 65, 69.

149 In Temkin (ed.), *Gabriel Orozco*, p. 163.

150 Fisher, 'Sleep of Wakefulness', p. 26.

151 D.T. Suzuki's *The Awakening of Zen* is quoted by Orozco in a note dated 10 December 2002, reprinted in Temkin (ed.), *Gabriel Orozco*, p. 180.

152 Interview with the author.

153 Notes by Orozco included in Temkin (ed.), *Gabriel Orozco: Photogravity*, p. 129.

154 Francesco Bonami, 'Sudden Death: Roughs, Fairways and the Game of Awareness', in *Gabriel Orozco: Clinton is Innocent*, p. 23.

155 Gabriel Orozco, 'Impact and *satori*: Instruments of comprehension', *Artforum*, 40:3 (2001), 118–23.

156 *relación entre la estructura y el accidente, entre las reglas y su apertura.* Orozco, 'Interview with G. Santamarina', p. 6.

157 'Spirograph: The Circular Ruins of Drawing' (2004), in Bois (ed.), *Gabriel Orozco*, p. 134.

158 Briony Fer, 'The Scatter: Sculpture as Leftover', in Helen Molesworth (ed.), *Part Object Part Sculpture* (Columbus, OH: Wexner Museum of Art, 2005), p. 231.

159 *Ibid.*

160 *Ibid.*

161 Quoted in Temkin (ed.), *Gabriel Orozco*, p. 175.

162 *Le marcheur, en dépit de sa légèreté, de son oisiveté et de sa nonchalance, serait l'individu scrupuleux par excellence.* Davila, *Marcher, créer*, p. 114.

163 Bourriaud, *Radicant*, p. 82.

164 'Rumours', p. 22.

165 'La Cour des Miracles', p. 101.

166 *Ce détail, ce scrupule, nous empêche de consommer la fluidité de la mégalopole et nous amène à regarder la mécanique des déplacements, l'énorme rouage qui l'entretient.* Davila, *Marcher, créer*, p. 114.

167 *logique de la rentabilité. Ibid.*, p. 94.

168 Medina, 'Fable Power', p. 95.

169 'How to Do Time with Art', in Biesenbach, Godfrey and Greenberg (eds), *Francis Alÿs*, p. 101. Cf. Christine Ross, *The Past is the Present; It's the Future Too: The Temporal Turn in Contemporary Art* (New York and London: Continuum, 2012), pp. 65–86.

170 Pamela M. Lee, 'Perpetual Revolution: Thomas Hirschhorn's Sense of the World', in *Forgetting the Artworld* (Cambridge, MA: MIT Press, 2012), p. 131.

171 *Ibid.*, p. 140.

172 *Ibid.*, p. 143.

173 For an account of this project, see Thomas Hirschhorn, *Deleuze Monument: les documents* (Paris: Thomas Hirschhorn, 2000), and my *Thomas Hirschhorn, Deleuze Monument* (London: Afterall, 2014).

174 Thomas Hirschhorn, 'Monuments' (February 2000), in *Critical Laboratory*, p. 45.

175 Benjamin Buchloh, 'Sculpture between Nation-state and Global Commodity Production', in Temkin (ed.), *Gabriel Orozco*, p. 39.

176 Benjamin Buchloh, 'Thomas Hirschhorn: Lay Out Sculpture and Display Diagrams', in Basualdo et al., *Thomas Hirschhorn*, p. 45.

177 Nato Thomson, 'Trespassing Relevance', in Gregory Sholette and Nato Thomson (eds), *The Interventionists: Users' Manual for the Creative Disruption of Everyday Life*, exh. cat. North Adams, Mass MoCA (Cambridge, MA: MIT Press, 2004), p. 15.

178 Hirschhorn, quoted by Lee, 'Perpetual Revolution', p. 119.

179 Sam Mendes (dir.), *American Beauty* (1999). 122 min.

180 Russ Spencer, 'Where you find it: In a culture of detritus, *American Beauty* screenwriter Alan Ball discovers heartbreaking beauty in garbage', *Salon*, 25

March 2000, http://www.salon.com/people/feature/2000/03/25/ball/ (accessed 13 May 2015)

181 See Gary Hentzi, '*American Beauty*' [review], *Film Quarterly*, 54:2 (2000–01), 46–50.

182 Fer, 'Spirograph', p. 136.

183 *Ibid.*, pp. 134, 136.

184 Briony Fer, 'Constellations in Dust: Notes on the Notebooks', in Temkin (ed.), *Gabriel Orozco*, p. 25.

185 Lorna Fox, 'Where Sculpture Happens', in Biesenbach, Godfrey and Greenberg (eds), *Francis Alÿs*, p. 195.

186 '99 Sacs plastiques (depot)' (1994), in *Critical Laboratory*, p. 165.

187 *Ibid.*, p. 167.

188 Antonio Negri, *Kairòs, Alma Venus, Multitudo* (2000), in *Time for Revolution*, trans. M. Mandarini (London: Bloomsbury, new edn, 2013), p. 48.

189 *Ibid.*, p. 148.

190 Hardt and Negri, *Empire*, p. 354.

191 Negri, *Kairòs,* pp. 171, 156.

192 *Ibid.*, p. 156.

193 *Ibid.*, p. 181.

194 Lee, 'Perpetual Revolution', p. 130.

195 Marcel Detienne and Jean-Pierre Vernant, *Les Ruses de l'intelligence: la mètis des Grecs* (Paris: Flammarion, 1974), p. 28.

196 Michael Hardt and Antonio Negri, 'The Becoming-Prince of the Multitude', *Artforum*, 48:2 (2009), p. 178.

197 Laymert Garcia dos Santos, 'Becoming Other to Be Oneself: Francis Alÿs Inside the Borderline', in Biesenbach, Godfrey and Greenberg (eds), *Francis Alÿs*, p. 189.

Liquid capitalism's new 'lightness and motility', argued Zygmunt Bauman in 2000, 'have turned into the paramount source of uncertainty for all the rest'.[1] Indeed, capitalism's short-term tactics of mobility and evasion have been systematically accompanied since the 1980s by strategies of downsizing and outsourcing that have radically transformed the very definitions of work and society. Terms such as 'flexploitation' and 'precarisation' were coined in the late 1990s to describe the new uncertain status of work within this new global context. The winners of liquid modernity's 'moral Darwinism', as Pierre Bourdieu called them, must combine their knowledge of high mathematics with a love of bungee jumping.[2] In contrast, the losers are the ones who fall off the tightrope on which they were uncertainly walking, only to find out that the traditional safety nets of family, society and state were removed during a downsizing exercise.

Bauman noted that liquid modernity dissolved those 'bonds which inter-lock individual choices in collective projects and actions', be they trade unions or family life.[3] Bourdieu similarly deplored how job precarity not only isolated the unemployed, but also favoured a highly individualist, hyper-competitive climate which destroyed the very 'values of solidarity and humanity'.[4] This inevitably leads to a profound depoliticisation of the population, according to Bourdieu: as precarity 'renders the whole future uncertain, it hinders … the minimal amount of belief and hope in the future that is required in order to rebel, above all collectively, against even the most intolerable present'.[5]

Could this combined depoliticisation and sense of precariousness account for the widespread apathy attributed to a generation often termed 'Generation X', after the eponymous novel by Douglas Coupland, and described as 'slack-ers' and losers? As he was writing *Generation X* in 1991, Coupland remembers, he 'had this sadness that some dimension of history, a certain kind of potency, was over…'[6] Indeed, he recalls Francis Fukuyama 'declaring the end of history' at the time. In 1989, Fukuyama had proposed that the end of history was a consequence of 'the total exhaustion of viable systematic alter-natives to Western liberalism'; this 'unabashed victory' marked, according to

Fukuyama, 'the end point of mankind's ideological evolution'.[7] This may certainly have been one of the reasons why, for Coupland's Generation X, 'Life felt stagnant.'[8] Not only had communism failed to build a viable alternative to capitalism: in these precarious times, young people also found themselves let down by liberalism itself, as they could no longer rely like their parents on a 'narrative structure to their lives', be it job security, a 'career arc', social benefits or stable institutions.[9]

The same year as Coupland's 1991 novel, Nirvana released a hit single described by *Time Magazine* as the 'anthem for apathetic kids';[10] in 'Smells like Teen Spirit', Kurt Cobain could hardly be bothered to come up with an intelligible chorus, and sang that 'it's fun to lose and to pretend', observing that he felt 'stupid and contagious'. Released a few months earlier than Nirvana's hit, Richard Linklater's 1991 cult movie *Slacker* similarly portrayed a generation of aimless young people. In this largely plotless film, characters roam around and do very little in Austin, Texas, conspicuously displaying a complete lack of ambition. 'No one in *Slacker* thinks they're going to remake society', acknowledged Linklater in an interview for *Artforum* in 1993.[11] 'They're more satisfied to hang out and snicker ironically with their friends.'

Irony was indeed what distinguished these Generation X slackers from their Beat predecessors and the other 1960s good-for-nothings who liked to 'hang out', as we saw in the first part of this book. The 1990s generation, according to John M. Ulrich's insightful 2003 study, found themselves caught in the paradoxical position of trying to resist against a society 'where "true" resistance and rebellion are said to be impossible because they are always already co-opted'.[12] These young people wanted to find a voice while simultaneously feeling that 'no "authentic" individual identity can be expressed, because it is always already mediated through commodities'. For this Generation X, then, 'self-conscious irony' offered itself 'as a kind of defensive subject position, a symbolic "resistance" painfully aware of its limited impact on the amorphous, all-pervasive consumer culture'.[13] Faced with this double bind, Generation X often adopted the persona of the loser. In the 1990 exhibition *Just Pathetic*, curator Ralph Rugoff showcased artists who similarly chose to play at being apathetic losers by creating work that deliberately 'makes failure its medium'.[14]

Not all members of Generation X, however, adopted the slacker's ironic attitude. Some sought to counter the very 'depoliticisation' and absence of 'hope and belief in the future' that Bourdieu was denouncing at the time. Bourdieu himself supported demonstrations by the French unemployed in 1998, and was associated with early manifestations of so-called 'alterglobal' thinking. A number of anti-precarity movements emerged around that time, including the ChainWorkers who came together in Milan around 1999 and organised the first European May Day demonstrations against precarity in

2001. Like the unemployed demonstrations in France, the ChainWorkers' actions in Italy also fed into an increasingly global 'alterglobal' 'movement of movement'. This movement rose to international prominence during the 1999 protests against the World Trade Organisation in Seattle. This event, as Nato Thomson noted, 'marked a critical moment in progressive political history because the rallying cry was not against a specific government, but against the intangible and relatively abstract international finance organizations that so perfectly represented the shift toward an unchecked, diffuse, international power'.[15] By 2001, the first World Social Forum, convened in the Brazilian city of Porto Alegre in opposition to the World Economic Forum in Davos, would famously proclaim that 'another world' – distinct from the liquid capitalist hegemony – was 'possible'. Bringing together tens of thousands of activists from around 100 countries, the WSF proposed another form of globalisation in which bonds could be forged across the planet to fight corporate globalisation and achieve new forms of 'global justice'.

Such a denunciation of the global neoliberal hegemony united varied constituencies ranging from intellectuals like Bourdieu to the indigenous movement of the Zapatistas in Mexico, or collectives favouring festive combinations of dance and subversion such as the ChainWorkers in Milan or Reclaim the Streets in Britain. By 2004, theorists such as Gene Ray and Nato Thomson could also point to the convergences between such alterglobal movements and new kinds of art practices. Not only did some collectives and protesters actually share the same 'tactics', as Nato Thomson pointed out in his essay for the exhibition that he curated under the title *The Interventionists*: they were also developing common tools to explore alternative ways of living and new forms of 'collective agency', as Ray saw it.[16] Naomi Klein explained in 2001 that the general 'spirit' shared by the very varied strands of the alterglobalisation movement was a desire to reclaim 'public' space and the 'commons' that had been subsumed by neoliberalism.[17] According to Ray, this would involve redefining the 'public sphere' outlined by Hannah Arendt in 'light of globalisation and the digital displacement of public space'.[18] A networked global solidarity thus emerged as an essential drive in this 'coalition of coalitions' in which various positions, concerns and methods could come together in opposition to the crises, insecurities and generalised precarity imposed by global liquid modernity.

This chapter is concerned with the general diagnosis of a changing, shrinking, if not vanishing public 'sphere of appearance' required for action, according to Arendt. On the one hand, the figure of the loser could be seen as responding to this disappearance through various forms of apathy, melancholy or cynicism. On the other hand, the activist – whether a member of the anti-precarity ChainWorkers or the many other related alterglobalisation movements – sought to reinvent new public spaces. These two central

figures – arguably two sides of the same coin – will frame my discussion of the precarious practices developed between 1991 and 2009 by artists such as Martin Creed, Thomas Hirschhorn, Francis Alÿs and Gabriel Orozco, which I introduced in the previous chapter. Analysing precarious practices in terms of contemporary debates concerning failure and precarity, I will demonstrate how they addressed the place of the 'public sphere' today, and delineated new spaces that are neither cynical nor melancholy, neither utopian nor nihilist.

Idiots and losers

'We cannot be more clever than Capital. That is futile. I don't want to be clever, I strive to be stupid.'[19] Such was the objective that Hirschhorn acknowledged in a 1998 interview with Alison Gingeras. Hirschhorn's early critics picked up on his recurrent use of terms such as 'stupidity' and 'weakness'. He was 'wagering on weakness', observed Jean-Yves Jouannais in 1994, while in 1998 Pascaline Cuvelier noted the artist's desire to 'show' 'in a stupid sort of way' that he was trying 'to connect things' that he didn't 'understand'.[20] The qualities of shabbiness, sloppiness, dirt, roughness and impurity celebrated by the artist in his works and writings contributed to this sense of deliberate inadequacy. Made out of pasted paper on wood or cardboard, Hirschhorn's early works appear half-finished, as if the artist had tried, without success, to create an ordered design. Moreover, Hirschhorn sought to leave such works 'exposed' and unprotected by strewing them on gallery floors, for example, or exhibiting them alongside abandoned debris and rubbish heaps in the street (figure 46).

This vulnerability in form and display resulted, according to Hirschhorn, from his failure to comprehend the violence, inequalities and injustice of the world. 'Exposing' his work to be trampled by visitors in his 1992 solo exhibition at the Hôpital Ephémère in Paris, Hirschhorn spoke of the shame experienced at the sight of beggars on the street, or images of innocent war victims in Yugoslavia.[21] Such unprotected works by Hirschhorn seemed to be crying out, like their author: 'I'm in deep shit, and so are you. I'm weak, and so are you. I'm lost, and so are you.'[22] In his 1995 book *Les Plaintifs, les bêtes, les politiques*, Hirschhorn made even more explicit such connections between his precarious designs and displays, on the one hand, and, on the other, his 'stupid' bewilderment in the face of lived precariousness in the world (figure 61).[23] The collages published in the book juxtapose logos and advertisements with press images of war and poverty, as well as images of displays by the artist. Scrawled in ballpoint pen next to the images, questions and exclamations voice the artist's anxieties in the face of monstrous inequalities, or convey his puzzlement at the fact that design can be beautiful even when it promotes objectionable agendas. The juxtapositions are crude, the questions apparently confused, naïve and stupid. We are pulled in by the artist's

Thomas Hirschhorn, page from *Les Plaintifs, les bêtes, les politiques* (Geneva: Centre **61**
Genevois de Gravure Contemporaine, 1995)

incomprehension, which is disarmingly sincere; his calls for help ('please help me', 'I don't understand!') make us feel responsible for our own thoughts and positions. It is in this sense that *Les Plaintifs, les bêtes, les politiques* embodies the very combination of vulnerability, confrontation and affective implication typical of Hirschhorn's *oeuvre*.

As Hal Foster has demonstrated, Hirschhorn's use of the term *bête* in the book's title brings together different characteristics of the artist's work. In addition to the desire to be foolish and stupid, the artist has highlighted the absence of reflection that he embraces when working quickly, without thinking – a state the artist describes as being *kopflos*, without a head – or when declaring his unconditional love as a fan. (Indeed, the 'stupid' questions of *Les Plaintifs, les bêtes, les politiques* have their counterparts in the fan's 'stupid' declarations of love in subsequent works such as the *Altars* that I discussed in the previous chapter – see figure 4.) Foster singled out one further use of the term *bête* in Hirschhorn's work: the sense of being '"dumbstruck" by the outrageous events of the world, such as the mass murder of innocent citizens during the Iraq war' (unbearable images of which Hirschhorn started to include in installations and collages from around 2005 onwards).[24]

In 2003, Jean-Yves Jouannais integrated his above-mentioned 1994 article about Hirschhorn's work into a larger study of idiocy in modern and contemporary art: *L'Idiotie: art, vie, politique – méthode*. A dizzying panorama of figures from David Medalla to Robert Filliou, and from Gustave Flaubert's Bouvard and Pécuchet to Laurel and Hardy, Jouannais's study of idiocy broaches themes ranging from slapstick, mediocrity and kitsch to amateur painting and esotericism.[25] With *Just Pathetic*, the exhibition I mentioned at the beginning of this chapter, Ralph Rugoff similarly tried to describe a new 1990s sensibility that sought to plumb the depths of the inadequate. According to Rugoff, 'pathetic art' engages with failure in diverse ways: by presenting 'flawed and shabby' constructions or 'frail' drawings and 'inane' doodles, by announcing ridiculously improbable projects, or by offering 'remnants of failed attempts to make art'.[26] In *Just Pathetic*, for example, George Herold's sculpture involved a pair of men's underpants in the beloved tradition of high-school pranks, while John Miller's objects coated in brown acrylic paste were undoubtedly scatological. The two key figures in the exhibition were Mike Kelley, who had started working in the late 1970s, and Cady Noland, daughter of abstract painter Kenneth Noland. In Kelley's homage to his dead cat (*Mooner*, 1990) the artist scattered a cat's litter tray, feeding dish and toys on an afghan blanket, whereas Noland casually heaped various objects, including an American flag, in a generic shopping basket. Both practices epitomised, according to Rugoff, a kind of 'pathetic assemblage', which 'doesn't try to poeticize its grungy materials'; it 'has no interest in redeeming the unworthy, in discovering the exotic or heroic in the everyday'.

Mike Kelley's work was similarly described as 'utterly beyond redemption' by Michael Wilson in a retrospective account of the 1990s.[27] '[U]sed and abused', Kelley's stuffed animals (figure 62) were, according to Wilson, the antithesis of Jeff Koons's gleaming *Rabbit* (of 1986) – which 'is glamorous and erotic despite its kitsch origins'. Indeed, Rugoff had explicitly contrasted

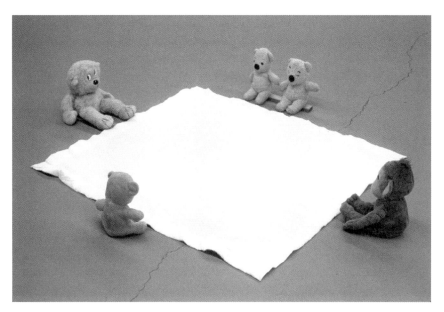

Mike Kelley, *Arena #7 (Bears)*, 1990 **62**

'pathetic' art with 'our cultural predilection for smoothness and order' as well as the 'semiotic delirium' of 1980s art.[28] As we saw in Chapter 4, a number of artists in the 1990s, including Mike Kelley, reacted against the slick aesthetic of 1980s art. Practices such as Kelley's or Miller's, argued Hal Foster in his 1996 *Return of the Real*, adopted the register of the abject in order to childishly transgress the taboos of order and cleanliness.[29] Indeed, Kelley and Miller were included in a 1993 exhibition titled *Abject Art*, which focused on a return of the repressed body in contemporary art practices exploring 'repulsion and desire' in textures and forms evoking undifferentiated substances such as bodily fluids.

Foster himself associated abject art not only with grunge, but also with the cult of 'slackers and losers' in contemporary art and culture.[30] Other contemporary critics teased out similar connections. Speaking of the 'loser' figure in a 1992 article in *Artforum*, Rhonda Lieberman praised the 'constitutionally deflated style' of artists such as Karen Kilimnik, Sean Launders or David Diao as 'a breath of fresh air after the generally humourless self-righteous and/or slick critiques of mastery prevalent' in 1980s practices (one imagines the critic was alluding to artists such as Sherrie Levine).[31] The 1990s artists praised by Lieberman cast themselves as losers by making oversize trousers with the words 'kick me' stitched in bright capital letters, like Sean Launders, or by scrawling on the wall 'Don't hate me because I am mediocre' as did Cary Leibowitz. They were, she argued, involved in a form of 'abjection' in that

they were 'resigned to a low state' as a result of their inability to measure up to their 'ideals'.[32]

In his catalogue essay for *Just Pathetic*, Rugoff cited Peter Sloterdijk's *Critique of Cynical Reason*: a study, first published in German in 1983, of the state of contemporary cynicism. Sloterdijk analysed what he called 'an enlightened false consciousness' which holds on to the philosophical project of the Enlightenment while admitting its failure.[33] This double bind leads to a cynical form of apathy. It is to this very impasse that Rugoff seems to be referring when he argues that 'since the meaning of a pathetic work can't be separated from its miserable material appearance, the possibility of constructing a solid political and polemical platform is sabotaged in advance'. Sloterdijk, for his part, believed that 'cynical reason' could be countered with a 'kynical irony' in which artists act like idiots, thus parodying the individual's powerlessness under capitalism. Quoting Sloterdijk among others, French curator Christine Macel would praise this subversive clown figure in the 2005 exhibition *Dionysiac*, which brought together 'abject' practices such as Paul McCarthy's as well as works by younger artists including Thomas Hirschhorn. According to Macel, such artists turned to ecstasy, laughter, eroticism, excess and confusion in the face of the world's tragic 'incoherence' and the 'death of myths and utopias'.[34] Macel also noted that the works in *Dionysiac* thumbed their noses at 1980s artistic practices, whether Koons's 'post-pop' mixture of entertainment and cynicism, or what she deemed a 'politically correct' anti-aesthetic.

The problem, however, with Sloterdijk's opposition between 'kynical irony' and 'cynical reason', as Hal Foster aptly noted, is that they are sometimes impossible to distinguish. Thus, argued Foster, the kind of 'simulated imbecilism, infantilism, or autism' at play in Mike Kelley's works and other abject practices embraced the pose of 'kynical irony' to such an extent that it appeared like 'the paradoxical defence of the already damaged, defeated, or dead'.[35] Foster read such tendencies as an exacerbated response to cynical reason: they pushed this 'pose of indifference to the point of disaffection'. Similarly, I would suggest that some of the artists' celebrations of scatological play or wild partying in *Dionysiac* could be read as so many forms of perverse regression as much as the subversive 'transgression' that Macel highlighted. Hirschhorn's excess stood out from the *Dionysiac* exhibition, I would argue, because his work involved construction more than destruction. His expenditure was channelled into production rather than revelry.

Indeed, while Hirschhorn's celebration of 'weakness' and 'stupidity' appeared to link his practice to those of losers and other 'pathetic' figures that cropped up in 1990s art and culture, the artist vehemently objected to such readings of his work. Dismissing 'the fashionable discourse surrounding idiocy', he repeatedly rebuked readings that cast his works in terms of a pathetic logic of 'self-cancellation' or self-abasing inadequacy.[36] When,

for example, French critic Guillaume Désanges underlined the *caractère dérisoire*, the laughable, ridiculous character of Hirschhorn's work, the artist protested that his work was only *dérisoire* in the eyes of those who believed that his desire to create works in public places was doomed to fail.[37] It was by fighting to carry out his projects to the end, argued Hirschhorn, that he was countering this very rhetoric of powerlessness – for it is precisely this rhetoric, I would add, that tends to lead to either 'cynical reason' or 'kynical irony'. In fact, when Hirschhorn put his works out in the street in *Jemand kümmert sich um meine Arbeit* (1992) (figure 46), he did not actually conceive this gesture as a pathetic 'self-sabotage'; instead of taking for granted the inevitability of their disposal at the hands of the dustmen, he was hopeful that someone would find one of them beautiful and hang it over their mantelpiece.[38]

'Striving to be stupid', for Hirschhorn, meant using weakness as a 'weapon' against an ever more intelligent capitalism. What he called a 'strategy of weakness' involved fighting an 'imposed weakness' with a 'willed' or 'voluntary' weakness.[39] Asking in *Les Plaintifs…* 'who is the winner?' and 'who is the loser?' next to a photograph of a destitute old man crouching in a shelter and another of an astronaut floating in space (figure 61), the artist evidently sought to unsettle conventional definitions of each term, and the hierarchy they set up. Here Hirschhorn appears close to the 'good-for-nothing' persona adopted by 1960s artists such as Robert Filliou, who challenged the ideal of the capitalist 'winner', as we saw in Chapter 3. Indeed, the incessant questions in *Les Plaintifs…* resonate with those constituting Filliou's 1965 *Ample Food for Stupid Thought* which similarly sought to destabilise accepted truths by asking readers to reflect on 'how much is too much?' or 'what are you going to do about it?' Unlike the light playfulness of Filliou's constructions and games, however, Hirschhorn's humour is darker – his book is couched in terms of urgency, indignation and despair. Soliciting the viewer affectively as well as intellectually, Hirschhorn refuses to indulge in a cynical double bind. As he explicitly stated, he is 'not interested in failure'.[40]

Pathetic, futile

At times, both the idiot and the loser took on the persona of the fan. For example, Karen Kilimnik alternated between 'scatter' sculptures made out of clichéd objects and characters drawn from a fictional teenager's avid consumption of popular culture, on the one hand, and paintings, drawings and notes about the stars she adored, on the other. In some works, Kilimnik compulsively copied images of Kate Moss from magazines, which she annotated with wistful observations and clusters of pink and white hearts. Another kind of activity favoured by pathetic fans is discussed by Jouannais in his chapter on 'mediocre' artists in *L'Idiotie*: Jonathan Monk's performances, *Waiting*

for Famous People (1995), involved the artist standing at an airport with cardboard signs bearing the handwritten names of celebrities ranging from Duchamp and Warhol to Madonna, Bruce Willis and the Beatles. The impossibility of these encounters underscores the 'second place' chosen by the artist from the outset, according to Jouannais.[41] As with Kilimnik, the fan's 'wannabe moment', to use Rhonda Lieberman's term, acts as the 'generative power of the work'.[42] In his *Altars* (figure 4), Hirschhorn unequivocally positioned himself as a fan, as he proclaimed his unconditional love to writers, artists and thinkers through a vocabulary of teddy bears, candles and love messages, sometimes scribbled on heart shapes that are strikingly similar to Kilimnik's. I would argue, however, that Hirschhorn's *Altars* stay clear of either Kilimnik's disquieting fascination or Monk's self-debasement.

In order to further understand Hirschhorn's unique brand of fandom, I will turn to another comparison, suggested by Désanges in his above-mentioned interview with the artist. After Princess Diana's fatal accident in the summer of 1997, a collective outpouring of grief led her fans to spontaneously dedicate an improvised street memorial to her at the Pont de l'Alma in Paris, and to fill in her honour the gardens of Kensington Palace, in London, with photos, flowers, notes, candles and teddy bears, much like those used by Hirschhorn in his own *Altars*. Hirschhorn, who was already interested in street altars dedicated to accident victims, would directly reference those homages to Princess Diana in his 1999 *Direct Sculpture* which was modelled on the way people had reclaimed and adapted an existing monument – the 'flame of liberty' near the Pont de l'Alma where Diana had died.

The connection between such homages to Princess Diana and Hirschhorn's *Altars* also came to art historian Margaret Iversen's mind as she looked at another work, Mark Wallinger's 2007 *State Britain* (figure 63).[43] *State Britain* was an exact replica, erected by Wallinger in the neoclassical Duveen Galleries of Tate Britain, of the elaborate construction that lonely maverick Brian Haw had been constructing since 2001 in front of the Houses of Parliament, in order to protest the sanctions and then the war on Iraq. Standing in the Duveen Galleries, I remember the installation exuding a heart-breaking melancholy, as Brian Haw's crazy mix of politics, Christianity, sentimentality and eccentricity lay exposed through banners, photographs, flimsy constructions and soft toys. Indeed, Wallinger's work presented itself as an elegy on three different levels. Firstly, *State Britain* functioned as a memorial to Brian Haw's display, which had been dismantled by the police a month after Wallinger had decided to present it at Tate. As the Tate documentation explained, Haw's stand had been outlawed according to a new 'Serious Organised Crime and Police Act' 'prohibiting unauthorised demonstrations within a one kilometre radius of Parliament Square'. As it happens, this exclusion zone geographically bisected the building of Tate Britain itself, so Wallinger 'marked a line on the

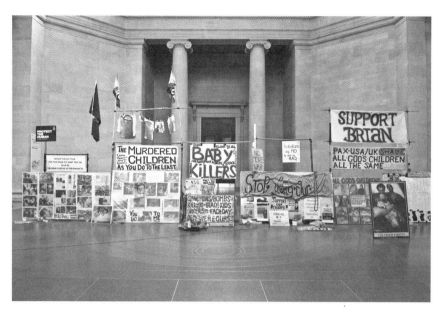

Mark Wallinger, *State Britain*, 2007. Installation at Tate Britain, London, 2007 **63**

floor of the galleries throughout the building, positioning *State Britain* half inside and half outside the border'.[44] In addition to mourning 'the erosion of civil liberties in Britain today', Wallinger's *State Britain* also stood, secondly, as a monument to the failed anti-Iraq-war protest, a reminder that the biggest demonstration ever to have been staged in Britain, in 2003, had not even been acknowledged by then Prime Minister Tony Blair. Finally, as Julian Stallabrass pointed out in an interview with Wallinger, *State Britain*, like other contemporary works, could only refer to 'past radicalism' 'with a bittersweet, nostalgic, and elegiac air, to say that the old era of political protest and art combined is something that we can never regain access to'.[45]

Melancholy, nostalgic: terms used to describe *State Britain* pertain to the affective. While Iversen thought of 'the raw collective emotional response one saw after Diana's death with all its sheer sentimentality',[46] Adrian Searle noted Haw's 'creepily sentimental horror'.[47] In Haw's display, mutilated dolls told us that the horrific images of victims of the Iraq war were 'unbearable'; teddy bears rallied to protest against the killing of children. Haw's use of soft toys connected Wallinger's work to Hirschhorn's outdoor *Altars* as well as to Mike Kelley's 'pathetic' assemblages (figure 62). This ambivalent motif, which stands as an easily recognisable signifier of infantilism and sentimentality, reveals the differences between Hirschhorn and these two other artists. Kelley's dirty, abandoned plush animals, as Michael Archer described them, 'speak of unbearable dereliction and loss' on an individual

level,[48] whereas Wallinger uses Haw's individual display to speak of the tragic deaths in the Iraq war, as well as the collective loss of citizens' political power post 9/11. In fact, the teddy bears in Wallinger's installation recall Kelley's 'pathetic art' because *State Britain* embraced a deeply melancholy tone that equally suggested a mournful resignation similar to Kelley's. In contrast, what Hirschhorn saw in the homages to Princess Diana near the Pont de l'Alma were not sentimental expressions of loss, but rather manifestations of the 'will of the heart' as he called it: the transformative ability that comes with love, adoration and unquestioning commitment. In the 'forced confrontation' between an official will of power 'coming from above' – embodied in the 'Flame of Liberty' monument – and the informal 'will of the heart' 'coming from beneath' emerged, according to Hirschhorn, a form of energy rather than elegy.[49]

A year after Wallinger's *State Britain*, Martin Creed created his own work for the Duveen Galleries at Tate Britain: *Work No. 850*, as we saw in Chapter 4, involved runners sprinting down the empty gallery one at a time, every thirty seconds (figure 54). While the humour of Creed's work certainly contrasted with the deep sadness of Wallinger's, I would nevertheless argue that *Work No. 850* also embodied a form of precariousness. The runners' bodies appeared fragile in the context of the neoclassical interior, as they recalled the heroic figures of Western sculpture and painting, as well as mirroring the visitors' bodies wandering in the respectable space of the museum. If Wallinger's melancholy anti-monumental shrine spoke of one man's failure to change the course of politics, and positioned the museum as the 'last resort for oppositional speech', as Foster put it,[50] Creed's light-footed work set up a contrast between the pulsating rhythm of fleeting bodies and the institution's ideals of beauty, knowledge and spectacle. Creed's *Work No. 850* offered a parody of both the museum as a space of entertainment and the very idea of 'performance' as a measure of success: the runners had no finish line to be crossed, no race to win, and many visitors did not even notice them.

The common rejection of any goal-driven productivity cultivated in the 1990s by Creed, as well as artists such as Orozco and Alÿs, might at first sight appear comparable to the attitudes of contemporary slackers and losers. *What's the Point of It?* was the title of Creed's 2014 retrospective, echoing the futility of his runners' single-minded efforts in the 2008 work at Tate. In 1999, Carlos Basualdo contrasted Alÿs's strolling 'without any illusion of finality' with the Situationists' utopian desire 'to imagine an autonomous subject' and their belief in an 'original experience' which was no longer sustainable in an age fully mediated by images.[51] Writing about Orozco's work in 1997, James Meyer explicitly aligned his wandering practice, exemplified as we saw in Chapter 4 by his photographs (figure 48) or his *Yielding Stone* (figure 49) in particular, with the 'feeling of aimlessness' displayed by the 'slacker'.[52] Indeed,

in an article for *Artforum*, Jack Bankowsky described the slacker as a 'subject without a mission':[53] 'without any illusion of finality' (like Alÿs according to Basualdo), with a 'feeling of aimlessness' (like Orozco according to Meyer).

Similarly, T.J. Clark's review of Orozco's retrospective at Tate Modern in 2010 was peppered with terms that had characterised descriptions of Generation X in the previous decades. For example, Clark commented on Orozco's 'knowing' acceptance of his 'belatedness', as well as the artist's 'lightly pessimistic' acknowledgement of the impossibility of making grand claims for art.[54] As we saw in Chapter 4, Orozco's starting point was indeed that 'everything has already happened'. Taking his distance from the revolutionary rhetoric of his muralist-artist father, Orozco preferred to disappoint his viewers instead. 'So what else do you expect?' T.J. Clark imagined Orozco's *Empty Shoe Box* (figure 45) to be knowingly, tauntingly, asking its viewers. Like those who criticised the Generation Xers' combination of irony and apathy, Clark was highly irritated by the 'sophistication of the built-in double bind' in Orozco's work. According to Clark, this double bind allows the artist to 'get away' with titillating viewers by playing on their preconceptions, while failing either to move or shock them.

Art historian Grant Kester also spoke of a double bind at work in the avowed futility of Alÿs's 2002 *When Faith Moves Mountains*, in which the artist invited 500 volunteers to shovel a sand dune just outside Lima (figure 60). For Kester, Alÿs's work embodied the retreat of politics into aesthetics inaugurated after the May 1968 uprisings, which heralded a widespread belief among intellectuals that any real emancipation was doomed to fail. This 'revolutionary impasse or "double bind"' had left the artist, according to Kester, with only two available options: either 'compromised engagement' or 'surrender'.[55] In this essay, Kester objects to this binary model and what he sees as the ensuing suggestion, in *When Faith Moves Mountains*, that:

> the only hope for a positive form of action, capable of resisting cooption and complicity, lies in the orchestration of a singular moment of joyful collectivity that is so brief, so ephemeral, so utterly disconnected from any broader or more sustainable narrative of resistance or emancipation, that it vanishes almost at the moment it is expressed.[56]

Indeed, when critics have compared Alÿs's work to that of 1960s figures such as Oiticica or Gordon Matta-Clark, the artist has systematically replied that he is less 'radical' than them, suggesting that revolution, for him, was never on the cards.[57]

In terms of his contemporaries, Alÿs has also readily admitted that his friend and fellow artist Santiago Sierra is more 'radical' than him. Alÿs acknowledges that he shares with Sierra a common feeling of 'inner revolt', a sense of 'incredible impotence'.[58] But, Alÿs goes on to explain, Sierra 'manages

to express' these feelings 'more harshly'. In one work from 2000, for example, Sierra tattooed a 160 cm line along the backs of four Spanish drug-addicted prostitutes, to whom he paid 'the price of a shot of heroin', thus saving them the trouble, he explained, of performing four fellatios for the same amount of money.[59] Although both Sierra's action and Alÿs's *When Faith Moves Mountains* are, arguably, equally absurd, they remain fundamentally distinct in my eyes. Whereas Sierra's dark work takes the form of a basic economic transaction, in which individuals are paid and exploited as objects following the logic of capitalism, Alÿs's work takes the form of a fable in order to criticise capitalism's quest for efficiency at all costs. Whereas Sierra's cynical mimicry revealed the alienation of precarious labour, Alÿs recruited volunteers in order to suggest that a collective effort, motivated by something other than financial gain, could also achieve a goal, even if it were barely visible. The 'inner revolt' experienced by Alÿs thus tends to be distilled 'in a more elusive or poetic way' in his work, as he noted himself.[60] Instead of the immediate shock of Sierra's performances, Alÿs's work function in two phases: an 'almost seductive' appearance and a second moment of critical reflection.[61] Thus, I would argue, Alÿs's work operates in the interval between Sierra's cynical anger and the melancholy resignation of artists such as Wallinger or the other above-mentioned 'pathetic' artists.

Alÿs's allusion to an 'incredible impotence' recalls Creed's emphasis on the 'feeling of total limitation' that drives his work.[62] Rather than anger, Creed's feeling comes from the fear of adding new objects to the world while knowing that he would need to 'live with' them, to take responsibility for this addition. This knowledge makes Creed anxious, unsure of what he wants, unable to move. Like Hirschhorn, Creed claims to like 'stupid' work.[63] In order to make 'weak' works deliberately, instead of being put in a position of weakness by an inflicted order, Hirschhorn selected fragile materials and placed his works in vulnerable positions. Stupidity, for Creed, involved keeping decisions and additions to a minimum, so that the work can almost pass unnoticed, because it is never imposed on the viewer.

Crucially, I would like to argue that Alÿs's 'incredible impotence' and Creed's 'total limitation', like Hirschhorn's 'willed stupidity' or Orozco's 'knowing' modesty, all serve to produce works that draw our attention to the shrinking sphere of action outlined by Arendt, *while simultaneously* resisting its disappearance – unlike the losers and slackers who tend to accept or even wallow in this impoverishment. In the remainder of this chapter, I will seek to articulate this dynamic movement of acknowledgement and resistance that lies, in my opinion, at the heart of precarious works. On the one hand, then, I will focus on the intricacies of the shrinking, vanishing spaces that such practices set up. On the other hand, I will follow Cuahtémoc Medina's suggestion that an Arendtian concern with a truly public space could constitute,

as she claims, a 'remedy for the futility of action and speech' – this very futility that may at first appear to be staged in precarious works such as Alÿs's.[64]

A 'syntax of weakness'

Reduced to a line, a point in space, a tiny interval, a boring sequence of banal events or objects, Creed's 1990s work, as we saw in Chapter 4, appeared to visualise a form of near paralysis. When Creed explained that his work 'comes about through a kind of failure', it is above all a failure to make decisions.[65] Unable to choose between the lights on or off in *Work No. 127*, Creed chose both. 'I don't know what I want', he sang in *Work No. 209* of 1997–99. Likewise, the runners in *Work No. 850* are, as we saw, going nowhere. Creed's feeling of 'total limitation', I would suggest, resonated with that of his contemporaries, including American artist Tom Friedman, who developed during the 1990s fragile, sometimes minuscule assemblages that could be compared to both Creed's and Orozco's works. When the young Friedman arrived in a new art college to start his MFA, his (conceptually bent) teachers asked him to explain his motivations: 'it paralysed me', he remembers.[66] He responded by painting his studio white, emptying it, and sitting in it looking at a metronome. (As we saw in Chapter 4, the metronome is an object also favoured by Creed.) Out of this original paralysis, Friedman, like Creed, developed a vocabulary of modified banal everyday objects, characterised by their lightness, sometimes verging on the invisible. Where Creed exhibited a crumpled ball of A4 paper (figure 52), Friedman showed two identically crumpled sheets of A4 paper in 1990. Where Creed chose to display a depressed ball of Blu-tack on a wall (figure 50), Friedman suspended in the corner of a room a 12.5 cm ball of pink chewing gum (made out of 1500 pieces of gum chewed over a long period, as we are informed by the wall-label). As in Orozco's work, the circle and sphere occur repeatedly in Friedman's production. For example, Friedman has formed different disk-like shapes on the floor. In one work from 1990 the disk is made out of a quantity of pink eraser shavings; in the 1994 *Dust Ball*, a surface of 'sifted dust' is topped by a 2 cm diameter ball of 'house dust' at its centre (figure 64). This tiny ball of dust appears like a cousin of Orozco's larger ball of plasticine, *Yielding Stone* (figure 49). Like Hirschhorn, Friedman has used plastic bags, cardboard boxes and masking tape. Other materials used by the American artist included spaghetti, plastic cups and straws, laundry detergent, toothpaste and toothpicks.

It is the differences, however, between Friedman's assemblages and the arrangements of Hirschhorn, Creed and Orozco that can help shed light on the latter artists' specifically precarious vocabulary of gestures. Hailed as an alchemist, magician or virtuoso, Friedman manipulates his materials in ingenious, dexterous, often extremely time-consuming ways in order to achieve results

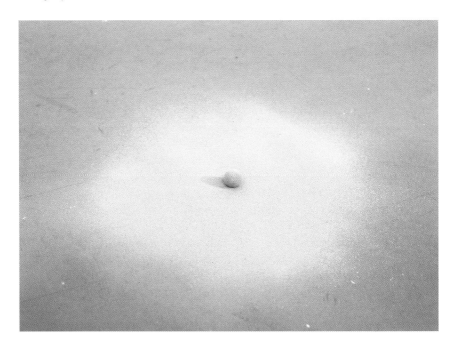

64 a and b. Tom Friedman, *Dust Ball*, 1994. TOP: Dust ball, 1.9 cm in diameter, on dust ground, 91.44 cm in diameter. BELOW: detail

that tend to elicit admiration. For example, he meticulously arranged a 'continuous ring of plastic drinking cups, one inside the other' in 1993, and erected an impressive 'starbust construction made with thousands of toothpicks' in 1995. Even the above-mentioned eraser shavings, house-dust circle or pink ball of bubble gum seem to be arranged artfully, as if in search for perfection. Rather than Orozco's aleatory geometries, or Creed's rhythmic reflexes, which I discussed in the previous chapter, the structures of Friedman's objects range from the tightly coherent to the highly complex, sometimes following a precise fractal logic of de-multiplication. Rather than the casual contingency of Creed depressing a lump of Blu-tack against the wall, of Alÿs stepping in a wad of chewing gum, or of Orozco rolling a ball of plasticine, Friedman's assemblages require time, skill and manipulation: chewed gum and house dust appear to have been carefully polished into spheres before being parodically displayed like precious objects. When Friedman speaks of the 'presence' of his 'vulnerable' objects, then, he does not have in mind their suchness, the 'nothing special' or *wu-shih* quality that I have emphasised in previous chapters. Unlike Creed's or Hirschhorn's 'stupid' work, Friedman displays a highly technical intelligence. Hirschhorn and Alÿs privilege the potentially endless temporality of labour, whereas Friedman's work operates in the logic of the goal-driven efficiency of work, even as he uses everyday, derisory materials.

If they stay clear of cynicism or melancholy, then, Creed's and Hirschhorn's 'stupid' work, like Alÿs's 'futile' performances or Orozco's fleeting gestures, also manage to turn their weakness into a strength without redeeming their practices through extraordinary craftsmanship. It is precisely this space, it seems to me, that philosopher Simon Critchley investigated in his 1997 book *Very Little… Almost Nothing* mentioned in my introduction. Critchley's interest lies less in socio-economic questions *per se* than in the metaphysical recognition of our 'exceedingly limited' and finite nature as human beings, compounded by both religious and political disappointments.[67] (In the preface to the 2004 edition, Critchley speaks of 'today's unending war against terror' as yet another 'tangible' reason for such disenchantment.)[68] What is most useful for our discussion of precarious works in the 1990s, however, is Critchley's focus on a 'dwindling sphere' – a phrase borrowed by the author from American poet Wallace Stevens – in which it may be possible to develop an 'active nihilism' distinct from a widespread 'sense of indifference, directionlessness or, at worst, despair'.[69] Critchley thus outlined ways of resisting nihilism by 'giving up the willfulness of the desire to overcome it'.[70] Tactics involved in this project may include a focus, like Stevens, on the 'sheer mereness of things', thereby shaking off 'the delusions of meaning'.[71] Another would entail developing, like Samuel Beckett, a humorous 'syntax of weakness', a kind of 'language endlessly undoing and undermining itself'. Beckett's 'making a meaning out of the refusal of meaning' is a means to resist

the temptation to 'stuff the world full of meaning and sign up to one or more salvic narratives of redemption'.[72] Such tactics, I would like to argue, are at play in the immanent materiality typical, as we saw in Chapter 4, of precarious works by Creed, Orozco, Hirschhorn and Alÿs. Like Critchley's case studies, these artists chose to *both* refuse a redeeming transcendence *and* to resist the nihilism or self-sabotage of avowedly irredeemable 'pathetic' practices. Furthermore, artists such as Creed, Orozco, Hirschhorn and Alÿs succeeded in this double refusal through a specific logic which, as Critchley would put it, involves 'learning to cultivate what Emerson calls "the low, the common, the near"'.[73]

Rather than turning, like Critchley, to Emerson, Beckett or Wallace Stevens, I would like to further analyse this precarious 'syntax of weakness' by way of a detour via another literary figure who, in my eyes, stands at the crossroads of these different literary aesthetics: the Swiss writer and poet Robert Walser. Described by Susan Sontag as 'a good-humoured, sweet Beckett',[74] Walser was concerned in his life and work with 'promulgating the claims of the anti-heroic, the limited, the humble, the small' (as Sontag put it).[75] Walser deliberately shirked success during a literary career that was cut short by his voluntary internment in a mental institution for the last thirty years of his life, during which he stopped publishing. Moreover, the characters that inhabit his fiction are very often described as losers – servile nobodys who would never stand out in a crowd, incompetent 'zeros' (as he called them), slackers who waste their time rambling aimlessly… Significantly, such marginal figures often demonstrate great sensitivity to the tiniest details of everyday life, closely observing, as Stevens would put it, the 'sheer mereness' of things and people. Finally, Walser's unique 'syntax of weakness' was noted by his contemporaries, including Walter Benjamin, who observed how 'each sentence' in the Swiss writer's prose 'has the sole purpose of rendering the previous one forgotten', or W.G. Sebald, who remarked that Walser's writing tends 'to dissolve upon reading … to vanish into thin air'.[76] Walser enjoyed weaving hesitant, uncertain narratives that sometimes comically contradict themselves. The 1917 short story entitled 'Nothing at all', for example, is a brief circular account of a housewife going into town to buy food for supper, being unable to decide what to buy, and returning with nothing. The narrator simply explains: 'The ability to make a decision is fine and good. But this woman possessed no such ability. She wanted to buy something really good and delicious for herself and her husband to eat. And for this fine reason she went to town; but she simply did not succeed, she simply did not succeed.'[77]

Reading this story, one is reminded of Creed's profound indecisiveness and his striving to reach a degree zero in his formal decisions. Tom Friedman admitted that he was attracted to Walser's attention to everyday minutiae, while his 'pathetic masculinity' appealed to John Miller, an artist who, as

we saw, was associated with both the 'pathetic' and 'abject' tendencies in 1990s art.[78] This latter statement was made by Miller during a roundtable on 'Robert Walser and the Visual Arts' held in New York in 1996, which also included international curator Hans-Ulrich Obrist, who had previously invited a number of contemporary artists (including Miller) to contribute to a *Robert Walser Museum* in a hotel in the Swiss German Alps in 1992. Walser's taste for rambles intersected with Obrist's curatorial interest, at the time, in the idea of a 'migratory' exhibitions 'on the move' that could take place in peripheral spaces both outside the museum (as in a hotel, for the *Robert Walser Museum*) and within art institutions.[79] For example, in *Migrateurs*, a landmark cycle of exhibitions that he curated at the Musée d'Art Moderne de la Ville de Paris between 1993 and 2003, Obrist invited artists to invest spaces other than the museum's exhibition galleries, thereby taking the risk that some exhibitions, inaccessible to the public, would pass altogether unnoticed. When he was invited in 1995, Orozco chose to show his *Socks* (papier-maché moulds of the interior of his socks) in two different ways: in a vitrine in the museum's entrance, and in a book reproducing images of these same objects as he had photographed them comically inserted among the feet of the stone relief figures on the building's façades.[80]

Walking was an important part of Walser's everyday life; one of his best-known short stories, 'The Walk' (1917), provides a most detailed account of the walker's experience. According to Obrist, Walser's rambles chimed with Michel de Certeau's celebration of walking as a 'practice of everyday life', in particular the fact that walking exceeds 'dichotomies of inside and outside, of place and non-place'.[81] Similarly, various critics have related Francis Alÿs's 'art of walking', which I outlined in Chapter 4, to Certeau's focus on the walker's 'experience of space'. Annelies Lütgens, for example, quoted Certeau's analysis of the walker's 'indefinite process of being absent and in search of a place' to describe Alÿs's elusive presence as he makes works in the street.[82] Cuahtémoc Medina, for his part, underlined Certeau's belief that walking 'is a substitute for the legends that used to open up space to something different'[83] – a direct echo of Alÿs's interest in fables, legends and rumours in his work.

In her analysis of Alÿs's walks and their relation to narrative, Lütgens invoked Walser as well as Certeau, as she drew an analogy between the Swiss writer's use of the 'literary genre of the *Kleine Form* or Minor Literature' and Alÿs's rambles.[84] Gilles Deleuze had defined minor literature as a form through which a writer on the margins of his or her community can appropriate a dominant official language. Describing Walser as a deliberately 'idiotic' figure in his above-mentioned *L'Idiotie*, Jouannais similarly insisted on the Swiss author's refusal to couch the 'nothingness' of his texts' 'content' in either officially or artistically accepted 'noble' forms.[85] According to Jouannais,

Walser thus defied both the stupidity of the bourgeoisie *and* all pretences to 'intelligent' art, thereby maintaining a deliberately marginal position.

According to Gilles Deleuze and Félix Guattari, minor literature involves shifting territories through 'deterritorialisation', and finding 'means' to express another 'sensibility' that has yet to come into existence.[86] Likewise, Lynne Cooke, in her introduction to the catalogue for a series of exhibitions inspired by Walser (at the Donald Young Gallery between October 2011 and December 2012), singled out the Swiss author's rambles as 'a strategy that encourages waywardness, an encounter with the unforeseen and happenstance'.[87] Furthermore, Cooke emphasised the relevance, for contemporary artists, of Walser's sensibility to the 'immediate and local', to 'dailiness and quiddities'. As Walser put it in 'The Walk': 'the man who walks must study and observe every smallest living thing' through forms of 'devoted self-effacement and self-surrender among objects'.[88] Walser's writings thus bring together an exploration of Certeau's practices of everyday life, Wallace Stevens' concern with the 'sheer mereness of things', as well as the immediate unpredictability and deterritorialisation of space involved in walking or locating works in the street – all crucial elements, as we have seen, in the precarious practices of Alÿs, Creed, Orozco and Hirschhorn.

Of these four artists, only Hirschhorn has explicitly acknowledged an interest in Walser, who is one of the many figures of whom he has declared himself to be a fan. In addition to dedicating a kiosk to him in 1999, Hirschhorn has made many references to the Swiss author in his work, and includes no less than three of Walser's books in what he calls his 'emergency library'.[89] Walser is one of the figures who Hirschhorn admires both for his 'radical' decision to stop writing in the last twenty years of his life, and for the 'existential uncertainty' that characterises his writings.[90] Walser, according to Hirschhorn, adopted 'a "weak" position' to the point that 'you are drawn into this current where you no longer know what is weak and what is strong'.[91] Indeed, *Les Plaintifs, les bêtes, les politiques* includes what Hirschhorn describes as an 'explosive' statement by Walser: 'when the weak regard themselves as strong'. One can note the influence of this reversal in *Les Plaintifs…*, which, as noted earlier, asks us to question the opposition between winners and losers, attackers and victims, strong and weak (figure 61). Furthermore, Hirschhorn made an explicit connection between Walser's 'resistance' and that of his own *Altars*, whose strength lies precisely in their vulnerability.

As Ben Lerner noted, the 'power' of Walser's writings is to be found in the intrinsic relationship between a resolute 'refusal of … domination' (noted by Sontag) and the frequent 'demands', on the part of his narrators, 'to be dominated'.[92] This ambiguous state is also central to philosopher Giorgio Agamben's analysis of Walser's writings. The Swiss author's 'ramble', argued Agamben, 'is an in-between-being (*Mittelwesen*), between making and

not-making, activity and passivity, being and not being'.[93] His characters are caught in a 'limbo' 'that is beyond perdition and salvation'[94] – thus returning us to Critchley's invitation to find ways of resisting any form of redemption. Furthermore, for Agamben, this state of limbo consigns things to 'being-thus … precisely and only … *thus*'[95] – the 'suchness' of *wu-shih* that we have encountered so far, this 'mereness of things' celebrated by Wallace Stevens. Thus, I would like to suggest that the complex space of Walser's minor litera-ture, which lies, like Certeau's practices of everyday life and like the walker's ramble, in a deterritorialised space beyond 'dichotomies of inside and outside, of place and non-place', may be precisely the site of immanent resistance favoured by Michael Hardt and Antonio Negri. Consequently, deliberately 'minor' works by Creed, Orozco, Alÿs and Hirschhorn can be read less as a passive surrender to the forces of neoliberal capital than as limbo spaces in which such dichotomies as 'inside and outside' could be exceeded, and new territories thereby opened. Just as Hirschhorn questioned the dichotomy between weak and strong by foregrounding the 'explosive force' of the vulner-able and the precarious, Orozco told Bonami, as we saw in Chapter 4, that his *Empty Shoe Box* (figure 45) was more likely to 'survive' if it let itself be kicked and trampled.

One work by Alÿs in particular embodies, in my eyes, the ways in which such oppositions between weak and strong, inside and outside, can be blurred. After *When Faith Moves Mountains*, Alÿs felt compelled to further reflect on the idea that 'sometimes doing something poetic can be political' and that 'sometimes doing something political can be poetic'. In order to address this question, Alÿs decided to perform one of his earlier walks once more, this time in a different, explicitly political context. *The Leak*, performed in São Paulo in 1995, had involved taking a walk with a leaking pot of blue paint, and exhibiting the empty can in the gallery on the artist's return. In *Sometimes doing something poetic can be political and sometimes doing something politi-cal can be poetic*, also known as *The Green Line* (figure 65), the artist carried out the same action in Jerusalem in 2004. Instead of the random ramble around the gallery in São Paulo, however, in Jerusalem Alÿs used green paint and followed the 'green line' drawn on a map by Moshe Dayan after the 1948 Arab–Israeli War, as the commander of the Israeli army demarcated for the first time the frontier between the two territories, which has since shifted in a terrible conflict that has shown no sign of abating. In order to better under-stand the possible interpretations of this absurd gesture, Alÿs then decided to interview a range of selected Israeli and Palestinian figures. *The Green Line* thus consists of a film of Alÿs's walking along the green line in Jerusalem, for which viewers can select a soundtrack of their choice from eleven recordings: as each individual responds to the images, childhood memories and the his-tory of Jerusalem mingle with political positions on the Israeli–Palestinian

65 Francis Alÿs, *The Green Line*, Jerusalem, 2004. In collaboration with Julien Devaux, Philippe Bellaiche and Rachel Leah Jones

conflict and borders. Though limited, the range of these diverging – and at times contradictory – interpretations constitutes the strength of this work. When Alÿs shows footage of his gesture to Palestinian activist Rima Hamami, for example, she tells him that his furtive presence reminds her of the stance adopted by Palestinians as they have to 'sneak' through checkpoints, as she puts it. Yet Israeli architect and theorist Eyal Weizman reads the same gesture as replicating the occupation of territories by Israeli settlers through the colonising act of mapping. In Alÿs's work, then, an incredibly violent discursive and military conflict between two enemies seems to be – at least temporarily – suspended; the dichotomy between weak and strong, victim and aggressor, briefly becomes as fluid and provisional as the dribbling green line of paint.

Tactics of survival around 2003

The opposition between Rima Hamami's and Eyal Weizman's interpretations of Alÿs's gesture finds its counterpart in the contrast between tactics and strategies outlined in Michel de Certeau's 1980 study of practices of everyday life, including walking. Strategies, according to Certeau, involve forms of 'political, economic or scientific' rationality, which define a space that needs to be mastered and controlled – like the Israeli coloniser's partition and organisation of space. It is the field of knowledge and power.[96] In contrast, tactics are the weapon of the weak, who have no control over the space of power and must resort to furtive movements like the Palestinians living in Jerusalem. Certeau compared tactics directly to the *mètis* described in Chapter 4, the practical intelligence that learns to seize opportunities as they arise. For Certeau, the field of tactics and ruses is that of making do (*faire avec*): the weak must cope with 'a network of established forces and representations' that has been imposed from above.[97] For example, Alÿs's *Green Line* confronted the strategic abstraction of the map with the tactical reality on the ground: he took advantage of the thickness of Dayan's green crayon to avoid as many Israeli checkpoints as possible.

Certeau's emphasis on tactics chimed with a tendency in alterglobalisation activism, which sought, as John Holloway would put in 2002, to 'change the world without taking power'.[98] As Geoffrey Pleyers retrospectively summarised it, many alterglobalisation activists at the turn of the millennium believed that the other possible world they wanted to imagine would 'not arrive tomorrow, after "The Revolution"', but could begin 'here and now, in the interstitial spaces of our societies, (re-) appropriated by actors and transformed into alternative and autonomous spaces of experience'.[99] Some groups focused on finding immediate and concrete solutions to given problems. This was the case, for example, with the Argentinean Colectivo Situaciones, which emerged in response to the economic crisis in that country in 2001. Rejecting

'the idea that the omnipotence of market flows (with the wars that accompany them) leave no space for any struggles for liberation', the Colectivo Situaciones believed that it was 'possible that power and its opposition can coexist long term without eliminating one another'.[100]

This text by Colectivo Situaciones was reproduced in the catalogue for Carlos Basualdo's *The Structure of Survival*, one of the main exhibitions included in the Venice Biennale in 2003. For this Biennale, chief curator Francesco Bonami extended invitations to a number of guest curators including Basualdo, Gabriel Orozco – who curated an exhibition entitled *The Everyday Altered* and Hans-Ulrich Obrist, who teamed up with Molly Nesbit and Rirkrit Tiravanija to organise *Utopia Station*. I would like to argue that the nexus of these three exhibitions usefully sheds light on some of the relations between art, globalisation and precariousness at the turn of the twenty-first century. Crossovers among the three exhibitions included the temporary tent-like structure of *Utopia Station*, which recalled the shanty town shelters that constituted a focus in *The Structure of Survival*. Both exhibitions also featured the Indian artist group RAQS media collective (who would be cited as an example of the new 'artist-activist' groups that emerged in the 1990s, according to Gene Ray's 2004 essay mentioned in this chapter's introduction). *Utopia Station* was explicitly aligned by its curators with an alterglobalisation agenda, as its journey via the Venice Biennale would involve a further stop at the World Social Forum in Porto Alegre in 2005.[101] As the curators made clear, *Utopia Station*'s 'invitation to self-organize speaks a political language already known' and 'already being practiced' by alterglobalisation groups.[102] Like the World Social Forum, the curators conceived *Utopia Station* as a platform for discussion, research and experimentation, 'as a field of starting points, many starting points being brought and offered by many different people'. Works ranged from posters giving different definitions of utopia to a bar where Danish collective Superflex served *Guaraná Power soft drinks*, produced by a guaraná farmers' cooperative in the Brazilian Amazon forest, who sought to resist the monopoly of the multinational corporations that purchased guaraná seeds cheaply.

Self-organisation and sustainability were also terms included in the press release for *The Structure of Survival*, which similarly addressed the ways in which 'ephemeral communal encounters and strategies of collective survival' had come to replace traditional forms of the 'public sphere' in the face of globalisation, 'corporate capitalism' and 'the consequent deterioration of the living conditions of developing world populations'.[103] Shanty towns, according to curator Basualdo, were well positioned to lead the way, inasmuch as they were already places where 'original forms of socialisation, alternative economies, and various forms of aesthetic agency are produced'.[104] In a 2004 article, philosopher Slavoj Žižek would echo this belief in 'new forms of social

awareness that emerge from slum collectives', going so far as to claim that they could contain 'the germs of the future and the best hope for a properly "free world"'.[105]

Indeed, one of the artists in *The Structure of Survival*, Marjetica Potrč, emphasised how the inventiveness, vitality and urgency of shanty town living could operate as powerful models of 'self-reliance, individual initiative, and small-scale projects'.[106] Such endeavours inspired her work in two different ways. Potrč sought to develop with local residents in shanty towns across the world practical solutions to specific problems of everyday life. For example, in Caracas, she developed a dry toilet that did not require any water supply. In the same way, elsewhere in *The Structure of Survival*, Turkish artist collective Oda Projesi presented a prefabricated house that they had designed to house families after the Adapazari earthquake in 1999.

The other aspect of Potrč's work, presented in installations and drawings in galleries, addressed the existing solutions that she encountered during her visits, where she admired the 'beauty' of slum architecture for example. While at *The Structure of Survival* Potrč showed drawings made in the Caracas slums, she exhibited the same year (at the Palais de Tokyo in Paris) a 'growing house' which she had admired in these shanty towns (figure 66). The 'iron wires sprouting from its rooftop', according to her, 'proclaim the vitality of the place'.[107] Similarly, Oda Projesi included in *The Structure of Survival* images of the annexes added since 1999 by residents to the prefabricated houses that they had provided; the collective marvelled at the ways in which residents 'construct these annexes by choosing the materials in accordance with their own conditions and needs, just like an artist or an architect'.[108] Just as Potrč praised the ways in which shanty towns were '[g]rowing without any control or planning',[109] contemporary architects such as Rem Koolhaas focused on the informal growth of global slums; his study of Lagos, for example, revealed that 'what seemed a completely random and improvised world included a number of very elaborate organizational networks' in places that 'were actually intensively emancipatory zones'.[110]

As we saw in Chapter 3, 1960s artists such as Kaprow or Oiticica had similarly admired the nonconformist architecture of outsiders, the homeless, or slum dwellers. Indeed, Oiticica's works played a crucial role in Basualdo's conception of *The Structure of Survival*, in addition to being included in the exhibition itself. Significantly, Basualdo had chosen Oiticica's 1967 motto *da adversidade vivemos* (on adversity we thrive) as the title of a 2001 exhibition of Latin American art at the Musée d'Art Moderne de la Ville de Paris, which showcased many of the Latin American artists who would subsequently figure in his *Structure of Survival* show (including Cildo Meireles, Fernanda Gomes, Meyer Vaisman and José Antonio Hernandez-Diez), in addition to others such as Francis Alÿs. The artists in the 2001 *Da Adversidade vivemos* exhibition

66 BELOW: Marjetica Potrč, *Caracas: Growing House*, 2003. Exhibited at *GNS*, Palais de Tokyo, Paris, 2003. TOP: Source image

were discussed in terms of their experience of a Latin American reality characterised, according to Basualdo, by 'constant precariousness' and 'adversity in tragically unstable socio-economic contexts'.[111] Guy Brett had described precariousness as a characteristic of Latin American art as early as 1989,[112] and would emphasise, one year later, how in Latin America 'many grass-roots movements' had 'appeared because of a complete loss of faith in the willingness or ability of governments to do anything about major problems'.[113] It was precisely this grassroots model that came to the fore in the 1990s, as movements such as the Zapatistas in Mexico served as an inspiration for alterglobalisation groups across the planet. In the same way, Latin American art practices in *Da Adversidade vivemos* could provide, according to Basualdo, a panorama of 'inventive' gestures of 'resistance' against prevailing conditions of adversity including injustice, increased poverty and the unstable social orders.[114]

In a 2003 essay entitled 'O Malabarista e a gambiarra' ('The juggler and the *gambiarra*'), Brazilian critic Lisette Lagnado, like Basualdo, referred to Oiticica's motto *da adversidade vivemos*.[115] In this article, Lagnado mapped out a new critical discourse about Brazilian contemporary art, including that of Marepe and Alexandre da Cunha, two of the artists included in *The Structure of Survival*. The Portuguese word *gambiarra* used by Lagnado to describe such practices is usually translated as 'making do' in English and refers to the temporary tactics and improvised tricks used in everyday life to deal with practical problems. A typical example would be the installation of wiring systems to tap into someone else's electricity – a pragmatic, if illegal, solution to a concrete problem. Living on adversity, according to Lagnado, thus involved making the most of scarce resources and cultivating a potentially subversive stance. Lagnado's discussion of *gambiarra* thus echoed Basualdo's description of adversity as a 'productive matrix' for creation and invention. By the beginning of the new millennium, it seemed that *gambiarra*, the tactics of the weak, needed to become more and more inventive in the face of globalisation's growing inequalities. In her article, Lagnado cited a recent newspaper article that recounted how twelve Cubans had transformed a 1951 Chevrolet van into a boat in order to try and immigrate illegally into the United States. Many works cited by Lagnado also referred to the *gambiarras* widespread in *favelas* and other impoverished spaces in Brazil.

One of the examples of contemporary works inspired by *gambiarra* cited by Lagnado was Jarbas Lopes's 2002 *Troca-Troca*, a performance during which the artist and seven of his friends reconfigured three red, yellow and blue Volkswagen Beetles in car shops around Rio de Janeiro, before driving these multi-coloured cars to a museum in Curitiba. A Volkswagen Beetle was dismantled by another Latin American artist, Damián Ortega, in Orozco's exhibition *The Everyday Altered* at the 2003 Venice Biennale. To create *Cosmic Thing*, Ortega fully disassembled the car, suspending its parts with wires like

a floating skeleton. Ortega underlined the socio-cultural associations of this car: made in Mexico, it is omnipresent in that country, whether as a green taxi in Mexico City or the well-loved working-class car that has been repaired and reconfigured many times during its lifetime. For curator Orozco, the 'practice of transforming' everyday 'objects and situations' emerged as a political tool for artists everywhere at the beginning of the twenty-first century.[116] It allowed individuals to appropriate and transform reality and 'make these altered objects the materials and tools of our revolutionary tomorrows'.[117]

The 'human scale', as well as the humour, fragility and immediacy, which characterise the works in *The Everyday Altered*, according to Orozco, recall in my eyes the very features of the *gambiarra*. Furthermore, as Jean Fisher wrote in relation to Orozco's own work, an 'aesthetic of salvage and recycling, of improvisation and taking advantage of immediate situations' could be seen as 'the conditions of lived experience in Latin American societies'.[118] This recalls Oiticica's motto 'on adversity we thrive' which, initially, urged Brazilian artists to turn into an advantage the very 'adversity' of everyday life in their country. The specific 'sensibility' detected by Fisher in Orozco's work certainly permeated *The Everyday Altered*, and the artist's reference to 'revolutionary tomorrows' in the exhibition's press release further cast this 'aesthetic of salvage and recycling' as a potential act of resistance and subversion.

Unlike the 'scruffiness' of Lagnado's *gambiarra*, however, the works in *The Everyday Altered* maintained a certain aloofness, described by Orozco in the press release as a 'meticulous violence' – required, for example, not only to disassemble every single part of Ortega's car, but also to carefully reassemble it as an anti-monumental form uncertainly hovering in the air. Moreover, whereas Lopes's reconfigured cars in *Troca-Troca* flirted with illicit practices of car theft and black market trade, Ortega's *Cosmic Thing* focused instead on a transfiguration of Mexico's mythical 'people's car'. In the works on display in *The Everyday Altered*, the *gambiarra*'s 'here and now' emergency appears mediated – whether through symbols, language or sculptural forms – just as Orozco's brand of object-making hinged on the tensions between physical presence and geometrical forms, between order and disorder.

The politics of making do

Like Ortega and Jarbas Lopes, Alÿs used a Volkswagen Beetle in a number of works. In the 2001 *Rehearsal I*, as we saw in the previous chapter, the Volkswagen appears as an extension of its driver trying, but failing, to drive up a hill, as he synchronises the car's movements to the recording of a rehearsing mariachi band. In sync with this halting soundtrack, the car here operates as a stand-in for Mexico and Mexicans. Since the film takes place at the Tijuana border, going uphill also serves as a metaphor for the Mexican economy

trying – and failing – to catch up with that of the United States. With this work, Alÿs started to reflect on the specific temporality intrinsic to the logic of uneven development: countries defined as 'underdeveloped' are expected to reach the economic level of 'developed' countries, which meanwhile continue to stride ahead, thus further widening the gap between rich and poor. Caught up in the endless pursuit of an elusive modernity, Mexico, according to Alÿs, is stuck in between two states, 'entre dos aguas' (between two waters), as the Mexican expression goes. Writing about *Rehearsal I* in 2003, Alÿs noted its resonance with the anti-globalisation protests that were taking place at the time against the fifth World Trade Organisation conference in Cancún.[119] In Mexico, this clash between globalisation and anti-globalisation translated differently, mused Alÿs: the Cancún demonstrations marked a crucial moment in which the 'modernity' of global capital was being challenged, when in fact this modernity had yet to actually fulfil its promises in Mexico itself. Indeed, a discussion at one of the World Social Forums was entitled 'modernity as illusion' – an image that clearly resonates with Alÿs's practice, which visualises such a space through the trope of the rehearsal for an endlessly deferred show (as in *Rehearsal I*), or the image of a mirage shimmering at the end of a desert road, as in his 2006 *Story of Deception*. It is precisely, then, *because* Latin America and developing countries had never fully reaped the fruits of modernity, while nevertheless being subjected to increasingly aggressive neoliberal policies in the age of globalisation, that these countries could promise to offer new models for alterglobalisation protests and the World Social Forums.

If Orozco and Ortega drew naturally from a Latin American 'aesthetic of salvage and recycling, of improvisation and taking advantage of immediate situations', as Fisher called it, the European Alÿs learnt his alterglobalisation lessons more consciously, by observing as a foreigner the everyday practices around his neighbourhood in Mexico City. His ongoing slide series of *Ambulantes*, started in 1992, reveal a wide range of street activities which spell out an infinitely varied language of 'pushing and pulling' in the city: the images show street vendors and peddlers, people transporting goods of all shapes and sizes in different ways – manually, in pushcarts, wheelbarrows, etc… *Ambulantes* is clearly inscribed in the field of Certeaudian tactics of 'making do'. On the one hand, Alÿs's photographs literally demonstrate practical tricks – such as how one can fit fourteen cardboard boxes on to one small hand-pulled cart. On the other hand, they point to the range of petty jobs that inhabitants of developing countries have to keep inventing in order to get by – in an informal economy that bypasses all forms of official organisation or regulation.

Mexican society, according to Alÿs, 'is governed by compromise';[120] it teems with forms of *gambiarra*, ways of tinkering, as Certeau would put it, with a dominant economy. This is why, Alÿs believes, 'the language of

compromise' became for him – whether 'consciously or not' – 'a tool of inte-
gration' into Mexican society. Compromise for Alÿs was not only a matter of
collaborating with others, including, as we saw in Chapter 4, the local sign-
painters in his neighbourhood. It also involved following an 'axiom' through,
accepting all outcomes as they come – whether when driving a car up a hill
in sync with a taped music rehearsal, asking 500 volunteers to move a sand
dune, or pushing a block of ice through the streets until it melts, as in his
earlier *Paradox of Praxis I* (figure 47). Thus Alÿs's embrace of the Cagean-
Brechtian model of chance, which we saw in Part I, is interlaced with the logic
of compromise that he associates with Mexican practices of making do, and
with allegorical readings of a specific Latin American relation to modernity.

Artists working in the tactical field of *gambiarra* and making do in the
1990s exploited a wide range of forms, from the creation of practical, func-
tional objects (like Potrč or Oda Projesi) to the imitation of everyday forms
of *bricolage* (by Potrč or Jarbas Lopes) or the aesthetic alteration of everyday
objects (Ortega); from discussions, research and documentation concerning
globalisation and uneven development (in *Utopia Station* and *The Structure
of Survival*) to visual allegories articulating these very questions (Alÿs). Three
related issues emerge from the political nexus of themes, concerns and prac-
tices embodied in the three main exhibitions at the 2003 Venice Biennale.
The first question relates to different ways of using precarious materials. For
example, Alexandre da Cunha's work, which was included in *The Structure
of Survival* and mentioned by Lagnado, often involves cheap objects (such as
raincoats, rakes, floor-cloths, plastic brooms and tape); he has also created
shelters made out of sleeping bags. In my eyes, da Cunha seems to be using
conventional signifiers of a precarious existence in a way that aestheticises,
rather than embodies or analyses, the nature of this condition. In this sense,
da Cunha's fragile constructions come closer to the 'self-sabotaging' aesthetic
of Rugoff's above-mentioned *Just Pathetic* exhibition than to the works in
Orozco's *Everyday Altered*. Indeed, in Basualdo's exhibition, da Cunha's
pieces shared fewer affinities with Potrč's notes on Venezuelan shanty towns
or Oda Projesi's emergency shelter than with the grubby studio sculpture of
American sculptor Rachel Harrison, which I briefly mentioned in Chapter 4
both in terms of its inclusion in the 2007 *Unmonumental* exhibition and its
differences from Hirschhorn's works. In fact, even Potrč's gallery installa-
tions such as *Growing House* (figure 66) raise the issue of aestheticisation – of
processes as well as materials. As Patricio del Real has pointed out, isolating
constructions from their contexts also 'extracts all life from the *events* of
actual physical shelter. In these delicate transplants, life must be preserved
but sterilized'; 'the stench of the slums has to be excised'.[121] Such practices as
Potrč's thus point to 'the risk', signalled by del Real, 'of artists appropriating
the slum dwellers' "otherness" for their own ends'.[122]

Indeed, another artist included in *The Structure of Survival*, the Angolan Antonio Ole, seemed to be participating even further in this process of aestheticisation, by turning shanty-town architecture into a decorative installation. By arranging found fragments of an impoverished architecture along the walls of the gallery in his *Township Wall*, I would suggest that Ole made poverty look cheerful and picturesque. This points to a second major pitfall in the exploration of practices of 'making do' and thriving on adversity, namely the risk of lapsing into a romantic stereotype of the carefree, cheerful pauper who accepts his or her condition without protest. Calls such as David Aradeon's, reproduced in the catalogue for *The Structure of Survival*, to remember that inhabitants of Brazilian shanty towns are 'poor but vibrant, sensitive and creative' can easily slip into a confirmation of such stereotypes.[123] Furthermore, this potential romance of poverty feeds into a final issue, which concerns the use of such clichés to buttress a neoliberal rhetoric of self-sufficiency and autonomy. For example, Potrč's insistence on 'reliance, individual initiative, and small-scale projects' runs the risk of echoing neoliberal justifications for the withdrawal of state support and welfare in order to let the free market run without any regulations. Similarly, Grant Kester has effectively criticised projects such as Superflex's *Guaraná Power*, served as we saw at *Utopia Station*, for their unquestioning 'embrace of market-based "solutions" and the cultivation of an "entrepreneurial" spirit' as somehow 'ideologically neutral'.[124] I agree with Kester that such a neoliberal rhetoric comes through when Superflex insisted, for instance, that their action with *Guaraná Power* differed from that of NGOs, which served according to them only to hinder 'creativity and initiative'.[125]

Alÿs, who had in fact worked for an NGO in Mexico before becoming an artist, did not for all that follow Superflex in offering to replace not-for-profit aid with market-driven projects. Moreover, he became particularly aware, early on, of the precarious position of his works along the tightrope between admiration and condescension, celebration and romanticisation. This came to the fore, I would argue, as he was planning in 1997 a film inspired by a local newspaper story about a dog called Negrito, which had lost a leg but went on to develop a very successful juggling trick using a bone from its broken paw. For Alÿs, this tale could illustrate the virtue of *valemadrismo*, the Mexicans' 'capacity to accommodate oneself to *mala fortuna*, to bad luck, and even more, to actually turn one's misfortune into an advantage'.[126] (The story appears to literally visualise Lagnado's analogy between the practice of *gambiarra* and that of the juggler.) Although Alÿs did not give the reasons why he abandoned this film, I would suggest that he may have been wary of the 'somewhat romanticised' nature of this 'account', which could easily lead to an occlusion of suffering through the celebration of *valemadrismo* or *gambiarra*.[127] In any case, Alÿs decided to abandon the film format, preferring instead to produce a bilingual spoof on Mexican tabloids (*The Story of Negrito, the 3-legged dog,*

February 1997). Thus, the work retains the affective dimension of the tale, but modulates it with irony, so that the dog that did not 'give up' could be neither romanticised nor held up as an ideal of private entrepreneurship. Alÿs's own trial and error process mirrors to some extent Negrito's story, demonstrating a form of mobility and adjustment in terms of medium and tone.

'When schon Globalisation, dann von unten!' (If globalisation is already here, then from below!). This scrap of paper, noticed by Pamela Lee during her visit to Hirschhorn's studio, resonates with the calls to action 'from below' among alterglobalisation players.[128] In their 2001 *Globalization from Below*, Jeremy Brecher, Tim Costello and Brendan Smith praised the 'power to transform the world' of a global, grassroots network united against the 'globalization from above' of corporations, markets, investors, economists and 'leaders of the world's richest nations'.[129] Their call thus echoed the ongoing opposition, at the time, between World Social Forum and World Economic Forum. Practices of *gambiarra* and making do – the weapons of the weak according to Certeau – were considered as new tools for a common agenda. In this context, as Patricio del Real noted, artists' practices and 'slum dwellers' tactics' could be seen to converge around 'a new perception of a shared political engagement'.[130]

At the same time, however, this kind of alliance ran various risks, as we have seen, arising from contemporary art's possible aestheticisation and romanticisation of survival practices developed in a context of extreme poverty and emergency. How, then, can precarious practices articulate a space 'from below', which, as Lee reminds us, 'is yet to come'?[131] And how can they avoid 'appropriating', as del Real put it, the 'otherness' of their allies 'for their own ends'? The remainder of this chapter will sketch out some answers to these two questions.

A new 'coalition'?

When I interviewed him, Hirschhorn explained to me that he wanted to counter the common usage of the term 'precarious' in the political debates around job precarity that were starting to emerge in 1990s Europe.[132] As we saw earlier in the positions of ChainWorkers' leader Alex Foti or sociologist Pierre Bourdieu, the word 'precarity' was initially used as a negative term in the 1980s and 1990s. 'Stop al precariato' ('put a stop to the precariat') read a poster for the first May Day protest organised by the ChainWorkers in Milan in 2001, in an entreaty to businesses and governments to regulate the private sector's policies of redundancy, outsourcing, downsizing and 'flexploitation' through short-term and part-time contracts. Speaking in 1997, Bourdieu would call for a resistance against global neoliberalism's new forms of 'domination' that instituted 'a generalised and permanent sense of insecurity aimed at forcing workers to submit and accept their exploitation'.[133]

In contrast, when Hirschhorn celebrated the precarious status of his *Altars* and *Monuments*, he sought to 'free' the word 'precarity' from its negative connotations.[134] The 'beauty of precariousness', according to Hirschhorn, lies in its temporality and vulnerability to the other.[135] As we saw in the preceding chapter, Hirschhorn started displaying his work in public space in the 1990s as a way of reaching out to a 'non-exclusive' audience and putting his work at risk. His first 'precarious' gallery, in 1994, simply consisted of a bath towel propped on two iron bars and a wall – a temporary awning meant to beckon passersby and 'protect' the works against bad weather, although in fact rain would destroy the *Ferrari-Galerie* that same day. Though more substantial, the 1996 *Kunsthalle Prekär*, constructed out of plastic sheeting on a peripheral site 'on the edge of the Hannover-Langenhagen airport', was also destroyed by the weather (rain, snow and wind) after only ten days.

By the time Hirschhorn built a 'precarious museum' in a housing project in a Parisian *banlieue* neighbouring his studio in 2002, the artist had left behind the idea of the temporary gallery as a frame to display his own artefacts, and started to work with residents in the very construction and presentation of works of art. The *Musée Précaire Albinet* thus involved exhibiting, in a low-income housing estate in Aubervillers, different works on loan from the Musée National d'Art Moderne by famous twentieth-century artists such as Warhol and Malevich (figure 67). (Needless to say, lengthy and complicated negotiations with that institution had been required to secure the loan of such highly valuable works.) For the *Musée Précaire Albinet* Hirschhorn worked with a

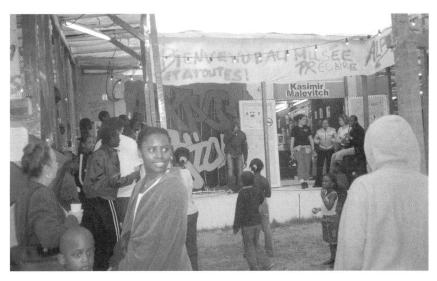

Thomas Hirschhorn, *Musée Précaire Albinet*, Cité Albinet, Aubervilliers, 2004. View of **67**
the opening of the exhibition featuring a work by Kasimir Malevich

team of *cité* residents in building and maintaining the 'museum', hanging a different work every week. Furthermore, locals and visitors were invited to attend a range of regular lectures, workshops and events around the artworks on display. According to the artist, this 'museum' was 'precarious' not only 'because the duration of its physical experience was limited in time' but also because it had to be 'reconstructed every day, every hour, every moment' with the residents of the Albinet housing estate.[136] As we saw in Chapter 4, Hirschhorn refuses to take for granted either the existence of his works in public space, or their acceptance by viewers. 'Nothing is more boring,' he goes on to explain, 'than something definite, something sure, something safe – because it just isn't the truth.' For a work to truly exist as such, to reach out to a 'non-exclusive' viewer, to affirm the necessity of art, philosophy and politics, it must be exposed to risk and criticism: it must be precarious.

Hirschhorn's inclusion, in two works of 2010 and 2011, of the sentence 'Les précaires sont sur le pied de guerre' ('The precarious are on the war path'), written on a banner in his displays, pointed to important shifts in the political valence of the term. As this sentence – culled from a newspaper or a demonstration placard – suggests, the unemployed and anti-precarity demonstrators had by then appropriated the term as a positive self-designation in the course of voicing their concerns and perspectives. Indeed, as Gerald Raunig has demonstrated, the discourse around precarity had shifted as early as the 2002 May Day parades.[137] As demonstrators marched under the banner 'The precariat rebels', they adopted precarity as a unifying term for a broad international movement. By 2004, the association of the *intermittents du spectacle* (temporary French stage and festival workers) had created a platform for new debates concerning the changing nature of work and of workers' rights in contemporary society. One of the slogans of the May Day parade that year ended up taking the surprising form of an outright celebration, with the cry 'Insecurity will prevail!'[138]

Since, as Bourdieu himself realised, insecurity has always been an inherent feature of capitalism, discussions of precarity at the turn of the twenty-first century often involved an acknowledgement that regular, full-time, long-term employment may in fact have been an exception, rather than the rule, in capitalist history.[139] The negative condemnation of precarity as a lack only emerged, it appeared, when white, middle-class, European and North American men had to face the real threat of unemployment for the first time since the 1930s, and became subjected to a precarity long experienced by women, immigrants and citizens of developing countries. No wonder, then, that the global South, and Latin America in particular, became an inspiration for alterglobalisation activism, and that Oiticica's motto, coined as he reflected on the specificities of the Brazilian situation, could be cited by Carlos Basualdo as a touchstone for his exhibitions *Da Adversidade Vivemos* and *The*

Structure of Survival. Precarity, as Francis Alÿs pointed out to me, is indeed largely a Western concept.[140] The artist noted that most of his neighbours in Mexico City had never had fully secure jobs, let alone a welfare system of protection. 'Mexican society doesn't really care about what will happen next month. If you have enough to pay for rent, food, and an outing, that's it, problem solved.' In Mexico, nobody is 'going to try and imagine' what they will be doing in the future, let alone rely on the security of a state pension. Such a short-term perspective turned out to be liberating for Alÿs. 'This complete absence of certainty' inspired him to develop an 'artistic logic' founded on an acceptance of the unpredictable. Like Hirschhorn's, such a practice foregrounded its fragility and potential disappearance. Indeed, as Jean Fisher also noted in her 1998 analysis of Orozco's work, 'the illusion of permanence and invulnerability cultivated by "First world" countries is unthinkable in the unpredictable conditions of the "Third World"'. The 'metaphor of erosion' which, as we saw in Chapter 4, runs through much of Orozco's work, speaks, according to Fisher, of the 'confusion and chaotic energy, the constantly changing states of decay and renewal characteristic of the daily life of Mexico City'.[141] This may also account for Orozco's emphasis on fragility and transformation in his *Everyday Altered* exhibition.

At the beginning of their careers in the 1990s, both Orozco and Alÿs shared the experience of leading precarious lives in a city with few opportunities for artists. This could perhaps call to mind, in this sense, the Californian scene from which Bruce Conner emerged in the early 1960s. Nevertheless, artists today, as Alÿs pointed out to me, lead lives that are far less precarious than artists in the past – indeed, both he and Orozco were quickly embraced by an increasingly globalised artworld, to the point of being offered mid-life retrospectives at major museums in 2010–11 and 2009–10, respectively. Precariousness, then, in the works of Alÿs, Orozco, Hirschhorn and Creed is less a reflection of their personal experiences as struggling artists than a state of being that drives their artistic choices. For Hirschhorn, precariousness is what allows him, and viewers, to 'stay awake', on their 'guards', 'receptive' to the world around them.[142] Similarly, Alÿs cultivates a 'state of extreme alertness'[143] during his walks, for example, as he lets his works record a 'give-and-take' between him and the places in which he circulates. For Jean Fisher, Orozco's works hover in a 'vacillating interval between states' such as sleep and wakefulness; such a state requires a kind of 'vigilance' in which one chooses to stop acting in order to act.[144] For Certeau, such alertness or vigilance is a key feature of the tactic as a form of the material intelligence (*mètis*) that I evoked in the last chapter. Terms used to describe such a state derive from the practices of war, hunting, or animals in hiding: to lie in wait, to be on the alert, on the look out, to keep an ear out, to be quick to seize opportunities. It involves not taking anything for granted, and trying to open up momentary spaces of defamiliarisation.

Where Lagnado described the *gambiarra* as a form of juggling, Fisher focused in a 2002 essay on the role of the artist as a 'trickster', citing as an example the Native American artist Jimmie Durham, who was also included in Orozco's *Everyday Altered* exhibition.[145] Durham was certainly a pioneer of new forms of assemblage in the 1980s, who, along with other figures of his generation such as the African-American artist David Hammons, explored the political potential of *bricolage* as a weapon of the 'subaltern', as it would be termed in postcolonial studies. In this sense, Hammons and Durham opened the pathway for the global explosion of assemblage, signalled by Orozco in *The Everyday Altered*, and pursued over the following decade. Although this tendency warrants a fuller discussion, I would like to focus here on Fisher's reading of Durham's practice as a trickster at the turn of the twenty-first century, because she related it less to the post-modernist debates with which the artist had engaged in the 1980s than to the carnivalesque turn in alterglobalisation protests led by such groups as Reclaim the Streets.

Such groups staged events which, like many in the ChainWorkers' May Day parades, used humour, masks, disguise, music and dance to transform protests into a cross between demonstrations, performances and parties. Gerald Raunig also inscribed these contemporary 'strategies of inventive cunning', 'confusion' and 'travesty' in the lineage of the *mètis* and the 'medieval figure of the jester', updated by 'the practice of the communication guerrillas of the 1990s'.[146] Such ruses of invention, according to Raunig, could be geared towards 'inventing new worlds', the production of possibilities.[147] This is why, according to Brian Holmes, such protests as Reclaim the Streets emphasised lived experience and singular subjectivities against global capital's 'sophisticated methods currently employed for physical and psychic control'.[148] According to Pleyers, such forms of 'festive resistance' as Reclaim the Streets fed into a broader form of alterglobalisation that he called the 'way of subjectivity',[149] in contrast with the 'way of reason' embodied by NGOs and more academic critiques of globalisation. This emphasis on lived experience united a wide range of forms, bringing together carnivalesque demonstrations such as Reclaim the Streets or the May Day parades with the indigenous struggles of the Zapatistas, whose 'subjective and expressive nature' and 'experience-centred engagement' appealed to a diverse audience within and beyond Latin America.

The convergence of such various constituencies in the alterglobalisation 'movement of movements' resonated with alliances forged within the emerging precariat. As we saw earlier, Žižek, like Basualdo, was looking in 2004 to the global slums for 'new forms of social awareness'.[150] Furthermore, Žižek defined the slum-dwellers of the world as the 'counter-class to the other newly emerging class, the so-called "symbolic class" (managers, journalists and PR people, academics, artists etc.) which is also uprooted and perceives itself as

universal'. Crucially, Žižek asked: 'is the "symbolic class" inherently split, so that one can make a wager on the coalition between the slum-dwellers and the "progressive" part of the symbolic class?' This kind of 'coalition' was precisely what the mobilisation of a global precariat sought to develop, as it brought together a wide variety of precarious workers ranging from freelance web designers to immigrant cleaners. Raunig related the disparate nature of this 'formless' precariat to Marx's contemptuous description of the lumpen-proletariat – a heterogeneous mass of beggars, swindlers, discharged soldiers and bohemian artists who were unable or unwilling to organise themselves into a social class.[151] For Marx and Engels this lumpenproletariat included those who had willingly chosen this self-marginalisation and self-exclusion from mainstream society. Similarly, theorist Isabell Lorey has analysed the operations of self-precarisation involved in choosing to be a self-employed, freelance academic, artist or cultural worker.[152] Crucially, the ambiguous position of artists as models for *both* the neoliberal celebration of creative self-entrepreneurship *and* the self-organisation of the new precariat has been the subject of wide-ranging debates.

When Arendt spoke of class divisions, as philosopher Sophie Loidolt has pointed out, she dismissed sentiments of pity as condescending, and privileged attitudes of solidarity and empathy instead. Solidarity, according to Arendt, involved setting up, as Loidolt put it, 'a permanent community of interests with the oppressed and exploited, over and above changes of moods and feelings'.[153] Rather than let passions drive hasty and fleeting actions, Arendt emphasised the importance of an 'empathy of understanding', an attempt to take into account the other's perspective in a public sphere that provided an alternative to the contemporary atrophy of experience. The potential coalition mentioned by Žižek occupies, in my eyes, this Arendtian sphere of empathy and solidarity. In the same way, when artists such as Creed, Orozco, Alÿs or Hirschhorn sought to join the dance of the world, as we saw in the preceding chapter, they positioned their work in this sphere. For example, Alÿs described the 'give-and-take' through which his work interacted with the city of Mexico, as his practices responded to those of his neighbours through 'an empathy, sympathy, a natural complicity, a constant talking back, a constant challenge'.[154]

This challenge constituted, according to Alÿs, an inspiration for his projects, a reminder of the uncertainties of reality as well as a model for making do. Alÿs's adoption of compromise as a guiding force for the redefinition of artistic practice, which we saw earlier, offers a similarly empathetic model through which to relate to the subjects with whom he coexists in Mexico City. As we saw in Chapter 4, when Alÿs improvised a shelter, like those of the homeless, he was imitating their way of inventively creating a space for themselves. Similarly, analogies between his *Ambulantes* seen pushing and

pulling carts for their work, and his own actions of pushing (a block of ice in the *Paradox of Praxis I*) and pulling (a magnetised dog in *The Collector*) in the streets of Mexico bring to light a shared process of inserting oneself in a wider urban economy of everyday practices by performing tactics of making do. Standing on the Zócalo along with plumbers and other repairmen, but with a sign advertising his services as a 'tourist' in *Turista* (figure 59), Alÿs implicitly aligned his precarious status as an artist – dependent on the art market's fundamentally unpredictable and uneven distribution of wealth – with that of the informal economy of his adoptive city.

As we saw in the previous chapter, Hirschhorn's choice of cheap, everyday materials recalled common practices; as Benjamin Buchloh has pointed out, this can be read as 'an act of solidarity' in itself.[155] Anyone who has used masking tape to repair a broken car window or tin foil to wrap something up can recognise these everyday materials and gestures. Such materials have no intrinsic value and require no specialised skill. Indeed, this is what allowed Hirschhorn to hire residents from housing estates to help him construct his *Monuments*: he could rely on them being able to use scissors and hammers, drills and screws to construct precarious objects and architectures out of plywood, plastic sheeting, plastic bags and masking tape. Crucially, as Hal Foster noted, it was along the 'interface' between what Rauning called the 'smooth forms of precarization' ('digital bohemians', 'intellos précaires' etc.) and the other constituency of the precariat, the 'migrants and *sans papiers*', that Hirschhorn 'sited' works such as the *Deleuze Monument* or the *Musée Précaire Albinet*.[156] There Hirschhorn confronted the precarious status of his role as an artist, and of the work of art, with the everyday reality experienced by a precarious population. Most directly, Hirschhorn offered paid work to the unemployed residents; on another level, such works took them seriously as an audience for contemporary art, culture and philosophy, thus affirming an equality between the artist and all his viewers.

Being together

New forms of 'sociability' lay at the heart of many alterglobal projects. In their text for *The Structure of Survival* for example, the Colectivo Situaciones mentioned the new 'experiences' that arose in Argentina following the major economic crisis that culminated in popular uprisings in December 2001. Such endeavours as occupied factories managed by workers or new experiments in art or healthcare all constituted, according to the Colectivo Situaciones, various 'means of affirming common values of solidarity and sociability'.[157] Experimenting with non-alienated forms of social relations through conviviality was a recurrent trope in such alternative experiences. 'For activists of the way of subjectivity', as Pleyers called them, 'conviviality and interpersonal

exchanges' were 'the essential markers of the advent of *another* world'.[158] This was a means to remedy what Bauman had called the 'friability … brittleness … transience … of human bonds and networks' dissolved by liquid modernity.[159] It is in this context that a 2004 *Artforum* article by Carlos Basualdo and Reinaldo Laddaga described both Hirschhorn's *Bataille Monument* and Potrč's projects in the Caracas slums as so many attempts to create 'experimental communities'.[160] In a 2005 article for *Flash Art*, Laddaga would focus more specifically on contemporary Latin American art practices developed in the wake of the continent's economic crises. Alÿs's *When Faith Moves Mountains*, argued Laddaga, participated in a broader 'interrogation' of the ways in which art can 'participate in the … invention of new forms of collective action'.[161]

Hirschhorn sought to introduce a sense of conviviality by locating the 2000 *Deleuze Monument* on a housing estate, in an outdoor space where residents and visitors could meet, talk and watch videos (figure 57). Similarly, Alÿs told me that 'collective actions' such as *When Faith Moves Mountains* or *Barrenderos* attempted to create 'a space of conviviality' that involved, at its most basic, 'being in the same place at the same time for the same goal or reason – even if three hours later everyone has gone back to their own private world'.[162] Recalling his experience of working as a demolition contractor as a student, Alÿs suggested that such collective, physical work produced 'a fantastic space of conviviality', tightening the bonds between workers and leading to 'intense' experiences. Hirschhorn also looked for moments of intensity in the construction, opening and events in his public works, while also considering the everyday experience of sharing the same space and time over a longer period than in Alÿs's work. For Hirschhorn, 'being there' has often meant 'being with'. Standing on a platform where Kurt Schwitters's *Merzbau* would have been, visitors to Hirschhorn's *Kurt Schwitters-Platform* (conceived in 2000 and built in 2011) were invited to connect mentally with this artist's destroyed work, just as standing in front of an *Altar* to Gilles Deleuze was a means of thinking about, and with, the philosopher. With works such as the *Deleuze Monument* or the *Bataille Monument*, this 'being with' became, in addition, a 'being together', further allowing art and philosophy to be put into action in a 'concrete' way, to use Deleuze's terminology.

Significantly, the forms of conviviality set up by Alÿs and Hirschhorn emerged within projects that were initiated by the artist, who subsequently turned to others to help him carry them out. This is why both Alÿs and Hirschhorn have been criticised for imposing their personal goals on their collaborators. Critic and curator Maria Lind, for example, objected to Hirschhorn's projects on the grounds that the only role available to a local participant in a work such as the 2002 *Bataille Monument* was that of 'executor' rather than 'co-creator'.[163] Lind went so far as to accuse Hirschhorn of

'"exhibiting" and making exotic marginalized groups and thereby contributing to a form of social pornography'. In contrast, Lind explained that collectives such as Oda Projesi (who, as we saw earlier, were included in *The Structure of Survival*) directly involved neighbourhood residents in the very planning of their collective activities, thus 'using art as means for creating and recreating new relations between people' and developing sustainable relationships that could extend beyond the artists' departure. Grant Kester similarly criticised Alÿs's distance from, and indifference to, the human, geographic and historical realities in which he intervenes. For example, in *When Faith Moves Mountains* (figure 60), Alÿs bussed in students from Lima and put them to work on an event that he had choreographed entirely in advance, rather than involving local residents living in the shanty town next to the dune to be shovelled, whose own personal precarious experiences would have been more relevant, according to Kester. Artists such as Alÿs and Hirschhorn, he argues, close themselves off from the reality in which they intervene by insisting on a form of artistic autonomy.[164] They refuse to learn from the strengths of local communities or the 'moments of success in the past and the present' that may be inherent to their history.[165]

As each side in this debate recognises, such critiques reveal the existence of radically diverging criteria in the assessment of collective art practices. It is evident that neither Hirschhorn nor Alÿs has sought to solve concrete problems in the social spaces in which they intervene, nor have they tried to give form to a collective portrait of these communities.[166] Unlike artist collectives such as Oda Projesi, Superflex, the Critical Art Ensemble or RAQS Media collective cited by others, Alÿs and Hirschhorn do not attempt to develop new forms of collaborative practices that would set them apart from the traditional single-author model. In what way, then, is it possible to speak of their projects as setting up temporary alliances within a global precariat?

According to Jean Fisher, Alÿs's *When Faith Moves Mountains* provided above all 'the conditions of possibility for a nascent political consciousness, one born from conviviality, a being-together as a coming-into-being of community'. The project, according to her, opposed this 'realization of shared existence' to an 'ever-increasing instrumentalization of life under globalism'.[167] This analysis could equally apply, I would argue, to the spaces produced by Hirschhorn. Indeed, as philosopher Jacques Rancière underlined in a 2009–10 exchange with Hirschhorn, the presence of the artist and the work over a continuous time set up a specific temporal framework in which to construct a space of appearance, 'affirming anybody's ability to see, produce and think'.[168] A 'fluctuating temporality', according to Rancière, allowed Hirschhorn's practice to operate at the junction of both the artist's work and the 'experiences of work' by others, *as well as* the junction between his free time and others' 'idle time', in an unpredictable, back-and-forth movement typical of 'current forms of precariousness and intermittence' in the job

market. 'Making different times equal', Rancière observed, is what enables Hirschhorn's work to 'create public spaces'. Indeed, my temporal experience of the 2013 *Gramsci Monument* allowed me to share a space of appearance with the artist, the residents of the Forest Houses housing estate, as well as guest speakers and other visitors; I was moved by the work's sheer pulsating energy. Although the *Gramsci Monument*, unlike the *Deleuze Monument*, was generously funded (by the Dia Art Foundation, as well as other foundations and private sponsors) and conceived with the full approval and financial support of the New York City authorities, it nevertheless set up a similarly precarious space, I would argue, in that its survival ultimately remained largely dependent on the good will, participation and decisions of all involved.

Alÿs's work, according to Cuauhtémoc Medina, similarly conjures a space of action which, in Arendt's terms, 'arises out of acting and speaking together', irrespective of a specific location. According to Arendt, it is in this space that humans can 'appear together' and to each other, as they meet, exchange ideas, make decisions and act. Indeed, for Arendt, action involves above all 'acting in concert'. According to Medina, Alÿs's work 'locates, preserves and activates' this space of appearance threatened by global capitalism.[169] Moreover, as Sophie Loidolt put it, action for Arendt occurs in 'a world *in common* (in the sense of a web of references), which is created only through shared communication about this world, and is constantly being created afresh and dynamically changing'.[170] This 'in-between' space of communication, according to Arendt, arises among other elements from the stories that are told about past deeds, out of the '"web" of human relationships'.[171]

'Fictionalising the real'

Stories are certainly central to Coupland's *Generation X*, in which the narrator states that he and his friends dropped out of the capitalist rat race in order to 'tell stories and to make' their 'own lives worthwhile tales in the process'.[172] His friend Claire opines: 'Either our lives become stories, or there's just no way to get through them.' Although political action is not what these 'Generation X' adults have in mind, this desire to tell stories is an important part of their search for experiences and relationships that have not been fully colonised by a voracious capitalism. Such 'Tales for an accelerated culture' (the subtitle of Coupland's novel) offer stories after the end of master-narratives as declared by Fukuyama. The novel speaks of the need to invent stories in a world where 'narrative templates', as Coupland put it, have been eroded. As the postcard for Alÿs's *Fairy Tales* suggests, we 'need to create' 'fables' rather than 'utopias'.

Unlike Coupland's fables, exchanged among a close-knit group of friends, the storytelling at play in Alÿs's and Hirschhorn's collective works operates on multiple levels: the narratives of their construction, the different stories told by

participants, and their dissemination after the fact. In Alÿs's work, as we saw in Chapter 4, stories come close to fables and rumours. Like Alÿs, Hirschhorn carefully documents collective works such as the *Deleuze Monument* through significant publications, as well as actively using the media to publicise the works during their lifetimes. Like Alÿs, Hirschhorn considers documentation and dissemination as a central component of the works, in order to infiltrate the stories of their making into a wider web of references.

According to Jean Fisher, Alÿs's *When Faith Moves Mountains* proposed 'a new narrative about reality'.[173] Absurdity can be used to create such new narratives. When in my interview with Alÿs I compared his *Green Line* (figure 65) to Allan Kaprow's *Sweet Wall* (figure 43), for example, he instantly focused on the shared absurdity of the two actions: the act of building and then destroying a wall made out of bread and jam in Berlin in 1970, like that of walking with a tin of dripping green paint along the original 'green line' drawn after the 1948 Arab–Israeli War, were both humorous responses to two very real oppressive walls. A poetic act can provoke, according to Alÿs, 'a moment of suspended meaning, a sensation of senselessness that may reveal the absurdity of the situation'.[174] This moment, this space that Alÿs tries to insert with some of his works, can be described as a 'hiatus', a break from 'the atrophy of a situation', a 'different perspective on things' which 'might then have the potential to open up a political thought'.[175] Such a description directly echoes what Rancière spoke of as a 'breathing room', which could allow artists and politicians to 'loosen the bonds that enclose possibility within the machine that makes the "state of things" seem evident, unquestionable'.[176] As we saw in Chapter 4, this is the space of the *kairos*, the 'breach' or 'interstice' that opens a 'breathing' space.

Rancière's definition of such relations between aesthetics and politics certainly appealed to a range of artists and theorists at the beginning of the twenty-first century. For Rancière, 'politics is not the exercise of, or the struggle for power': rather, it 'consists in reconfiguring the distribution of the sensible'.[177] This not only resonated with the alterglobalisation discourses which, as we saw, believed in changing the world without taking power; it also helped conceptualise a politics of art that differed from avant-garde forms of critique based on binary oppositions, including that of the centre and margin, which no longer appeared relevant in the 1990s. I agree with Mark Godfrey that Rancière's definition of politics as 'a reconfiguration of the given perceptual forms' appears to describe perfectly works such as Alÿs's *Green Line*, in which 'the act disrupts existing ways of visualising or understanding the situation, and creates new ways of making it visible'.[178] In his 2010 analysis of Alÿs's work as a 'vanishing mediator' who intervenes in a situation and then disappears, T.J. Demos similarly drew on Rancière's definition. Demos highlighted the 'new forms of visibility' in Alÿs's *Green Line* 'that free up spaces

for creative analysis and discussion'[179] – embodied in the work itself by the interviews which, as we saw, diverged and contradicted each other.

The editors of the 2009 volume *Communities of Sense* further developed the implications of Rancière's definition of aesthetics for twenty-first-century art and criticism, by relating it to the philosopher's writings about community and dissensus. 'Rancière's description of temporary solidarities that are constantly renegotiated through disagreement', they argued, complemented new definitions of community, by Jean-Luc Nancy for example, as a 'contingent being-together'[180] – definitions that could apply, as we saw, to forms of alterglobal activism as much as to collective works by Alÿs and Hirschhorn. Of particular interest to me is Rancière's focus on the notion of 'appearance', cited in *Communities of Sense*, which recalls Arendt's 'space of appearance'. Just as this space was central to Arendt's conception of politics, Rancière considers that 'there is politics from the moment there exists the sphere of appearance of a subject'.[181]

Rancière goes one step further than Arendt, however, in considering this sphere as a 'mechanism for producing difference', for 'the political constitution of nonidentary subjects'. Such subjects are able to 'disturb a specific division of the perceptible by linking together separate worlds and organizing spaces where new communities can be formed'.[182] Where Arendt deplored 'the atrophy of the space of appearance and common sense' in contemporary society,[183] Rancière spoke of a 'loss of appearance' 'in our contemporary age of consensus' which erases divisions and differences among individuals.[184] If art is defined as a political reconfiguration of the sensible and the visible, it can participate in a broader 'mechanism for producing difference' through dissensus, by setting up spaces of appearance in which dissenting voices can be heard.

In a 2009 essay, Vered Maimon discussed such processes more specifically in relation to turn-of-the-century works by the Atlas Group and Pierre Huyghe, which blur the relations between the real and the fictional. Through the manipulation of such ambiguities, argued Maimon, such practices succeed in disrupting forms of consensus by highlighting the very process of 'staging of appearances' 'in which subjects can enact incompatible claims with regard to what is perceived as "common"'.[185] Evidently, Hirschhorn, Alÿs, Orozco and Creed do not share with Walid Raad or Huyghe the same strategies of blurring the relations between fiction and documentary, nor are they involved in what Carrie Lambert-Beatty has described as the 'para-fictional' in contemporary art.[186] Nevertheless, I would argue that their precarious works are involved in 'fictionalising the real', as Rancière called it, via the stories they insert into the concrete field of everyday experience.[187]

'Art and politics,' explained Rancière, 'construct "fictions", i.e. material re-arrangements of signs and images, relations between what we see and what we say, between what we do and what we can do.'[188] This is why fictions

can participate in a redistribution of the sensible and open up new 'breathing' spaces. Furthermore, since storytelling, as Arendt explained, is 'a way of understanding the sense of our actions in a web of human references', it can also serve to produce the kind of 'public' space of appearance delineated by both Arendt and Rancière. As Maimon put it, this space acts 'as a productive mechanism that enables processes of subjectivization' – it is a space 'in which subjects enact claims that both link and separate them from the social whole'.[189]

Bare life

Alliances and differences among subjects came to the fore in discussions of precarity after 2004, as critics started to address the difficulties involved in bringing together widely disparate constituencies under this common term. Many acknowledged that the 'precariat' could not be considered as a new informal revolutionary class, as some had thought it might be at the turn of the decade. George Yúdice had warned as early as 1989 that celebrations of Certeau's subversive tactics of making do often failed to '*distinguish* among the practitioners of such tactics in terms of how the tactics enable them to survive and [to] challenge their oppressibility'.[190] Similarly, theorists such as Brett Neilson and Ned Rossiter would draw in 2008 on Sandro Mezzadra's discussion of capitalism as translation – which I mentioned in the last chapter – in order to underline those irreducible differences between, say, a freelance web designer, an immigrant working as a cleaner and a nomadic artist. 'Nobody would deny that some forms of precarity cannot translate into others', they insisted.[191] Indeed, nobody can deny the fundamental differences between Alÿs's *Turista* and the plumber selling his services on the Zócalo, nor that between the *Ambulantes* going about their work and the artist pushing a block of ice. Alÿs's and Orozco's forms of 'making do' are obviously not responses to a need to survive. Similarly, Hirschhorn's status remained resolutely distinct from that of the unemployed men whom he hired on projects such as the *Deleuze Monument* or the *Musée Précaire Albinet*.

Nevertheless, Neilson and Rossiter concluded that the shared experience of precariousness could continue to serve as a starting point for political organisation, as long as the differences between each situation within this alliance were acknowledged. The main question, they argued, 'concerns how this untranslatability is constituted'.[192] Similarly, I would like to argue that artists creating precarious artworks may be able to make visible these untranslatable nodes by exploring this space of appearance through dissensus (as it is understood by Rancière). Particularly relevant among those points of opacity is the relation between those whose precarious circumstances are endured as a matter of survival, and those who voluntarily subject themselves to precarious conditions as a matter of choice.

In a 1997 article mentioned earlier, James Meyer criticised Orozco's brand of 'lyrical' nomadism for obscuring such differences.[193] An attendant risk, explained T.J. Demos in 2010, was that of the global nomad claiming a problematic 'neutrality' that would signify a 'withdrawal from politics'.[194] Practices such as Orozco's, argued Demos elsewhere, may appear to 'naively romanticise the privileges of borderless travel while overlooking how the less-privileged are excluded from that same freedom'.[195] Like Kester, both Meyer and Demos warned of the dangers of passing over the specific material conditions of a gesture. Different solutions were offered by Meyer and Demos. Meyer countered 'lyrical nomadism' with the 'critical nomadism' of Renée Green or Christian-Philip Müller, which focused on the contemporary *flâneur*'s institutional, historical and discursive frameworks. For his part, Demos turned to other wandering figures such as the exile and the refugee who, according to him, have served as models for contemporary artists including Emily Jacir and Yto Barrada. Unlike the nomadic artist, the refugee must live on the move as a necessity rather than as a choice.

In this text, Demos makes use of Giorgio Agamben's concept of 'bare' or 'naked life', which was also central to Okwui Enwezor's 2002 *Documenta*, and has since been developed by other theorists, including art historian Anthony Downey.[196] According to Agamben, the refugee can be considered as nothing less than the paradigmatic figure of a contemporary age in which a wide range of individuals have been excluded from the political sphere of human rights and representation, and are thus condemned to a 'bare life' bent on survival. 'Bare life', according to Agamben, is life 'exposed' to a 'death' decreed by a sovereign power – whether through extreme poverty, warfare, police repression or anti-immigration laws that lead illegal immigrants to risk their lives and force some of them into temporary camps for undetermined periods of time.[197] With the concept of 'bare life', Agamben combined Arendt's analysis of the refugee condition (in her 1943 essay entitled 'We Refugees') with her prescient analysis of labour in *The Human Condition*. Like Arendt, Agamben started from the ancient Greek distinction between *zoe* (animal life, related to the labour of survival) and *bios* (the citizen's political life in a group, which involves work and action). Agamben believed, however, that the balance between labour, work and action that lies at the heart of Arendt's 1958 study of the human condition has been lost in today's political context. Drawing on Michel Foucault's definition of biopolitics as the inescapable impact of power on individual bodies as they come under the control of social, political and economic institutions of modern capitalism, Agamben concluded: 'We can no longer distinguish … between our biological life as living beings and our political existence.'[198] For Agamben, it is precisely this condition, in which the biological and the political come together, that is made visible in the refugee's 'bare life'.

Inasmuch as nation states can use emergencies as an excuse to declare a 'state of exception' at any time, thereby divesting citizens of their rights, Agamben argued that we are all potential refugees; our precarious existences are dependent on arbitrary, unpredictable national and international decisions. As 'the process by which exception everywhere becomes the rule', explained Agamben, 'the realm of bare life – which is originally situated at the margins of the political order – gradually begins to coincide with the political realm'.[199] Thus a new 'zone of irreducible indistinction' emerges, which blurs the differences between 'exclusion and inclusion, outside and inside, *bios* and *zoe*, right and fact'. This is a sphere of survival in which the refugee is divested of his dignity, his possibility to act, and must survive in an in-between space characterised by a permanent sense of displacement and disorientation.

In his essay on Alÿs as a 'vanishing mediator', Demos focused on the artist's 'displaced situation' as a Belgian artist in Mexico.[200] Though far less precarious than the refugee's 'bare life', Alÿs's status as an outsider enabled him, according to Demos, to develop an 'exile aesthetic' that transformed a potentially negative experience of displacement into a strength. Demos underlined Alÿs's 'sensitivity towards difference': it allowed him to give 'form to political crises', and to offer 'a creative proposal for bypassing deadlock', in the aforementioned *Green Line* for example (figure 65).[201] With such a work, argues Demos, Alÿs managed to introduce a 'hiatus' and 'suspension'[202] which recall, as we saw earlier, Rancière's 'breathing space'.

The ease of Alÿs's intervention as a 'vanishing mediator' in Jerusalem risks promulgating, however, an image of what Demos called the 'false universality of the nomadic'.[203] Although Alÿs avoided as many Israeli checkpoints as possible during his walk, it is evident that he could not have crossed those that he did had he been Palestinian. In a more general text on exile in contemporary art, Demos gave examples of works that avoid suggesting such 'false universality'. Another work that took place in Israel, for example (which is also cited in Downey's essay on 'bare life'), was Multiplicity's 2003 *Solid Sea 03*. For this work, Multiplicity – a Milan-based collective of 'architects, geographers, artists, city planners, photographers, sociologists, economists and moviemakers' (as Downey described them)[204] – divided into two teams, which each made a journey along the exact same distance through the West Bank. One group took a taxi driven by a Palestinian, the other travelled with an Israeli driver: the latter's one-hour journey contrasted with the former's five-hour drive, through checkpoints and along gravel roads. 'The divergence between the two,' concluded Demos, 'dramatises the significant disparities of mobility today, which depend on the identity of the traveller.'

Like Multiplicity's *Solid Sea*, Yto Barrada's *A Life Full of Holes: The Strait Project*, a photographic project carried out between 1998 and 2004 in her hometown of Tangiers, firmly anchored an investigation of 'bare life' in a

specific context. Barrada's photographs all hint at the waiting, and yearnings, of African migrants in Tangiers, as they dream of crossing over to Europe via the Strait of Gilbraltar. Since 1991, the European Union's Schengen Agreement has closed off this passage, so this journey has to be carried out illegally. Both Demos and Downey noted that those who attempt such a trip are called the 'burnt ones' because they have burned their passports before embarking so that they cannot be returned to their home countries if they get caught. According to Downey, Barrada's series thus visualises two 'zones of indistinction' (in Agamben's terms): the waiting in Tangiers is the migrant's in-between space, while the 'burnt ones' are reduced to the 'bare life' of refugees stripped of their rights.

The Strait of Gibraltar was also the location of Alÿs's 2008 *Don't Cross the Bridge Before You Get to the River* (figure 68). This work involved 'a line of kids' extending from each side of the Strait in order to meet across the water on the horizon. Each child held a little boat made with a sail stuck on a flip-flop. Barrada's series, significantly titled *A Life Full of Holes*, emphasised forms of absence and disappearance by making visible an ongoing movement

Francis Alÿs, *Don't Cross the Bridge Before You Get to the River*, Strait of Gibraltar, 2008. **68**
In collaboration with Julien Devaux, Rafael Ortega, Felix Blume, Ivan Bocara, Jimena Blasquez, Roberto Rubalcava, Begoña Rey, Abbas Benhnin and the kids of Tarifa and Tangiers

between forced stasis and fantasies of escape, or the ghost-like bodies caught up in the no man's land of migration. In contrast, Alÿs's work was playful and joyous, as the children swam against the waves with their 'shoe boats', and attempted to form a line that would stretch along the horizon, joining the two continents as in a fairytale. Included in the documentation exhibited along with the film of *Don't Cross the Bridge Before You Get to the River* in Marrakech in 2009, as Mark Godfrey reported, were newspaper clippings concerning the harsh reality of clandestine migration, as well as a question, written out by the artist: 'How can one at the same time promote global economy and limit the movement of people around the globe?'[205] Such a question directly addressed the very concerns raised by Meyer, Demos and Downey; it was cited by Godfrey as he sought to explicitly situate Alÿs's work in the context of discussions of the migrant's 'bare life' and works such as Yto Barrada's. Noting that security measures in 2000 had diverted illegal immigration away from the Strait of Gibraltar towards 'far more precarious and much longer crossings' via Sicily or the Canary Islands, Godfrey aptly asked: 'what can be made of Alÿs's decision to work in the Gibraltar Strait with the visible bodies of children play-enacting a ritual of passage', rather than 'at the sites of real migrant crossings with the normally invisible bodies of adult refugees?'[206]

In *Don't Cross the Bridge…* Alÿs did not seek to distinguish between the European and North African sides of the strait, and could thus be accused of blurring the specificities of each situation. Instead, what comes through in this work is the conviviality of a temporary alliance, typical, as we have seen, of Alÿs's other collective actions. Like the *Barrenderos* who smiled as they performed their absurd action of pushing rubbish together (unlike their every-day work of sweeping the street, which is a source of effort and tedium), the children in *Don't Cross the Bridge…* are laughing. They are playing with toys: the sea is a site of pleasure as well as uncertainty. What is emphasised, then, as in *When Faith Moves Mountains*, is a coming together, the 'coming-into-being of community' singled out by Jean Fisher, which Godfrey also relates to Agamben's own term, the 'coming community'.[207] This contemporary fable for the age of globalisation offers, in Godfrey's eyes, an optimistic 'visualisation' of a formless community of the future which exceeds national boundaries.

This conviviality, and sense of community, does not, however, emerge without difficulty. As we saw in the last chapter, physical friction, rubs and accidents play a central role in many of Alÿs's works, as so many metaphors for labour, effort and the disruption of the smooth homolingual order of capitalism. Similarly, I agree with Godfrey that in the film documentation of *Don't Cross the Bridge…* the waves that keep the children from aligning their boats in a straight line 'serve as a constant reminder of the impediments to, and impossibility of, easy transit'.[208] It is precisely at the moment in which the

perfect horizontal line wavers and blurs, in which the project is on the verge of failure, that 'bare life' is suggested.

Although Hirschhorn's projects such as the above-mentioned *Deleuze*, *Bataille* and *Gramsci* monuments or the *Musée Précaire Albinet* extended over a much longer period than Alÿs's *When Faith Moves Mountains* or *Don't Cross the Bridge Before You Get to the River*, I would like to argue that they similarly brought together the biological dynamics of labour (or 'bare life') and the Arendtian 'space of appearance' required by action. Thus, to use Agamben's words, both Hirschhorn and Alÿs focus on the fundamental articulation between 'our biological life as living beings', on the one hand, 'and our political existence', on the other. It is in this sense that I would suggest that their practices, as well as those of Orozco and Creed, all operate within this 'opaque zone of indistinction' in which Agamben urged us 'to find the path of another politics'. This 'zone of indistinction', I would suggest, has replaced Arendt's shrinking 'sphere of appearance'. It emerges at the crossroads of labour and action, as artists articulate joins that point to the concrete realities brushed aside by an ever-lighter capital, as they open up fragile spaces for temporary alliances, as their tactics hint at change as well as survival.

It was partly in response to the so-called 'war on terror' launched by the American government after the September 11 attacks of 2001 that Judith Butler published a series of essays, written between 2001 and 2004, on the question of 'precarious life'.[209] Butler sought to address what she saw as a violent political discourse which posited as 'ungrievable' the lives of those considered to be 'Other' (be he or she a terrorist, a member of the 'axis of evil', a prisoner jailed at Guantanamo Bay, or simply a Palestinian). Butler turned to French philosopher Emmanuel Lévinas's writings on ethics in order to highlight the basic fact that 'we come to exist … in the moment of being addressed, and something about our existence proves precarious when that address fails'.[210] Butler concluded, firstly, that ethics require us 'to be awake to what is precarious in another life' and hence to become aware of our shared precariousness.[211] Secondly, Butler raised an issue that resonated with Rancière's contemporary writings about the 'distribution of the sensible': it is political power, she argued, that decides whose lives are grievable and whose existences are considered to lack the right to protection (thus endowing them with the quality of 'bare life' described by Agamben). Thirdly, Butler advocated a 'sense of the public in which oppositional voices are not feared, degraded or dismissed'[212] that is close to Rancière's 'space of appearance' that emerges through dissensus. Thus Butler's call to focus on 'what can appear, what can be heard' resonated with Rancière's definition of a 'space of appearance' in which potential redistributions of the sensible can operate.

Further reflecting, ten years on, on debates concerning precarity and precariousness, Butler distinguished between 'precariousness' as 'a function

of our social vulnerability and exposure' and 'precarity' as 'differentially' and 'unequally' 'distributed': while the former 'is always given some political form', the latter is experienced differently by those who are deemed to count 'as human' and those who are not.[213] Nevertheless, argues Butler, an awareness of our 'shared condition of precarity' can serve 'as a social condition of political life' in order to contest normative discourses of exclusion.[214] It is in this sense that Butler emphasises the shared 'precarious bonds' that are 'structured by the condition of mutual need and exposure'.[215]

In addition to bringing together Agamben's and Rancière's perspectives, and explicitly relating them to the concepts of precariousness and precarity, Butler's writings appear to me to map out the very space of precarious works that I have discussed in this book. The 'mutual need and exposure' discussed by Butler echo the 'give-and-take' and willed vulnerability that lie at the heart of precarious works from the 1960s to the first decade of this millennium. Moreover, Butler's emphasis on precariousness as a 'shared condition' from which to build a political space of action aptly describes, in my eyes, the relationships that these works try to set up between the artist and the world, and between the work and its viewers.

Unlike those of Multiplicity or Yto Barrada, for example, the precarious practices that I have discussed in Part II of this book address Agamben's 'bare life' in their form, formation and mode of address, rather than by investigating a specific site or group. Like their 1960s predecessors, these contemporary artists engage neither in representation nor in identifiable subject matter. This is why I would like to conclude this chapter by returning to Agamben's writings, and in particular to his discussion of Robert Walser's characters, which can be read, as James Phillips has suggested, as 'positive counterfigures' of the refugees and their 'bare life'.[216] As we saw earlier in this chapter, Walser's characters inhabit, according to Agamben, a 'limbo' which may at first sight be compared to the 'zone of indistinction' of 'bare life'. Yet Walser's characters differ, argues Phillips, 'from both the rightless individual of the internment camp and the citizen with his or her battery of rights' in that their relation with sovereign law is more elusive.[217] Through play, suggests Agamben, such figures remain in a limbo in which they are simultaneously *both* refugee and citizen, as well as *neither* one nor the other. Walser's characters have somehow 'become creatures of such flightiness and levity that the action of the law encounters nothing substantial on which it might inflict suffering'.[218] At the same time, as we saw, such characters must constantly elude the risk that their forms of play, absurdity, lightness and elusiveness be subsumed by intelligent capitalism and immaterial labour, which always seek to replace the political sphere of appearance with ever more sophisticated forms of leisure, consumption and entertainment. If Walser's light and elusive antihero appears as an 'allegory of carefreeness [*sic*]' for Agamben (as Phillips

argues),[219] this figure must also remain careful – scrupulously responsible, 'awake' to others (as Butler would put it). This is the fine line, I would argue, along which Orozco and Creed, Alÿs and Hirschhorn take the risk of situating their precarious works.

Notes

1 Zygmunt Bauman, *Liquid Modernity* (Cambridge and Malden, MA: Polity Press and Blackwell, 2000), p. 121.
2 Pierre Bourdieu, 'Le néo-libéralisme, utopie (en voie des réalisation) d'une exploitation sans limites' (January 1998), in *Contrefeux: propos pour servir à la résistance contre l'invasion néo-libérale* (Paris: Editions Liber, 1998), p. 116. Unless otherwise stated, all translations are mine.
3 Bauman, *Liquid Modernity*, p. 6.
4 Pierre Bourdieu, 'La précarité est aujourd'hui partout' (1997), in *Contrefeux*, p. 98.
5 *en rendant tout l'avenir incertain, elle interdit … ce minimum de croyance et d'espérance en l'avenir qu'il faut avoir pour se révolter, surtout collectivement, contre le présent, même le plus intolérable. Ibid.*, p. 96.
6 Douglas Coupland, 'Generation XVIX' (2013), in *Generation X: Tales for an accelerated culture* (1991) (London: Abacus, new edn, 2013), n.p.
7 Francis Fukuyama, 'The End of History?', *The National Interest*, 16 (Summer 1989), 3.
8 Coupland, 'Generation XVIX', n.p.
9 Douglas Coupland, in Steve Lohr, 'No More McJobs for Mr. X', *New York Times*, 29 May 1994, sec. 9, p. 2.
10 *Time*, 6 January 1992 (US edition), p. xvi.
11 Richard Linklater, in Lane Relyea, 'What me work?' [interview], *Artforum*, 31:8 (1993), 75.
12 John M. Ulrich, 'Generation X: A (Sub)Cultural Genealogy', in Andrea L. Harris and John M. Ulrich (eds), *GenXegesis: Essays on Alternative Youth (Sub)culture* (Madison: University of Wisconsin Press, 2003), p. 19.
13 *Ibid.*, p. 20.
14 Ralph Rugoff, *Just Pathetic* (Los Angeles: Rosamund Felsen Gallery, 1990), n.p.
15 Nato Thomson, 'Trespassing Relevance', in Gregory Sholette and Nato Thomson (eds), *The Interventionists: Users' Manual for the Creative Disruption of Everyday Life*, exh. cat. North Adams, Mass MoCA (Cambridge, MA: MIT Press, 2004), p. 15.
16 Gene Ray, 'Another (Art) World is Possible', *Third Text*, 18:6 (2004), 572.
17 Naomi Klein, 'Reclaiming the Commons', *New Left Review*, 9 (May–June 2001), 82.
18 Ray, 'Another (Art) World is Possible', 567.
19 Alison Gingeras, 'Striving to be Stupid: A Conversation with Thomas Hirschhorn', in Alison Gingeras (ed.), *Thomas Hirschhorn: London Catalog* (London: Chisenhale Gallery, 1998), p. 6.
20 Jean-Yves Jouannais, 'Thomas Hirschhorn: Wagering on Weakness', *Art*

Press, 195 (1994), pp. 56–8; Gingeras, 'Striving to be Stupid', p. 1; Pascaline Cuvelier, 'Weak Affinities: The Art of Thomas Hirschhorn', *Artforum*, 36:9 (1998), pp. 132–5.

21 Thomas Hirschhorn, 'About My Exhibition at Hôpital Ephémère' (April 1992), in *Critical Laboratory: The Writings of Thomas Hirschhorn*, ed. Lisa Lee and Hal Foster (Cambridge, MA: MIT Press, 2013), p. 160.

22 Thomas Hirschhorn, 'Fifty-Fifty' (January 1993), in T. Hirschhorn, *Thomas Hirschhorn, Katalog* (Berlin: Künstlerhaus Bethanien, 1995), p. 28. Author's translation from the French differs slightly from that in *Critical Laboratory*, p. 5.

23 Thomas Hirschhorn, *Les Plaintifs, les bêtes, les politiques* (Geneva: Centre Genevois de Gravure Contemporaine, 1995). For an analysis of this book, see Benjamin Buchloh, 'Detritus and Decrepitude: The Sculpture of Thomas Hirschhorn', *Oxford Art Journal*, 24:2 (2001), 54–7.

24 Hal Foster, 'Towards a Grammar of Emergency', in Thomas Hirschhorn (ed.), *Thomas Hirschhorn: Establishing a Critical Corpus* (Zürich: JRP Ringier, 2011), p. 172.

25 Jean-Yves Jouannais, *L'Idiotie: art, vie, politique – méthode* (Paris: Beaux Arts Magazine éditions, 2003).

26 Rugoff, *Just Pathetic*, n.p.

27 'Just Pathetic: Michael Wilson on Sore Winners', *Artforum*, 43:2 (2004), http://business.highbeam.com/4137/article-1G1-123628550/just-pathetic-michael-wilson-sore-winners (accessed 13 May 2015)

28 Rugoff, *Just Pathetic*, n.p.

29 Hal Foster, *The Return of the Real: Art and Theory at the End of the Century* (Cambridge, MA: MIT Press, 1996), ch. 5.

30 *Ibid.*, p. 164.

31 Rhonda Lieberman, 'The Loser Thing', *Artforum*, 30:1 (1992), 79.

32 *Ibid.*

33 Peter Sloterdijk, *Critique of Cynical Reason* (1983) (Minneapolis: University of Minnesota Press, 1987). My discussion of Sloterdijk's book is indebted to Foster, *Return of the Real*, pp. 118–24.

34 Christine Macel, 'L'art en excès de flux ou Le tragique contemporain', in Christine Macel (ed.), *Dionysiac* (Paris: Centre Georges Pompidou, 2005), n.p.

35 Foster, *Return of the Real*, p. 124.

36 'Avant/Après: Entretiens avec Thomas Hirschhorn par Guillaume Désanges' ('Après', April 2004), in Thomas Hirschhorn (ed.), *Musée Précaire Albinet* (Paris: Xavier Barral and Laboratoires d'Aubervilliers, 2005), n.p.; Ross Birrel, 'The Headless Artist: An interview with Thomas Hirschhorn on the friendship between art and philosophy, precarious theatre and the Bijlmer Spinoza-Festival', *Art & Research: A Journal of Ideas, Contexts and Methods*, 3:1 (2009–10), http://www.artandresearch.org.uk/v3n1/hirschhorn2.html (accessed 12 May 2014).

37 'Avant/Après', n.p.

38 Interview with the author, Aubervilliers, 20 March 2009.

39 *La faiblesse voulu [sic] permet de vaincre la faiblesse subi [sic], imposé.* Thomas Hirschhorn, 'A propos de mon exposition à la Galerie nationale du Jeu de

Paume' (1994), in *Thomas Hirschhorn, Katalog*, p. 14. The French *faiblesse voulue* is translated as 'sought-after weakness' in the English translation by M. Stevens: 'Regarding my Exhibition of *Wall-display, Rosa Tombola, Saisie, Lay-out* (1988–1994) at the Galerie Nationale du Jeu de Paume' (30 March 1994), in *Critical Laboratory*, p. 171.

40 Thomas Hirschhorn, quoted in Craig Garrett, 'Thomas Hirschhorn: Philosophical Battery', *Flash Art*, 238 (October 2004), 93, http://www.papercoffin.com/writing/articles/hirschhorn.html (accessed 12 May 2014).

41 Jouannais, *L'Idiotie*, p. 114.

42 Lieberman, 'The Loser Thing', 79.

43 Yve-Alain Bois, Guy Brett, Margaret Iversen and Julian Stallabrass, 'An Interview with Mark Wallinger', *October*, 123 (Winter 2008), 193.

44 Press release, cited in *ibid.*, p. 185.

45 *Ibid.*, p. 201.

46 *Ibid.*, p. 193.

47 Adrian Searle, 'Bears against Bombs', *The Guardian*, 16 January 2007, http://www.theguardian.com/world/2007/jan/16/humanrights.politicsandthearts (accessed 14 May 2015).

48 Michael Archer, *Art since 1960* (London and New York: Thames and Hudson, 1997), p. 190.

49 'Sculptures directes (Direct Sculptures)' (February 2000), in Florian Matzner (ed.), *Public Art: A Reader* (Ostfildern-Ruit: Hatje Cantz, 2nd edn, 2004), p. 251.

50 'Precarious: Hal Foster on the Art of the Decade', *Artforum*, 48:4 (2009), p. 207.

51 Carlos Basualdo, 'Walks', in Thierry Davila (ed.), *Francis Alÿs* (Antibes: Musée Picasso, 2001), p. 190.

52 James Meyer, 'Nomads: Figures of Travel in Contemporary Art' (1997), in Alex Coles (ed.), *Site-Specificity: The Ethnographic Turn* (London: Black Dog Publishing, 2000), p. 11.

53 Jack Bankowsky, 'Slackers', *Artforum*, 30:3 (1991), 96.

54 T.J. Clark, 'At Tate Modern', *London Review of Books*, 33:4 (17 February 2011), http://www.lrb.co.uk/v33/n04/tj-clark/at-tate-modern (accessed 14 May 2015).

55 Grant Kester, 'Lessons in Futility: Francis Alÿs and the Legacy of May '68', *Third Text*, 23:4 (2009), 411.

56 *Ibid.*, 419.

57 See, for example, 'La Cour des Miracles: Francis Alÿs in conversation with Corinne Diserens, Mexico City, 25 May 2004', in Annelies Lütgens and Gijs van Tuyl (eds), *Francis Alÿs: Walking Distance from the Studio* (Wolfsburg: Kunstmuseum Wolfsburg, 2004), p. 111.

58 'Shoulder to Shoulder: A Conversation between Gerardo Mosquera, Francis Alÿs, Rafael Ortega, and Cuauhtémoc Medina' (Havana, Cuba, 5 September 2003), in Francis Alÿs and Cuauhtémoc Medina (eds), *When Faith Moves Mountains* (Madrid: Turner, 2005), p. 102.

59 *160 cm Line Tattooed on 4 People*, El Gallo Arte Contemporáneo, Salamanca, Spain, December 2000. See: http://www.tate.org.uk/art/artworks/sierra-160-cm-

line-tattooed-on-4-people-el-gallo-arte-contemporaneo-salamanca-spain-t11852/ text-summary (accessed 14 May 2015).

60 'Shoulder to Shoulder', p. 102.

61 *Ibid.*, p. 104.

62 Anon. (dir.), *Martin Creed* (London: Illuminations, 2001), 26 min.

63 Alex Coles, 'Martin Creed: A Case of the Irritating Critique?' [interview], *Documents*, 20 (Spring 2001), 32.

64 Hannah Arendt, *The Human Condition* (1958) (Chicago: University of Chicago Press, 2nd edn, 1998), p. 197. Quoted in Cuahtémoc Medina, 'Fable Power', in Russel Ferguson et al., *Francis Alÿs* (London: Phaidon, 2007), p. 106.

65 Anon. (dir.), *Martin Creed.*

66 'Denis Cooper in Conversation with Tom Friedman', in D. Cooper et al., *Tom Friedman* (London: Phaidon, 2001), p. 8.

67 Simon Critchley, *Very Little, Almost Nothing: Death, Philosophy, Literature* (1997) (London and New York: Routledge, 2nd edn, 2004), p. xvii.

68 *Ibid.*, p. xviii.

69 *Ibid.*, p. xix.

70 *Ibid.*, p. xxv.

71 *Ibid.*, p. xxiv.

72 *Ibid.*, p. xxiv.

73 *Ibid.*, p. xxv.

74 Susan Sontag, 'Walser's Voice', in Robert Walser, *Selected Stories*, trans. C. Middleton (New York: Vintage Books, 1983), p. vii.

75 *Ibid.*, p. viii.

76 Walter Benjamin and W.G. Sebald, quoted by Ben Lerner, 'Robert Walser's Disappearing Acts', *New Yorker* (3 September 2013), http://www.newyorker.com/ books/page-turner/robert-walsers-disappearing-acts (accessed 14 May 2015).

77 Robert Walser, 'Nothing at all' (1917), in *Selected Stories*, pp. 109–10.

78 John Miller, in 'Panel Discussion', in Tamara S. Evans (ed.), *Robert Walser and the Visual Arts* (New York: Graduate School and University Center, the City University of New York, 1996), p. 58.

79 See Hans-Ulrich Obrist, 'A Peripheral Museum', in *ibid.*, pp. 63–79; Hans-Ulrich Obrist, 'Museum on the Move' (1997), *Art Orbit*, 1 (March 1998), http://www. artnode.se/artorbit/issue1/index.html (accessed 15 May 2015).

80 See Ileana Parvu, 'L'Espace des chaussettes: *Socks* (1995) de Gabriel Orozco dans le projet *Migrateurs*', in Ileana Parvu (ed.), *Objets en procès: Après la dématériali-sation de l'art* (Geneva: Métispresses, 2012), pp. 103–21.

81 Obrist, 'Museum on the Move'.

82 Annelies Lütgens, 'Francis Alÿs and the Art of Walking', in Lutgens and van Tuyl (eds), *Francis Alÿs*, p. 55.

83 Medina, 'Fable Power', p. 78.

84 Lütgens, 'Francis Alÿs and the Art of Walking', p. 57.

85 Jouannais, *L'Idiotie*, p. 19.

86 Gilles Deleuze and Félix Guattari, *Kafka. Pour une littérature mineure* (1975) (Paris: Editions de Minuit, 1996).

87 Lynne Cooke, 'In the Shadow of Robert Walser', in Lynne Cooke (ed.), *A Little Ramble: In the Spirit of Robert Walser* (New York: Donald Young Gallery, 2013), p. 152.

88 'The Walk' (1917), in *Selected Stories*, p. 86.

89 'Artist's Choice', in Carlos Basualdo et al., *Thomas Hirschhorn* (London: Phaidon, 2004), pp. 112–17.

90 Thomas Hirschhorn, 'Courage: What Gives me Courage', in *Where Do I Stand? What Do I Want?*, *Art Review*, Annual 2007–08, n.p.; Birrel, 'The Headless Artist'.

91 Benjamin Buchloh, 'An Interview with Thomas Hirschhorn' (2003), in *Critical Laboratory*, p. 351.

92 Lerner, 'Robert Walser's Disappearing Acts'.

93 Giorgio Agamben, 'Warum war und ist Robert Walser so wichtig?' (2005), http://www.mikrogramme.de/e945/e935/ (accessed 15 May 2015).

94 Giorgio Agamben, *The Coming Community* (1990), trans. M. Hardt (Minneapolis: University of Minnesota Press, 1993), p. 6.

95 *Ibid.*, p. 39.

96 Michel de Certeau, *L'Invention du quotidien, vol. I: Arts de faire* (1980), ed. Luce Giard (Paris: Gallimard, 1990), p. xlvi.

97 *se débrouiller dans un réseau de forces et de représentations établies. Ibid.*, p. 35.

98 John Holloway, *Change the World without Taking Power: The Meaning of Revolution Today* (2002) (Ann Arbor: Pluto Press, 2nd edn, 2005).

99 Geoffrey Pleyers, *Alter-Globalization: Becoming Actors in a Global Age* (Cambridge and Malden, MA: Polity Press, 2010), p. 91.

100 Colectivo Situaciones, 'Through the Crisis and Beyond: Argentina', in Francesco Bonami (ed.), *Dreams and Conflicts: The Dictatorship of the Viewer: 50th International Art Exhibition [Venice Biennale]* (New York: Rizzoli, 2003), p. 246.

101 For an excellent insight into this parallel, see T.J. Demos, 'Is Another World Possible? The Politics of Utopia in Recent Exhibition Practice', in Maria Hlavajova, Simon Sheikh and Jill Winder (eds), *On Horizons: A Critical Reader in Contemporary Art* (Utrecht and Rotterdam: BAK and Post editions, 2011), pp. 52–82.

102 Molly Nesbit, Hans-Ulrich Obrist and Rirkrit Tiravanija, 'What is a Station?', *e-flux* (2003), http://www.e-flux.com/projects/utopia/about.html (accessed 15 May 2015).

103 Carlos Basualdo, 'The Structure of Survival', press release (2003), http://universes-in-universe.de/car/venezia/bien50/survival/e-press.htm (accessed 15 May 2015).

104 Carlos Basualo, 'On the Expression of the Crisis', in Bonami (ed.), *Dreams and Conflicts*, p. 243.

105 Slavoj Žižek, 'Knee Deep', *London Review of Books*, 26:7 (2 September 2004), http://www.lrb.co.uk/v26/n17/print/zize01_.html (accessed 17 May 2006).

106 Hans-Ulrich Obrist, 'A Conversation with Marjetica Potrč' (2002), in Livia Paldi (ed.), *Marjetica Potrč: Next Stop, Kiosk* (Llubjana: Llubjana Museum of Art, 2003), p. 41.

107 Marjetica Potrč, 'Five Ways to Urban Independence', in *ibid.*, p. 79.

108 Oda Projesi, 'Annex', www.odaprojesi.com (accessed 20 March 2006).

109 Marjetica Potrč, 'Urban' (2001), in Paldi (ed.), *Marjetica Potrč*, p. 31.

110 Rem Koolhaas, 'Fragments from a Lecture on Lagos', in Okwui Enwezor (ed.), *Under Siege, Four African Cities: Freetown, Johannesburg, Kinshasa, Lagos. Documenta 11, Platform 4* (Ostfildern-Ruit: Hatje Cantz, 2002), p. 177. See also Koolhaas's film *Lagos Wide and Close: An Interactive Journey into an Exploding City* (Amsterdam: Submarine, 2005).

111 Carlos Basualdo, 'A propos de l'adversité', in Carlos Basualdo (ed.), *Da Adversidade Vivemos* (Paris: Musée d'Art Moderne de la Ville de Paris, 2001), p. 13.

112 Guy Brett, 'A Radical Leap', in *Art in Latin America, The Modern Era, 1820–1980* (London: Hayward Gallery, 1989), p. 255.

113 Guy Brett, 'Border Crossings', in *Transcontinental: Nine Latin American Artists* (Birmingham: Ikon Gallery, 1990), p. 16.

114 *geste inventif et, simultanément, de résistance.* Basualdo, 'A propos de l'adversité', p. 15.

115 Lisette Lagnado, 'El Malabarista e la gambiarra', *Trópico* (2003), http://p.php.uol.com.br/tropico/html/textos/1693,1.shl (accessed 15 May 2015). I am indebted to Kiki Mazzucchelli for introducing me to this text as well as to the concept of the *gambiarra*.

116 Gabriel Orozco, 'The Everyday Altered', press release, 2003, http://universes-in-universe.de/car/venezia/bien50/cotidiano/e-press.htm (accessed 15 May 2015).

117 *Ibid.* I have amended the original 'revolutionary mornings' which appears to be an erroneous translation of the Spanish *mañanas*.

118 Jean Fisher, 'The Sleep of Wakefulness' (1993), in Yve-Alain Bois (ed.), *Gabriel Orozco* (Cambridge MA: MIT Press, 2009), pp. 21–2.

119 Francis Alÿs, 'Politics of Rehearsal', in *Francis Alÿs: BlueOrange 2004* (Cologne: Walther König, 2004), pp. 11–12.

120 'La Cour des Miracles', p. 111.

121 Patricio del Real, 'Slums do Stink: Artists, *bricolage* and Our Need for Doses of "Real" Life', *Art Journal*, 67:1 (2008), 99.

122 *Ibid.*, 85.

123 David Aradeon, 'Are We Reading Our Shanty Towns Correctly?', in Bonami (ed.), *Dreams and Conflicts*, p. 264.

124 Grant Kester, *The One and the Many: Contemporary Collaborative Art in a Global Context* (Durham, NC: Duke University Press, 2011), p. 129.

125 Superflex, quoted in *ibid.*, p. 128.

126 'La Cour des Miracles', p. 85.

127 *Ibid.*

128 Pamela M. Lee, 'Perpetual Revolution: Thomas Hirschhorn's Sense of the World', in *Forgetting the Artworld* (Cambridge, MA: MIT Press, 2012), p. 146.

129 Jeremy Brecher, Tim Costello and Brendan Smith, *Globalization from Below: The Power of Solidarity* (Cambridge, MA: South End Press, 2000), p. ix.

130 del Real, 'Slums do Stink', 85.

131 Lee, 'Perpetual Revolution', p. 146.

132 Interview with the author.

133 *La précarité s'inscrit dans un mode de domination d'un type nouveau, fondé sur l'institution d'un état généralisé et permanent d'insécurité visant à contraindre les*

travailleurs à la soumission, à l'acceptation de l'exploitation. Bourdieu, 'La pré-carité est aujourd'hui partout', p. 99.

134 Interview with the author.

135 Thomas Hirschhorn, 'Precariousness', in *Where Do I Stand?*, n.p.

136 *Ibid.*

137 Gerald Raunig, *A Thousand Machines: A Concise Philosophy of the Machine as Social Movement*, trans. A. Derieg (Los Angeles: Semiotext(e), 2010).

138 *Ibid.*, p. 87.

139 See Angela Mitropoulos, 'Precari-Us?', in John Barker et al., *Mute Precarious Reader: Texts on the Politics of Precarious Labour* (London: Mute, 2005), pp. 12–19.

140 Francis Alÿs, interview with the author, Mexico City, 23 September 2008.

141 Fisher, 'Sleep of Wakefulness', p. 25.

142 *tu dois être éveillé, sur tes gardes, ou être réceptif à des choses.* Thomas Hirschhorn, interview with the author.

143 Francis Alÿs, 'Fragments of a Conversation in Buenos Aires', in *Francis Alÿs, A Story of Deception: Patagonia 2003–2006* (Buenos Aires: Museo de Arte Latinomerico and Fundación Eduardo F. Costantini, 2006), p. 81.

144 Fisher, 'Sleep of Wakefulness', p. 28.

145 Jean Fisher, 'Toward a Metaphysics of Shit', in Okwui Enwezor (ed.), *Documenta 11, Platform 5: Exhibition Catalogue* (Ostfildern: Hatje Cantz, 2002), pp. 63–70.

146 Raunig, *A Thousand Machines*, pp. 71–2.

147 *Ibid.*, p. 71.

148 Brian Holmes, 'Do-It-Yourself Geopolitics: Cartographies of Art in the World', in Gregory Sholette and Blake Stimson (eds), *Collectivism after Modernism: The Art of Social Imagination after 1945* (Minneapolis: University of Minnesota Press, 2007), p. 288.

149 Pleyers, *Alter-Globalization*, p. 50.

150 Žižek, 'Knee Deep'.

151 Raunig, *A Thousand Machines*, pp. 80–2.

152 See, for example, Isabell Lorey, 'Governmentality and Self-Precarization: On thc Normalization of Cultural Producers', *transversal*, 11 (2006), special issue on 'Machines and subjectivity', http://eipcp.net/transversal/1106/lorey/en (accessed 15 May 2015).

153 Sophie Loidolt, 'The Understanding Heart and Expanded Judgment, in the Eyes of Hannah Arendt', in Peter Pakesch and Adam Budak (eds) *Human Condition: Empathy and Emancipation in Precarious Times* (Graz and Cologne: Kunsthaus Graz and Walther König, 2010), p. 199.

154 *une empathie, sympathie, une complicité naturelle, de donnant donnant, de renvoi de balle constant.* Alÿs, interview with the author.

155 Benjamin Buchloh, 'Thomas Hirschhorn: Lay Out Sculpture and Display Diagrams', in Basualdo et al., *Thomas Hirschhorn*, p. 46.

156 Foster, 'Towards a Grammar of Emergency', p. 164. He is citing Raunig, *A Thousand Machines*, p. 78.

157 Colectivo Situaciones, 'Through the Crisis and Beyond', p. 245.

158 Pleyers, *Alter-Globalization*, p. 50.

159 Bauman, *Liquid Modernity*, p. 14.

160 Carlos Basualdo and Reinaldo Laddaga, 'Rules of Engagement: Art and Experi-mental Communities', *Artforum*, 42:7 (2004), http://www.thefreelibrary.com/Rules+of+engagement%3a+from+toilets+in+Caracas+to+new+media+in+new...-a0114594243 (accessed 15 May 2015).

161 Reinaldo Laddaga, 'Almost Brothers', *Flash Art*, 38:243 (2005), 112.

162 'Walking the Line: Francis Alÿs interviewed by Anna Dezeuze', *Art Monthly*, 323 (February 2009), 4.

163 Maria Lind, 'Actualisation of Space' (2004), quoted in Claire Bishop, *Artificial Hells: Participatory Art and the Politics of Spectatorship* (London: Verso, 2012), p. 21.

164 See Kester, *The One and the Many*, ch. 1.

165 Kester, 'Lessons in Futility', 420.

166 For examples of such practices, see, for example, Kester, *The One and the Many*, and Katarzyna Kosmala and Miguel Imas (eds), *Precarious Spaces: The Arts, Social and Organizational Change* (Bristol: Intellect Books, forthcoming).

167 Jean Fisher, 'In the Spirit of Conviviality: When Faith Moves Mountains', in Ferguson et al., *Francis Alÿs*, p. 119.

168 'Conversation: Presupposition of the equality of intelligence and love of the infinitude of thought: an electronic conversation between Thomas Hirschhorn and Jacques Rancière' (2009–10), in *Critical Laboratory*, p. 375.

169 Medina, 'Fable Power', p. 106. The quote by Arendt cited by Medina is from *The Human Condition*, p. 198.

170 Loidolt, 'The Understanding Heart', p. 203.

171 Arendt, *Human Condition*, p. 183.

172 Coupland, *Generation X*, p. 10.

173 Fisher, 'In the Spirit of Conviviality', p. 119.

174 Francis Alÿs, quoted in Mark Godfrey, 'Politics/Poetics: The Work of Francis Alÿs', in Klaus Biesenbach, Mark Godfrey and Kerry Greenberg (eds), *Francis Alÿs* (London: Tate, 2010), p. 9.

175 'Russel Ferguson in Conversation with Francis Alÿs', in Ferguson et al., *Francis Alÿs*, p. 40.

176 Fulvia Carnevale and John Kelsey, 'Art of the Possible: An Interview with Jacques Rancière', *Artforum*, 45:7 (2007), http://www.egs.edu/faculty/jacques-ranciere/articles/art-of-the-possible/ (accessed 15 May 2015).

177 Rancière, *Aesthetics and its Discontents* (2004), cited in Godfrey, 'Politics/Poetics', p. 24.

178 Godfrey, 'Politics/Poetics', p. 25.

179 T.J. Demos, 'Vanishing Mediator', in Biesenbach, Godfrey and Greenberg (eds), *Francis Alÿs*, p. 179.

180 Beth Hinderliter, Vered Maimon, Jaleh Mansoor and Seth McCormick, *Communities of Sense: Rethinking Aesthetics and Politics* (Durham, NC: Duke University Press, 2009), p. 2.

181 Rancière, cited in *ibid.*, p. 9.

182 *Ibid.*

183 Arendt, *Human Condition*, p. 209.

184 Rancière, cited in Hinderliter et al., *Communities of Sense*, p. 9.

185 Vered Maimon, 'The Third Citizen: On Models of Criticality in Contemporary Artistic Practices', *October*, 129 (Summer 2009), 101.

186 Carrie Lambert-Beatty, 'Make-believe: Parafiction and Plausibility', *October*, 129 (Summer 2009), 51–84.

187 *Le réel doit être fictionné pour être pensé.* Jacques Rancière, *Le Partage du sensible: Esthétique et politique* (Paris: La Fabrique Editions, 2000), p. 61. This quote is translated and discussed in Corinne Diserens, 'Borders and Subway Exits', in Alÿs and Medina (eds), *When Faith Moves Mountains*, p. 160.

188 *La politique et l'art construisent des 'fictions', c'est-à-dire des réagencements matériels des signes et des images, des rapports entre ce qu'on voit et ce qu'on dit, entre ce qu'on fait et ce qu'on peut faire.* Jacques Rancière, 'Le Partage du sensible: Interview', *Multitude* (2007), http://www.egs.edu/faculty/jacques-ranciere/articles/le-partage-du-sensible-interview/ (accessed 15 May 2015).

189 Maimon, 'The Third Citizen', p. 101.

190 George Yúdice, 'Marginality and the Ethics of Survival', *Social Text*, 21 (1989), 216.

191 Brett Neilson and Ned Rossiter, 'Precarity as a Political Concept, or, Fordism as Exception', *Theory, Culture & Society*, 25:7–8 (2008), 65.

192 *Ibid.*, 59.

193 Meyer, 'Nomads', p. 11.

194 Demos, 'Vanishing Mediator', p. 179.

195 T.J. Demos, 'The Ends of Exile: Toward a Coming Universality', in Nicolas Bourriaud (ed.), *Altermodern: The Tate Triennial* (London: Tate, 2009), n.p.

196 Demos quotes Agamben's essay 'Beyond Human Rights', from *Means without End: Notes on Politics* (1996), trans. V. Binetti and C. Casarino (Minneapolis: University of Minnesota Press, 2000). Anthony Downey uses Agamben's term as the title for his discussion of contemporary art practices: 'Zones of Indistinction: Giorgio Agamben's "Bare Life" and the Politics of Aesthetics', *Third Text*, 23:2 (2009), 109–25.

197 Giorgio Agamben, *Homo Sacer: Sovereign Power and Bare Life* (1995), trans. D. Heller-Roazen (Stanford, CA: Stanford University Press, 1998), p. 55.

198 Agamben, 'In this exile (Italian diary, 1992–94)', in *Means without End: Notes on Politics*, p. 138.

199 Agamben, *Homo Sacer*, p. 12.

200 Demos, 'Vanishing Mediator', p. 178.

201 *Ibid.*, p. 179.

202 *Ibid.*

203 Demos, 'The Ends of Exile', n.p.

204 Downey, 'Zones of Indistinction', p. 121.

205 Godfrey, 'Politics/Poetics', p. 26.

206 *Ibid.*, p. 27.

207 *Ibid.*

208 *Ibid.*

209 Judith Butler, *Precarious Life: The Powers of Mourning and Violence* (New York and London: Verso, 2004).

210 *Ibid.*, p. 130.

211 *Ibid.*, p. 134.

212 *Ibid.*, p. 151.

213 Judith Butler, 'Post Two', in Jasbir Puar, Lauren Berlant, Judith Butler, Bojana Cvejic, Isabell Lorey and Ana Vujanovic, 'Precarity Talk: A Virtual Roundtable', *The Drama Review*, 56:4 (2012), 169.

214 *Ibid.*, 170.

215 *Ibid.*, 169.

216 James Phillips, 'Agamben's Limbos: Robert Walser and the Refugee', *Textual Practice*, 28:2 (2014), 290.

217 *Ibid.*, 298.

218 *Ibid.*, 296.

219 *Ibid.*, 296.

Postscript: on the humanism of precarious works

Against 'de-humanising' abstractions

Concrete, here and now, everyday, relative, immanent: the vocabulary that describes the precarious works in this study outlines a specific field of experience. This is a field on a human scale – unspectacular, unmonumental, as fragile as our relations and as finite as our brief lives. It is the space of the human condition, variously described by Hannah Arendt, Jacques Rancière, Giorgio Agamben, Maurice Blanchot and Michel de Certeau, but also D.T. Suzuki and Robert Walser, as well as sociologists from David Riesman to Zygmunt Bauman – to cite but some of the authors who have accompanied us on this journey. This is also a field concerned with living – biologically, through our labouring bodies, but also artistically and politically, through an 'art of living' that seeks a balance between imagination and creation, between work, labour and action. This humanist approach, as we saw, was conceived as a response to the alienating developments of capitalism from the late 1950s to the first decade of the twenty-first century. By emphasising the concrete, the experiential and the vulnerable, precarious works in the 1960s and in the 1990s sought to resist the ever-increasing abstraction of global, immaterial flows of information and capital that distorted human relations to the world, to their activities and to each other.

As we have seen, the 'almost nothing' that I introduced at the beginning of this book has taken on various forms: the production of nothing of value (works made out of waste, as well as 'badly made' or 'not-made' projects, to use Robert Filliou's terms); a yearning to be 'nothing special' (the Zen expression applicable to different kinds of borderline art that threaten to disappear into everyday life); the desire to do nothing (to waste time and effort); a choice to be a good-for-nothing (and to refuse the very notion of success). Turning this set of dismissive terms into positive values, precarious artworks retrieve the castoffs of a capitalism that seeks to homogenise the world of things and experience, transforming objects into signs, humans into highly efficient performers, from the 1950s 'organisation man' to the virtuoso of immaterial labour. In the 1960s, artists adopted the countercultural attitude

of the 'good-for-nothing' – by deliberately failing to produce anything, and by sometimes identifying with those who own nothing. They dropped out of the cycle of production and consumption, adopting marginal positions in order to evolve new combinations of art, play and action. As these marginal spaces shrank in the 1990s, artists sought to infiltrate, with their precarious works, the smooth workings of the global capitalist machine, like a grain of sand that would cause a slight friction, slow down or even clog up the circulation of signs, value and immaterial labour. Precarious practices have thus repeatedly proposed alternatives, however fleeting and minute, to the abstract and homogenising logic of capitalism. They have also evaded modern forms of melancholy or despair, apathy, nihilism or cynicism. Together, the precarious practices studied in this book map out a fragmented, dispersed and mobile geography that exists on the borderline between appearance and disappearance. This map turned out to be a constellation of encounters and joins, as well intervals, limbos and moments that may become opportunities.

Kairos, as I have suggested, is one of the names for this kind of opportunity that must be seized in the instant – this study has expanded on its central role. As we have seen, it is the weak who make the most of the *kairos*, as they mobilise the wealth of their collective material intelligence and the multiplicity of their tactical ruses. In this way, the fundamental instability and uncertainty of the precarious is turned into a set of cultural, social and political forces that can subvert the given order of capitalism from within. As capitalism has colonised every sphere of our existence, and there is no more distinction between outside and inside, *zoe* and *bios*, or labour and action, the *kairos* appears as the last potential site of a rupture. Rather than a simple reversal of binary values, however, the *kairos* promises to open up a breach, a fissure – a 'breathing' space, as Rancière put it, in which the given order can be disturbed and rearranged differently.[1]

Furthermore, Antonio Negri's take on the *kairos*, mentioned in Chapter 4, emphasised its 'vacillating' nature and the 'restless state' that it appeals to.[2] Such terms bring to my mind not only the teetering 'borderline' status of precarious works, but also the 'restlessness' singled out by Vassilis Tsianos and Dimitris Papadopoulos as a key characteristic of 'the embodied experience of precarity' (alongside 'vulnerability', 'unsettledness' and 'affective exhaustion', among others).[3] Similarly, as we saw in the introduction, Lauren Berlant spoke of our precarious attempts to 'maintain footing, bearings, a way of being, and new modes of composure amid unraveling institutions and social relations of reciprocity'.[4]

Learning how to do nothing and 'nothing special', how to truly pay attention to the details of the world and how to 'join' in its 'dance' (as Kaprow termed it): such are the skills, as we have seen, that are required to capture

the minute, quasi-imperceptible *kairos*. Indeed, the very qualities of the elusive, evasive, intangible, transient, fleeting *je-ne-sais-quoi*, which have peppered my descriptions of precarious practices, are also those of the *kairos*. Consequently, they remain as difficult to pin down as the *kairos* itself. In fact, the *mètis*, this 'material intelligence' which knows how to seize the *kairos*, evaded theorisation by Greek philosophers precisely because it dealt with particulars rather than general truths. According to Jankélévitch, whose reflections on *Le Je-ne-sais-quoi et le presque rien* I mentioned in this book's introduction, such particulars radically challenge the very language and function of philosophy. Similarly, Blanchot and Certeau could only acknowledge that the everyday's very nature eluded any scientific study.

Such difficulties may account for the ultimately narrow body of artworks that I have examined in this study, in my search to provide a specific vocabulary of terms and issues with which to understand precarious practices. Nonetheless, I would be ready to follow Hal Foster in envisaging different 'registers' of precarious artworks, of which the trajectory outlined in this book may be only one.[5] Using Foster's taxonomy, I would conclude that this study has tended towards 'poetic' forms of precariousness exemplified, according to him, by the work of Gabriel Orozco, though the dynamics between poetry, performance and action take different forms in the practice of Hirschhorn, Creed or Alÿs. Despite these differences, the 'register' of precariousness mobilised by these four artists remains clearly distinct from Mike Kelley's 'outlandish', Mark Wallinger's 'mournful' or Isa Genzken's 'desperate' variations, which I discussed in relation to the 'pathetic' (in the case of Kelley and Wallinger) and the 'unmonumental' (in Genzken's work). Equally, I would gladly invite future studies to focus on other precisely delineated fields of terms associated with the precarious. To complement Thierry Davila's study of the infra-thin, or Jean-Yves Jouannais's survey of idiocy, new research could address the qualities of the 'forlorn', the 'sloppy' or the 'trifling', as well as trace a history of 'silliness', or 'boredom', in modern and contemporary art…

Returning to the *kairos*, I would like to pick up on an analogy noted by Roland Barthes in his course on *Le Neutre*.[6] The affinity perceived by Barthes between the *kairos* and the Zen moment of enlightenment (the *satori*) may shed light on some of the recurrent connections that have emerged in this study between precarious works and Zen philosophy as it was popularised in the West. While the influence of Zen Buddhism on twentieth-century art has been studied very effectively by art historians and curators such as Jacquelynn Baas and Alexandra Munroe, I have focused on one specific strand of this reception: the invitation, by Zen philosophers, to pay particular attention to the everyday, the ordinary and the concrete.[7] Like the *kairos*, this set of Zen-inflected concerns has helped me establish crucial oppositions with which to describe the features of precarious works: precarious works, as we have seen,

privilege the immanent rather than the transcendental, the fragment rather than the system, the instant rather than eternity, the material rather than the intellectual, the matter-of-fact rather than the spiritual, becoming rather than being. In their 'restless', 'vacillating' borderline state, I would argue, precarious works constantly oscillate between the two terms of each of these oppositions – by inverting and subverting them as much as by blurring and rearranging them.

In his in-depth comparison of concepts of 'efficacy' in 'Western' and 'Eastern' philosophies, François Jullien compared the European legacy of the ancient Greek *kairos* to ancient Chinese philosophy.[8] Like Marcel Detienne and Jean-Pierre Vernant, whose study of the Greek *mètis* drew on mythology as well as fishing manuals, Jullien's summary of this ancient Chinese 'thought' is compiled from manuals of war, politics and diplomacy which the author read alongside Lao Tzu's Taoist texts. Since key Taoist notions were integrated into the version of Zen Buddhism popularised in the West by authors such as Alan Watts and D.T. Suzuki, and since I have demonstrated that precarious practices have repeatedly engaged with definitions of 'efficacy' and 'efficiency', Jullien's book is particularly relevant to my study. While Jullien acknowledged that the logic of the *kairos* and that of Chinese approaches to 'efficacy' appear to share similar features, he highlighted crucial differences between these Western and Eastern perspectives. According to Jullien, the *kairos* – as it has been studied from ancient Greece to Jankélévitch's more recent account – has always remained tied to a Western individualist model of decisive action, which serves to affirm the hero's control over nature and his fate. In contrast, in the Chinese thought analysed by Jullien, the individual is invited to disappear into the natural course of events, intervening at the opportune moment only as discreetly as possible, by following a process from its nearly imperceptible beginnings to its inevitable conclusion. Rather than an opposition between *kairos* and its rational, controllable counterpart, *kronos*, Chinese philosophy considers time as a course that one should neither try to study scientifically nor dismiss, as in the West, as simply governed by fate or contingency. This course of time and events must be embraced fully, according to Jullien, in order to detect its infinitesimal variations and submit to its potential transformations.

Jullien's comparison, which I will not develop further here, points to one of the fundamental ambiguities at the heart of the precarious practices discussed in this book. On the one hand, I have suggested that such practices, inspired directly by Zen philosophy in some cases, sought to approximate states of *wu-wei*, doing nothing. They tried to merge with the everyday, to be attuned to its most minute detail, in a constant give-and-take with the materiality of the world, to the point of imitating nature in its aimlessness and casualness, thus challenging any form of heroism. This attitude allowed precarious

practices to propose anti-spectacular, anti-monumental forms, and to explore modes of being and living built on reciprocal relations of dependency that challenged Western definitions of selfhood fundamental to neoliberalism. On the other hand, Arendt's celebration of action, which remains a fundamentally Western concept according to Jullien, has also served as a key landmark in this study, as I have tried to define the politics of the precarious work within a web of interpersonal relationships coming together, through conviviality, storytelling and disagreement, within a common space of appearance. Following on from Jullien's study, then, I would like to suggest that precarious practices exist in an intermediate space between Eastern and Western models of thought and contradictory definitions of 'efficacy'. It is within this ambivalent space that different forms and emphases may be further discerned among precarious works, by analysing their respective relations to nature, the everyday and the 'given', and their involvement in maintaining the shrinking 'space of appearance' of political action.

In Chapter 1, for example, I teased out such distinctions within the practice and reception of junk practices, by opposing artists who sought to organise found materials (whether Jean Follett, Richard Stankiewicz or John Chamberlain) to those who let the obdurate grittiness of individual elements come through and disrupt such semantic and aesthetic order (including Rauschenberg and Oldenburg). Within the latter, more precarious category, I argued that Kaprow and Conner went one step further by proposing forms that suggest natural flows – of change and contamination respectively. By putting pressure on the very limits of the artwork as a self-contained material object, such practices introduced the possibility of action and performance into the cycle of production and consumption embodied by junk art. Similarly, a tendency towards the 'disintegration of form' discussed in Chapter 2 led to new forms of 'borderline' art (as Brecht called it) or 'art without art' (in Lygia Clark's words), thus further blurring the distinction between being and becoming, in art as in life. Such 'interfaces' (as Lawrence Alloway would later describe them) between art and the everyday further dissolved with the various practices discussed in Chapter 3, where apparently banal experiences – such as eating a meal, drinking beer, fishing, hanging out and chatting – became the material and subject matter of a range of works. These precarious practices, I argued, proposed nothing less than an art of living, sometimes accompanied by calls for revolutionary action, or at the very least the disappearance of art-making as a specialised and professionalised category of everyday experience. The deskilling of sculpture, started with junk assemblage in the early 1960s and pursued by artists such as Filliou and Nauman later in the decade, participated in this wider agenda. All these different practices were thus united in their shared desire to contradict the kind of goal-oriented order of efficiency singled out by Jullien in Western

thought – which coincided precisely with the model of profit-driven capital-
ism and an increasingly organised society.

Like their 1960s precursors, the 1990s practices discussed in Part II
embraced what Jullien described as a Chinese rejection of the capitalist
means-end logic, as they attempted to slow down, deviate or disturb its
operations. This may partly explain why, as we saw in Chapter 5, precarious
practices by Orozco, Creed, Alÿs and Hirschhorn shunned virtuoso forms
of assemblage such as Tom Friedman's as much as they kept their distance
from solution-driven political projects by Marjetica Potrč, Oda Projesi and
Superflex. This may also be a reason why, unlike the immaterial practices of
the artists-as-'semionauts' discussed by Nicolas Bourriaud, or the 'super-flat'
practices of Takashi Murakami analysed by Pamela Lee, contemporary pre-
carious practices sought to interrupt and weigh down the flows of ever more
buoyant capital. 'Images of water' constitute the focus of one of Jullien's chap-
ters: in Chinese philosophies of 'efficacy', such images suggest suppleness and
adaptability, strength as well as weakness – liquidity rather than fluidity, as I
suggested in Chapter 4.

Among the precarious works by the four artists whom I have selected,
and within each of their specific practices, there also exist, of course, impor-
tant variations – between the personal and the collective (as in Alÿs's or
Hirschhorn's works), but also in terms of their singular positions and sensi-
bilities. Within the shared field of precariousness that I have outlined, I have
dwelt on similarities rather than differences. Nevertheless, a closer compari-
son would bring out the differences between Creed's near-paralysing rejec-
tion of all forms of hierarchy, which may have been inflected by his Quaker
upbringing, and Orozco's deliberately 'vulnerable' position, chosen in reac-
tion to both the heroism of Mexican muralist painting and a global art market
dominated by European and North American artists. Similarly, Hirschhorn's
sometimes 'fanatical' desire – as the artist himself described it – to reach a
'non-exclusive' audience may appear at odds with Alÿs's embrace of what he
saw as Mexican strategies of 'compromise', even if the effects of these differ-
ent drives, as we saw, sometimes converge. Indeed, one may wonder whether
the Mexican *valemadrismo* discussed by Alÿs, like the Brazilian *gambiarra*
celebrated by Oiticica and Orozco, or the trickster figure embodied by Jimmie
Durham (according to Jean Fisher), comes closer to the Occidental *kairos* of
the ancient Greek *mètis* and the Baroque 'manner' discussed by Jankélévitch,
or to the Oriental instant that must be seized in its flow… Similarly, Barthes's
hypothesis that John Cage may be one of the 'rare' occidental figures to truly
practise *wu-wei* – the Zen practice of 'not doing', 'not striving' – may partly
explain why the Cagean students Brecht and Kaprow have turned out to play
such pivotal roles in my study.[9] I would even go so far as to argue that these
two artists went one step further than Cage's experiments, in that they sought

to subject their work to the 'corrosive forces' of the everyday (as Blanchot called them)[10] in more direct and radical ways, which would be subsequently taken up and pursued by artists such as Orozco, Alÿs, Hirschhorn and Creed.

The trouble with humanism

However much they flirt with anonymity and imperceptibility, precarious practices nevertheless remain strongly tied to the humanist perspective singled out by Jullien. Arendt's humanism was in fact directly inspired by the model of the Athenian *polis* where action and politics were intrinsically linked to thought. Indeed, the image of the public *agora*, where action and discussion can take place freely, remains present in participatory 'activities' by Kaprow as well as Alÿs's works on the Zócalo or Hirschhorn's public *Monuments*. The balance between action, labour and work that constituted Arendt's ideal was premised on the structure of the Athenian *polis* which distinguished between the citizens who could engage in thought and action on the one hand, and those who were deprived of citizenship on the other. In addition to barbarians and foreigners, non-citizens included all those individuals engaged in sustaining, through labour, the male citizens' biological existence: women and slaves.

Just as Arendt's implicit gendering of the work/labour/action distinctions was criticised by some feminists in the 1970s and 1980s as sustaining a hegemonic hierarchy between female domestic labour and male public action,[11] the feminist perspective on labour does not appear to have had a direct impact on the mostly male artists who explored the relation between work, labour and leisure at the time (as we saw in Chapter 3). In an unpublished conversation with Allan Kaprow in 1981, his former student Suzanne Lacy recalled an incident at CalArts, where he had organised an 'activity' that involved some sweeping – a recurrent motif in his work, as we saw in Chapter 3. During the performance, as Lacy remembered, feminist artist Faith Wilding apparently shouted out from the audience something along the lines of: 'It's not art if you're a housewife.'[12] Neither, I would add, is it play or poetry, as Kaprow's 'useless work' sought to suggest. For a woman artist, as Helen Molesworth has pointed out, 'it is difficult for the necessary tasks of housework to be rendered parodically as useless or noncommodifiable labor'.[13] No one can deny that the endless repetition of household chores is considerably less amusing or poetic when it constitutes the drudgery of domestic life.

For Molesworth, this gendered perspective at least partly explains why women artists in the 1970s often adopted a different approach to the relations between work and labour from their male Minimalist and conceptual counterparts, as they often drew from their own everyday experiences of their labour as mothers and housewives. Thus, for example, Martha Rosler's 1974

super-8 film *Backyard Economy*, which shows the artist performing every-day tasks such as hanging up the laundry or watering the plants, blurred the distinction between art and everyday life – in the same vein as the precarious works of Kaprow, for example – while also drawing 'attention to the status of women's unpaid labor in the marketplace', according to Molesworth.[14] In this sense, Rosler's film differed from 'good-for-nothing' practices discussed in Chapter 3, whether Bruce Nauman's idle pacing around his studio or Tom Marioni's *The Act of Drinking Beer with Friends is the Highest Form of Art*. Instead, it came closer to the 'Maintenance' performances held in the living room of Womanhouse, the artist-run space in which Faith Wilding was involved among other female artists in Los Angeles in 1972. Such performances involved a woman ironing a sheet and other performers scrubbing the floor. Similarly, Mierle Laderman Ukeles documented, between 1970 and 1973, her activities as a mother and wife in her *Private Performances of Personal Maintenance as Art*. Meanwhile, in their 1973–75 *Women and Work*, Margaret Harrison, Kay Hunt and Mary Kelly collected daily schedules from female workers in a South London factory in order to address 'the division of labour in industry' by revealing, among other elements, the way in which women had to juggle factory work and labour at home.

Confronted by Lacy, Kaprow conceded that, unlike women, men tended to 'universalize and heroize' the alienation of modern life by turning such experiences 'into great causes and philosophical issues'.[15] Although he became more conscious of this 'generalizing' tendency after his encounters with feminism, Kaprow admitted that he could not make work that directly addressed social and political issues such as those explored in Lacy's work. The precarious works discussed in this study have all, as we have seen, similarly eschewed the explicitly activist practices developed by artists such as Lacy. More generally, Kaprow's avowed inclination to 'universalize' (if not to 'heroize'), which frequently goes hand in hand with the Arendtian humanism of precarious works, points to an asymmetrical gendering of precariousness and the everyday. Significantly, as Shannon Jackson has underlined, the sweeping and vacuuming 'tasks' proposed by Allan Kaprow as well as choreographers such as Steve Paxton and Robert Dunn 'changed when a female body executed them', such as that of dancer Lucinda Childs (in the 1966 *Vehicle*).[16] As Jackson suggests, this would explain why Jill Johnston's use of household objects including a broom and a vacuum cleaner in her performance of Cage's 1960 *Music Walk for Dancer* met with the composer's disapproval. When women artists, rather than men, performed such everyday tasks, their works were received differently: rather than experiments in form and process, they were immediately cast as content-driven explorations of body and identity politics, as feminist interrogations of labour division, and critiques of the hierarchy between work, labour and action.

In this context, Shannon Jackson, like Jill Johnston, believes that Alison Knowles's *Proposition* to 'make a salad', which I discussed in Chapter 3, takes on particular significance because it was conceived by a woman;[17] indeed, I also pointed out that Knowles's relation to work was different from that of some of her Fluxus counterparts. Nevertheless, I would argue that the fact that works such as *Proposition* and *Identical Lunch* took on the form of texts, and that they could be performed by men as well as by Knowles herself, allowed them to be received more easily within a male-dominated 'universalising' perspective on art/life dynamics. Unlike Ukeles or the Womanhouse performers, for example, Knowles herself resisted being identified as a feminist. (While the important role of the event score may account for the remarkable number of women artists in Fluxus, those performances that foregrounded the female body were not welcomed by all their male counterparts.)[18]

As Jackson has demonstrated in her admirable study of Ukeles's work, this artist's performances of domestic tasks such as washing the steps of the Wadsworth Museum (*Hartford Wash: Washing Tracks, Maintenance Outside*, 1973) articulated the 'art/life binary' in a different way from male conceptual artists by revealing the 'invisible systems and labor' on which the smooth running of the artwork and art institution – like the household – depends.[19] When Ukeles cleaned the Wadsworth Museum, she also exposed the fact that poor, often non-white men and women would normally be performing such labour – in the same way as the Athenian *polis*, in Arendt's account, was dependent on the invisible labour of slaves and women. In her 1969 'Maintenance Art Manifesto', Ukeles contrasted the avant-garde celebration of creation, originality, innovation, change and progress with the maintenance activities traditionally associated with labour in the Arendtian sense: all the domestic activities that serve to 'keep the dust off', 'preserve the new; sustain the change; protect progress'.[20]

Among the 'universal' figures of precariousness that have emerged from the practices discussed in this book, the 'good-for-nothing' is an interesting case study by which to consider what Jackson has termed the 'disavowal of support' required for the freedom of a hegemonic class of individuals.[21] In light of Jackson's analysis, it is no coincidence that women are largely absent from the 2006 *History of Loafers, Loungers, Slackers and Bums in America*, as its author Tom Lutz acknowledged himself.[22] In his account, Lutz dwelt briefly on the case of Beat writer Joyce Johnson, for example, who worked as a secretary as she put up Kerouac in her apartment while he was busy writing. Apparently, Kerouac had the nerve to remark to Johnson: 'If I had to go and apply for jobs like you, they'd have to drag me into Bellevue in two days. That's why I am and always will be a bum, a dharma bum, a rucksack wanderer.'[23] Behind many 'rucksack wanderers', it turns out, were working mothers and companions. In many cases, the chosen idleness and 'uselessness' of

the slacker or good-for-nothing were dependent on the work and labour of others.[24] If one of the rucksack wanderer's counterparts can be found in the figure of the refugee, as we saw in Chapter 5, they also include those who cannot move at all because, like many housewives, they are tied to a location because they need to care for their children, or, in the case of undocumented workers, because they need to hide.

Such questions raised by the precarious practices in this study reflect more general debates concerning precarity as they emerged at the turn of the twenty-first century. As Angela Mitropoulos explained, the 'experience of regular, full-time, long-term employment', like the distinction between work and leisure, was not only revealed to be 'an exception in capitalist history', but it had also 'presupposed vast amounts of unpaid domestic labour by women and hyper-exploited labour in the colonies'.[25] And just as calls for a united global 'precariat' were accused of ignoring this history and smoothing over such dramatically different experiences, some may reproach precarious practices for their deliberately naïve desire to forge symbolic alliances between the artist and those living precariously, irrespective of their differences. In order to avoid pursuing a 'well-meaning but empty humanism', warned Tavia Nyong'o in 2013, those interested in developing 'new solidarities based' on the 'shared vulnerabilities' of 'precarious life' 'must remain scrupulously attentive to the constitutive and uneven distribution of that vulnerability'.[26]

Just as Shannon Jackson has successfully brought 'maintenance' practices such as Ukeles's to bear on a broader history of contemporary performance and installation art, this present study would have much to gain from being complemented by research on other artists who have been more directly affected by precarity in their everyday experience, whether women artists such as Ukeles and Rosler or an illegal immigrant like Tehching Hsieh.[27] One could also imagine a fruitful comparison between the 'junk' aesthetic discussed by Joshua Shannon in the context of early 1960s New York (which I analysed in Chapter 1) and the assemblages constructed by African-American artist Noah Purifoy with the burnt debris from the riots that took place in his Los Angeles neighbourhood of Watts in 1965. Following Purifoy, a significant contribution to Californian 'junk' and 'funk' aesthetics was made by a group of African-American assemblagists, from which emerged David Hammons, whose work I mentioned in Chapter 5. The related question of deskilling, which runs through the precarious works of Nauman, Filliou and Hirschhorn, would similarly take on new meanings when considered from the vantage point of artists engaging in reworking 'skills' traditionally associated with women, such as knitting or sewing, or folk art traditions marginal to canons of 'high' art. Orozco was certainly not the only artist to integrate references to indigenous culture – Mexican traditions in his case – in order

to complicate such divisions. As we saw in Chapter 6, Brazilian artist Hélio Oiticica's 1967 call to live 'on adversity', and to turn the weaknesses of his developing country into strengths, became a reference point as the global art market became more receptive to contemporary practices outside of Europe and North America at the turn of the twenty-first century. A more general study of precarious practices in Latin America, as well as a survey of such practices on other continents, could also be envisaged in order to tease out the significance and tactical value of this term in such different contexts.

Certainly, then, one should not forget, as Lauren Berlant reminds us, that 'the economic and political processes' responsible for precarity vary 'according to locale, gender, race, histories of class and political privilege'. Taking this into account does not, for all that, lead Berlant to reject the possibility of imagining that these different constituencies can come together within the general idea of the 'precariat'. Rather, Berlant proposes that the 'precariat' be defined less as a social than 'a fundamentally affective' 'class'.[28] Her excellent study develops concepts in order to describe this affective experience of precariousness, including the image of the 'impasse'. This impasse, I would suggest, relates in a number of ways to the shrinking space of appearance to which some precarious works appeared to respond, as I demonstrated in this book. In the first place, Berlant conceived the impasse as 'a stretch of time in which … the activity of living demands' two states of being, akin to the forms of attention set up by precarious works: 'both a wandering absorptive awareness', on the one hand, and on the other hand 'a hypervigilance that collects material that might help to clarify things, maintain one's sea legs'.[29] Secondly, the precarious work's frequent blurring of the borderline between art and everyday, form and formlessness, recalls Berlant's description of the impasse as 'a middle without boundaries, edges, a shape', as '[i]t is experienced in transitions and transactions'.[30] Thirdly, the feelings of inertia and 'impotence' that I related to some precarious works by Martin Creed and Francis Alÿs seem to operate in the same way as the 'portrayal of immobility' as a 'living paralysis' and 'playful repetition' which, according to Berlant, 'has become a convention of representing the impasse' in the 1990s 'cinema of precarity' that she discusses.[31] In fact, as she demonstrates, this 'cinema of precarity' deals specifically with the experience of living in an 'impasse'.

In her analyses of films by the Dardennes brothers and Laurent Cantet, Berlant focuses mainly on the way '[p]eople are destroyed' and 'discouraged' in this impasse, and how they try 'maintaining … things' despite the difficulties that they encounter. She acknowledges, however, that 'playful and enthralled' modes of making do with the 'impasse' of precariousness may also be possible.[32] The precarious practices that I have discussed in this study certainly fall into this latter category, and I would suggest that their playful lightness is what sets them most clearly apart from other precarious practices.

As we have seen, they tend to perform a specific mode of affective address that is 'enthralled' – rather than melancholy like Mike Kelley's plush toys or Mark Wallinger's *State Britain*, or angry like Edward Kienholz's or Santiago Sierra's works.

How one occupies the affective 'impasse' of precariousness undoubtedly depends on whether it is possible to escape it. The introduction of humorous and poetic 'breathing' spaces and intervals between art and reality does not operate in the same way for artists who have the luxury of taking a distance from the direct impact of lived precarity in their everyday experience, and for those who can afford this less easily in the face of sexism, racism or poverty. In the precarious practices discussed in this book, the experience of precariousness is mediated via symbolic or metaphorical alliances with the vulnerable and the weak. In this way, such works plumb a shared affective precariousness in an optimistic, if not celebratory, mode. The artists in this study thus choose to occupy an ambiguous 'limbo' between the passing *flâneur* and the refugee outcast, as we saw in Chapter 5; they take on the slippery role of the 'jester', the 'trickster', the 'acrobat' or the 'vanishing mediator'. Sometimes they join in the 'dance', sometimes they step aside, disappearing as mysteriously as they appeared.

This ambivalence is also embodied in the 'borderline' status of the precarious artwork. Hovering on the boundary between autonomous art and the formless everyday, between something and nothing, such borderline practices have nevertheless managed to remain art-like enough to be exhibited and exchanged in the art world. (Whereas artists in the 1960s often had to invent new ways of displaying and distributing their works, as well as earning a living, by the time Hirschhorn, Alÿs, Creed and Orozco started working in the 1990s, a market for the 'almost nothing' was in place.) At the same time, however, such works question the very conditions through which the art object is given both value and form in a public sphere where fixed oppositions and categories are open to discussion, revision and transformation.

Thus, while the artists' aspiration to produce 'universal' works failed to tackle the gender and racial inequalities at play in precarity, I would like to argue that their practices nevertheless embody networks of 'mutual dependence' as Shannon Jackson termed them.[33] In particular, as we saw, they require a 'hypervigilant' attention attuned to the details of singular lived experience, thus making themselves vulnerable to change, uncertainty and instability. To rehearse Nyong'o's formula, I would suggest that the precarious works discussed in this study materialise one kind of 'borderline' affective experience that manages to point to 'shared vulnerabilities', while also avoiding the pitfalls of an 'empty' humanism, by contributing to a more general awareness of the 'constitutive and uneven distribution' of precarity. This is achieved precisely by inviting comparisons with other precarious practices

and experiences – whether that of precarious labourers, vagrants or the informal economy and shanty towns widespread in developing countries.

I would like to draw an analogy here with the ways in which other readings of Arendt's work have complicated the image that feminists such as Adrienne Rich or Mary O'Brien had perceived as a sexist hierarchy in the distinctions between work, labour and action outlined in *The Human Condition*. At the turn of the twenty-first century, for example, philosopher Seyla Benhabib argued that Arendt did not in fact exclude the private, domestic sphere as a potential 'space of appearance'. Drawing on Arendt's account of Rahel Varnhagen's nineteenth-century salon, published the same year as *The Human Condition*, Benhabib pointed to another kind of space for action, unlike that of the Greek *polis* to the extent that it brought together the personal and the political, the private and the public.[34] Benhabib's emphasis on a *narrative* model for action, characterised by discussion as well as 'gossip', resonates with the significance of storytelling that has emerged in this study of precarious practices. Considering the nineteenth-century salon as a space in which to explore, as Benhabib put it, 'new forms of sociability, association, intimacy, friendship, speaking and writing habits, tastes in food, manners and arts, as well as pastimes, and leisure activities'[35] similarly evokes the experiments in a new art of living in which precarious practices have often been engaged.

For their part, two political theorists, Bonnie Honig and Chantal Mouffe, have retrieved the openness and fluidity that lies at the heart of Arendt's model of the 'sphere of appearance'. Honig perceived in Arendt's writings 'a view of the self as a complex site of multiplicity whose identities are always performatively produced':[36] unstable, they are open to discussion and revision in the field of political action. For Mouffe, this entailed a process of negotiation: 'political practice', she argued, 'cannot be envisaged as simply representing the interests of preconstituted identities, but as constituting those identities themselves in a precarious and always vulnerable terrain'.[37] This, of course, chimes with Rancière's analysis of 'dissensus', which I discussed in Chapter 5.

While Honig drew on Judith Butler's writings on performative identity, and we have seen how Butler's reflections on precariousness converged with the precarious practices discussed in this study, Butler herself directly addressed Arendt's humanist model in a 2011 lecture.[38] Here Butler proposed a new reading of Arendt's 1958 distinction between work, labour and action in light of recent forms of protest which involved occupying specific locations – whether the Occupy movement camping on New York's Liberation Plaza, or the Egyptian revolution during which thousands kept their protest going on Cairo's Tahrir Square for over eighteen days. Butler emphasised how such forms of political expression relied on bodies that not only 'acted in concert', as in Arendt's definition of action in the public sphere of the *polis*, but also

lived, ate and slept 'in public' – biological activities associated with Arendt's description of labour, traditionally isolated in the private domestic sphere and performed by women and slaves excluded from politics. For Butler, these protests demonstrated above all that the 'space of appearance' outlined by Arendt 'does not belong' solely 'to a sphere of politics separate from a sphere of survival and of need'. Thus, concluded Butler, 'even the life stripped of rights' – what Agamben called 'bare life' – 'is still within the sphere of the political, and is thus not reduced to mere being'. Invisible, labouring, precarious bodies also have the power to come together in 'concerted action' and thus bring into being a 'space of appearance'. As I have suggested elsewhere, Hirschhorn's desire to carry out projects such as the *Deleuze* or *Gramsci* monuments on housing estates (figure 57) gives form to works in which 'concerted action' is inseparable from the very 'maintenance' activities discussed by Ukeles in her 1969 manifesto: it is a matter of sustaining, as much as giving birth to, an ongoing possibility for dialogue.[39]

The other precarious works in this study, from Lygia Clark's *Caminhando* (figure 29) or Filliou's cardboard assemblages (figure 35) to Creed's crumpled paper ball of paper (figure 52), from Brecht's event scores (figure 23) to Orozco's *Yielding Stone* (figure 49), from Kaprow's to Alÿs's melting ice sculptures (figures 6 and 47), have all similarly tended, in different ways, to blur the distinctions between work, action and labour outlined by Arendt. Such practices gave birth to borderline spaces at the crossroads of the artistic, the biological and the political. Thus, as we saw, precarious practices operate at the site of immaterial work in contemporary capitalism, where distinctions between these activities have collapsed, as have past divisions between leisure and work, productive work and non-productive labour, public and private. As Isabell Lorey has argued, the very division between individual freedom and self-fulfilment on the one hand, and, on the other hand, the exploitation of others that is required for their maintenance – the framework of 'mutual dependence' analysed by Shannon Jackson – becomes blurred as it is internalised within the precarious affective experience of the self-precarised immaterial worker.[40]

In this sense, I would argue that the redefinition of artistic labour in precarious practices significantly contributes to the ongoing reflections on art's potential to question the capitalist model first analysed by Arendt. In this context, precarious works can be seen to perform a 'heteronomous' disruption similar to those performed, according to Jackson, by 'social works', as well as to what John Roberts considered to be at play in Duchamp's readymades.[41] Such heteronomy, according to Jackson and Roberts, destabilised the fixed boundaries of the artwork by inscribing its ontological definition within the social dynamics of work and labour, thus questioning the separation between self and others, between interiority and exteriority, on which the concept of the autonomous artwork is predicated.

Writing about Duchamp's 'refusal of work', exemplified in his readymades as well as his *oeuvre* as a whole, Maurizio Lazzarato similarly underscores that the artist's rejection of both the working conditions and the marketable features of autonomous art yielded a reflection, beyond binary oppositions, on what a subject can *become* outside the means-end logic of capitalist production. The various kinds of 'good-for-nothings' discussed in this study, I would argue, followed Duchamp's path to laziness and have similarly proposed ways of 'living' and 'acting' 'differently'.[42] Writing in 2014, Lazzarato significantly related Duchamp's refusal of work to the renewed political actions of the French *intermittents du spectacle*, ten years after their first demonstrations in 2004 (which I mentioned in Chapter 5). Like Duchamp, the author suggested, this precarious collective claimed their rights to freedom from the exploitation of capitalist work and from the self-exploitation it requires through the artist's self-precarisation.

As I have demonstrated, precarious practices are similarly involved in maintaining the possibility of a political space of action and discussion, which is constantly threatened by the ever more efficient logic of capitalist work and consumption. By inscribing their fragile, temporary, contingent works within a web of stories, actions and relations, they entrust us with the responsibility of keeping alive such precarious intervals between appearance and disappearance. Just as the political body, as Butler suggested, is *both* 'vulnerable and demanding', I would argue that precarious artworks are *both* vulnerable and demanding, *both* dependent and full of potential.[43] However light, absurd or humorous, they can thus perform an 'ethical' turn.

Notes

1 Fulvia Carnevale and John Kelsey, 'Art of the Possible: An Interview with Jacques Rancière', *Artforum*, 45:7 (2007), http://www.egs.edu/faculty/jacques-ranciere/articles/art-of-the-possible/ (accessed 15 May 2015).

2 Antonio Negri, *Kairòs, Alma Venus, Multitudo* (2000), in *Time for Revolution*, trans. M. Mandarini (London: Bloomsbury, 2013), p. 171.

3 Vassilis Tsianos and Dimitris Papadopoulos, 'Precarity: A Savage Journey to the Heart of Embodied Capitalism', *Transversal* (October 2006), http://eipcp.net/transversal/1106/tsianospapadopoulos/en (accessed 15 May 2015).

4 Lauren Berlant, *Cruel Optimism* (Durham, NC: Duke University Press, 2011), p. 197.

5 'Precarious: Hal Foster on the Art of the Decade', *Artforum*, 48:4 (2009), note 5, 260.

6 Roland Barthes, *Le Neutre: Cours au Collège de France, 1977–1978*, ed. Thomas Clerc (Paris: Seuil, 2002), p. 218.

7 See Jacquelynn Baas and Mary Jane Jacob (eds), *Buddha Mind in Contemporary Art* (Berkeley, CA: University of California Press, 2004); Jacquelynn Baas, *Smile of the Buddha: Eastern Philosophy and Western Art from Monet to Today* (Berkeley, CA: University of California Press, 2005); Alexandra Munroe (ed.), *The Third*

Mind: American Artists Contemplate Asia, 1860–1989 (New York: Guggenheim Museum, 2009).

8 François Jullien, *Traité de l'efficacité* (Paris: B. Grasset, 1996). Trans. J. Lloyd, *A Treatise on Efficacy: Between Western and Chinese Thinking* (Honolulu: University of Hawai'i Pres, 2004).

9 Barthes, *Le Neutre*, pp. 223–4.

10 Maurice Blanchot, 'La Parole quotidienne', in M. Blanchot, *L'Entretien infini* (Paris: Gallimard, 1969), p. 365.

11 See the critiques by Adrienne Rich and Mary O'Brien, summarised in Finn Bowring, *Hannah Arendt: A Critical Introduction* (London: Pluto Press, 2011), pp. 127–9.

12 Typed, unpublished conversation between Allan Kaprow and Suzanne Lacy, 1981, p. 10. Getty Research Institute, Allan Kaprow Papers, Box 53, Folder 18.

13 Helen Molesworth, 'Work Ethic', in Helen Molesworth (ed.), *Work Ethic* (Baltimore and University Park, PA: Baltimore Museum of Art and Penn State University Press, 2003), p. 43.

14 *Ibid.*

15 Unpublished conversation between Kaprow and Lacy, p. 15.

16 Shannon Jackson, *Social Works: Performing Art, Supporting Publics* (Abingdon: Routledge, 2011), p. 89.

17 See *ibid.*, and Jill Johnston, 'Flux Acts', *Art in America*, 6 (June 1994), 78.

18 See Kathy O'Dell, 'Fluxus Feminus', *TDR (The Drama Review)*, 41 (Spring 1997), 43–60.

19 Jackson, *Social Works*, p. 93.

20 Mierle Laderman Ukeles, 'Maintenance Art Manifesto' (1969), reprinted in Peter Selz and Kristine Stiles (eds), *Theories and Documents of Contemporary Art* (Berkeley and Los Angeles: University of California Press, 1996), p. 622.

21 *Ibid.*, p. 31.

22 Tom Lutz, *Doing Nothing: A History of Loafers, Loungers, Slackers and Bums in America* (New York: Farrar, Straus and Giroux, 2006).

23 Quoted in *ibid.*, p. 234.

24 For more on this issue, see Barbara Ehrenreich, *Hearts of Men: American Dreams and the Flight from Commitment* (New York: Anchor Books, 1983), ch. 5.

25 Angela Mitropoulos, 'Precari-Us?', in John Barker et al., *Mute Precarious Reader: Texts on the Politics of Precarious Labour* (London: Mute, 2005), p. 16.

26 Tavia Nyong'o, 'Situating Precarity between the Body and the Commons', *Women & Performance: a journal of feminist theory*, special issue 23:2 (2013), 158.

27 On the latter's precarious practice, see, for example, Alex Pittman, 'Dis-Assembly Lines: Gestures, Situations, and Surveillances', in *ibid.*, 178–92; and Adrian Heathfield and Tehching Hsieh, *Out of Now: The Lifeworks of Tehching Hsieh* (London: Live Art Development Agency, 2009).

28 Berlant, *Cruel Optimism*, p. 195.

29 *Ibid.*, p. 4.

30 *Ibid.*, p. 200.

31 *Ibid.*, p. 212.

32 *Ibid.*, p. 200.

33 Jackson, *Social Works*, p. 35.

34 This account of Benhabib's reading is based on Bowring's summary in *Hannah Arendt*, pp. 137–40.

35 Seyla Benhabib, *The Reluctant Modernism of Hannah Arendt* (2003), quoted by Bowring, *ibid.*, p. 140.

36 Bonnie Honig, 'Toward an Agonistic Feminism: Hannah Arendt and the Politics of Identity', in Bonnie Honig (ed.), *Feminist Interpretations of Hannah Arendt* (1995), quoted in Bowring, *ibid.*, p. 144.

37 Chantal Mouffe, *The Democratic Paradox* (2000), quoted in Bowring, *ibid.*, p. 145.

38 Judith Butler, 'Bodies in Alliance and the Politics of the Street', *Transversal*, special issue 'Occupy and Assemble' (September 2011), http://eipcp.net/transversal/1011/butler/en (accessed 12 May 2014).

39 See my *Thomas Hirschhorn, Deleuze Monument* (London: Afterall, 2014), pp. 72, 82–3.

40 Isabell Lorey, 'Virtuosos of Freedom: On the Implosion of Political Virtuosity and Productive Labour', in Gerald Raunig, Gene Ray and Ulf Wuggenig (eds), *Critique of Creativity: Precarity, Subjectivity and Resistance in the 'Creative Industries'* (London: Mayfly, 2011), ch. V.

41 Shannon Jackson, *Social Works*; John Roberts*, The Intangibilities of Form: Skill and Deskilling in Art after the Readymade* (London and New York: Verso, 2007).

42 *pour agir différemment, il faut vivre différemment.* Maurizio Lazzarato, *Marcel Duchamp et le refus du travail, suivi de Misère de la sociologie* (Paris: Les Prairies ordinaires, 2014), p. 47. For further insights into Duchamp's refusal of work, see Helen Molesworth, 'Work Avoidance: The Everyday Life of Marcel Duchamp's Readymades', *Art Journal*, 57:4 (1998): 50–61.

43 Butler, 'Bodies in Alliance'.

Select bibliography

Alberro, Alexander. *Conceptual Art and the Politics of Publicity* (Cambridge, MA: MIT Press, 2003).

Agamben, Giorgio. *The Coming Community* (1990), trans. M. Hardt (Minneapolis: University of Minnesota Press, 1993).

—— *Homo Sacer: Sovereign Power and Bare Life* (1995), trans. D. Heller-Roazen (Stanford, CA: Stanford University Press, 1998).

—— *Means without End: Notes on Politics* (1996), trans. V. Binetti and C. Casarino (Minneapolis: University of Minnesota Press, 2000).

—— 'Warum war und ist Robert Walser so wichtig?' (2005), www.mikrogramme.de/e945/e935/ (accessed 15 May 2015).

Alloway, Lawrence. 'Junk Culture', *Architectural Design*, 31 (March 1961), 122.

—— 'Introduction', in *Eleven from the Reuben Gallery* (New York: Guggenheim Museum, 1965), n.p.

—— *Topics in American Art since 1945* (New York: Norton, 1975).

Alloway, Lawrence, et al. *New Forms, New Media* (New York: Martha Jackson Gallery, 1960).

Alÿs, Francis, and Cuauhtémoc Medina (eds). *When Faith Moves Mountains* (Madrid: Turner, 2005).

Alÿs, Francis, et al. *Francis Alÿs: The Liar, the Copy of the Liar* (Guadalajara and Monterrey: Arena Mexico Arte Contemporáneo and Galeria Ramis Barquet, 1994).

Alÿs, Francis, et al. *Francis Alÿs, A Story of Deception: Patagonia 2003–2006* (Buenos Aires: Museo de Arte Latinomerico and Fundación Eduardo F. Costantini, 2006).

[Alÿs, Francis]. 'Walking the Line: Francis Alÿs interviewed by Anna Dezeuze', *Art Monthly*, 323 (February 2009), 1–6.

Amerson, Price, and Cynthia Charters. *The Slant Step Revisited* (Davis, CA: Richard L. Nelson Gallery, University of California Davis, 1983).

Applin, Jo, Anna Dezeuze and Julia Kelly (eds). 'Forum: *Assemblage*/Bricolage', *Art Journal*, 67:1 (2008), 24–99.

Arendt, Hannah. *The Human Condition* (1958) (Chicago: University of Chicago Press, 2nd edn, 1998).

—— *Between Past and Future: Six Exercises in Political Thought* (New York: Viking, 1961).

Baas, Jacquelynn. *Smile of the Buddha: Eastern Philosophy and Western Art from Monet to Today* (Berkeley: University of California Press, 2005).

—— (ed.). *Fluxus and the Essential Questions of Life* (Hanover, NH, and Chicago: Hood Museum of Art, Dartmouth College, and University of Chicago Press, 2011).

Baas, Jacquelynn, and Mary Jane Jacob (eds). *Buddha Mind in Contemporary Art* (Berkeley: University of California Press, 2004).

Baker, Elizabeth, and Joseph Raffaele. 'The Way-Out West: Interviews with Four San Francisco Artists', *Art News*, 66:4 (1967), 38–40, 72–75.

Barker, John, et al. *Mute Precarious Reader: Texts on the Politics of Precarious Labour* (London: Mute, 2005).

Barron, Stephanie, Serie Bernstein and Ilene Susan Forst (eds). *Reading California: Art, Image, and Identity, 1900–2000* (Berkeley: University of California Press, 2000).

Barthes, Roland, *Le Neutre: Cours au Collège de France, 1977–1978*, ed. Thomas Clerc (Paris: Seuil, 2002).

Basualdo, Carlos (ed.). *Da Adversidade Vivemos* (Paris: Musée d'Art Moderne de la Ville de Paris, 2001).

—— (ed.). *Tropicália: a Revolution in Brazilian Culture, 1967–1972* (Chicago: Museum of Contemporary Art, 2006).

Basualdo, Carlos, Benjamin H.D. Buchloh, Alison Gingeras et al. *Thomas Hirschhorn* (London: Phaidon, 2004).

Basualdo, Carlos, and Reinaldo Laddaga, 'Rules of Engagement: Art and Experimental Communities', *Artforum*, 42:7 (2004), www.thefreelibrary.com/Rules+of+engagement%3a+from+toilets+in+Caracas+to+new+media+in+new...-a0114594243 (accessed 15/05/2015).

Bauman, Zygmunt. *Liquid Modernity* (Cambridge and Malden, MA: Polity Press and Blackwell, 2000).

Beal, G.W.J., et al. *Wiley Territory* (Minneapolis: Walker Art Center, 1979).

Beaune, Jean-Claude (ed.). *Le Déchet, le rebut, le rien* (Seyssel: Champ Vallon, 1999).

Becker, Wolfgang. 'Interview with Robert Filliou', in *Robert Filliou: Commemor* (Aachen: Neue Galerie im Altern Kunsthaus, 1970), n.p.

Berenstein Jacques, Paola. *A estética da ginga – a arquitetura das favelas através da obra de Hélio Oiticica* (Rio de Janeiro: Casa da Palavra and Rioarte, 2001).

Berlant, Lauren. *Cruel Optimism* (Durham, NC: Duke University Press, 2011).

Biesenbach, Klaus, Mark Godfrey and Kerryn Greenberg (eds). *Francis Alÿs: A Story of Deception* (London: Tate, 2010).

Birnbaum, Daniel. 'A Thousand Words: Gabriel Orozco Talks about His Recent Films', *Artforum*, 36:10 (1998), 114–15.

Birnbaum, Daniel et al. *Textos sobre la obra de Gabriel Orozco* (Mexico and Madrid: Conaculta and Turner, 2005).

Bishop, Claire. *Artificial Hells: Participatory Art and the Politics of Spectatorship* (London: Verso, 2012).

Blanchot, Maurice. 'L'Homme de la rue', *Nouvelle Revue Française*, 114 (June 1962), 1070–81, reprinted as 'La Parole quotidienne', in M. Blanchot, *L'Entretien infini* (Paris: Gallimard, 1969), pp. 355–66.

Blom, Ina. *On the Style Site: Art, Sociality and Media Culture* (Berlin: Sternberg Press, 2007).

Blume, Eugen, Gabriele Knapstein and Catherine Nichols (eds). *Fast Nichts: Minimalistische Werke aus der Friedrich Christian Flick Collection im Hamburger Bahnhof* (Berlin and Cologne: SMB-Dumont, 2005).

Bois, Yve-Alain (ed.). *Gabriel Orozco* (Cambridge, MA: MIT Press, 2009).

Bois, Yve-Alain, et al. *Gabriel Orozco* (London: Thames and Hudson, 2006).

Bonami, Francesco. 'Now is for ever, again', *Tate Etc.*, 15 (Spring 2009), www.tate.org.uk/context-comment/articles/now-ever-again (accessed 9 April 2011).

—— (ed.). *Dreams and Conflicts: The Dictatorship of the Viewer: 50th International Art Exhibition* (New York: Rizzoli, 2003).

Bonami, Francesco, et al. *Gabriel Orozco: Clinton is Innocent* (Paris: Musée d'Art Moderne de la Ville de Paris, 1998).

Bonito Oliva, Achille (ed.). *Ubi Fluxus ibi motus 1990–1962* (Venice: Biennale, 1990).

Boswell, Peter, Bruce Jenkins and Joan Rothfuss. *2000 BC: The Bruce Conner Story Part II* (Minneapolis: Walker Art Center, 2000).

Bourdieu, Pierre. *Contrefeux: propos pour servir à la résistance contre l'invasion néo-libérale* (Paris: Editions Liber, 1998).

Bourriaud, Nicolas. *Relational Aesthetics* (1998), trans. S. Pleasance and F. Woods (Dijon: Presses du réel, 2002)

—— *Postproduction. Culture as Screenplay: How Art Reprograms the World*, trans. J. Herman (New York: Lukas and Sternberg, 2002).

—— *Radicant. Pour une esthétique de la globalisation* (Paris: Denoël, 2009).

—— 'Precarious Constructions: Answer to Jacques Rancière on Art and Politics', *Open*, 17 (2009), special issue on 'A Precarious Existence: Vulnerability in the Public Domain', 20–36.

—— (ed.). *Altermodern: The Tate Triennial* (London: Tate, 2009).

Bowring, Finn. *Hannah Arendt: A Critical Introduction* (London: Pluto Press, 2011).

Brecher, Jeremy, Tim Costello and Brendan Smith. *Globalization from Below: The Power of Solidarity* (Cambridge, MA: South End Press, 2000).

Brecht, George. 'Events: Scores and other occurrences', 12/28/61, *cc V TRE No.1 FLUXUS* (January 1964), 2.

—— *Chance Imagery* (New York: Something Else Press, 1966).

—— *Notebook II, October 1958–April 1959*, ed. Dieter Daniels (Cologne: Walther König, 1998).

—— *Notebook IV, September 1959–March 1960*, ed. Dieter Daniels (Cologne: Walther König, 1998).

—— *Notebook V, March–November 1960*, ed. Dieter Daniels (Cologne: Walther König, 1998).

—— *Notebook VI, March 1961–June 1961*, ed. Dieter Daniels (Cologne: Walther König, 2005).

Brecht, George, and Robert Filliou. *Games at the Cedilla; or, The Cedilla Takes Off* (New York: Something Else Press, 1967)

Brett, Guy. *Kinetic Art: The Language of Movement* (London: Studio Vista, 1968).

—— *Exploding Galaxies: The Art of David Medalla* (London: Kala Press, 1995).

—— 'Between Work and World: Gabriel Orozco' (1998), in Bois (ed.), *Gabriel Orozco*, pp. 51–8.

—— (ed.). *Force Fields: Phases of the Kinetic* (Barcelona and London: MACBA and South Bank Centre, 2000).

—— (ed.). *Hélio Oiticica in London* (London: Tate, 2007).

Brett, Guy, et al. *Hélio Oiticica* (London: Whitechapel Gallery, April 1969).

Brett, Guy, et al. *Hélio Oiticica* (Paris: Galerie nationale du Jeu de Paume, 1992).

Brett, Guy, et al. *Lygia Clark* (Marseille: Musée d'Art Contemporain, 1997).

Buchloh, Benjamin. 'The Sculpture of Everyday Life' (1996), in Bois (ed.), *Gabriel Orozco*, pp. 31–49.

—— 'Detritus and Decrepitude: The Sculpture of Thomas Hirschhorn', *Oxford Art Journal*, 24:2 (2001), 41–56.

—— 'Thomas Hirschhorn: Lay Out Sculpture and Display Diagrams', in Basualdo et al., *Thomas Hirschhorn*, pp. 42–93.

—— 'Sculpture between Nation-state and Global Commodity Production', in Temkin (ed.), *Gabriel Orozco*, pp. 34–43.

Buchloh, Benjamin, and Judith Rodenbeck (eds). *Experiments in the Everyday: Allan Kaprow and Robert Watts – Events, Objects, Documents* (New York: Miriam and Ira D. Wallach Art Gallery, Columbia University, 1999).

Buci-Glucksmann, Christine, *Esthétique de l'éphémère* (Paris: Galilée, 2003).

Budak, Adam, and Peter Pakesch (eds). *Human Condition: Empathy and Emancipation in Precarious Times* (Graz and Cologne: Kunsthaus Graz and Walther König, 2010).

Burnham, Jack. 'Systems Esthetics', *Artforum*, 7:1 (1968), 30–5.

Butler, Judith. *Precarious Life: The Powers of Mourning and Violence* (New York and London: Verso, 2004).

—— 'Bodies in Alliance and the Politics of the Street', *Transversal*, special issue 'Occupy and Assemble' (September 2011), http://eipcp.net/transversal/1011/butler/en (accessed 12 May 2014).

Cage, John. *Silence: Lectures and Writings by John Cage* (Middletown, CT: Wesleyan University Press, 1961).

Carpenter, Ele, and Graham Gussin (eds). *Nothing* (Sunderland: Northern Gallery for Contemporary Art, 2001).

Certeau, Michel de. *L'Invention du quotidien, vol. I: Arts de faire* (1980), ed. Luce Giard (Paris: Gallimard, 1990).

Chandler, John, and Lucy Lippard. 'The Dematerialization of Art', *Art International*, 12:2 (1968), reprinted in Lucy Lippard, *Changing: Essays in Art Criticism* (New York: Dutton, 1971), pp. 255–76.

Clark, Lygia. *Livro-Obra* (Rio de Janeiro: Lygia Clark, 1983).

Clark, T.J. 'At Tate Modern', *London Review of Books*, 33:4 (17 February 2011), www.lrb.co.uk/v33/n04/tj-clark/at-tate-modern (accessed 14 May 2015).

Clark Hodges, Donald. 'Junk Sculpture: What Does It Mean?', *Artforum*, 1:5 (1962), 34.

Coles, Alex. 'Martin Creed: A Case of the Irritating Critique?' [interview], *Documents*, 20 (Spring 2001), 25–35.

Copeland, Mathieu (ed.). *Vides: une retrospective* (Paris and Zurich: Centre Pompidou and JRP Ringier, 2009).

Cooke, Lynne (ed.). *A Little Ramble: In the Spirit of Robert Walser* (New York: Donald Young Gallery, 2013).

Cooper, Denis, et al. *Tom Friedman* (London: Phaidon, 2001).

Corner, Philip. *The Identical Lunch* (San Francisco: Nova Broadcast Press, 1973).

Coupland, Douglas. *Generation X: Tales for an Accelerated Culture* (1991) (London: Abacus, new edn, 2013).

Coyle, Diane. *The Weightless World: Strategies for Managing the Digital Economy* (Oxford: Capstone, 1997).

Creed, Martin, et al. *Martin Creed: Works* (London: Thames and Hudson, 2010).

Critchley, Simon. *Very Little, Almost Nothing: Death, Philosophy, Literature* (1997) (London and New York: Routledge, 2nd edn, 2004).

Davila, Thierry. *Marcher, Créer: Déplacements, flâneries, dérives dans l'art de la fin du XXe siècle* (Paris: Editions du Regard, 2002).

—— *De l'inframince: Brève histoire de l'imperceptible de Marcel Duchamp à nos jours* (Paris: Editions du regard, 2010).

—— (ed.). *Francis Alÿs* (Antibes: Musée Picasso, 2001).

de Salvo, Donna (ed.). *Open Systems: Rethinking Art c.1970* (London: Tate, 2005).

del Real, Patricio. 'Slums Do Stink: Artists, *bricolage* and Our Need for Doses of "Real" Life', in Applin, Dezeuze and Kelly (eds), 'Forum: *Assemblage*/Bricolage', 83–99.

Demos, T.J. 'The Ends of Exile: Toward a Coming Universality', in Bourriaud (ed.), *Altermodern*, n.p.

—— 'Is Another World Possible? The Politics of Utopia in Recent Exhibition Practice', in Maria Hlavajova, Simon Sheikh and Jill Winder (eds), *On Horizons: A Critical Reader in Contemporary Art* (Utrecht and Rotterdam: BAK and post editions, 2011), pp. 52–82.

Detienne, Marcel, and Jean-Pierre Vernant. *Les Ruses de l'intelligence: la mètis des Grecs* (Flammarion: Paris, 1974).

Dezeuze, Anna. 'How to Live Precariously: Lygia Clark's *Caminhando* and Tropicalism in 1960s Brazil', *Women & Performance: a journal of feminist theory*, 23:2 (2013), special issue on 'Precarious Situations: Race, Gender, Globality', edited by Tavia Nyong'o, 226–47.

—— 'Photography, Ways of Living, and Richard Wentworth's *Making Do, Getting By*', *Oxford Art Journal*, 36:2 (2013), 281–300.

—— *Thomas Hirschhorn, Deleuze Monument* (London: Afterall, 2014).

—— (ed.). *The 'Do-It-Yourself' Artwork: Participation from Fluxus to New Media* (Manchester: University of Manchester Press, 2010).

Diserens, Corinne (ed.). *De l'œuvre à l'événement: Nous sommes le moule. A vous de donner le souffle* (Nantes and Dijon: Musée des beaux arts and Presses du Réel, 2005).

Downey, Anthony. 'Zones of Indistinction: Giorgio Agamben's "Bare Life" and the Politics of Aesthetics', *Third Text*, 23:2 (2009), 109–25.

Duchamp, Marcel. *À l'infinitif* (New York: Cordier & Ekstrom, 1966).

Ehrenreich, Barbara. *Hearts of Men: American Dreams and the Flight from Commitment* (New York: Anchor Books, 1983).

Elderfield, John (ed.). *Essays on Assemblage* (New York: Harry N. Abrams, 1992).

Ellegood, Anne. *The Uncertainty of Objects and Ideas: Recent Sculpture* (Washington, DC: Hirshhorn Museum and Sculpture Garden, Smithsonian Institution, 2006).

Enwezor, Okwui, et al. *Thomas Hirschhorn: Jumbo Spoons and Big Cake* (Chicago: Art Institute of Chicago, 2000).

Evans, Tamara S. (ed.). *Robert Walser and the Visual Arts* (New York: Graduate School and University Center, City University of New York, 1996).

Fer, Briony. 'The Scatter: Sculpture as Leftover', in Helen Molesworth (ed.), *Part Object Part Sculpture* (Columbus, OH: Wexner Museum of Art, 2005), pp. 222–33.

—— 'Spirograph: The Circular Ruins of Drawing' (2004), in Bois (ed.), *Gabriel Orozco*, pp. 121–37.

—— 'Constellations in Dust: Notes on the Notebooks', in Temkin (ed.), *Gabriel Orozco*, pp. 22–33.

—— *Martin Creed* (Vancouver: Rennie Collection, 2011).

Ferguson, Russel, et al. *Francis Alÿs* (London: Phaidon, 2007).

Ferreira d'Oliveira, Caroline, and Marianne Lanavère (eds). *Densité ± 0* (Paris: Ecole nationale supérieure des Beaux-Arts, 2004).

Filliou, Robert. *A Filliou Sampler* (New York: Something Else Press, 1967).

—— *Teaching and Learning as Performing Arts* (Cologne and New York, Koenig, 1970).

Fischer, Alfred M. (ed.). *George Brecht Events: A Heterospective* (Cologne: Ludwig Museum, 2005).

Fisher, Jean. 'The Sleep of Wakefulness' (1993), in Bois (ed.), *Gabriel Orozco*, pp. 17–29.

—— 'Toward a Metaphysics of Shit', in Okwui Enwezor (ed.), *Documenta 11, Platform 5: Exhibition Catalogue* (Ostfildern: Hatje Cantz, 2002), pp. 63–70.

—— 'In the Spirit of Conviviality: When Faith Moves Mountains', in Ferguson et al., *Francis Alÿs*, pp. 109–21.

Flood, Richard, et al. *Unmonumental: The Object in the 21st Century* (London and New York: Phaidon and the New Museum, 2007).

Foster, Hal. *The Return of the Real: Art and Theory at the End of the Century* (Cambridge, MA: MIT Press, 1996).

—— 'Precarious: Hal Foster on the Art of the Decade', *Artforum*, 48:4 (2009), 207–9, 260.

—— 'Towards a Grammar of Emergency', in Hirschhorn (ed.), *Thomas Hirschhorn*, pp. 162–81.

Fraser, Ian. 'Affective Labor and Alienation in *Up in the Air*', in Ewa Mazierska (ed.), *Work in Cinema: Labor and the Human Condition* (New York: Palgrave Macmillan, 2013), ch. 1.

Fukuyama, Francis. 'The End of History?', *The National Interest*, 16 (Summer 1989), 3–18.

Garver, Thomas H. *Bruce Conner: Sculpture/Assemblages/Drawings/Films* (Waltham, MA: Brandeis University, 1965).

Garver, Thomas H. [Bruce Conner], 'Bruce Conner Makes a Sandwich', *Artforum*, 6:1 (1967), 51–5.

Gingeras, Alison (ed.). *Thomas Hirschhorn: London Catalog* (London: Chisenhale Gallery, 1998).

Gorz, André. *Métamorphoses du travail. Quête du Sens. Critique de la raison économique* (Paris, Galilée, 1988).

—— *L'Immatériel: Connaissance, valeur et capital* (Paris, Galilée, 2003).

Green, David (ed.). *Makeshift* (Brighton: University of Brighton Gallery, 2001).

Hamilton, Jaimey. 'Arman's System of Objects', *Art Journal*, 67:1 (2008), 43–57.

Hardt, Michael, and Antonio Negri. *Empire* (Cambridge, MA: Harvard University Press, 2000).

Harren, Natilee. 'La Cédille qui ne finit pas: Robert Filliou, George Brecht and Fluxus in Villefranche (deregulated version)' (2012), www.artandeducation.net/paper/la-cedille-qui-ne-finit-pas-robert-filliou-george-brecht-and-fluxus-in-villefranche/ (accessed 9 May 2015).

Harris, Steven. 'The Art of Losing Oneself without Getting Lost: Brecht and Filliou at the Palais Idéal', *Papers of Surrealism*, 2 (Summer 2004), 1–18.

Harris, Andrea L., and John M. Ulrich (eds). *GenXegesis: Essays on Alternative Youth (Sub)culture* (Madison: University of Wisconsin Press, 2003).

Hatch, Kevin. *Looking for Bruce Conner* (Cambridge, MA: MIT Press, 2012).

Herrigel, Eugen. *Zen in the Art of Archery: Training the Mind and Body to Become One* (1953), trans. R.F.C. Hull (London: Penguin, 2004).

Hinderliter, Beth, Vered Maimon, Jaleh Mansoor and Seth McCormick. *Communities of Sense: Rethinking Aesthetics and Politics* (Durham, NC: Duke University Press, 2009).

Hirschhorn, Thomas. *Les Plaintifs, les bêtes, les politiques* (Geneva: Centre Genevois de Gravure Contemporaine, 1995).

—— *Thomas Hirschhorn, Katalog* (Berlin: Künstlerhaus Bethanien, 1995).

—— 'Where Do I Stand? What Do I Want?', *Art Review*, Annual (2007–08).

—— *Critical Laboratory: The Writings of Thomas Hirschhorn*, ed. Lisa Lee and Hal Foster (Cambridge, MA: MIT Press, 2013).

—— (ed.). *Deleuze Monument: les Documents* (Paris: Thomas Hirschhorn, 2000).

—— (ed.). *Musée Précaire Albinet* (Paris: Xavier Barral and Laboratoires d'Aubervilliers, 2005).

—— (ed.). *Thomas Hirschhorn: Establishing a Critical Corpus* (Zürich: JRP Ringier, 2011).

Hollein, Max, and Martina Weinhart (eds). *Nichts/Nothing* (Ostfildern: Hatje Cantz, 2006).

Holloway, John. *Change the World Without Taking Power: The Meaning of Revolution Today* (2002) (Ann Arbor: Pluto Press, 2nd edn, 2005).

Jamet-Chavigny, Stephanie, and Francoise Levaillant (eds). *L'Art de l'assemblage: Relectures* (Rennes: Presses Universitaires de Rennes, 2011).

Jackson, Shannon, *Social Works: Performing Art, Supporting Publics* (Abingdon: Routledge, 2011).

——'Just-in-time: Performance and the Aesthetics of Precarity', *The Drama Review*, 56:4 (2012), 10–31.

Jankélévitch, Vladimir. *Le Je-ne-sais-quoi et le presque rien* (1957) (Paris: Seuil, new edn, 1980).

Johnstone, Stephen (ed.). *The Everyday* (London and Cambridge, MA: Whitechapel and MIT Press, 2008).

Jouannais, Jean-Yves. *L'Idiotie: art vie, politique – méthode* (Paris: Beaux Arts Magazine éditions, 2003).

Jullien, François. *Traité de l'efficacité* (Paris: B. Grasset, 1996).

Kalinovska, Milena (ed.). *Beyond Preconceptions: The Sixties Experiment* (New York: Independent Curators International, 2000).

Kaprow, Allan. *Assemblage, Environments & Happenings* (New York: Harry N. Abrams, 1966).

—— *Essays on the Blurring of Art and Life* (Berkeley: University of California Press, 1993).

Kerouac, Jack. *The Dharma Bums* (1958) (London and New York: Penguin, 1986).

Kester, Grant. 'Lessons in Futility: Francis Alÿs and the Legacy of May '68', *Third Text*, 23:4 (2009), 407–20.

—— *The One and the Many: Contemporary Collaborative Art in a Global Context* (Durham, NC: Duke University Press, 2011).

Kirby, Michael (ed.). *Happenings: An Illustrated Anthology* (New York: E.P. Dutton, 1965).

Klein, Naomi. 'Reclaiming the Commons', *New Left Review*, 9 (May–June 2001), 81–9.

Knapstein, Gabriele. *George Brecht: Events – über die Event-Partituren von George Brecht aus den Jarhren 1959–63* (Berlin: Wiens Verlag, 1999).

Knowles, Alison. *Journal of the Identical Lunch* (San Francisco: Nova Broadcast Press, 1971).

Kosmala, Katarzyna, and Miguel Imas (eds). *Precarious Spaces: The Arts, Social and Organizational Change* (Bristol: Intellect books, forthcoming).

Kostelanetz, Richard. *The Theater of Mixed Means: An Introduction to Happenings, Kinetic Environments, and Other Mixed-Media Performances* (New York: Dial Press, 1968).

—— (ed.). *John Cage* (London: Allen Lane, The Penguin Press, 1971).

Kotz, Liz. *Words to be Looked At: Language in 1960s Art* (Cambridge, MA: MIT Press, 2007).

Kuan Wood, Brian. 'Is it Heavy or Is it Light?', *e-flux journal,* 61 (January 2015), www.e-flux.com/journal/is-it-heavy-or-is-it-light/ (accessed 9 January 2015).

Laddaga, Reinaldo. 'Almost Brothers', *Flash Art*, 38:243 (2005), 110–12.

Lagnado, Lisette. 'El Malabarista e la gambiarra', *Trópico* (2003), http://p.php.uol.com.br/tropico/html/textos/1693,1.shl (accessed 15 May 2015).

Laniol, Eric. *Logiques de l'élémentaire (le dérisoire dans les pratiques contemporaines)* (Paris: L'harmattan, 2004).

Lauf, Cornelia, and Susan Hapgood (eds.). *FluxAttitudes* (Gent: Imschoot, 1991).

Lauson, Cliff (ed.). *Martin Creed: What's the point of it?* (London: Hayward Publishing, 2014).

Lazzarato, Maurizio. 'Immaterial Labor', in Michael Hardt and Paulo Virno (eds), *Radical Thought in Italy* (Minneapolis: University of Minnesota Press, 1996), pp. 133–47.

—— *Marcel Duchamp et le refus du travail, suivi de Misère de la sociologie* (Paris: Les Prairies ordinaires, 2014).

Lee, Pamela M. *Forgetting the Artworld* (Cambridge, MA: MIT Press, 2012).

Leiber, David, and Tom Sachs. *American Bricolage* (New York: Sperone Westwater, 2000).

Lerner, Ben. 'Robert Walser's Disappearing Acts', *New Yorker* (3 September 2013), www.newyorker.com/books/page-turner/robert-walsers-disappearing-acts (accessed 14 May 2015).

Lévi-Strauss, Claude. *La Pensée sauvage* (Paris: Plon, 1962).

Lewallen, Constance M. (ed.). *A Rose Has no Teeth: Bruce Nauman in the 1960s* (Berkeley: University of California Press, 2007).

Lieberman, Rhonda. 'The Loser Thing', *Artforum*, 30:1 (1992), 78–82.

Lingwood, James (ed.). *Francis Alÿs: Seven Walks, London, 2004–2005* (London: Artangel, 2005).

Lippard, Lucy. *Six Years: The Dematerialization of the Art Object from 1966 to 1972* (1973) (Berkeley: University of California Press, new edn, 1997).

Livingston, Jane, and Marcia Tucker. *Bruce Nauman: Works from 1965 to 1972* (Los Angeles and New York: Los Angeles County Museum of Art and Praeger, 1972).

Lorey, Isabell. 'Governmentality and Self-Precarization: On the Normalization of Cultural Producers', *transversal*, 11 (2006), special issue on 'Machines and subjectivity', http://eipcp.net/transversal/1106/lorey/en (accessed 15 May 2015).

Lütgens, Annelies, and Gijs van Tuyl (eds). *Francis Alÿs: Walking Distance from the Studio* (Wolfsburg: Kunstmuseum Wolfsburg, 2004).

Lutz, Tom. *Doing Nothing: A History of Loafers, Loungers, Slackers and Bums in America* (New York: Farrar, Straus, and Giroux, 2006).

Macel, Christine (ed.). *Dionysiac* (Paris: Centre Georges Pompidou, 2005).

Mailer, Norman. 'The White Negro: Superficial Reflections on the Hipster', *Dissent* (Autumn 1957), reprinted in *Dissent* (20 June 2007), www.dissentmagazine.org/online_articles/the-white-negro-fall-1957 (accessed 7 May 2015).

Maimon, Vered. 'The Third Citizen: On Models of Criticality in Contemporary Artistic Practices', *October*, 129 (Summer 2009), 85–112.

Marioni, Tom. *Writings on Art, 1969–1999* (San Francisco: Crown Point Press, 2000).

—— *Beer, Art, and Philosophy: A Memoir* (San Francisco: Crown Point Press, 2003).

Marter, Joan (ed.). *Off Limits: Rutgers University and the Avant-garde, 1957–1963* (Newark, DE: Newark Museum, 1999).

Matzner, Florian (ed.). *Public Art: A Reader* (Ostfildern-Ruit: Hatje Cantz, 2nd edn, 2004).

Medalla, David (ed.). *Signals* (1964–66) (London: Institute of International Visual Arts, 1995).

Medina, Cuauhtémoc (ed.). *Francis Alÿs: Walking Distance from the Studio* (Mexico City: Antiguo Colegio de San Ildefonso, 2006).

Menger, Pierre-Michel. *Portrait de l'artiste en travailleur: Métamorphoses du capitalisme* (Paris: Seuil, 2002).

Meyer, James. 'Nomads: Figures of Travel in Contemporary Art' (1997), in Alex Coles (ed.), *Site-Specificity: The Ethnographic Turn* (London: Black Dog Publishing, 2000), pp. 10–26.

Meyer-Hermann, Eva, Andrew Perchuk and Stephanie Rosenthal (eds). *Allan Kaprow – Art as Life* (Los Angeles and London: Getty Research Institute and Thames and Hudson, 2008).

Mezzadra, Sandro. 'Living in Transition: Toward a Heterolingual Theory of the Multitude', *Transversal* (June 2007), http://eipcp.net/transversal/1107/mezzadra/en (accessed 13 May 2015).

Milman, Estera (ed.). *Fluxus: A Conceptual Country*, special issue of *Visible Language*, 26:1–2 (1992).

Molesworth, Helen. 'Work Avoidance: The Everyday Life of Marcel Duchamp's Readymades', *Art Journal*, 57:4 (1998), 50–61.

—— (ed.). *Work Ethic* (Baltimore and University Park, PA: Baltimore Museum of Art and Penn State Unversity Press, 2003).

—— (ed.). *Part Object Part Sculpture* (Columbus, OH: Wexner Museum of Art, 2005).

Mundy, Jennifer (ed.). *Lost Art: Missing Artworks of the Twentieth Century* (London: Tate, 2013).

Munroe, Alexandra (ed.), *The Third Mind: American Artists Contemplate Asia, 1860–1989* (New York: Guggenheim Museum, 2009).

Nauman, Bruce. *Please Pay Attention Please: Bruce Nauman's Words: Writings and Interviews*, ed. Janet Kraynak (Cambridge, MA: MIT Press, 2002).

Negri, Antonio. *Kairòs, Alma Venus, Multitudo* (2000), in *Time for Revolution*, trans. M. Mandarini (London: Bloomsbury, new edn, 2013).

Neilson, Brett, and Ned Rossiter. 'Precarity as a Political Concept, or, Fordism as Exception', *Theory, Culture & Society*, 25:7–8 (2008), 51–72.

Nöel, Ann, and Emmett Williams (eds). *Mr. Fluxus: A Collective Portrait of George Maciunas, 1931–1978* (London: Thames and Hudson, 1997).

Oiticica, Hélio. *Aspiro ao Grande Labirinto*, ed. Luciano Figueiredo et al. (Rio de Janeiro: Rocco, 1986).

Orozco, Gabriel. 'Impact and *satori*: Instruments of Comprehension', *Artforum*, 40:3 (2001), 118–23.

Packard, Vance. *The Wastemakers* (Harmondsworth: Penguin Books, 1960).

Paldi, Livia (ed.). *Marjetica Potrč: Next Stop, Kiosk* (Llubjana: Llubjana Museum of Art, 2003).

Parvu, Ileana (ed.). *Objets en procès: Après la dématérialisation de l'art* (Geneva: Métispresses, 2012).

Phillips, James. 'Agamben's Limbos: Robert Walser and the Refugee', *Textual Practice* 28:2 (2014), 289–303.

Phillips, Lisa (ed.). *Beat Culture and the New America, 1950–1965* (New York and Paris: Whitney Museum of American Art and Flammarion, 1996).

Pleyers, Geoffrey. *Alter-Globalization: Becoming Actors in a Global Age* (Cambridge and Malden, MA: Polity Press, 2010).

Puar, Jasbir, with Lauren Berlant, Judith Butler, Bojana Cvejic, Isabell Lorey and Ana Vujanovic, 'Precarity Talk: A Virtual Roundtable', *The Drama Review*, 56:4 (2012), 163–77.

Rancière, Jacques. *Le Partage du sensible: esthétique et politique* (Paris: La Fabrique Editions, 2000).

Raunig, Gerald. *A Thousand Machines: A Concise Philosophy of the Machine as Social Movement*, trans. A. Derieg (Los Angeles: Semiotext(e), 2010).

Raunig, Gerald, Gene Ray and Ulf Wuggenig (eds). *Critique of Creativity: Precarity, Subjectivity and Resistance in the 'Creative Industries'* (London: Mayfly, 2011).

Ray, Gene. 'Another (Art) World is Possible', *Third Text*, 18:6 (2004), 565–72.

Reich, Robert. *The Work of Nations: Preparing Ourselves for Twenty-first-century Capitalism* (New York: Vintage, 1992).

Reps, Paul. *Zen Flesh Zen Bones* (Garden City, NY: Doubleday, 1961).

Ressler, Oliver, and Gregory Sholette (eds). *It's the Political Economy, Stupid! The Global Financial Crisis in Art and Theory* (London: Pluto Press, 2013).

Ridout, Nicolas, and Rebecca Schneider (eds). 'Precarity and performance', special issue of *The Drama Review*, 56:4 (2012).

Rifkin, Jeremy. *The Age of Access: The New Culture of Hypercapitalism, Where All of Life is a Paid-for Experience* (New York: J.P. Tarcher/Putnam, 2000)

Roberts, John. *The Intangibilities of Form: Skill and Deskilling in Art After the Readymade* (London and New York: Verso, 2007).

Robinson, Julia (ed.). *New Realisms, 1957–1962: Object Strategies between Readymade and Spectacle* (Cambridge, MA, and Madrid: MIT Press and Museo nacional Centro de arte Reina Sofía, 2010).

Rodenbeck, Judith F. *Radical Prototypes: Allan Kaprow and the Invention of Happenings* (Cambridge, MA: MIT Press, 2011).

Ross, Christine. *The Past is the Present; It's the Future Too: The Temporal Turn in Contemporary Art* (New York and London: Continuum, 2012).

Rugoff, Ralph. *Just Pathetic* (Los Angeles: Rosamund Felsen Gallery, 1990).

—— 'Touched by your Presence: Invisibility in Art', *Frieze*, 50 (January–February 2000), www.frieze.com/issue/print_article/touched_by_your_presence/ (accessed 6 May 2015).

—— *Invisible: Art about the Unseen, 1957–2012* (London: South Bank Centre, 2012).

—— (ed.), *A Brief History of Invisible Art* (San Francisco: California College of the Arts Wattis Institute for Contemporary Arts, 2005).

Scanlan, John. *On Garbage* (London: Reaktion Books, 2005).

Schafner, Ingrid (ed.), *The Big Nothing* (Philadelphia: Institute of Contemporary Arts, 2004).

Seitz, William. *The Art of Assemblage* (New York: Museum of Modern Art, 1961).

—— 'Assemblage: Problems and Issues', *Art International*, 6 (February 1962), 26–34.

Selz, Peter (ed.). *Funk* (Berkeley: University of California, 1967).

Shannon, Joshua. *The Disappearance of Objects: New York Art and the Rise of the Postmodern City* (New Haven, CT: Yale University Press, 2009).

Shattuck, Roger. *The Banquet Years; The Arts in France, 1885–1918: Alfred Jarry, Henri Rousseau, Erik Satie, Guillaume Apollinaire* (London: Faber and Faber, 1958).

Sholette, Gregory, and Nato Thomson (eds). *The Interventionists: Users' Manual for the Creative Disruption of Everyday Life* (Cambridge, MA: MIT Press, 2004).

Sholette, Gregory, and Blake Stimson (eds). *Collectivism after Modernism: The Art of Social Imagination after 1945* (Minneapolis, MN: University of Minnesota Press, 2007).

Sontag, Susan. *Against Interpretations and Other Essays* (New York: Octagon Books, 1982).

Spoerri, Daniel. *An Anecdoted Topography of Chance* (1962–1966) (London: Atlas Press, 1995).

Standing, Guy. *The Precariat: The New Dangerous Class* (London and New York: Bloomsbury, 2011).

Suzuki, D.T. *Zen Buddhism: Selected Writings of D.T. Suzuki*, ed. William Barrett (New York: Doubleday, 1956).

—— *Introduction to Zen Buddhism* (New York: Grove, 1964).

—— *The Awakening of Zen*, ed. Christmas Humphreys (Boulder, CO: Prajná Press, 1980).

Suzuki, Shunryu. *Zen Mind, Beginner's Mind: Informal Talks on Zen Meditation and Practice*, ed. Trudy Dixon (1970) (London and Boston: Weatherhill, new edn, 1999).

Temkin, Ann (ed.), *Gabriel Orozco: Photogravity* (Philadelphia: Philadelphia Museum of Art, 1999).

—— (ed.), *Gabriel Orozco* (New York: Museum of Modern Art, 2009).

Tillman, Pierre. *Robert Filliou: nationalité poète* (Dijon: Presses du Réel, 2006).

Torres, David. 'Francis Alÿs, simple passant/Walking the Dog', *Art Press* 267 (April 2001), 18–23.

Tsianos, Vassilis, and Dimitris Papadopoulos, 'Precarity: A Savage Journey to the Heart of Embodied Capitalism', *Transversal* (October 2006), http://eipcp.net/transversal/1106/tsianospapadopoulos/en (accessed 15 May 2015).

Virno, Paolo. 'Virtuosity and Revolution: The Political Theory of Exodus' (1996), www.generation-online.org/c/fcmultitude2.html (accessed 5 May 2015).

Walser, Robert. *Selected Stories*, trans. C. Middleton (New York: Vintage Books, 1983).

Watts, Alan W. *The Way of Zen* (1957) (London: Thames and Hudson, 1958).

—— 'Beat Zen, Square Zen, and Zen' (1959), in Alan Watts, *This is it and Other Essays on Zen and Spiritual Experience* (New York: Vintage Books, 1973), pp. 78–110.

Weidman, Phil. *Slant Step Book* (Sacramento, CA: The Art Co., 1969).

Whiteley, Gillian. *Junk: Art and the Politics of Trash* (London and New York: I.B. Tauris, 2010).

[Wilson, Michael]. 'Just Pathetic: Michael Wilson on Sore Winners', *Artforum*, 43:2 (2004), http://business.highbeam.com/4137/article-1G1-123628550/just-pathetic-michael-wilson-sore-winners (accessed 13 May 2015)

Žižek, Slavoj. 'Knee Deep', *London Review of Books*, 26:7 (2 September 2004), www.lrb.co.uk/v26/n17/print/zize01_.html (accessed 17 May 2006).

Films and videos

Anon. (dir.). *Martin Creed* (London: Illuminations, 2001). 26 min.

Linklater, Richard (dir.). *Slacker* (1991). 100 min.

Mendes, Sam (dir.). *American Beauty* (1999). 122 min.

Nelson, Gunvor, and Dorothy Wiley (dirs). *Five Artists: BillBobBillBillBob* (1971). 16mm film. 70 min.

Reitman, Jason (dir.). *Up in the Air* (2009). 109 min.

Archives

Museum of Modern Art, New York: René d'Harnoncourt Papers; William Seitz Papers; Curatorial Exhibition Files, Exh #691–695; Registrar Exhibition Files, Exh. #695.
Archives of American Art, Smithsonian Institution, Washington, DC: oral histories.
Getty Research Institute, Los Angeles: Allan Kaprow Papers, Jean Brown Papers, Dick Higgins Papers.

Unpublished interviews

Francis Alÿs, Mexico City, 23 September 2008.
Thomas Hirschhorn, Aubervilliers, 20 March 2009.
Alison Knowles, New York, 17 March 2011.
Tom Marioni, San Francisco, 8 January 2009.
Gabriel Orozco, New York, 23 January 2009.
William T. Wiley, Washington, DC, 3 October 2009.

Index

Notes. Page numbers in *italic* indicate illustrations. Artworks and books are listed under the authors' names; films and exhibitions are listed under their titles.